Contents

Foreword

In 1984 Heinz Berggruen and his family donated ninety works by Paul Klee to The Metropolitan Museum of Art. These eleven paintings, seventy-one watercolors, and eight black-and-white drawings constitute one of the most important gifts in the history of the Museum. Overnight the Metropolitan became a major center for the study of this German artist.

Mr. Berggruen, a prominent collector and art dealer, has been principally interested in the work of such late nineteenth- and twentieth-century masters as Cézanne, Seurat, Matisse, Picasso, and, of course, Klee. Over many years he assembled, with a discriminating eye for quality, the ninety works by Klee he gave to the Metropolitan.

All aspects of Paul Klee both as a painter and as a draftsman are illustrated by The Berggruen Klee Collection. The works span the career of the artist from his student days in Bern in the 1890s to his death in Muralto-Locarno in 1940. The earliest work is a precisely penciled view of Bern drawn in 1893 when Klee was thirteen years old, and the latest is a gouache painted in the year of his death. More than half of the works in the collection were executed during the painter's most active years, 1921 through 1931, when he taught at the Bauhaus, first in Weimar and then in Dessau.

Mr. Berggruen's interest in Klee began in the United States, to which he emigrated in 1936. While traveling on his honeymoon in 1937, he purchased, in Chicago, his very first picture, a watercolor by Paul Klee. It was *Phantom Perspective*, 1920 (see p. 122). This work, in his own words, became a sort of talisman to him. That talisman is today part of his gift to The Metropolitan Museum of Art.

In Paris after World War II Heinz Berggruen established himself as a leading dealer in twentieth-century prints, drawings, and paintings. To

his distinguished career as a dealer he added one as a publisher. Notable among his publications are: *Picasso: Carnet Catalan* (1958), *Paul Klee: Les Années 20* (1971), and the definitive catalogue of paintings by Juan Gris compiled by Douglas Cooper with Margaret Potter (1977). The catalogues of the exhibitions held in his gallery are elegant in format and remain perfect examples of their kind.

The Berggruen Klee Collection ranks as a major addition to the development of the Metropolitan's Department of 20th Century Art, and selections from it will be permanently exhibited on a rotating basis in The Berggruen Klee Gallery in The Lila Acheson Wallace Wing. Mr. Berggruen has also generously given to the Museum the most important part of his extensive Klee library, as well as valuable related documents.

I also welcome the opportunity to thank Götz Adriani, the director of the Kunsthalle Tübingen in Germany. At his instigation, The Berggruen Klee Collection will be shown at the Kunsthalle in the early part of 1989. In Tübingen the collection will be complemented by nineteen additional works by Klee associated with Mr. Berggruen. These are the thirteen works that Mr. Berggruen gave to the Musée National d'Art Moderne, Paris, in 1972, and the six that remain in his private collection. The Stuttgart publisher Gerd Hatje will publish an augmented German edition of this volume for that occasion.

William S. Lieberman, Chairman of the Museum's Department of 20th Century Art, participated extensively in each stage of the publication and exhibition of this collection. Mr. Lieberman and Mr. Berggruen have been close friends for more than forty years in Paris and New York. In arranging the transfer of The Berggruen Klee Collection to the Metropolitan, Mr. Lieberman was assisted by Ashton Hawkins, Vice President, Secretary and Counsel, and by Kay Bearman, Administrator of the Department of 20th Century Art.

Sabine Rewald, Assistant Curator in the Department of 20th Century Art, is the perceptive author of this book. She catalogued the entire Berggruen Klee Collection and contributed to its publication a candid interview given her by the artist's son, Felix.

Philippe de Montebello
Director
The Metropolitan Museum of Art

Some Stations on My Klee Itinerary

When Paul Klee died in 1940, I was twenty-six years old. I could have known him, but I didn't, having left my native Germany in 1936 without ever seeing a work by Klee or, for that matter, hearing his name. This was all quickly corrected when, a few months later, I arrived in San Francisco and went to that city's modern museum. There I had my first encounter with Klee.

How can I explain why I was immediately and intensely drawn to his work? Was it the abrupt transplantation of a very young and fragile person, a youngster with unfulfilled literary ambitions, to a new and very different environment? Subconsciously, Klee's work must have evoked the emotional vibrations that filled the many happy years of my youth in pre-Nazi Berlin. There in San Francisco a love story commenced that has not ended to this day.

About a year after my first introduction to the magic of Klee—for it was, indeed, magic to me—I met an elderly man who was willing to sell me a watercolor. The work was, typically, an extremely subtle composition and reminded me of Kafka, whom I had just discovered. It was called *Perspectiv-Spuk*. I remember that I paid the man one hundred dollars, a great deal of money to me at the time. I never parted with the picture, carrying it with me wherever I went, and I am happy that it is now, fifty years later, in the Klee collection that I have given to The Metropolitan Museum of Art (see page 122).

War came, I was drafted into the U.S. Army, and there was neither time nor opportunity to look for other works by the artist who was to mean so much to me. Many years later I made a discovery that gave me endless satisfaction. Let me explain. Having become involved with the visual arts on a professional basis—a rather fancy way of putting it, but how else can one define an art dealer?—I soon found out that, as in most

other professions, there is a great deal of jealousy among artists. I mean *living* artists. The dead ones are fine—Rembrandt is great; so is Tintoretto; so is Cézanne. Picasso loved Cézanne, but with few exceptions (Matisse in particular) did not have much respect for his contemporaries. To my delight, I learned that one of those exceptions was Paul Klee. Picasso had a deep admiration for him and in the late 1930s made one of his rare trips abroad to Bern and visited Klee. Since, as a collector and a dealer, I had become very involved with Picasso over the years, this gave me great joy. The living artist whom I most admired shared my love for Klee.

What was my involvement with Klee? What was it that drew me so close to his work from the very beginning and increasingly over the years? Klee himself, who is most articulate in his numerous writings (diaries, lectures, essays), says he is not concerned with our everyday world but with the world beyond our commonplace reality: "I cannot be understood in purely earthly terms. For I can live as happily with the dead as with the unborn. Somewhat nearer to the heart of all creation than is usual. But still far from being near enough."

Klee's world is not an abstract world any more than Klee is an abstract painter. It is a world both related to and yet far removed from what we see around us. It is a world of mystery and fantasy, of dreams and whims, and yet it is a world that is never gratuitous and certainly not obvious. Klee gently takes us by the hand and says, "There, look around. This is my domain." It is a world of silence and of subtle sounds, a world of poetry and muted music. This very secret and confidential realm brings endless discoveries and surprises to those who enter. Once I became quite obsessively involved in this universe, I realized that there were other people like myself who were addicted to Klee. His art was their drug, and those who could afford it added to their growing collections of his work. These people form a club that has no laws or bylaws. It is a club of unwritten rules in which every member, under the spell of his idol, realizes what Klee means when he says in his "Creative Credo" of 1920: "Art does not render the visible; rather, it makes visible." One of the most fervent Klee admirers and collectors whom I had the fortune to meet invariably used to address his letters to me and other Klee fiends with the opening greeting "Dear Klee-Mate." I am sure that Klee, who knew no English, would have been delighted with this salutation. Aren't we fortunate to be Klee-Mates?

In 1948, I opened my first gallery in Paris. To call it a gallery seems pretentious. It was a tiny shop on the ground floor of a lovely small building overlooking the Place Dauphine. It was in the heart of Paris, below the apartment of the actors Yves Montand and Simone Signoret.

The place was too small to hold formal exhibitions or even to display pictures properly.

A few years later and a few blocks away I found a larger place on the rue de l'Université. (To finance the new gallery I sold the Place Dauphine shop to the Montands, who converted it into a kitchen, which it remains today.)

My first exhibition, accompanied by a modest catalogue, already of the elongated shape that was to become a trademark of my shows, was devoted to Paul Klee. It was a show of graphics only and was, in fact, the first display of Klee graphics ever held in Paris. It was the beginning of many exhibitions presenting rare or new works by Schwitters, Arp, Picasso, Matisse, Miró, and other masters of our time. I believe, however, the most striking shows were the ones devoted to Klee held about once every two or three years.

Whenever we mounted a Paul Klee exhibition, we knew that people would wait outside for the gallery to open each morning. (We opened as early as nine o'clock!) The shows concentrated on many aspects of Klee's work: drawings, watercolors, paintings, his early period, the Bauhaus production, and his late works. The catalogues contained texts by prominent French writers, such as Claude Roy and Jacques Prévert.

I always had the idea—the non-French reader will forgive me, but the English translation cannot reflect the play on words—to organize an exhibition called *Les Klee du Paradis* (The Keys to Paradise).* I never did that show. Without being aware of it, I must have been waiting for the doors of the new wing at The Metropolitan Museum of Art to open to let us now all enjoy *Les Klee du Paradis*.

<div align="right">

Heinz Berggruen
Paris
October 1986

</div>

*The French word *clés* (keys) is pronounced the same as the artist's name.

Preface

Paul Klee was born in Bern in 1879. In his youth he was torn between music and painting, but as a profession decided on the latter and went to Munich in 1898 to learn to draw. He stayed there three years. After an extended visit to Italy, he returned to Bern where he underwent a prolonged period of self-education as an artist, attending lectures on anatomy, experimenting with various techniques, and working mainly on paper and in black and white. Later, he saw much of Kandinsky and his Blue Rider friends. He was also influenced by the Cubism of Braque and Picasso, and took great interest in the method with which Delaunay and Macke represented color, light, and form. In 1914, on a visit to Tunisia, Klee fell in love with color. By 1915, he had devised his unique style of abstracted forms and merry symbols. Turning his back on nature, he drew his subjects from his imagination, his reactions to the world around him, past experiences, poetry, music, and things botanical and scientific—in short, a world of fancy, full of irony, whimsy, and impish humor, yet interwoven, especially toward the close of his life, with melancholy.

Humor played a large part in Klee's art and life. As his letters, poems, and the titles of his works reveal, he was also a master of the pun. I like to think that he might have been amused that someone named Berggruen, German for "green mountain," would collect Klee, which means "clover."

Heinz Berggruen was born in Berlin in 1914. Growing up in that city, he returned to it in 1934, after studying medieval art for two years in Grenoble and Toulouse. He then turned to journalism, writing articles for the leading newspaper, the *Frankfurter Zeitung*. His essays were deft observations on life in the German metropolis, and in style they were comparable to the vignettes in "The Talk of the Town" that intro-

duce each issue of *The New Yorker.* Mr. Berggruen's pieces were marked by a sharp eye, an ear for dialogue, and a pungent humor, qualities his friends continue to enjoy today.

Recipient of a scholarship from the University of California at Berkeley, Heinz Berggruen emigrated to the United States in 1936. The following year he joined the staff of the *San Francisco Chronicle,* reviewing art and music; married; and bought his first Klee. As he says, "It was a fluke," for it was not until 1945 that he became seriously interested in the art of Paul Klee. By that time he had been drafted into the United States Army, and had been sent to Germany as part of the Army's military intelligence branch. In Munich he met people active in publishing and in the arts who awakened his interest in art books and prints and again in Klee. Mr. Berggruen did not return to the United States after World War II, but instead he moved to Paris where he was appointed deputy head of fine arts for the newly created UNESCO (United Nations Educational, Scientific, and Cultural Organization). Finally, in 1948, he took a decisive step and became a dealer in rare and out-of-print art books, opening a small gallery at 15, Place Dauphine, Paris. He thus followed in the footsteps of his grandfather, Oskar Berggruen, who had been the first publisher for the Gesellschaft für vervielfältigende Kunst (Society for Graphic Art). This society, between 1879 and 1930, published the magazine *Die Graphischen Künste.*

In 1950 Heinz Berggruen moved his gallery to larger quarters at 70, rue de l'Université, two blocks away from today's Musée d'Orsay, where the gallery still operates under his name. At this location, Mr. Berggruen exhibited the works of major twentieth-century artists, placing an emphasis on their graphic art and works on paper, including Chagall, Dubuffet, Ernst, Gris, Matisse, Miró, Morandi, Picasso, Schwitters, and Klee. In 1981, he retired, but his gallery has continued under the management of Antoine Mendiharat, his longtime collaborator.

As Mr. Berggruen writes in his essay, he never met Paul Klee. Indeed, he had left his native Germany in 1936 without ever having seen a work by the artist. He was fortunate, however, in meeting after the war three German art dealers who had promoted Klee's work in New York during the 1930s and 1940s: J. B. Neumann, Curt Valentin, and Karl Nierendorf. These men came from Berlin or had worked there before the war, just like Berggruen himself.

The paths of the Berggruen and Klee families did cross, however, even if indirectly, through Mr. Berggruen's present wife, Bettina. In 1952 the future Mrs. Berggruen, who is the daughter of the celebrated actor Alexander Möissi, took part in a radio play in Bern directed by Paul Klee's only son, Felix.

During the 1950s, Mr. Berggruen's gallery in Paris became the center for Klee in France and even in the whole of Europe. The first

exhibition at his gallery, in 1952, was devoted to the prints of Klee, and it was followed by many more Klee exhibitions in the following decades. In fact, Heinz Berggruen organized more exhibitions of the works of Paul Klee than of any other artist.

It is no exaggeration to say that Heinz Berggruen is among those who are responsible for Klee's present popularity. Every city seemingly wants a Klee exhibition. In 1987 alone, cities as large, small, and as far apart as New York, Kiel, Cleveland, Mendrisio, Pasadena, Innsbruck, Philadelphia, Nuremberg, San Francisco, Graz, Salzburg, Vienna, and Bern mounted one-man exhibitions of his work. And The Berggruen Klee Collection in The Metropolitan Museum of Art will generate ever-greater interest in Klee.

Sabine Rewald
Assistant Curator
Department of 20th Century Art

Acknowledgments

Anyone who wants information on Klee will—sooner or later, by letter or in person—consult the Paul Klee Stiftung in the Kunstmuseum Bern. During the summer of 1985, thanks to a Theodore Rousseau Memorial Travel Grant from The Metropolitan Museum of Art, I was fortunate to work for several weeks at the Stiftung.

I am indebted to Jürgen Glaesemer, the director of the Paul Klee Stiftung, Bern, who placed this remarkable documentary and visual archive on Klee at my disposal. I also received assistance from his staff, among them Marie-Françoise Haenggli-Robert, Stefan Frey, and Wolfgang Kersten. They kindly answered my many questions, first at the Stiftung, and subsequently by mail. Also in Bern, Eberhard W. Kornfeld gave sound advice; Elka Spoerri most generously let me stay at her apartment near the Cathedral; and Kåthi Bürgi talked to me about Klee whom she knew well.

During the same summer and again in the winter of 1986, it was a pleasure to meet with Felix Klee and his wife, Livia Meyer-Klee. In the course of the last three years Felix Klee has tirelessly provided information, sent photographs, and answered queries. I wish to thank him for enduring my hundreds of questions during an entire week in February 1986, accompanying it with his usual good cheer.

In Lucerne, the late Siegfried Rosengart and his daughter Angela showed me their collection of works by Klee, offered advice, and gave me information on the history of some of the paintings. In Basel, Christian Geelhaar of the Kunstmuseum Basel gave assistance *in situ* and later via mail.

In Europe, I also received assistance from Werner Schmalenbach at the Kunstsammlung Nordrhein-Westfalen, Düsseldorf; Mrs. Schulz-

Hoffmann at the Bayerische Staatsgemäldesammlung, and Jelena Hahl at the Städtische Galerie im Lenbachhaus, both in Munich; Magdalena M. Moeller at the Sprengel Museum, Hannover, and Mrs. Margrit Sprengel, its benefactress; Ole Henrik Moe at the Sonja Henie-Niels Onstad Foundation, Oslo; Jessica Boissel at the Musée National d'Art Moderne, Centre Georges Pompidou, and Maurice Jardot at the Galerie Louise Leiris, both in Paris; Sabine Hartmann at the Bauhaus Archiv, Berlin; Ulrike Gauss at the Staatsgalerie Stuttgart. Antoine Mendiharat of the Galerie Berggruen & Cie, Paris, helped with the transfer of parts of the Berggruen Klee library to The Metropolitan Museum of Art and was helpful in many other ways.

I received photographs or assistance from Annette Baumeister, Stadtmuseum Düsseldorf; Elisabeth Biondi, Vanity Fair, New York; Hans Brockstedt, Hamburg; Martina Bochow-Goltz and Monika Kimmig-Goltz, Munich; Rosel Gollek, Städtische Galerie im Lenbachhaus, Munich; Ernst-Gerhard Güse, Münster; Erich R. Heller, Oberoesterreichisches Landesmuseum, Linz; Ilse Holzinger, Gabriele Münter- und Johannes Eichner-Stiftung, Munich; Klaus Lankheit, Karlsruhe; Achim Moeller, New York; Peter-Klaus Schuster, Neue Pinakothek, Munich; Alice Strobl, Graphische Sammlung Albertina, Vienna; Volker Wahl, Nationale Forschungs- und Gedenkstätten der Klassischen deutschen Literatur, Goethe- und Schiller-Archiv, Weimar; Hugo Weidenhaupt, Staatsarchiv Düsseldorf.

In compiling the provenance and exhibition histories of the individual works in this collection, I was helped by numerous colleagues, gallery personnel, and collectors. I wish to thank William R. Acquavella, New York; Christoph von Albertini, Aathal, Switzerland; Siegfried Adler, Hinterzarten, Germany; Angelika Affentranger, Galerie Nathan, Zürich; the late Mrs. Alfred H. Barr, Jr., New York; Vivian Barnett, The Solomon R. Guggenheim Museum, New York; Julian Barran, Sotheby's, London; John Barratt, Monte Carlo; Ute-Meta Bauer, Kunstverein, Hamburg; Arne Belenius, Ab Belfur, Stockholm; Susanne Brunner, Kunstmuseum, Lucerne; Christopher Burge, Christie's, New York; S. Chew, Christie's, London; Gérald Cramer, Geneva; Catherine de Croës, Commissariat Général aux Relations Internationales, Brussels; Emilie Dana, Busch-Reisinger Museum, Cambridge, Mass.; Ralph J. Dosch, Sotheby's, Zürich; Roland Dorn, Städtische Kunsthalle Mannheim; Bernd Dütting, Galerie Ernst Beyeler, Basel; Marianne Feilchenfeldt, Zürich; C. L. Fischer, The Netherlands; O. E. Fischer, Krefeld; Björn Fredlund, Göteborgs Konstmuseum; Hubertus Froning, Museum Folkwang, Essen; Gabrowski Gallery, London; Melissa Glick, ICA, Boston; James Goodman, New York; Siegfried Gohr, Kunsthalle, Cologne; Gisela Götte, Clemens-Sels-Museum, Neuss; Pamela Griffin,

Arts Council of Great Britain, London; B. Hensel, Kunstgewerbeschule der Stadt Zürich; Karl-Heinz Hering, Kunstverein für die Rheinlande und Westfalen, Düsseldorf; Helga Hinse, Staatliche Galerie, Dessau; B. C. Holland, Chicago; Ingrid Hutton, Leonard Hutton Galleries, New York; Sidney Janis, New York; Jevta Jevtovic, Musée National de Belgrade; Laura Laughlin Johnson, Sotheby's, New York; J. M. Joosten, Stedelijk Museum, Amsterdam; Roman Norbert Ketterer, Campione; Vicki Kendall, The Museum of Modern Art, New York; Heidi Knorsch, Frankfurter Kunstverein; Dieter Koepplin, Kupferstichkabinett der Öffentlichen Kunstsammlung, Basel; Rudolf Koella, Kunstmuseum Winterthur; Carlo Kos, Klagenfurt; Dorothy Kosinski, Basel; Claude Lapaire, Musée d'Art et d'Histoire, Geneva; Peter Carsten Lempelius, Munich; J. M. Lebrecht-Ellis, Geneva; Robert Lewin, Brook Street Gallery, Ltd., London; Nancy C. Little, M. Knoedler & Co., Inc., New York; Gilbert Lloyd, Marlborough Fine Art Limited, London; Heikki Malme, Ateneumin Taidemuseo, Helsinki; Donald McKinney, Hirschl & Adler Modern, New York; Barbara Mirecki, Donald Young Gallery, Chicago; Markus Mizne, Monte Carlo; Jack Mognaz, Marlborough Gallery, Inc., New York; Judy A. Mowinckel, Norton Simon Museum of Art, Pasadena; Claudia Neugebauer, Galerie Ernst Beyeler, Basel; Ernst Nolte, Hauswedell & Nolte, Hamburg; Nina Öhman, Moderna Museet, Stockholm; Constance B. Pemberton, Sotheby's, London; Jessie W. Petcoff, Duke University Museum of Art, Durham; Margaret Potter, New York; Mrs. Käthe Ralfs, Brunswick; John Richardson, New York; Bernadette van Rijckevosel, Sotheby's, Amsterdam; Giovanni Romano, Galleria d'Arte Moderna, Turin; Virginia Rowe, Lee, Mass.; Mr. and Mrs. Peter Rubel, Piru, Calif.; Erica Rüegger, Kunstmuseum, Winterthur; Serge Sabarsky, New York; Eleanore Saidenberg, New York; Ellen Schall, Maier Museum of Art, Lynchburg, Va.; Rosanna Maggio Serra, Museo Civico di Torino; Sidra Stich, University of California, Berkeley; Darko Schneider, Musée d'Art Moderne, Zagreb; Catherine L. Spence, Art Gallery of Ontario; Nancy Spector, The Solomon R. Guggenheim Museum, New York; the late A. James Speyer, The Art Institute of Chicago; Alfred Stendahl, Hollywood; Ursula Sturzenegger, Bernisches Historisches Museum; John Tancock, Sotheby's, New York; Patricia Tang, E. V. Thaw & Co., Inc., New York; Susan M. Taylor, Wellesley College, Mass.; Patricia H. Tompkins, James Goodman Gallery, Inc., New York; Erwin Treu, Ulmer Museum, Ulm; Kathryn Vawey, University of Newcastle upon Tyne; Marie Waterhouse, *St. Louis Post-Dispatch*; Annabel Wilson, Christie's, London; Cameron Wolfe, The Denver Art Museum; J. van der Wolk, Rijksmuseum Kröller-Müller, Otterlo; Jörg Zutter, Öffentliche Kunstsammlung, Basel.

I used various libraries in New York and want to thank Jane Ekdahl

and Daniel Pearl of The Museum of Modern Art; Sonja Bay at The Solomon R. Guggenheim Museum; and Alain Tarika, New York, who gave me access to his large personal library.

Richard Tooke, Rights and Reproductions, The Museum of Modern Art, was as always helpful. David Rattray, the poet, gave fine suggestions for the translation of Klee's titles. F. C. Schang of Delray Beach donated parts of his Klee library and archive to The Metropolitan Museum of Art and talked to me about the period when he collected Klee.

I am grateful to Barbara Hardtwig, Munich, for reading the Chronology and the Index of Names.

Klee's use of various materials was ingenious, and it requires an expert to determine what these are in each work. I received information on technique and media from Lucy Belloli and Maryan W. Ainsworth of the Department of Paintings Conservation at The Metropolitan Museum of Art, and from Margaret Holben Ellis of the Department of Paper Conservation at The Metropolitan Museum of Art and Chairman of the Conservation Center, the Institute of Fine Arts, New York. I especially want to thank Margaret Holben Ellis for the detailed analysis of Klee's mediums in the works on paper in this collection (79 works out of a total of 90), for always being available with expert advice, and for her infectious enthusiasm for Klee's work.

Many others on the staff of The Metropolitan Museum of Art were very helpful. I want to thank Deanne Cross and Diane Kaplan, The Photograph and Slide Library; Arvia Higgins, Photograph Studio; Ida Balboul, Rochelle Cohen, Kendall Cornell, Kathy Hart, Elaine Kend, Lisa M. Messenger, and Salvatore Porcellati, all of the Department of 20th Century Art. In the Editorial Department, I want to thank Gwen Roginsky and Pamela Barr for help with this book, Teresa Egan for taking care of many loose ends, and Kathleen Howard for her good ideas. John P. O'Neill, notwithstanding his many responsibilities as Editor in Chief and General Manager of Publications, took time for this book and was a spirited editor and friend.

I particularly want to thank William S. Lieberman, Chairman, Department of 20th Century Art, for entrusting me with this book. He read the entire manuscript, gave fine editorial suggestions and advice on the catalogue, and was as always most supportive.

It was a pleasure to collaborate with Heinz Berggruen on this publication. He provided initial bibliographical material, general and particular information on Klee, as well as many books, photographs, and documents. Mr. Berggruen also submitted to a lengthy interview, and he was generous with his advice, enjoyably leavening it all with his dry wit.

S. R.

An Interview with Felix Klee

By Sabine Rewald

What do we know of the life and work of Paul Klee? Quite a lot. Fortunately for the researcher, Klee was a compulsive record keeper. He kept a catalogue of his works, confided to paper his thoughts on art, prepared his Bauhaus lectures word for word, wrote a diary from 1898 to 1918, and was a great letter writer.

Thus, if we have questions concerning the title, date, medium, or authenticity of a picture, his work catalogue will supply the answer. This unique and precious book is kept by the Paul Klee Stiftung in the Kunstmuseum Bern. For his theories on painting, color, and art, we can turn to his published Bauhaus lectures and to his articles. Most of the latter, together with Klee's music criticism, can be read in Christian Geelhaar's 1976 compilation of Klee's writings. We can also consult the artist's mostly unpublished pedagogical writings, stored in the Klee Stiftung, which comprise more than 3,000 pages of notes, drawings, and diagrams, all accumulated during his ten years of teaching at the Bauhaus from 1921–31. If we cannot go to Bern, we can consult the two volumes by Jürg Spiller in which he published parts of these documents.

In addition, many fine studies on Klee and on his work have been written. They cover topics as varied as Klee's relationship to Cubism, music, nature, Romanticism, the Blue Rider group, Tunisia, America, the Bauhaus, primitive art, childhood, World War I, poetry, color, technique, and so on. These books and essays fill several bookshelves, thanks to the pens of Franciscono, Geelhaar, Glaesemer, Grohmann, Haftmann, Hausen-

Hans Klee, Paul Klee's father (*third from left*), as a seminary student in Altdorf (near Nuremberg), Germany, 1866. Collection Felix Klee

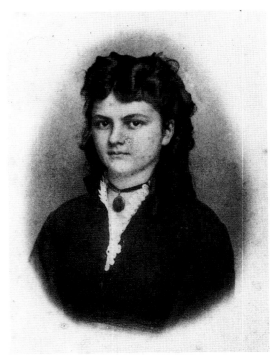

Ida Marie Klee, née Frick, Paul Klee's mother, 1873. Collection Felix Klee

stein, Haxthausen, Jordan, Kagan, Kersten, Felix Klee, Lanchner, Suter-Raeber, Verdi, Werckmeister, Wittrock, and others.

For matters of a more personal nature, we can turn to Klee's letters and his diary. The latter spans the years of his youth and young adulthood, from 1898 to 1918, and, written with a glance toward posterity, gives a vivid, if somewhat formal account of how he became an artist. It was published in 1957 by his only son, Felix Klee. The more down-to-earth and informal Klee appears in the hundreds of letters and postcards that he wrote to his family between 1893–1940. Alternately erudite and facetious, they often describe minute details of his everyday life. Filling two thick volumes, these letters appeared in print in 1979, thanks once more to Felix Klee. No longer young, with a grown-up grandchild, Felix and his wife, Livia Meyer-Klee, live in Switzerland. Because Felix Klee has inherited his father's thoroughness, sense of humor, and has an excellent memory, it was this writer's good fortune that he agreed to a series of interviews. Their purpose was to fill in, if possible, some gaps in our knowledge about the artist, by bringing to light things not mentioned in the vast literature on Paul Klee or in the artist's own writings. And this is how in February 1986 Felix and his wife graciously received me every day for a week in their comfortable apartment. Winter can be very cold on the Swiss plateau, and every morning at 10 A.M. sharp a bottle of Marc de Champagne, Felix's choicest brandy, would be brought out to revive me. Seated side by side on a little Biedermeier sofa, we would sip, while Felix would kindly answer my many questions and reminisce about life with his father to whom he was especially close. In the following pages I have tried to sum up chronologically the salient points of our conversations, which were conducted in German and which I have translated into English. The names of people mentioned in the interview are listed in the Index of Names.

Sabine Rewald: We know from Klee's letters that you spent some time with your father's parents. How do you remember them and what do you think were the most striking facets of their characters?

Felix Klee: My grandfather, Hans Klee, was a talented music teacher who could play seven instruments. He was a great teacher, but as he was also very authoritarian and feared nobody, he got into quarrels wherever he went. As a result, he had to quit jobs in three dif-

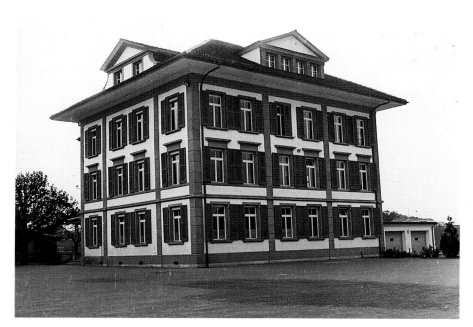

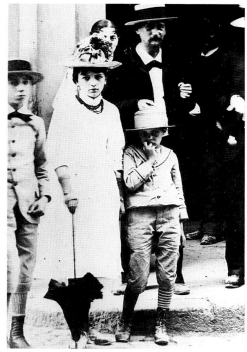

Schoolhouse in Münchenbuchsee, near Bern, the birthplace of Paul Klee.
Collection Felix Klee

Paul Klee (*right*) with his older sister
Mathilde, Bern, 1890. Collection Felix Klee

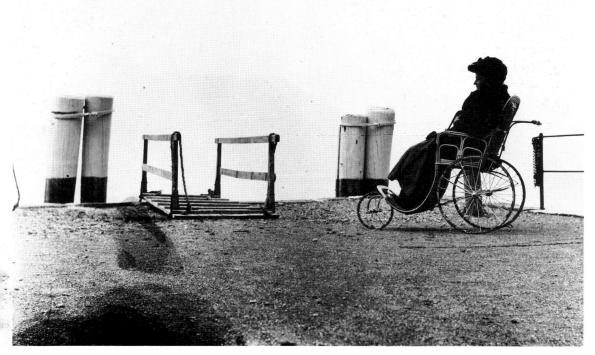

Ida Marie Klee in Leissingen, Lake Thun, October 1902.
Photograph Paul Klee. Collection Felix Klee

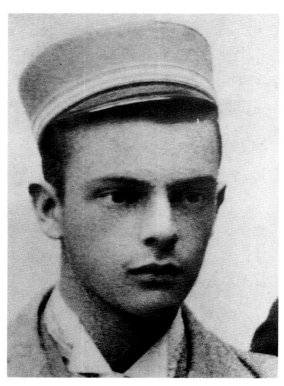

Paul Klee as a senior at the gymnasium in Bern, 1898. Collection Felix Klee

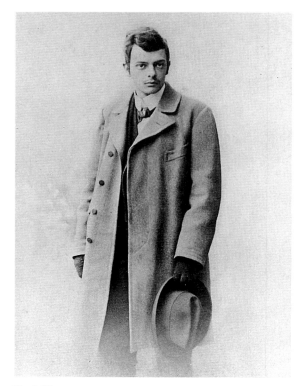

Paul Klee in 1900. Collection Felix Klee

ferent localities in Switzerland—Watzenhausen, Altstetten, and Basel—before coming to Bern in 1879. The Bernese, fortunately for him, are not too serious about their quarrels, which usually end up in a good laugh. Consequently, he taught music in Bern, and what is more, in the same school for fifty-two years, until he retired in 1931, much against his will.

As a child, he grew up in modest circumstances in Würzburg, Germany. Trained as an elementary-school teacher, he first taught in Armorbach, a small village near the Odenwald, in Baden-Würtemberg. There, at the castle of Armorbach, he would play the violin for the princess of Leiningen, who was fond of chamber music. She thought he could do better than teach in an elementary school and offered him a scholarship at the conservatory in Stuttgart to become a music teacher. There he met a young Swiss girl, Ida Frick, who was studying singing. They married, and it was she who persuaded him to move to Switzerland. She was the only person he was afraid of. My grandmother Ida came from a very colorful family. Her mother had innumerable children by her husband, at least twelve I believe,

though not all of them survived. After her husband got into trouble with the law for making a lethal liqueur from absinthe, which had become illegal, she left him and moved to Besançon in France. There she had two more children, one being my grandmother Ida. Nobody knows who the father was, but many thought at the time he might have been of Algerian origin.

Then something tragic happened. In 1899, when she was only forty-three years old, my grandmother became completely paralyzed. I knew her only as an invalid in a wheelchair, cared for by the entire household. Also I remember that she was really hard on her husband, always putting him down.

On the other hand, she was very partial to her son, Paul, and she collected everything he made: his beautiful childhood drawings, and all his exercise books, including his geometry exercise book, containing some three hundred caricatures in the margins. I still have them.

She was instrumental in having the seven-year-old Paul take violin lessons. And when Paul decided to paint, she supported his idea of going to study in

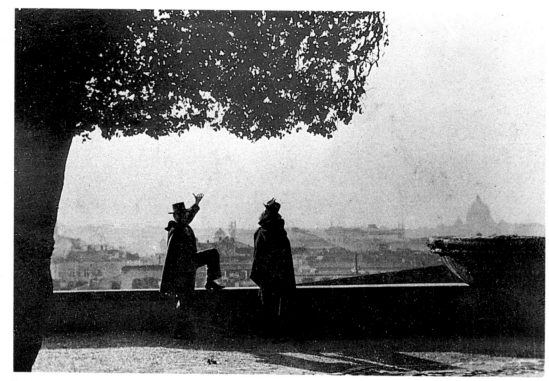

Paul Klee (*left*) and Hermann Haller in Rome, February 1902.
Photograph Karl Schmoll von Eisenwerth. Courtesy Felix Klee

Munich. My grandfather, however, could never see why his son did not become a professional musician, especially since, thanks to his early training, he had become such an accomplished one. He did not understand Paul's pictures and did not want something that bizarre to turn into a profession. However, my grandmother always had her way, and so my grandfather had to come up with the money for his son's art training. He never complained, nursed his sick wife, and took a second mortgage on his house to pay for Paul's studies in Munich.

I often visited my grandparents in Bern. Their house at Obstbergweg 6 was modest but decent, though badly proportioned. The garden was small but beautiful, and I remember many cats, who practically owned the place.

What did my grandfather hang on his walls? Only minor things, such as reproductions. He loved pictures of fine old Bernese farmhouses that looked like palaces. My father had an older sister, Aunt Mathilde, who acted as a servant in the house and also as its manager. She rented the top floor to various people. Below, on the second floor, were three rooms. In the smallest, my fa-

ther had lived as a child. From his window he had painted little landscapes in oil on the tiles of the façade. They are still there. My grandfather also had his room on this floor. You can't imagine the state of that room. A chain smoker, he would, every two months or so, suffer from nicotine poisoning, which did not prevent him from reaching the age of ninety-one.

Downstairs were two more rooms. One belonged to my grandmother, the other was the dining room, which contained a grand piano. Here my grandfather gave singing lessons to his many private pupils, all of whom happened to be girls.

SR: You, too, like your father, grew up in a musical family. Would you care to comment on that?

FK: While I was growing up, it was my mother, an accomplished pianist, who made money by giving piano lessons, because, for a long time, my father could not support us. We then lived in a three-room apartment in Munich. As it was on the third floor of a building on a courtyard behind a larger one, we never saw the sun. It

was always dark. In the large dining room there was a grand piano, on which my mother used to give her lessons. Then came a living room stuffed with heavy dark furniture. Here stood another piano on which my mother, by pushing a silencer, could play noiselessly late into the night. Finally, there was the communal bedroom in which, when I was a child, we slept as follows: I was on one side, my father was in the middle where the two beds had been pulled together, and my mother was on the other side. When I was eleven years old, they fixed up a bed for me under my mother's grand piano in the dining room. Only the kitchen, on the other side of the building, received a fair amount of light. That is where my father cooked and painted.

How did my parents meet? My father took his violin along with him when he went to Munich to learn to draw. He worked a lot and, as he said later, also lived quite a wild life and drank a lot. All the while he played the violin and went to all the operas and concerts. One day, at a chamber-music evening, he met my mother. In a letter to his friend Hans Bloesch in Bern, he describes in detail their first encounter and how music brought them together. They played duos, but apparently my father also played solos and my mother a great fugue by Bach. The strong bond thus created between them soon cast a shadow on his other flirtations.

They became secretly engaged in the summer of 1901. However, because of her strict and rough-edged Bavarian father, Ludwig Stumpf, a doctor who looked down upon artists, they had to wait until 1906 to get married. Incidentally, my mother never visited her father again after her marriage.

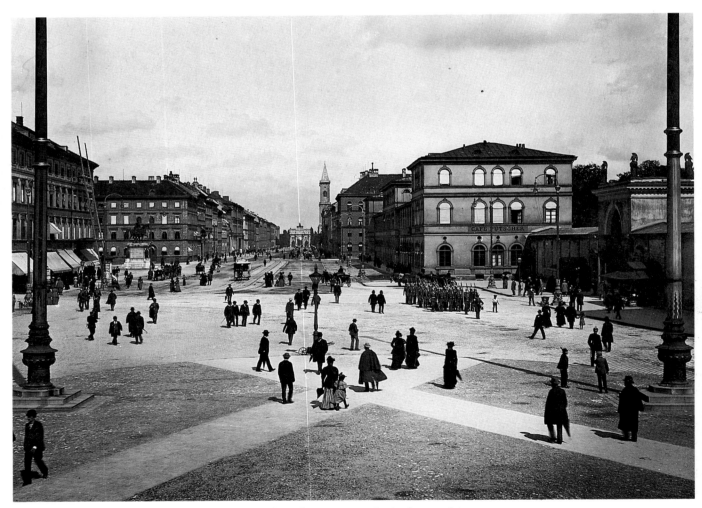

Munich at the turn of the century (Odeonsplatz with Ludwigstrasse in the background).
Photograph Roger-Viollet, Paris

During their five-year engagement, as my father had returned to Bern, my parents hardly saw each other. Only through their correspondence and brief vacations two or three times a year, did they keep in touch. In Bern, my grandparents received my mother as their own daughter, whereas in Munich, my parents had to meet secretly in hotels. My mother was no prude, and pretty soon bobbed her hair, threw off her corset, and smoked.

True, their engagement lasted surprisingly long, but it seems their commitment to each other did not limit them in any way. Both were devoted to their work. My mother would go to the opera alone, sometimes every week. As it appears to me now, in retrospect, they probably had a good relationship, both before their marriage and after, although each remained his own person.

As a child, I had little contact with my mother. Her lessons often took her out of the house, and when she returned, she was tired and did not wish to be disturbed. I mainly knew my father until the time when he had to go to war in March 1916. He brought me up, played with me, and built all my toys: a puppet theater, a train, a farm, and boats that did not float. What talents he had! The titles of his works and his wonderful letters to my mother show he was also a fine poet. Klee's earlier letters, those to his writer friend Bloesch, for instance, were not yet as polished. One realizes when reading them, that he felt, somehow, in competition with Bloesch, and that is perhaps why he started to write poems and aphorisms.

My father also wrote reviews for the various newspapers that Bloesch published in Bern. He wrote on the musical scene in Bern (1904–6) and later on the art exhibitions and musical events in Munich. Also, with his violin, he substituted in the Bern Orchestra and even went on tour with it!

I always say his taste in music started with Bach and ended with Mozart. However, he also grappled with Wagner and bought his collected works. As for the theater, he never cared for it. He would say that one can change a play, but one can't do the same with the music of an opera.

My father's other talents? He was a great cook. As a young man, he would spend entire days in the kitchen of the hotel that two of his aunts owned in Beatenberg, above Lake Thun. There he learned many great recipes because they always hired the best Italian and French chefs.

The only dish that my mother could cook was a vegetable-and-meat casserole. When we were alone

Lily Klee, née Stumpf, Paul Klee's future wife, in Oberhofen, Lake Thun, 1904. Photograph Paul Klee. Collection Felix Klee

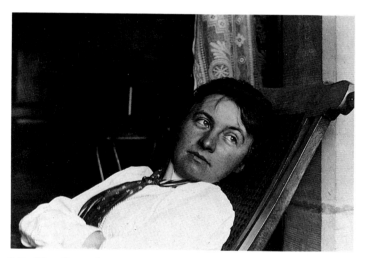

Lily Klee, Bern, August 1903.
Photograph Paul Klee. Collection Felix Klee

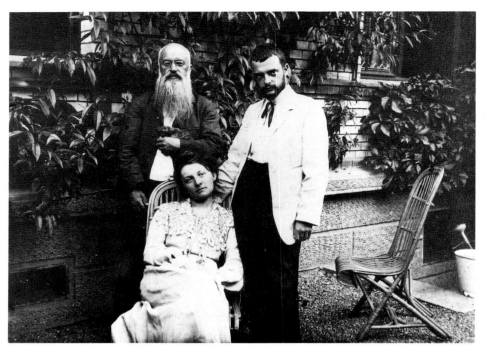

Hans, Lily, and Paul Klee in the garden of Hans Klee's house at Obstbergweg 6, Bern, September 1906. Collection Felix Klee

during the war, my mother and I would eat in a vegetarian restaurant because the food was better there than at home.

Excellent at arithmetic, my father also had a very precise bookkeeping system for our household. Every day he recorded all receipts and expenses in a big book. When he bought a pencil for twenty pfennigs, the expense would be listed in that book.

SR: Your father once said, "Bookkeeping is fun and whiles away the time." Can you say more about his love of keeping records of everything?

FK: Yes, when I was very ill as a child, he established a fever chart, taking my temperature three times a day for two months. During my first two years, he also recorded my weight, what I ate, my first words, my moods, my reactions, and my gestures. Just as precisely, from 1911 on he recorded all his works in an oeuvre catalogue. It was truly scientific!

Klee divided his works into panel paintings, polychromatic sheets (watercolors, gouaches, temperas, pastels), monochromatic sheets (drawings), graphics,

and sculptures. Also, until 1924, he numbered all his works, starting anew each year with number one. From 1925 until his death in 1940, however, he replaced these numbers with a combination of letters and numbers for several reasons. His dealer in Munich at the time was Hans Goltz. Originally from Prussia, Goltz had the typical Berlin outspokenness. In 1924, for instance, Goltz said to my father: "Listen, Mr. Klee, one always knows exactly how many works you have painted in the course of one year. That doesn't look so good when one wants to sell them. When a painter produces three hundred works a year, they are just not worth that much anymore." Since the clients made a fuss, and then the dealer made a fuss, my father said: "It's simple. I will just add letters, then nobody will be able to find out."

It even happened that in 1939, when he recorded 1,239 works consecutively in his work catalogue, he ran out of simple letters and had to use double letters and numbers.

He did not record his works daily, but waited until he had collected a group of about ten to give them inventory numbers in his oeuvre catalogue, so that the chronological sequence is not always strictly observed.

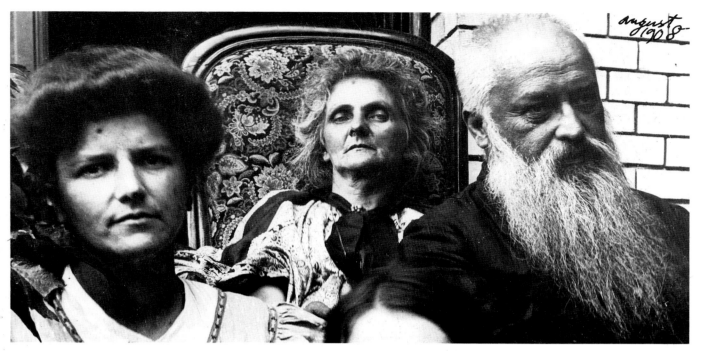

Mathilde, Paul Klee's sister, and Ida Marie and Hans Klee at Obstbergweg 6, Bern, August 1908.
Photograph Paul Klee. Collection Felix Klee

Even as a child, he had kept a work catalogue that listed 300–400 works, and he discontinued it only when he left Bern in 1898. This book does not exist anymore. In his new work catalogue, started in 1911, he listed only those works from his childhood that he still felt worthwhile. He described each work's technique, the components of his colors, and the kind of paper he had used. However, he also guarded certain secrets, as when he had painted with his fingers. First recorded in simple exercise books and then in regular file folders, this work catalogue adds up to more than ten volumes. The Klee Stiftung in the Kunstmuseum Bern stores this catalogue, and as long as I am alive, it will not be published because between his techniques and his numbering, fakers would have too easy a time.

My father established a very precise standard regarding the monetary value of his works, classifying them with Roman numerals from I to X. A watercolor I would cost 200 marks, and a watercolor X would cost 500 marks. In addition, there was the Special Class "S.Kl." (or "S.Cl."). This abbreviation took precedence over the Roman X. When unexpected visitors wished to buy a Klee, my father was not caught unawares and could readily say: "Oh, there is an X, this costs 500 marks."

From his output of approximately 10,000 works, he recorded somewhat more than 9,000 in his work catalogue. The other thousand he forgot. Over 5,000 of his works are drawings. Klee did not like to sell drawings because they were always cheaper than his watercolors. Besides, drawing was the backbone of his art. Very few of his works are purely painterly, without any trace of something graphic. Since he hated to part with his drawings, he devised a "transfer method." Actually, it is the carbon-copy principle—only he did not care for the blue or red brands of carbon paper one could buy in stationery stores at the time. So he made his own by covering a thin piece of paper with a special black paint. By retracing one of his drawings through his homemade carbon paper, and by touching up the new drawing with watercolor, he could keep the original drawing and at the same time earn more money by selling a watercolor.

My father was very thrifty as well as a good craftsman. Whenever possible he made things himself. He also prepared his own glue with flour. With this glue he mounted all his drawings and watercolors on fine card-

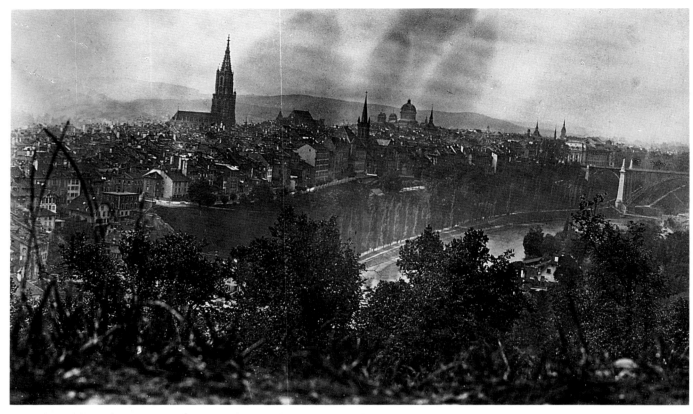

View of Bern from the Rosengarten, 1909. Photograph Paul Klee. Collection Felix Klee

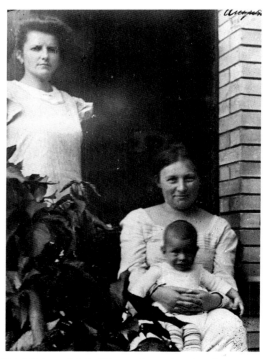

Mathilde and Lily Klee with Paul and Lily's son, Felix (detail), at Obstbergweg 6, Bern, August 1908. Photograph Paul Klee. Collection Felix Klee

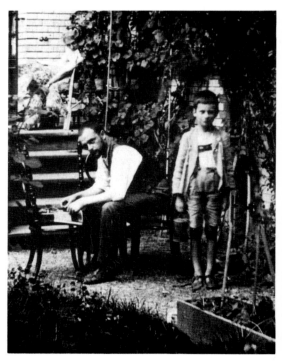

Ida, Paul, and Felix Klee (*left to right*) in the garden at Obstbergweg 6, Bern, Summer 1914. Collection Felix Klee

board. He never used passe-partouts. Considering the enormous quantity of his production, they would have cost too much time to make and too much money. When he was not satisfied with a picture, he turned it over and painted on the back of the sheet or canvas. I have never seen him tear up any work. He had no use for wastebaskets.

SR: Do you remember any of the artists of the Blue Rider group?

FK: Yes, I remember many because at that time in Munich my parents saw a great deal of them. Franz Marc dropped in sometimes in the evening. On these occasions, as I had already gone to bed in the next room, I could hear through the wall my parents playing chamber music. Marc's wife came by more often because she took piano lessons from my mother.

Despite the fact that Kandinsky had been our neighbor for many years, living two houses away from us in the Ainmillerstrasse in Munich, it was only in 1911 that my father got to know him. Until that time Paul Klee had lived quite an isolated life, working hard and exhibiting now and then at the annual New Secession exhibition. His contacts with dealers and the art market came later. He actually met Kandinsky through Louis Moilliet, a schoolfriend from Switzerland. Moilliet, who was well-off and well traveled, mentioned one day that he had discovered a great and strange painter: Kandinsky. The latter, by profession a lawyer, had come to Munich from Russia in 1891, and he was already thirty years old by the time he started to paint in the Impressionist style. Then came his Fauve period, and in 1909–10, he made his first abstract pictures. My father felt somewhat overwhelmed by this Kandinsky, who introduced him to all the artists of the Blue Rider group. Also very important for my father was the fact that Kandinsky showed an interest in his work. It made him realize that he was not all alone, and that other artists had the same goals. He also was eager to have some of his works included in the Blue Rider almanac that Kandinsky and Marc were compiling at the time. However, only one of his small black-and-white watercolors ended up in it.

Kandinsky, who had no children, was always very friendly to me. He lived with Gabriele Münter, and whenever I made too much noise, my parents dropped me off at their place. What fun I had there! They were better off than we were, and Kandinsky's apartment was much more elegant. Everything was in Art Nouveau, and the doors were painted white. I would draw pictures

The art dealer Hans Goltz, before World War I, Munich. Collection Martina Bochow-Goltz, Munich

Alfred Kubin, c. 1903. Collection Städtische Galerie im Lenbachhaus, Munich

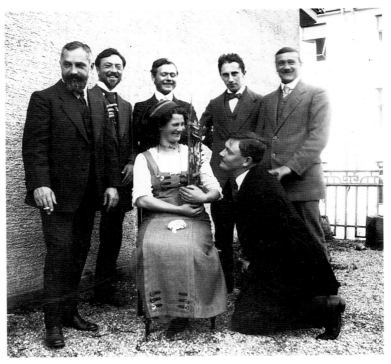

Wassily Kandinsky's balcony at Ainmillerstrasse 36, Munich, 1912. (*Left to right, back row*): Cuno Amiet, Kandinsky, Helmut Macke, Heinrich Campendonk, Louis Moilliet. (*Left to right, front row*): Amiet's wife and August Macke. Photograph probably Gabriele Münter.
Collection Gabriele Münter- und Johannes Eichner-Stiftung, Munich

Wassily Kandinsky on the balcony at Ain-millerstrasse 36, Munich, 1912.
Photograph probably Gabriele Münter. Collection Gabriele Münter- und Johannes Eichner-Stiftung, Munich

Gabriele Münter in Dresden in a dress de-signed by Kandinsky, 1905. Collection Gabriele Münter- und Johannes Eichner-Stiftung, Munich

in Kandinsky's studio, leaving many of them with him. They are all deposited now, along with Kandinsky's estate, at the Musée National d'Art Moderne in Paris.

As I remember him, Kandinsky had quite a loud laugh, always wore glasses, and was nattily dressed. Between him and my father existed a true friendship. My parents also saw Marianne von Werefkin, who lived with Alexei von Jawlensky, and to whose house the entire intellectual and artistic society of Munich would flock weekly.

August Macke visited us rarely, but Alfred Kubin came often. My father had already met the latter in 1910, one year before his contact with the Blue Rider group. Kubin had a bald head, a pointed nose, and unforgettable piercing eyes. Also, he seemed the only one to recognize my father's unique talent and appeared to fear that Klee would become the better artist of the two. Perhaps in order to keep a tab on my father's development and to stay in close touch with his singularity, he bought many of Klee's drawings. Today they are in the Albertina in Vienna.

On the walls of our apartment in Munich my father hung mostly his own works and the pictures that he had traded with his friends Marc, Kandinsky, or Jawlensky. In the bathroom we had an engraving of Munch's *The Kiss*, 1895. This Munich period ended abruptly when World War I was declared on August 1, 1914. Marc and Macke went to war. Kandinsky, Jawlensky, and all the other foreigners fled to Switzerland on the last train.

SR: Did you see your father during the war?

FK: As my father was never stationed far away from Munich during World War I, he would come home on leave every two or three weeks. When he could not come, we would visit him—for instance, in Landshut, where he was posted as a recruit in 1916, right after being drafted. I shall never forget his room there at Klötzelmüllerstrasse 16, which he had rented in order to play the violin and to paint in his free time.

My father was nearly sent to the front, but, by pulling various strings, my mother prevented that from happening. Instead, he was transferred to the flying school at Schleissheim, near Munich, where he rented a room in a farmhouse. Having taken along stacks of his lithograph *Destruction and Hope*, 1916, he touched them up there with watercolor, adding colored triangles, circles, stars, and moons.

After nine months he was transferred to another flying school in Gersthofen, near Augsburg, where he worked in the paymaster's office. As the paymaster

Franz Marc (*left*) and Wassily Kandinsky with the woodcut for the cover of their *Blaue Reiter* almanac, Munich, 1911–12. Private collection

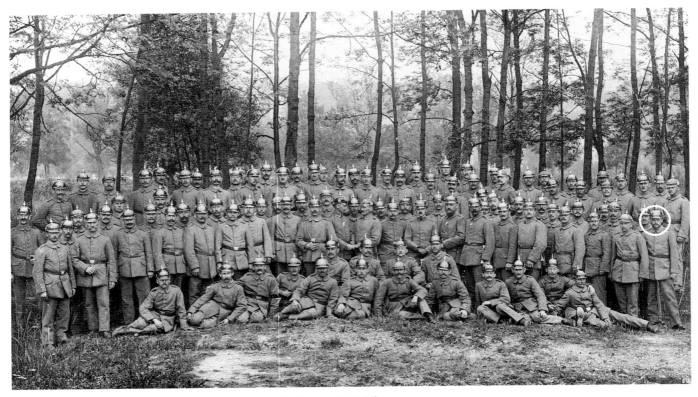

Paul Klee's army unit in Landshut, Germany, 1916. Collection Felix Klee

Schlösschen Suresnes in Munich, at the turn of the century. Photograph Stadtarchiv München

could not count, my father did most of the work. This made him indispensable and enabled him to paint whenever he found a moment, storing his works in his desk drawer. At that time he began to paint on airplane linen. After a plane had crashed and the dead had been removed, my father, armed with scissors, would rush to the field and cut off pieces of the linen with which the planes were then covered. After the war my father rented a studio in the beautiful, though completely neglected, eighteenth-century Schlösschen Suresnes in Schwabing, the artists' quarter of Munich. This move had been arranged by Hans Reichel, a very interesting man and painter who also occupied a studio there. Incidentally, Reichel's sister took piano lessons from my mother. She was a friend of the poet Rainer Maria Rilke, who lived briefly in the house just in front of ours in the Ainmillerstrasse. My father knew Rilke well, but, not being a night owl, he did not care for his large parties.

This Suresnes period was most productive because my father started to paint in oil, something he had done only intermittently before. I should add that it was the time of the Räterepublik. There were street fighting, shootings, unrest, and a curfew after dark. Strangely enough, my father managed to get hold of a pass that permitted him to stay in his studio until 9 P.M. and to come home after the curfew hours. As for Suresnes, it was there that for three weeks during June 1919 Hans Reichel hid the revolutionary Ernst Toller, one of the founding fathers of the Räterepublik. When Toller was discovered and sent to prison, Reichel and his wife were arrested. Toller had earlier taken refuge at Rilke's. The police also searched our house but did not find anything.

SR: Klee's letters to his wife, after joining the Bauhaus in Weimar in 1921, convey the impression of a man who is not quite attuned to its fervent ideology. Could one compare him to a poet in a toolshop?

FK: Not quite. He somehow felt at home there, even if many of its forces and currents went against his grain. As early as November 1920, when he first went to Weimar to see what the Bauhaus was all about, his visit turned out to be most agreeable as he knew many of the people there, such as Lyonel Feininger, Oskar Schlemmer, and Johannes Itten.

When he arrived for his job in 1921, his reaction was rather more housewifely than euphoric. Walter Gropius, the director, had asked Oskar Schlemmer to pick

Paul Klee as a soldier, Landshut, Germany (detail), 1916. Collection Felix Klee

Felix Klee in Munich, 1919. Photograph Paul Klee. Collection Felix Klee

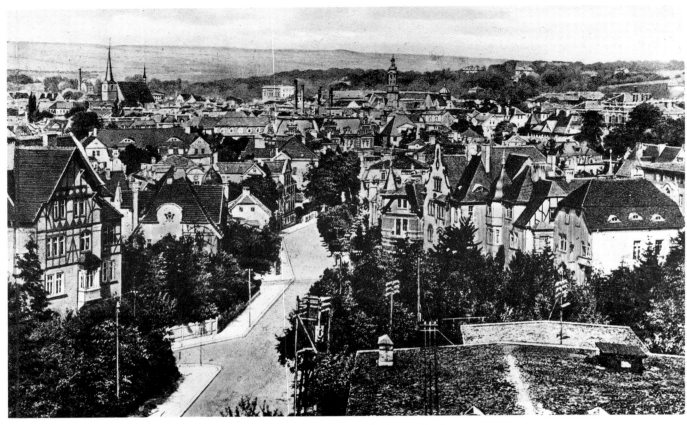

View of Weimar, c. 1920. Photograph Staatsbibliothek Preussischer Kulturbesitz, Berlin

Goethe's house in Weimar, c. 1920.
Photograph Staatsbibliothek Preussischer Kulturbesitz, Berlin

Goethe's summerhouse in Weimar during the winter, after 1900.
Photograph Louis Held, Weimar. Courtesy Volker Wahl,
Goethe- und Schiller-Archiv, Weimar

Klee up at the train station. Schlemmer, wearing his best dark suit, welcomed Klee, whose first question was: "Tell me, Mr. Schlemmer, what is the price of meat here in Weimar?"

During his first six months at the Bauhaus, my father traveled between Weimar and Munich, remaining always fourteen days in each city. He adopted this way of life because he did not want to give up his Munich residence before having established a new one in Weimar. During his fourteen-day-long absences, he would keep his pupils busy by giving them exercises to do.

I arrived at the Bauhaus in October 1921. Being fourteen years old, I was the youngest student, the others being between seventeen and twenty years of age. To be admitted to the Bauhaus school, one had to submit proof of one's creative talent as regards drawing, painting, or design. The trial period for every student was then the compulsory preliminary course, lasting from September until Easter. How lucky I was to take this course as it was then given by Johannes Itten! He owed his success as a teacher to his talent at loosening up his students because most of them were tense. In his youth Itten had been a student of my grandfather, Hans Klee, in Bern. Itten's course was superbly yet tightly structured, consisting of three subjects lasting two hours each: "Analyses of the Paintings of Old Masters," "Drawing after the Nude," and "Studies of Materials" in the experimental workshops. He would give us exercises to perform, such as: "Imagine a globe being attacked from the outside." We had to express it visually, with the help of huge sheets of foil, paper, and charcoal. Afterward we looked a mess. In "Analyses of the Paintings of Old Masters," for example, he would project a slide of the famous Christmas picture *The Adoration of the Three Magi*, 1424, by Master Franke and have us reproduce it.

I remember Itten always wearing the same red violet suit, which gave him a monklike appearance. Itten was a Mazdaist, a follower of a strict religious sect whose disciples did not eat meat or milk products. He attracted quite a few Mazdaist students to the Bauhaus. For them the hard times of rampant inflation and lack of the most essential foods were catastrophic because they found little besides carrots to eat and they nearly starved to death.

During the preliminary course, or trial period, we would sit around and observe the various craft workshops, the better to choose the one in which we would like to work during the following three years. There were workshops for many subjects: weaving, printing,

The Bauhaus in Weimar, Workshop Building (former Grand Ducal School of Arts and Crafts, built by Henry van de Velde in 1904). Photograph Louis Held, Weimar. Courtesy Volker Wahl, Goethe- und Schiller-Archiv, Weimar

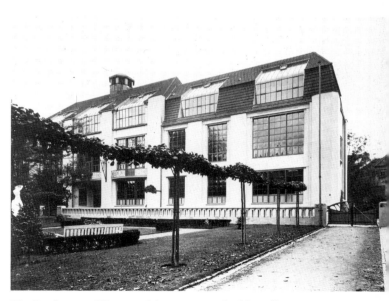

The Bauhaus in Weimar, Administrative Building (former Grand Ducal Saxon Academy of Art, built by Henry van de Velde in 1904). Photograph Collection Bauhaus Archiv, Berlin

Johannes Itten in Weimar, early 1920s.
Photograph Collection Bauhaus Archiv, Berlin

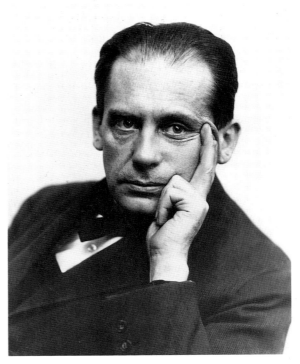

Walter Gropius in Weimar, 1920.
Photograph Hugo Erfurth.
Courtesy Bauhaus Archiv, Berlin

Lyonel Feininger in Weimar, before 1925.
Photograph Hugo Erfurth.
Courtesy Bauhaus Archiv, Berlin

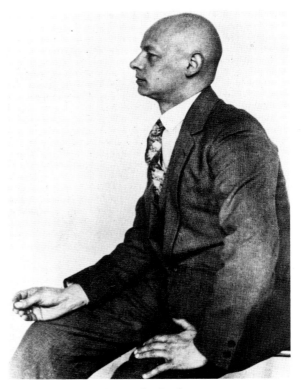

Oskar Schlemmer during the Bauhaus years, 1920s.
Photograph Collection Bauhaus Archiv, Berlin

typography, wall painting, cabinetmaking, metal, stone sculpture and woodcarving, stained glass, bookbinding, pottery, and the stage. Using this craft later on a professional basis was never really the goal.

I had chosen the cabinetmaking workshop in which Marcel Breuer was also an apprentice. Many years later I heard he had become an architect. At the time I was in New York and was told of a museum that he had built without putting any windows in it [Whitney Museum of American Art]. This surprised me a bit. I never went to see it.

Every workshop was taught by a master craftsman as well as by an artist. The latter, called the "form master" (artistic advisor), might breeze through the workshop about once a month, offering advice and suggestions. There were no real final exams at the Bauhaus. Each student took an examination, first as journeyman and later as master craftsman. From 1928 on, however, when a student completed his courses, he received a Bauhaus diploma without having to pass any tests. Classes lasted from 8 A.M. until 2 P.M. There were never more than about 150 students, about one half of whom

were girls. About 30 to 40 students enrolled every year in the preliminary course, and some would always drop out.

One heard about the Bauhaus through word of mouth. Many students had been soldiers in World War I and had served on the front. Also, many came from Russia, Switzerland, France, England, and Holland.

I should mention that we wore our hair in rather extravagant ways, either very long or completely shaven off. Nobody had any money. The tuition amounted to a negligible sum, and the materials were free. When in Weimar, the Bauhaus was subsidized by the state of Thüringia and later in Dessau by the city itself. In Weimar we lived in rented furnished rooms. The older students, among them Marcel Breuer and Herbert Bayer, lived in the Preller Haus, a small boarding house. They could cook there, while the rest of us, for a small fee, ate in the students' mess.

At the Bauhaus we were completely isolated from the rest of the world; even if from 1923 on, people would come to see our exhibitions, it was mainly to poke fun at them. No, I never attended my father's lectures. He had

Paul Klee in Weimar, April 1925.
Photograph Felix Klee.
Collection Felix Klee

Wassily Kandinsky in Weimar, before 1925.
Photograph Hugo Erfurth (?).
Courtesy Bauhaus Archiv, Berlin

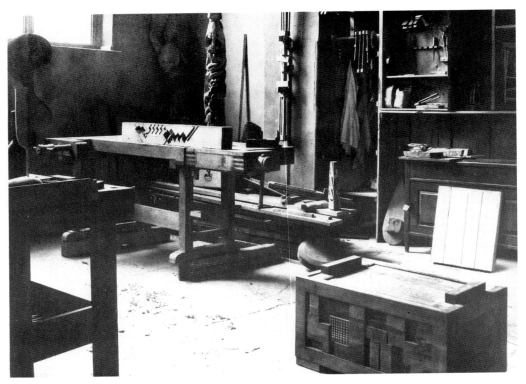

Woodcarving workshop at the Weimar Bauhaus, c. 1923.
Photograph Collection Bauhaus Archiv, Berlin

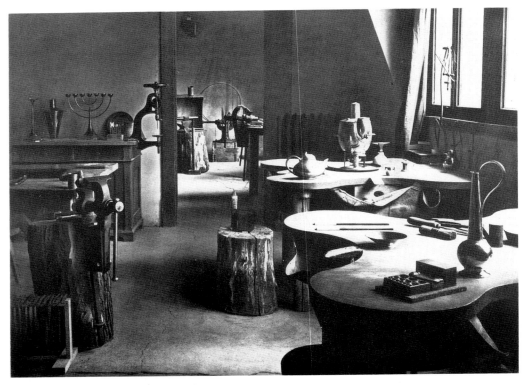

Metal workshop at the Weimar Bauhaus, c. 1923.
Photograph Collection Bauhaus Archiv, Berlin

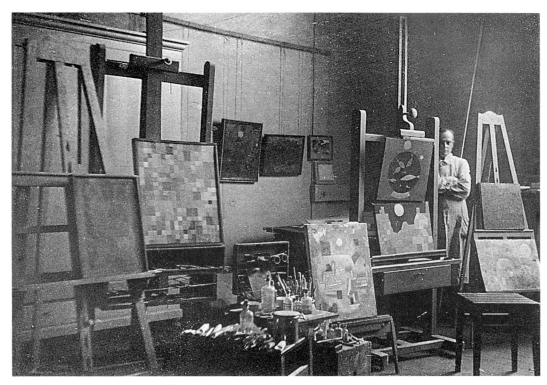

Paul Klee in his studio at the Weimar Bauhaus, 1925.
Photograph Felix Klee. Collection Felix Klee

only a small circle of enthusiastic followers, those who could understand him. Not everyone could. In the beginning many came out of curiosity and then quit.

Every Saturday we had a dance, complete with orchestra, at which we frolicked and did our special Bauhaus dance. We worked quite a bit preparing these events, sewing costumes and putting on disguises; it was all on a shoestring. Neither my father nor Kandinsky danced. As my mother loved to dance, however, she would say to me: "Come dance with me." Kandinsky's Russian wife, Nina, also loved dancing and would remain on the dance floor until midnight.

The Bauhaus period was the happiest time of my life. What I liked about it was that one worked on one's own and as one pleased; it was not a compulsory education. Also it was the time of first loves, and it was romantic, in harmony with Weimar's own past, its park, Goethe's summerhouse, and the artificial ruins.

It was because of his admiration for Gropius that my father followed the Bauhaus's move from Weimar to Dessau in 1925. Although some of the other masters had already left, the governing body (Council of Masters) still consisted of all his good friends—Feininger,

The Prellerhaus, Weimar, the living quarters of older Bauhaus students, 1920.
Photograph Collection Bauhaus Archiv, Berlin

The building at Am Horn 53, Weimar, 1978. Klee's apartment was on the second floor.
Photograph Sadao Wado. Courtesy Felix Klee

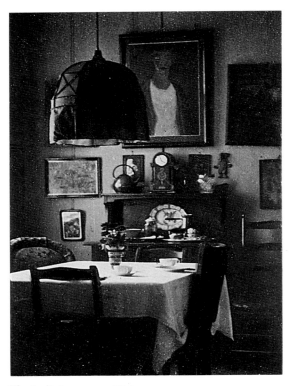

Klee's dining room, Weimar, 1925.
Photograph Felix Klee.
Collection Felix Klee

Kandinsky, and Schlemmer. Once more my father traveled to and fro. This time he stayed seven days in Weimar and then seven days in Dessau. In the interim keeping two studios proved healthy; each time he took a fresh look at the works he had left behind for a week.

In Dessau we were in close contact with the other Bauhaus masters, and that was fun. The masters, like my father, lived in the three two-family houses that Gropius had built in the Burgkühner Allee. We shared ours with Kandinsky, but only the laundry facilities in the basement were used by both families. Kandinsky's apartment had a definite Russian flavor. In one of his rooms, a wall was completely covered with gold leaf, while another room was all black. I did not see many pictures on his walls, and as for his furniture, he owned some old pieces and then had Breuer build him some new ones. I saw Kandinsky every day. Our paths would cross. Just as he would ride to the Kühnauer Lake, I would return from it. He would sit on his bicycle, a pre–World War I model, like a proud Russian general. When I passed, he would nod graciously.

Only in Dessau did I learn to swim and to ride a bicycle. You must realize that we were a totally unsportive family. In fact, my father always made fun of sports, saying that in sports one did not exercise one's head.

Unfortunately, by 1923 Johannes Itten had already left the Bauhaus, and László Moholy-Nagy took over Itten's preliminary course. Moholy-Nagy cut a comical figure at the Bauhaus. Elegant and a little coquettish, he would flutter around like a butterfly without ever hewing to a straight line. We poked fun at him, while the older "Bauhäusler" were very critical of Moholy-Nagy.

My father called Gropius, the director of the Bauhaus, "the silver prince," meaning it figuratively. Married to Alma Mahler, the widow of the composer Gustav Mahler, he and his wife kept a fine house. Alma was a first-class hostess and had kept a "salon" while in Weimar. Everybody was very sorry when Gropius left the Bauhaus in 1928, although we were all very fond of his successor, Hannes Meyer. Meyer, however, had very different ideas, and the Dessau Bauhaus became very stiff and regulated. Everything now was geared toward architecture. A rigid schedule of ten hours a day kept people busy from early in the morning until late at night, and on top of that came emphasis on gymnastics and sports. It all was in complete contrast to the founding ideas of the Weimar Bauhaus.

Meyer's Communist leanings led to his downfall

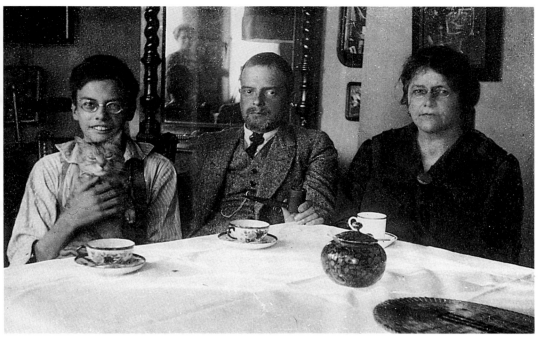

Felix, Paul, and Mathilde Klee in Klee's apartment in Weimar, Autumn 1922.
Collection Felix Klee

in Dessau. Meanwhile, after his dismissal, Dessau's mayor, Fritz Hesse, was able to appoint Mies van der Rohe in his place, and thus save the Bauhaus for a little while. In Dessau, Meyer's six-year-old daughter, Livia, would sit in the audience when I gave my puppet-theater performances. We never lost sight of each other, and in May 1982, my first wife, Efrossina Greschowa, a Bulgarian singer, having died, we were married.

My puppet theater turned me into a magician, equally popular with young and old. In Weimar, I gave a performance every fourteen days for the children and adults, while later in Dessau I performed only for the children. My love of the theater dates back to those puppet-theater days, which led me to take a job as an assistant director at the Friedrich Theater in Dessau, where I worked from 1926 to 1928. In the early days of the Weimar Bauhaus, the stage workshop was mostly for the students' own fun, and only later, after Oskar Schlemmer took it over from Lothar Schreyer, in 1923, did it turn into something more structured. Even then the theater group lived more or less from hand to mouth, and it had no fixed repertory. Schlemmer conceived mainly pantomimes for the Bauhaus stage and

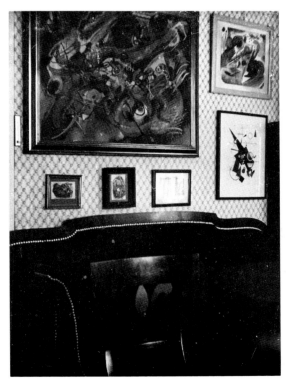

A room in Klee's apartment in Weimar, 1925.
The large painting is Kandinsky's *Sketch I for Composition 7*, 1913.
Photograph Collection Felix Klee

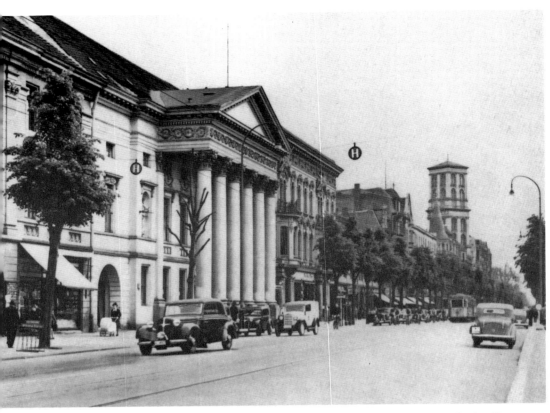

Dessau before World War II (Kavalierstrasse with the theater and the Leopolddankstift).
Photograph Collection Bauhaus Archiv, Berlin

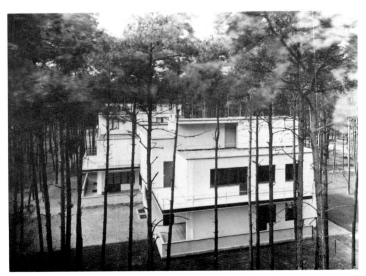

The Masters' houses in Dessau, built by Walter Gropius in
1926. Photograph Lucia Moholy-Nagy. Courtesy Felix Klee

also the now-famous Bauhaus dances, such as the Pole
Dance, the Metal Dance, and many others.

I remember Schlemmer as a very amusing and
thoughtful man. Perhaps one might criticize him for
working in too many media at once. He was a painter,
sculptor, draftsman, and dancer, as well as form master
in the woodcarving and stonecarving workshop. In
Weimar, from 1923 on, he directed the stage workshop,
and later in Dessau he also directed the Bauhaus stage,
which Gropius had designed. I came to know Oskar
Schlemmer more intimately later on. I worked as an
assistant director at the Breslau Stadttheater from
1930–32, and he, having accepted a teaching job at the
State Academy for Arts and Crafts in 1929, came and
stayed at my apartment. In some ways he seemed to
have always remained a student, a person fond of
pranks. Had I been on my own, I would have joined the
stage workshop at the Bauhaus. However, my father
rejected this idea outright, saying categorically: "No,
you won't go into the stage workshop, that is a class for

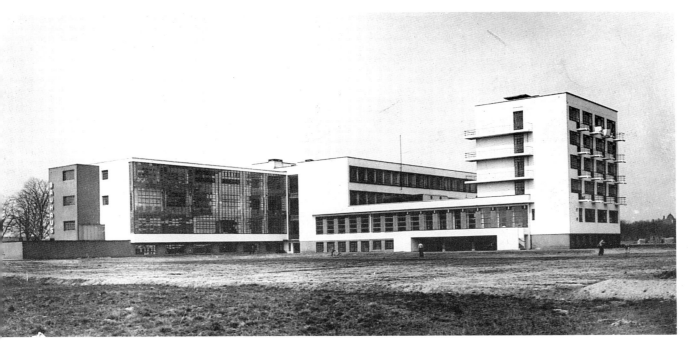

The Bauhaus in Dessau, built by Walter Gropius in 1925–26. View from the southeast.
Photograph Keystone. Courtesy Bauhaus Archiv, Berlin

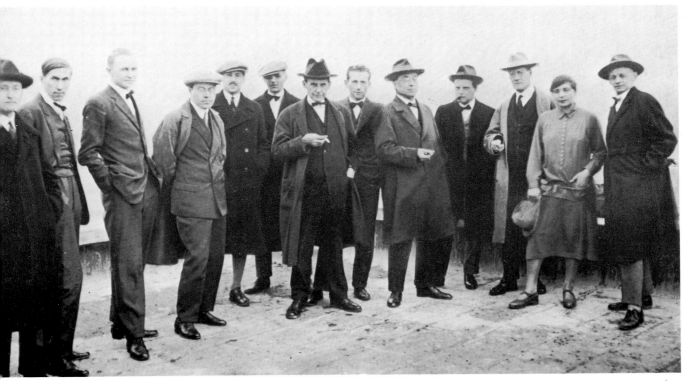

Faculty of the Dessau Bauhaus, 1926. (*From left to right*): Josef
Albers, Hinnerk Scheper, Georg Muche, László Moholy-Nagy,
Herbert Bayer, Joost Schmidt, Walter Gropius, Marcel Breuer,
Wassily Kandinsky, Paul Klee, Lyonel Feininger, Gunta Stölzl,
and Oskar Schlemmer. Collection Felix Klee

Walter Gropius in his office at the Dessau Bauhaus, c. 1927.
Photograph Deutsche Photothek, Berlin. Courtesy Bauhaus
Archiv, Berlin

Hannes Meyer, Gropius's successor as director of the
Dessau Bauhaus, after 1928.
Photograph Umbo (Otto Umbehr). Courtesy Bauhaus
Archiv, Berlin

Marcel Breuer in Dessau, before 1928.
Photograph Collection Bauhaus Archiv, Berlin

László Moholy-Nagy during the Bauhaus years, 1920s.
Photograph Collection Bauhaus Archiv, Berlin

lazy." He would never have vented such sharp criticism against anybody else, and today I still wonder why e did so.

I remember the performance of Schlemmer's *Triadic Ballet*, which, after its premiere in Stuttgart in 1922, chlemmer staged for a few weeks in August 1923 at he Weimar Bauhaus. Everything about it was then improvised, and much was left to chance. However, this improvisation made a lot of sense because it added an appealing liveliness. Recently I saw on television the ew Stuttgart production of the *Triadic Ballet* that now ours the world with great success. Today the performance is highly polished with a technical savoir-faire that was completely unknown at the time. Also today it is accompanied by percussion and drums, while in our day the background was classical music. For those of us who knew it in the 1920s, today's version is not the same.

Apropos the theater, my father went to every performance given in the theaters of Weimar and Dessau. It was his main source of amusement. He must have seen Moussorgsky's opera *Boris Godunov* at least six times and Smetana's *The Bartered Bride* just as often.

As for social life at the Bauhaus, my father carefully avoided it after having had his fill of Bauhaus parties. Nobody could tie him down. Apart from his teaching

Workroom and drawing studio for students in the preliminary course at the Dessau Bauhaus, c. 1929. Photograph Walter Peterhans. Courtesy Bauhaus Archiv, Berlin

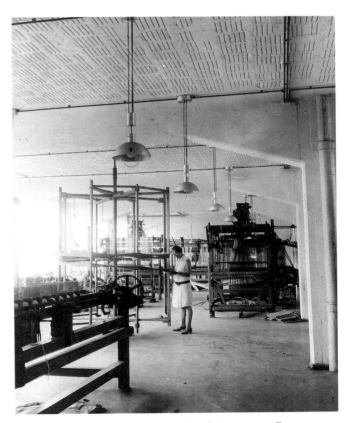

Weaving workshop at the Dessau Bauhaus, 1920s. Gunta Stölzl (?) in foreground. Photograph Collection Bauhaus Archiv, Berlin

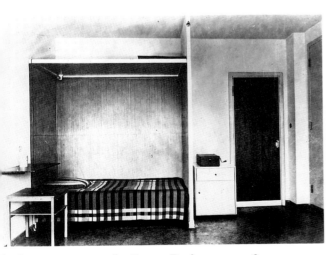

Student apartment at the Dessau Bauhaus, c. 1926. Photograph Walter Peterhans. Courtesy Bauhaus Archiv, Berlin

Paul Klee (*left*) and Alfred Kubin in Klee's apartment in
Dessau, December 1931. Collection Felix Klee

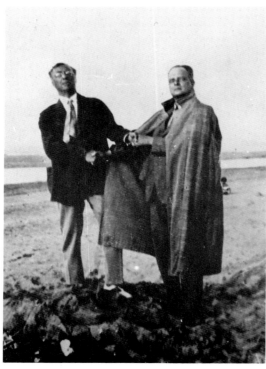

Wassily Kandinsky (*left*) and Paul Klee as "Goethe
and Schiller" on the beach in Hendaye, France,
August 1929. Collection Felix Klee

assignments, he was just like a civil servant, going to his
studio on the dot at 9 A.M., taking a lunch break at
noon, and returning to his studio in the afternoon.

Everybody at the Bauhaus received a small salary. In
order to keep abreast of inflation, which was then in its
final stage, the masters were paid every two days. Then,
in 1924, after the currency was stabilized, my father
received a salary of 3,000 Reichsmarks per year.[1] With-
out additional income from the sale of his pictures, my
father would not have been able to cover the household
expenses, pay for his materials and occasional trips, or
afford my mother's periodic stays in a sanatorium. My
father spent very little money on himself. Once in a
while he went on a trip to Italy or France, which he
paid for from a Swiss bank account specially kept for
travel purposes. He never owned a car or a radio and
only acquired a gramophone later. As for a telephone,
he only agreed to have one after pressure from my
mother. In Dessau the shops were at least thirty minutes
away from the Bauhaus, and she wanted to order her
groceries by phone. My father, however, would say:
"This devil's box won't enter the house." She insisted,

1 3,000 Reichsmarks, about $750 at the time, is equivalent to
about $15,000 today.

46

nd he finally had to give in, but he wanted it installed deep down in the basement, which could only be reached by a dangerously steep staircase. As a compromise the telephone ended up in a box reserved for the fuses in a corridor between the dining room and the kitchen on the first floor. Anyway, sometimes he just had to use it, as when my mother was in a sanatorium and he had not written for a day or so. Her complaints would arrive via the telephone: "Why have you not written today? I am without any news." Then he would go to the fuse box, and he ended up quite enjoying talking with her long distance.

My mother's nerves had probably suffered from the days when she gave all those piano lessons and felt under great stress. She had become impatient and unstable, and she began to like spending long periods in sanatoriums, where she had time to read the paper, write letters, and distance herself from her usual life. She was always interested in Anthroposophy—Rudolf Steiner's movement—knew the literature on it well, and had like-minded friends. She also went in for astrology and wrote many horoscopes for herself.

My father was called "der liebe Gott" at the Bauhaus, probably because he was always right, never mingled in anybody's disputes, and kept carefully aloof, although in his earlier days he had been sometimes exalted and hot-tempered. He was exclusive in his relationships. When he did not like someone, he would never invite this person to our house. His most outstanding characteristics, I would say, were that he never acted hastily and he talked little, least of all about his work.

SR: The two years your father spent as a professor at the State Academy in Düsseldorf from 1931 to 1933, after he left the Bauhaus in 1931, seemed to have been happy ones. Can you explain why?

FK: My father felt very much at home in Düsseldorf. He liked the pleasant and fair climate of the Rhineland, and he appreciated the easygoing attitude of the people there, which contrasted with the difficult character and stubbornness of the Germans in the rest of the country. Actually, my father never felt completely at ease in a German atmosphere, even less so after the rise of the National Socialists. Also the weather in Dessau was usually a little cold and windy, the landscape was boring, and the surroundings were bleak. Anyway, at that time, the Bauhaus had started to fall apart because so many of the masters were leaving. Moreover, my

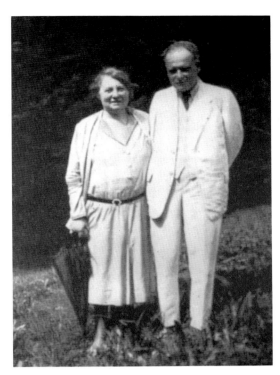

Paul and Lily Klee in Lucerne, Switzerland, 1930.
Collection Felix Klee

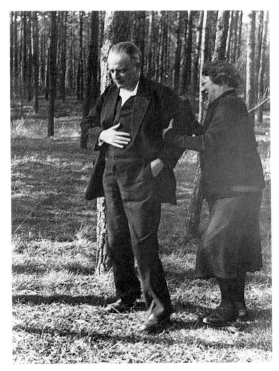

Paul and Lily Klee in Dessau, 1933.
Photograph Bobby Aichinger. Courtesy Felix Klee

47

Paul Klee in his studio at the Dessau Bauhaus, 1928. Photograph Lucia Moholy-Nagy. Courtesy Felix Klee

father had always coveted a professorship at a traditional academy, and in Düsseldorf he was now part of one.

For the third time in his life, he traveled between two cities and two studios, staying fourteen days in Dessau and fourteen days in Düsseldorf. My mother remained in Dessau because he had difficulties finding a suitable apartment in Düsseldorf. He continued to paint his more or less Constructivist pictures in Dessau, but in Düsseldorf he started the Pointillist ones. In both of his studios he was pleased to see again the works he had left behind fourteen days earlier. In Düsseldorf the National Socialists never bothered him. In Dessau, however, during his absence in March 1933, they had searched his house and had confiscated his entire correspondence with my mother. She had kept every one of his letters and postcards. So my mother, a sturdy and energetic Bavarian, went straight to the S. A. headquarters in Dessau and demanded them back. Victoriously, she carted them away.

My father felt very comfortable at the Düsseldorf Academy, where he had nice colleagues and only about nine students in his painting class. Every day on his way

to the Academy, he would stop and buy food for the delicious meals he then prepared on two spirit stoves in his studio. He never went to a restaurant or ate in the Academy's mess.

I also worked and lived in Düsseldorf at the time, and I visited him nearly every day in his studio, a large room with three windows. It was his realm, and he was happy in it. Having been categorized by the National Socialists as "subversive" and his art as "degenerate," my father was given notice on April 21, 1933, of his immediate suspension as of May 1. He never set foot in the Academy again. Ironically, just then he had rented an apartment at Heinrichstrasse 36, on the outskirts of Düsseldorf, and the move from Dessau to Düsseldorf had been arranged. The furniture from Dessau arrived on May 1, and from that day until December 23, 1933, he lived at that address. My wife and I lived on the upper floor, directly above my parents. There, in complete peace, working furiously, he created a large number of drawings and paintings. I don't believe he sold any works in Düsseldorf, but he did not care. Walter Kaesbach, the director of the Düsseldorf Academy, had also been dismissed from his post. He wanted Klee to move with him

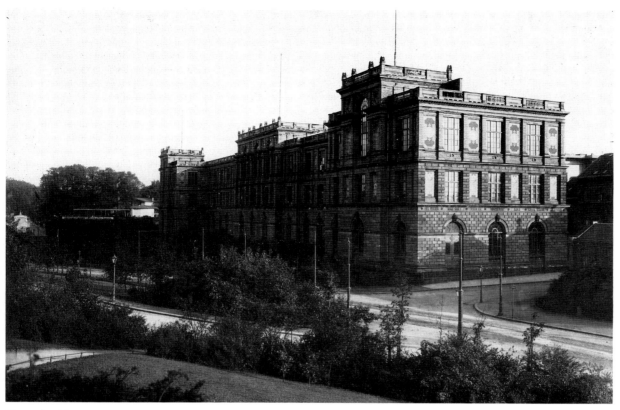

The Düsseldorf Academy, built by Hermann Riffort between 1875 and 1879, c. 1930.
Collection Staatsarchiv Düsseldorf, Fotosammlung Söhn

to the Swiss side of Lake Constance, where he had bought a house. He envisaged it as part of a future artists' colony. In fact, the painters Otto Dix and Erich Heckel did live there at some later date. My father was sure of his ground, however, and did not want to leave Düsseldorf. Far from wanting to emigrate to Switzerland, he always said: "I can very well remain here." But my mother, repeatedly, like a Bavarian trumpet, would insist: "You must leave Germany, there is nothing left for you to do here." As always, she had the wit to sense the way the wind was blowing, went to the authorities, and arranged a smooth emigration to Switzerland. Their possessions and all his pictures were put in a big moving van, which arrived safely in Bern a few weeks later. We had been lucky. The van caught fire and was completely destroyed on its way back to Germany.

Klee's apartment at Kistlerweg 6, Bern, 1936.
Collection Felix Klee

SR: How did Paul Klee spend his last years in Bern?

FK: My father's last years in Bern were difficult ones, even though a few Bern collectors, such as Hermann Rupf and Hannah Bürgi-Bigler, more or less looked

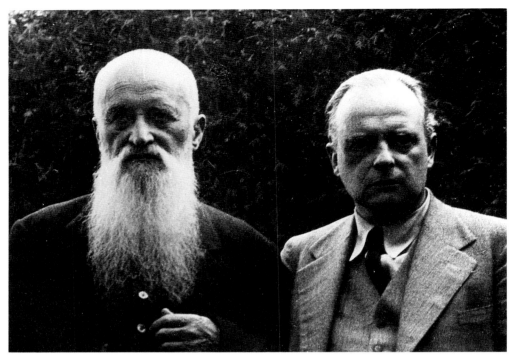

Hans and Paul Klee in Bern, 1935.
Photograph Lily Klee. Collection Felix Klee

Paul Klee (*left*) and Cuno Amiet in Amiet's garden
in Oschwand, Switzerland, 1935.
Collection Felix Klee

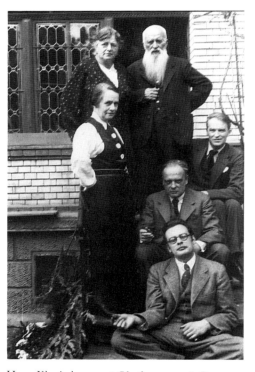

Hans Klee's house at Obstbergweg 6, Bern,
1935. (*At the top*): Mathilde and Hans Klee.
(*Center*): Will Grohmann and his wife.
(*Bottom*): Paul and Felix Klee.
Photograph Lily Klee. Collection Felix Klee

after him and made sure that he did not starve to death. When my parents arrived in Bern at the end of December 1933, they lived briefly with Hans Klee, his father, in the house at Obstbergweg 6. Apparently, Hans Klee smiled ironically, insinuating that Hitler had not been too wrong in rejecting the art of his son, as if to say: "See, I was right all along." Well, by then Hans Klee had become pretty obstinate. Retired, he lived for another seven years, until 1940, almost exactly as long as his son, Paul.

My parents found it impossible to stay with my grandfather, especially since my mother was very protective of my father and sensitive to any criticism of him. They moved to a furnished apartment in which my father felt uncomfortable. But, later, after their belongings arrived from Düsseldorf, they rented, in early spring 1934, a three-room apartment in Elfenau, a residential section of Bern. As always, my parents lived very simply. Everything was neatly arranged. His studio, which had a balcony, measured only about twenty square meters. It served as his headquarters. A large drawing board, which could be tilted at different angles like that of an architect, filled most of the room. He painted his large pictures on this drawing board. By then he was too frail to stand at his easel, and therefore painted mostly sitting down. In 1935 my father came down with the measles. Then he was diagnosed as having scleroderma, an incurable illness. We thought it had been brought on by the measles, but all the doctors rejected this idea. Scleroderma, which causes the gradual drying up of the body's fluids, exhibits ever new and different symptoms. Some victims suffer from paralyzed hands, but luckily for my father, this did not happen. In his case his esophagus had lost its elasticity. He could no longer swallow solid food—not even a grain of rice—and had to live on a liquid diet. Since he had difficulties whenever he swallowed, he always ate alone. His heart got weaker, and he had to give up smoking and playing the violin. Also he lost weight, his skin tightened, and his appearance changed. You can see these changes in the photographs of him made in 1939 and 1940.

Even though he looked different, my father remained gentle and serene in manner. Since his illness progressed irregularly, with alternate high and low points, there were periods during which he felt better. When he felt ill, as for example in his worst year, 1936, when he produced only twenty-five works, he would take cures in sanatoriums at Tarasp or Montana, above Sierre in the Valais.

Paul and Felix Klee and Hermann Rupf and Margrit Rupf-Wyss on the steps of the cathedral in Solothurn, 1938. Collection Felix Klee

Paul and Felix Klee on the balcony of the apartment at Kistlerweg 6, 1934.
Photograph Bobby Aichinger. Collection Felix Klee

Paul Klee in Bern, 1939.
Photograph Fotopress Zürich. Collection Felix Klee

Then, all of a sudden, during the last three and a half years of my father's life, between 1937 and 1940, he created an amazingly large number of works in a completely new style. More than 1,200 in the single year of 1939! Lines turned into bars, and his colors became strong and vibrant, unknown elements of his art until then. This late work is the least accessible, but in my opinion it is his most important. When I visited my father during the summers of 1937 to 1939, it was usually just for a month. I would sleep in the guest room, which, filled to the brim with all the works he could not sell, looked like a storeroom.

Of course, I remember Picasso's visit, a very unpleasant incident. Picasso had visited a friend in Geneva. He then came to Bern to see Bernard Geiser, who was preparing the second volume of the oeuvre catalogue of Picasso's graphics and who had also arranged a visit by Picasso to my father. Picasso and Geiser lost track of

time, and instead of coming at 3 P.M., as had been arranged, Picasso finally turned up at 5 P.M. After waiting for two hours, my father was so upset that he did not want to have anything more to do with Picasso.

Klee's application for Swiss citizenship is quite another saga! When he returned to Bern in 1933, it was as a German citizen. Then, like all foreigners who wanted to become Swiss, he had to wait a certain time. His first application, soon after his return, was turned down for technical reasons. In 1939 my father applied again. The war and bureaucratic delays slowed things down, and his death on June 29, 1940, a few weeks before his case was to be acted upon, cancelled everything.

In conclusion, let me say how pleased I am that Mr. Berggruen should have given so many of my father's works to The Metropolitan Museum of Art. I visited it several times, trying in vain to see all it has to offer. For me it is a house of dreams, but such a labyrinth.

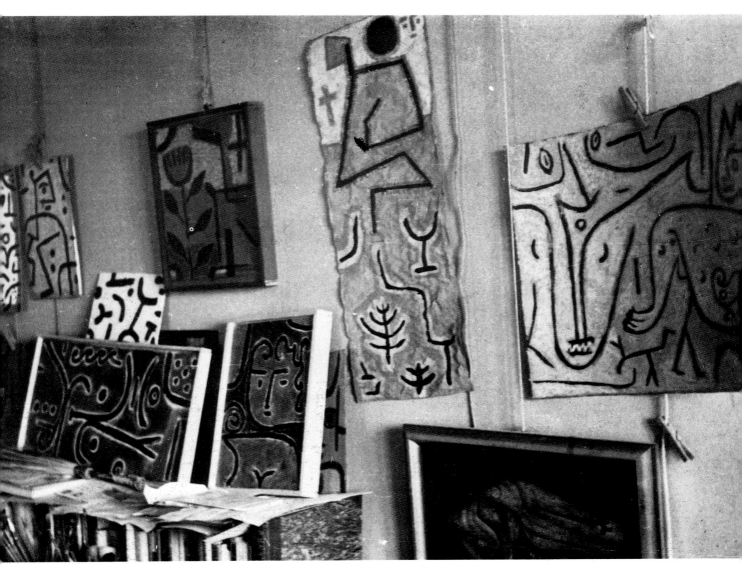

Klee's studio at Kistlerweg 6, Bern, 1938. Photograph Felix Klee. Collection Felix Klee

The Berggruen Klee Collection

NOTE

German titles are the artist's. Klee mounted all his works—except his panel paintings—on auxiliary supports of light cardboard. These supports are considered original components of his works. In most cases he noted his titles in black ink above or below a black marginal line he had drawn below the image on this support. Klee numbered his works in sequence each year, beginning with number one. The date of each work is followed by this inventory number. He recorded these titles, dates, and inventory numbers in his oeuvre catalogue, now in the Paul Klee Stiftung in the Kunstmuseum Bern. Sometimes he recorded the title only in his oeuvre catalogue and not on the work. Also the title on a work might differ somewhat from that in his oeuvre catalogue. Thus both are listed here. Klee's own notations of mediums are included in the Addendum. His penciled notations "S.Kl." or "S.Cl." (*Sonderklasse*) denote works the artist especially liked. Similarly, the penciled Roman numerals "I" to "X" refer to a price system the artist established for his past and present works in 1925. "I" represents the lowest price and "X" the highest. Klee began his oeuvre catalogue in 1911, retroactively including works dating back to 1893 and continuing it through May 1940. In the dimensions—of the primary support only—height precedes width.

Junkerngasse in Bern
Blick auf die Junkerngasse in Bern
1893

Pencil on wove paper mounted on heavy paper;
2⅞ × 5⅛″ (7.3 × 13 cm). Signed and dated,
in pencil (lower right): *P. Klee 24. Okt. 1893.*

Klee was only thirteen years old when he drew this precise pencil study. It shows a rear view of a row of houses on the Junkerngasse—one of Bern's oldest and finest residential streets—as one looks from the southeast corner of the observation promenade of the cathedral of Bern.[1] The houses on the Junkerngasse are of Gothic origin, except for No. 47, topped by a pediment, which was built from c. 1746 onward for Hieronymous von Erlach (1667–1748), a former mayor of Bern. Today the building contains municipal offices. Two houses to the left, at No. 51, the poet, doctor, and scientist Albrecht von Haller (1708–77) lived from 1766–72.

In a letter of 1901, Klee mentions a contemporary resident of the Junkerngasse, his friend Fritz Brun (1878–1959), the pianist, composer, and conductor, who lived at No. 55.[2] Brun's house stands just beyond the edge of Klee's drawing. It is the last house on the left in the photograph (fig. 1). In this house Klee, who had become an accomplished violinist, participated in a chamber-music performance of Mozart's Symphonie Concertante in E-flat in October 1910. The River Aare flows below at the right.

1 Eberhard W. Kornfeld identified the specific location on the Junkerngasse depicted in Klee's drawing, and he photographed it from the observation promenade of the cathedral.

2 Felix Klee, ed., *Paul Klee Briefe an die Familie*, I (*1893–1906*); II (*1907–40*) (Cologne: DuMont Buchverlag, 1979), II, p. 700. Hereafter cited as *Briefe*.

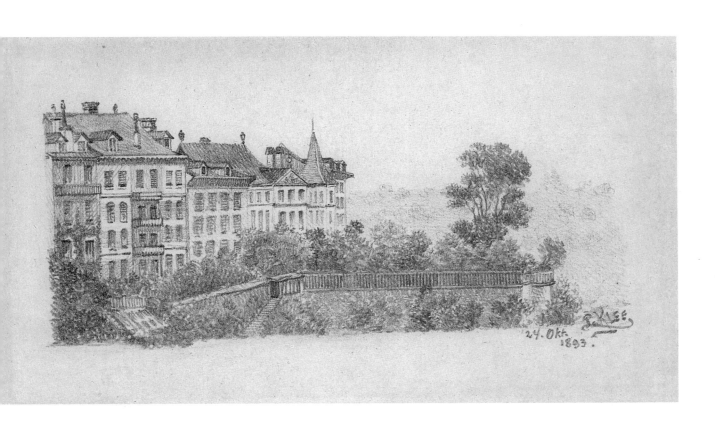

Fig. 1. View of houses nos. 45–55 [right to left] on the Junkerngasse, Bern, 1984. Photograph Eberhard W. Kornfeld, Bern

1908 73 Bildnisskizze n. Felix

Sketch of Felix Klee
Bildnisskizze nach Felix Klee
1908

Black ink wash on wove paper bordered with black
ink mounted on light cardboard; 7⅝ × 6½″
(19.4 × 16.5 cm). Signed, in black ink (lower
right): *Klee*. Inscribed, on the light cardboard,
in black ink (lower left): *1908 73 Bildnisscizze n.
Felix*. Recorded in Klee's oeuvre catalogue as:
Bildnisscizze nach Felix.

Flattery was never on Klee's mind when he made portraits of his family,
be it with his camera (fig. 2), his brush, or his pen. This small sketch of
his one-year-old son, Felix, was painted during Klee's self-imposed
apprenticeship as an artist when he worked only in black and white.[1] He
wrote to his wife, Lily, from Bern on October 15, 1908: "I am now
sketching with the watercolor brush—black; everything at great speed in
tonal gradations after nature. That, rather than coloration, is the quin-
tessence of the great and genuine art of painting."[2] In Munich, during
the first years of their marriage, Lily Klee supported the family by giving
piano lessons, while Klee painted and took care of Felix and the house-
hold. In order to reduce their expenses, Lily often worked at home in
Munich, while Paul and Felix stayed with Klee's parents in Bern. It was
during one of these visits, lasting from the end of August until mid-
October in 1908, that Klee painted four sketches of his son, this being the
last one.

Fig. 2. Felix Klee in the garden of his
grandparents' house at Obstbergweg 6,
Bern, 1908. Photograph Paul Klee.
Collection Felix Klee

NOTE: This was one of forty-five works
that Klee sent to the art historian Eckhart
von Sydow, Leipzig, in the early part of
1919. Von Sydow kept three works and
returned the others, among them this
one.

1 Felix Klee was born in Munich on
November 30, 1907.

2 *Briefe*, II, p. 692. Translation from
Charles Werner Haxthausen, *Paul Klee: The
Formative Years* (New York and London:
Garland Publishing, 1981), p. 294.

Garden in St. Germain,
The European Colony Near Tunis
Garten in der Tunesischen Europäerkolonie St. Germain
1914

Watercolor on laid paper mounted on light cardboard;
8½ × 10¾″ (21.6 × 27.3 cm). Signed, in black
ink (lower right): *Klee*. Inscribed, on the light
cardboard, in black ink: *1914/213 Garten in der
Tunesischen Europäerkolonie St. Germain*; in pencil
(lower left): *S.Kl.* Recorded in Klee's oeuvre
catalogue as: *Garten in St.-Germain b. Tunis*.

Klee's penciled notation "S.Kl." (*Sonderklasse*), on the lower left below
the title, denotes a work the artist especially liked and that he wished to
keep.

In 1914, during the second and third weeks of April, Klee visited
Tunisia with two friends, the painters August Macke and Louis Moilliet.
The sale of eight of his watercolors to the Bernese pharmacist Charles
Bornand paid his travel expenses. Following in the footsteps of De-
lacroix, Monet, Renoir, and Matisse, Klee went to Tunisia determined to
learn all about color. Working out-of-doors, he gradually tried to detach
color from literal description and to use it independently. He still felt
insecure about color, having worked mainly in black and white. He also
felt that he needed a final push toward abstraction, which Tunisia pro-
vided.

Fig. 3. Dr. Ernst Jäggi's weekend house
at St. Germain, 1982. Photograph Ernst-
Gerhard Güse, Münster

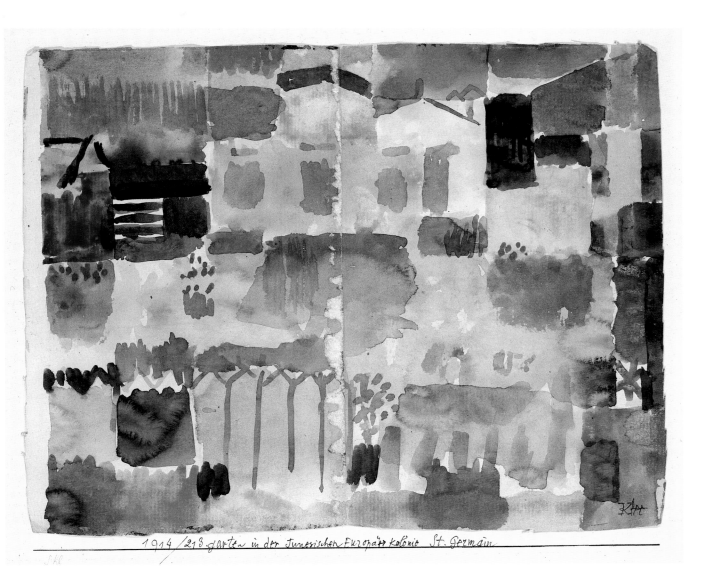

1914/213 garten in der Tunesischen Europäer kolonie St. Germain

Fig. 4. August Macke, *Tunisian View*, 1914. Chalk on paper; 4¼ × 6¼" (10.4 × 15.6 cm). The Metropolitan Museum of Art, New York. Purchase, Anna-Maria and Stephen Kellen Foundation Gift, 1987

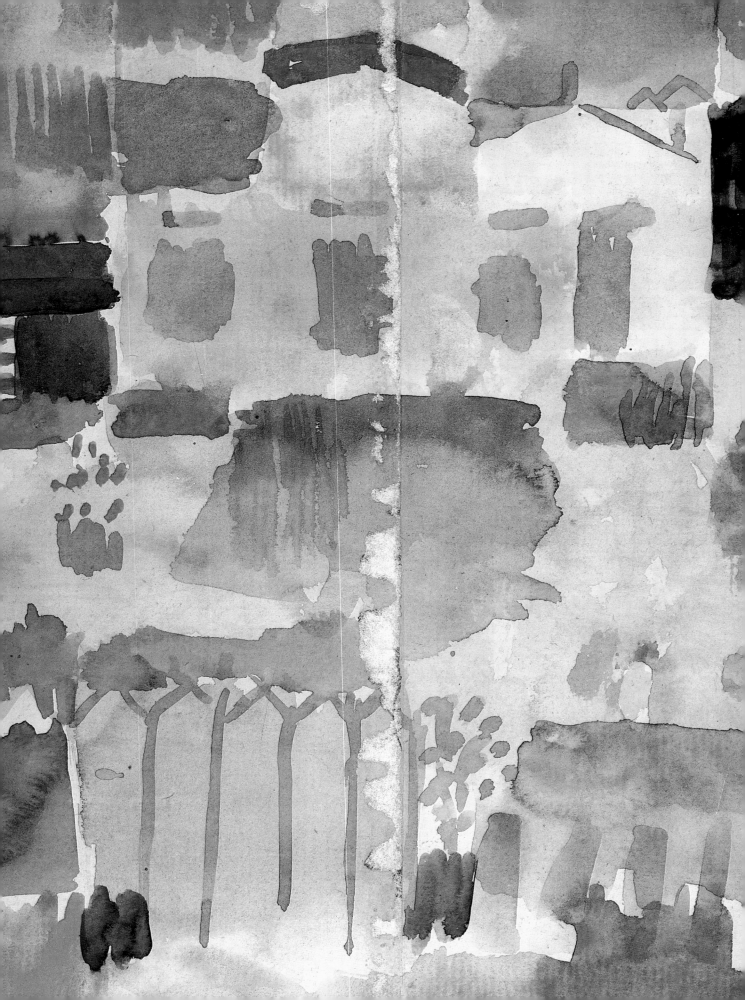

Since the age of eighteen, Klee had kept a diary, but he had neglected it a bit in the two years preceding this trip. The artist, however, took his diary along to Tunisia, and in it he carefully recorded his impressions in telegraphic style. The diary entries form a lively travelogue, complete with amusing anecdotes and with descriptions of people and landscapes. He also observed his own responses to the famous colors and light of Tunisia, quite factually at first, then gradually more poetically as he and his friends drew closer to Kairouan, their last destination on the trip.

At their first stop, in Tunis, the three painters were the guests of Moilliet's friend, the Bernese physician Dr. Ernst Jäggi. The indispensable guidebook of that period—Karl Baedeker's *The Mediterranean*, in the English edition of 1911—recommends Dr. Jäggi as one of five local doctors to consult in case of emergency.[1]

The three friends spent the Easter holiday at Dr. Jäggi's country house at St. Germain (see fig. 3), a spot southeast of Tunis on the Mediterranean Sea. Macke wrote to his wife, Else: "We sit here in the midst of an African landscape, draw [see fig. 4], write, Klee paints watercolors."[2] And Klee recorded in his diary for April 11: "St. Germain near Tunis. [Painted] some watercolors on the beach and from the balcony. The watercolor on the beach is still somewhat European. Could have been done at Marseille. In the second one, for the first time, I got the feel of Africa."[3]

Although Klee was carried away by the colors he experienced in North Africa, the watercolors he actually painted there are no brighter or more colorful than those he executed before or after his trip. However, when Klee later evoked Tunisia from memory, he used colors more intense, though no longer dictated by nature (see pages 91 and 124).

This work belongs to a group of nine watercolors Klee painted in St. Germain.[4] He reduced the landscape into various rectangles of yellows, mauves, blues, and muted shades of green and purple that wash over and seep into each other. The result is a loosely—yet evenly—textured tapestry with a few bold strokes indicating a gable on the left, a roof above a four-windowed façade in the upper center, and a tall fence in the foreground. All this is enlivened with spots and patches of green, suggesting shrubs, trees, and grass.

Fig. 5. Verso of *Garden in St. Germain, The European Colony Near Tunis*, with various pen-and-ink sketches by Klee

1 Karl Baedeker, *The Mediterranean* (Leipzig, London, and New York: Karl Baedeker, 1911), p. 33.

2 Quoted in Else Erdmann-Macke, *Erinnerungen an August Macke* (Stuttgart: W. Kohlhammer Verlag, 1962), p. 241.

3 Felix Klee, ed., *The Diaries of Paul Klee 1898–1918*, translated by Pierre B. Schneider, R. Y. Zachary, and Max Knight (Berkeley, Los Angeles, and London: University of California Press, 1964), p. 290. Hereafter cited as *Diaries*.

4 Altogether Klee painted about thirty watercolors in Tunisia. The vertical white line in the center of the watercolor has always been assumed to indicate the spot where Klee fastened the sheet to a board with a rubber band to prevent it from flying away in the wind while working out-of-doors. However, Margaret Holben Ellis, Consulting Conservator of Prints and Drawings at The Metropolitan Museum of Art, has established that the white line consists of remnants of adhesive and paper fibers from another secondary support to which Klee had previously adhered this drawing. Apparently, Klee folded the watercolor in half and then adhered it to a second sheet of paper with a vertical line of glue. Later, after detaching it, Klee left the white line—probably because he liked the effect.

Hammamet with Its Mosque

Hammamet mit der Moschee

1914

Watercolor and pencil on two sheets of laid paper mounted on light cardboard; 8⅛ × 7⅝" (20.6 × 19.4 cm). Signed, in black ink (upper left): *Klee.* Inscribed, on the light cardboard, in black ink: *1914 199 Hammamet mit der Moschee.* Watermark along bottom edge: CANSONS MONGOLFIER. Recorded in Klee's oeuvre catalogue as: *Hammamet mit der Moschee.*

On April 14, 1914, Klee and the two painter friends he had traveled with to Tunisia—Macke and Moilliet—visited Hammamet, a small town on the Mediterranean. About an hour and a half by car southeast of Tunis, it was highly recommended by the travel guide authority of the time, Karl Baedeker, for its "picturesque location," its "pretty bathing-beach," and its "healthy winter climate."[1] Klee and his two fellow painters did not stay at the Hôtel de la Plage, the town's only hotel, but lodged with a "mean French woman" who offered them "indigestible food."[2]

Klee described Hammamet in his diary: "The city is magnificent, right by the sea, full of bends and sharp corners. Now and then I get a look at the ramparts!!! On the streets one sees more women than in

Fig. 6. The Mosque at Hammamet, 1982. Photograph Ernst-Gerhard Güse, Münster

64

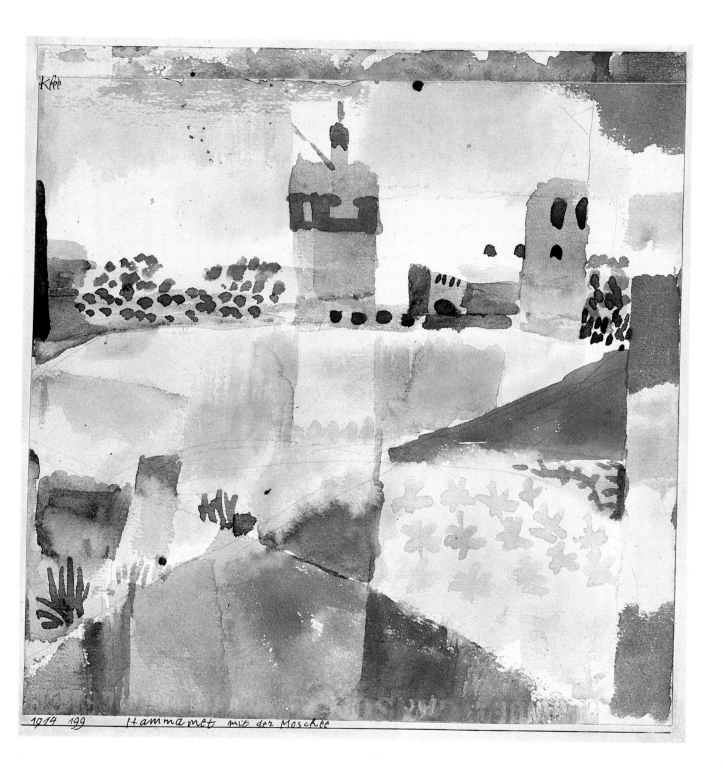

1914 199 Hammamet mit der Moschee

Tunis. Little girls without veils, just like at home. Then, too, one is allowed to enter the cemeteries here. There is one splendidly situated by the sea. A few animals graze in it. That is fine. I try to paint. The reeds and bushes provide a beautiful rhythm of patches."[3]

This view of Hammamet's mosque demonstrates like a textbook Klee's path to abstraction. The lower section of the watercolor is made up of abstract translucent color planes influenced by the work of Robert Delaunay that he had seen two years before in Paris and by that of his traveling companion August Macke, whereas the upper part shows the mosque surrounded by two towers and gardens. Klee added a strip of paper to the right, probably so he could add another spot of blue to the sky. Similarly, he cut off a small piece of red from the lower edge, turned it 180 degrees around, and glued it to the upper edge. He thus established a formal and colored link between the upper and lower parts.

A photograph taken in 1982 shows the actual site depicted in Klee's watercolor (see fig. 6).

Klee dated and numbered his works in sequence each year. Thus it would appear that works bearing high inventory numbers, such as *Hammamet with Its Mosque* (1914.199) and *Garden in St. Germain, The European Colony Near Tunis* (1914.213), were painted at the end of 1914. But according to Suter-Raeber, both works belong to a group of twelve watercolors that Klee painted in Tunisia during his visit in April but only catalogued and numbered after Christmas that year.[4]

1 Karl Baedeker, *The Mediterranean* (Leipzig, London, and New York: Karl Baedeker, 1911), pp. 564–65.

2 *Diaries*, p. 293.

3 *Ibid.*, p. 292.

4 Regula Suter-Raeber, "Paul Klee: Der Durchbruch zur Farbe und zum abstrakten Bild," *Paul Klee: Das Frühwerk 1883–1922*, compiled by Armin Zweite, exhibition catalogue (Munich: Städtische Galerie im Lenbachhaus, 1979–80), p. 133.

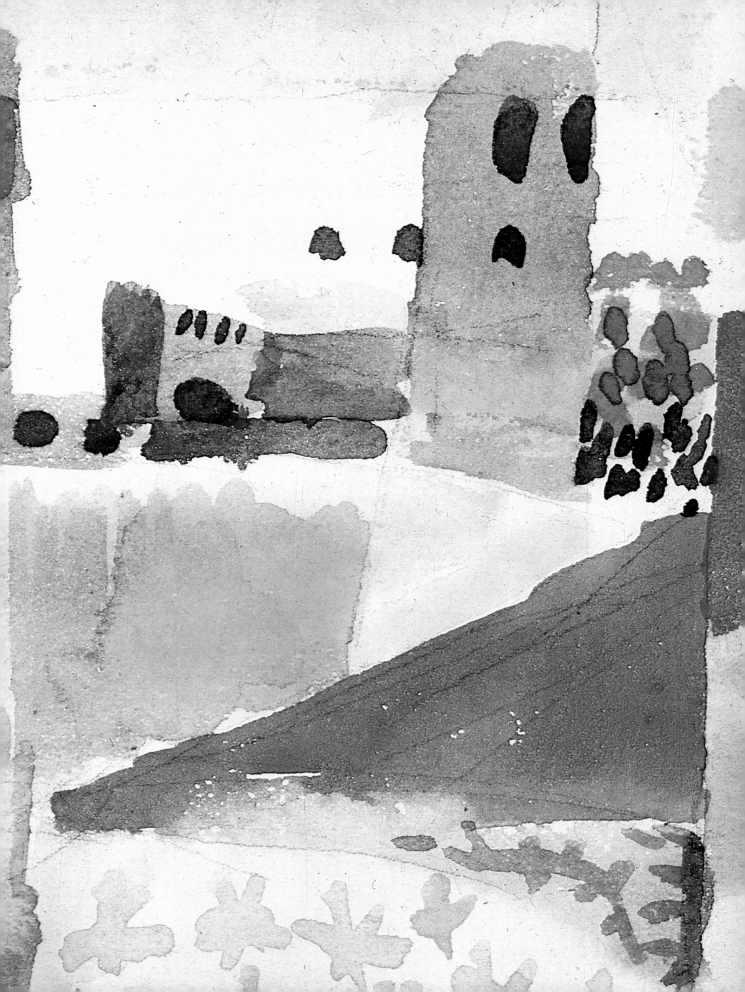

Untitled

1914

Watercolor on laid paper mounted on light cardboard; 4 × 4⅜″ (10.2 × 11.1 cm). Initialed, in black ink (upper right): *Kl.* Dated and numbered, on the light cardboard, in black ink (lower left): *1914 94.* Recorded in Klee's oeuvre catalogue as: *Aquarell (wie 1914 85)* [Watercolor (as 1914 85)].

One year before he executed this untitled watercolor—in 1913—Klee had made his first few completely abstract black-and-white prints and drawings. He executed these works after he had come into contact with the French avant-garde during his second visit to Paris in spring 1912. During that trip he met Robert Delaunay, Henri Le Fauconnier, and Karl Hofer. He had seen the works of Georges Braque and Pablo Picasso at the German art historian Wilhelm Uhde's house and those of André Derain, Maurice Vlaminck, and Picasso at Kahnweiler's gallery. At the Bernheim-Jeune gallery, he had become acquainted with the paintings of Henri Matisse.

In the earlier part of 1914, before leaving for Tunisia in April, Klee had again made some completely abstract works in color. However, they lack the freedom and spontaneity that marked his pictures after his return from North Africa.

This small, untitled watercolor was painted in the "Tunisian" style, evoking the works he had executed at Hammamet and at St. Germain that same year (see pages 61 and 65). Herein lie the seeds of his colored squares of 1923 and 1924, which Grohmann called his "Magic Squares."[1]

1 Will Grohmann, *Paul Klee*, translator unknown (New York: Harry N. Abrams, 1954), pp. 213–14.

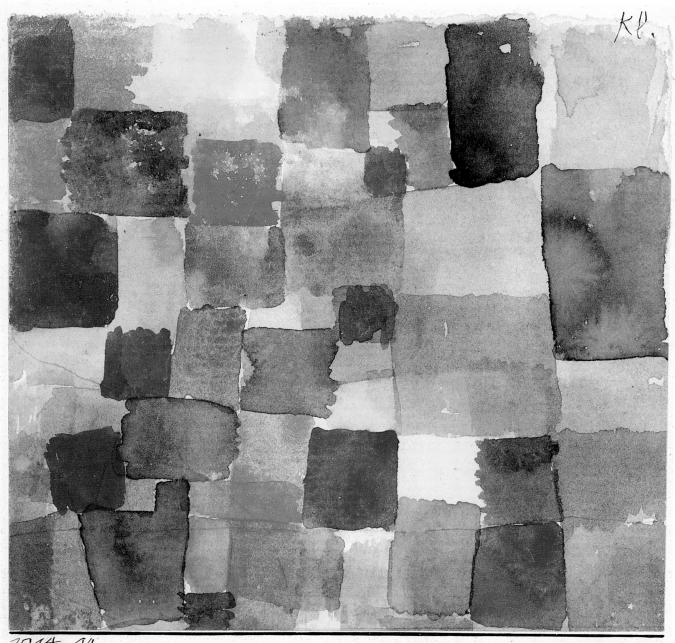

Kl.

1914 94

Untitled

1914

Watercolor and pen and black ink on laid paper
mounted on light cardboard; 4¼ × 5⅛"
(10.8 × 13 cm). Signed, in black ink (center
right): *Klee*. Dated and numbered, on the light
cardboard, in black ink (lower left): *1914 147*. Recorded in
Klee's oeuvre catalogue with an inventory number but no
title.

Actually, Klee did not continue working in his "Tunisian" style after his
return from North Africa in April 1914. (*Untitled*, 1914, page 69, and a
few other works of this series are exceptions.) Immediately after his
return to Munich in April, Klee wrote in his diary: ". . . Every time a type
grows beyond the stage of its genesis, and I have reached the goal, the
intensity gets lost very quickly, and I have to look for new ways. It is
precisely the way which is productive—this is the essential thing; becom-
ing is more important than being."[1]

Thus line reappears in Klee's work. Here it forms a composition of
spiky triangles, irregular rectangles, diamonds, and odd curves. These
shapes are filled with thin washes of cool or warm hues of color.

1 *Diaries*, p. 307.

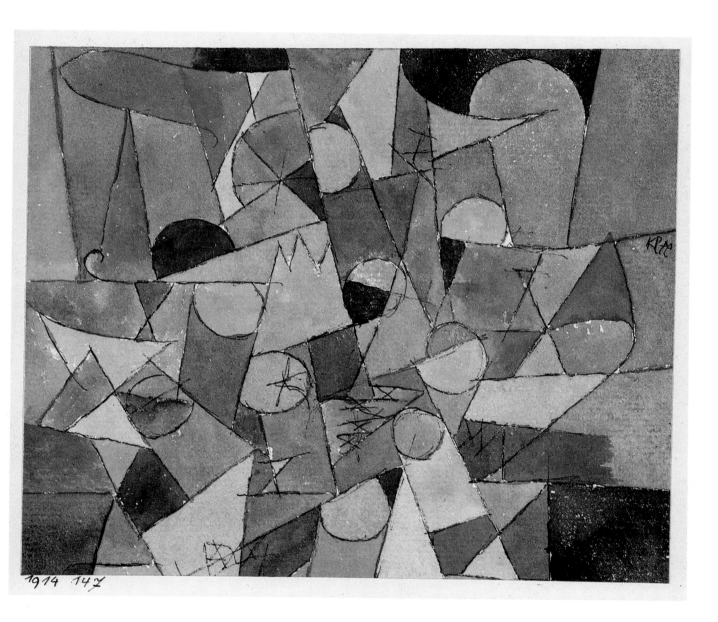

1914 147

Movement of Vaulted Chambers
Bewegung der Gewölbe
1915

Fig. 7. Robert Delaunay, *Saint-Séverin*, 1909. Oil on canvas; 39⅛ × 29⅛" (99.3 × 73.9 cm). The Minneapolis Institute of Arts. The William Hood Dunwoody Fund

Watercolor on laid paper mounted on light cardboard; 7⅞ × 9⅞" (20 × 25.1 cm). Signed, in black ink (upper right): *Klee*. Dated and numbered, on the light cardboard, in black ink (lower left): *1915 53*; titled, in pencil (lower left): *Bewegung der Gewölbe*. Recorded in Klee's oeuvre catalogue as: *Bewegung gotischer Hallen* (Movement of Gothic Halls).

". . . He created a type of picture which is sufficient unto itself and which, without borrowing from nature, uses planes and forms which lead an absolutely *abstract* experience."[1] These words might have been written about Klee's watercolor. However, they were not.

It was Klee himself, who, in 1912, in his role as art and literary critic for the monthly Bernese magazine *Die Alpen*, thus expressed his own admiration for Robert Delaunay in an article written on the occasion of an exhibition of the *Moderner Bund* at the Kunsthaus Zürich. Two of Delaunay's *Windows on the City* of 1912 were shown there. Later, Klee translated Delaunay's essay *La Lumière*, which appeared in the January 1913 issue of *Der Sturm* magazine.

In *Movement of Vaulted Chambers* Klee emulates most closely those qualities that he admired in Delaunay's work. Although all connections with the outside world have apparently been severed, the elongated and slightly curved shapes to the right do evoke the Gothic archways in Delaunay's series of paintings entitled *Saint-Séverin* of 1909 (fig. 7).

1 Christian Geelhaar, ed., *Paul Klee Schriften Rezensionen und Aufsätze* (Cologne: DuMont Buchverlag, 1976), p. 108. Translation from Michel Hoog, *R. Delaunay*, translated by Alice Sachs (New York: Crown Publishers, 1976), p. 62.

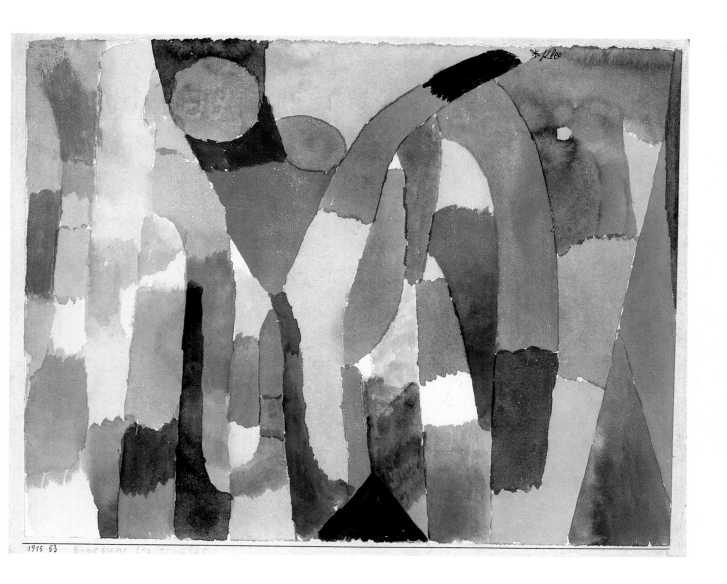

1915 53 Bewegung der Gewölbe ✳ Klee

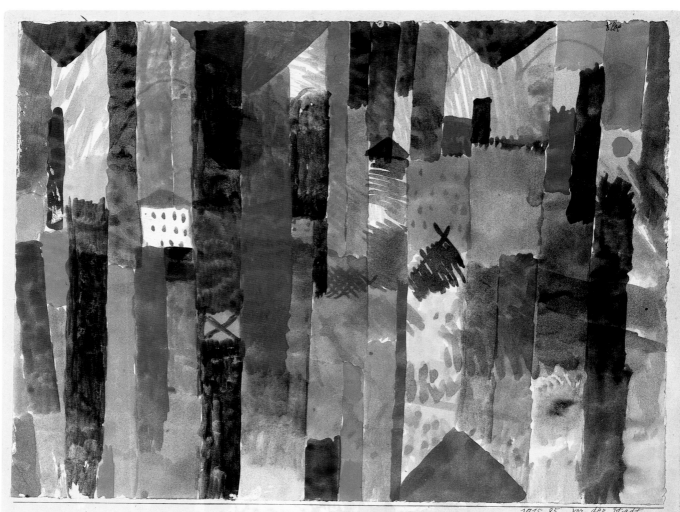

1915 85 vor der Stadt

Before the Town
Vor der Stadt
1915

Watercolor on wove paper mounted on light cardboard;
8⅞ × 11¾″ (22.5 × 29.8 cm). Signed, in black
ink (upper right): *Klee*. Inscribed, on the light
cardboard, in black ink (lower right): *1915 85 vor
der Stadt*. Recorded in Klee's oeuvre catalogue as:
vor der Stadt.

Klee did not care to sketch only at such picturesque sites in Munich as
the Hirschau, an extension of the Englischer Garten. According to his
son Felix, he also visited empty lots and the unromantic modern houses
on the outskirts of Munich and along the Nymphenburg Canal in
Milbertshofen.

This watercolor belongs to a group of ten works (nine dated 1915
and one 1914) whose titles and formal elements refer in one way or
another to existing, new, or still unfinished parts of a city. Here one
white and two orange rectangles are pierced by black dots suggesting
façades of houses wedged between brilliantly colored stripes of various
widths and lengths. Painted with a quick, loose brush and covered by
various odd scribbles, the composition could convey the rawness and
randomness that one may see on the outskirts of an expanding city.

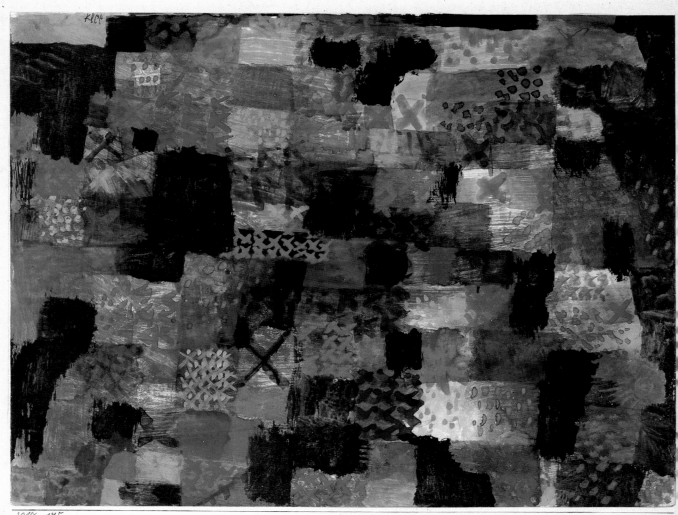

Klee

1915 175

Deep Pathos
Schweres Pathos
1915

Gouache and watercolor on wove paper mounted on light
cardboard; 7⅛ × 9⅛″ (17.8 × 23.2 cm). Signed,
in black ink (upper left): *Klee*. Dated and numbered,
on the light cardboard, in black ink (lower left):
1915 175. Recorded in Klee's oeuvre catalogue as:
schweres Pathos.

No collector purchased this work when it was first shown as *Abstract
Watercolor* in the New Secession exhibition held in Munich in the sum-
mer of 1916. Klee subsequently changed its title to *Deep Pathos* for the
exhibition's tour to Frankfurt am Main in the following year. It sold.[1]

 Was it a spirit of irony that made Klee choose such a somber title
for a composition whose rather untidily interlocked squares and rec-
tangles, stippled with little dots and cross-stitchlike patterns, form a
merry patchwork?

1 See O. K. Werckmeister, "Klee im
Ersten Weltkrieg," *Paul Klee: Das Frühwerk
1883–1922*, compiled by Armin Zweite,
exhibition catalogue (Munich: Städtische
Galerie im Lenbachhaus, 1979–80), p. 185.

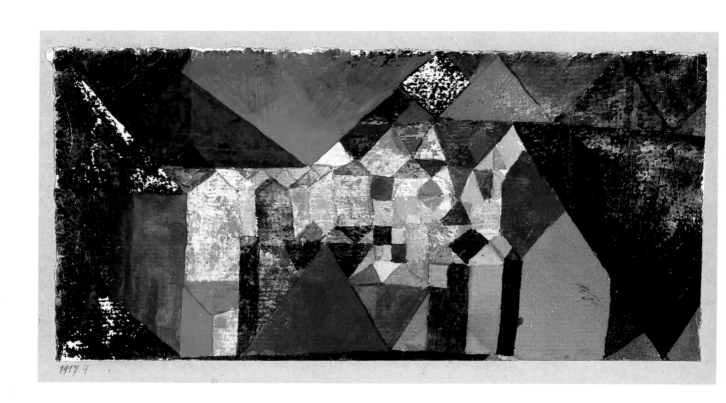

Municipal Jewel
Städtisches Juwel
1917

Watercolor, gouache, and pencil on gesso on laid paper mounted on light cardboard; 3⅞ × 7¾" (9.8 × 19.7 cm). Initialed, in black ink (lower right): *Kl.* Dated, on the light cardboard, in pencil reinforced with brown ink (lower left): *1917*; numbered, only in brown ink (lower left): *4*. Recorded in Klee's oeuvre catalogue as: *Städtisches Juwel Besitzer Goltz* (Municipal Jewel owned by Goltz).

In March 1916 Klee was drafted into the German Army and sent as a recruit to Landshut in Bavaria. In January 1917, after two transfers, he was assigned to a desk job in the paymaster's office of the Royal Bavarian flying training school in Gersthofen, near Augsburg. He had, in fact, benefited from an unwritten decree exonerating talented young Munich artists from being sent to the front.

At Gersthofen Klee had more time for his own work, and he did not let the events of the war affect him. A fatal accident at the flying school, he commented laconically to his wife, was only a fine prelude for the next day's flying exercises, concluding: ". . . I sit here safe and warm and feel no war within me."[1]

Municipal Jewel shows no reflection of the war. In fact, as he noted in his diary and also in a letter to his wife, he felt that his work had progressed faster during these difficult times than it would have during a quiet, humdrum existence.[2]

Jürgen Glaesemer ascribes the luminosity and intensity of color in most of the watercolors of this period to the influence of the *Blaue Reiter* group with whom Klee had come into contact in 1911 and especially to his friend Franz Marc.[3] The latter's death in March 1916 deeply affected Klee.

Municipal Jewel is probably one of the first works that Klee was able to paint at Gersthofen. Small, translucent geometric forms, surrounded by somber larger ones, give the effect of a big crystal shimmering in darkness, thus possibly giving Klee the idea for this title.

1 *Briefe*, II, p. 884.

2 *Ibid.*, p. 876.

3 Jürgen Glaesemer, *Paul Klee: The Colored Works in the Kunstmuseum Bern*, translated by Renate Franciscono (Bern: Kornfeld and Cie, 1979), p. 39.

Libido of the Forest
Triebkraft des Waldes
1917

Watercolor on gesso on cloth mounted on light
cardboard; 5⅝ × 7½″ (14.3 × 19.1 cm). Signed, in
gray ink (lower right): *Klee*. Dated and numbered, on
the light cardboard, in brown ink (lower left): *1917 29*.
Recorded in Klee's oeuvre catalogue as: *Triebkraft
des Urwaldes*.

". . . The evening yesterday was very colorful so that I was inspired to
paint a new kind of watercolor while lying down in the forest."[1] Thus
Klee wrote to his wife, Lily, on March 18, 1917. He might have been
referring to *Libido of the Forest*, which is indeed different in style from
all his previous watercolors. While lying on the ground in early spring,
Klee must have enjoyed the new life all around him. Hence, no doubt,
the loose swirls that remind one of the drawings of magnetic fields seen
in physics textbooks.

As for all his other works painted during World War I, Klee used
whatever scrap of material was handy. In this case it was a piece of
airplane linen.

1 *Briefe*, II, p. 875.

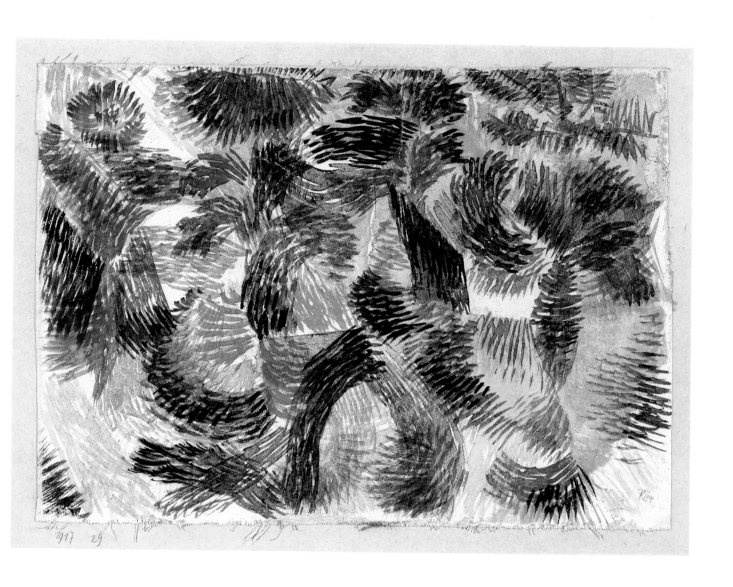

1917 29

Colorful Architecture

Farbige Architektur

1917

Gouache on wove paper mounted on light cardboard;
6¾ × 5⅜" (17.1 × 13.3 cm). Signed, in black
ink (upper left): *Klee.* Dated and numbered, on the
light cardboard, in black ink (lower left): *1917.54.*
On the original cardboard backing, in Klee's
handwriting, in blue pencil: *AR 265/1917 54/*
Farbige Architectur/Klee. In a different hand,
in black ink (below): *München—Mai 1920.*
Klee recorded the work's inventory number in his oeuvre catalogue
but instead of a title wrote: *Verkauft Goltz Mai Juni 20* (Sold to
Goltz May June 20).

During World War I, every moment that Klee could get away from his
clerical duties in the paymaster's office at Gersthofen was devoted to his
work. He would take a box of watercolors and paint out-of-doors. When
the weather was bad, he used his desk drawer as a work area and as a
storage bin: "I worked yesterday and today as if I were at home; the only
difference being that I work in my drawer, which protects me against
surprises."[1] Here a green moon and its mauve crescent are the only
curved forms within an angular composition whose rectangles, triangles,
and squares suggest roofs and façades of houses.

1 *Diaries,* p. 380.

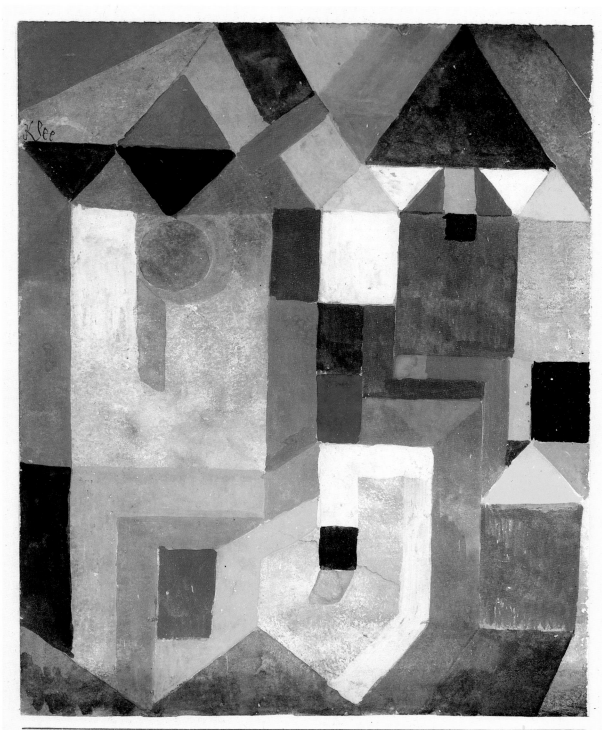

1917. 54.

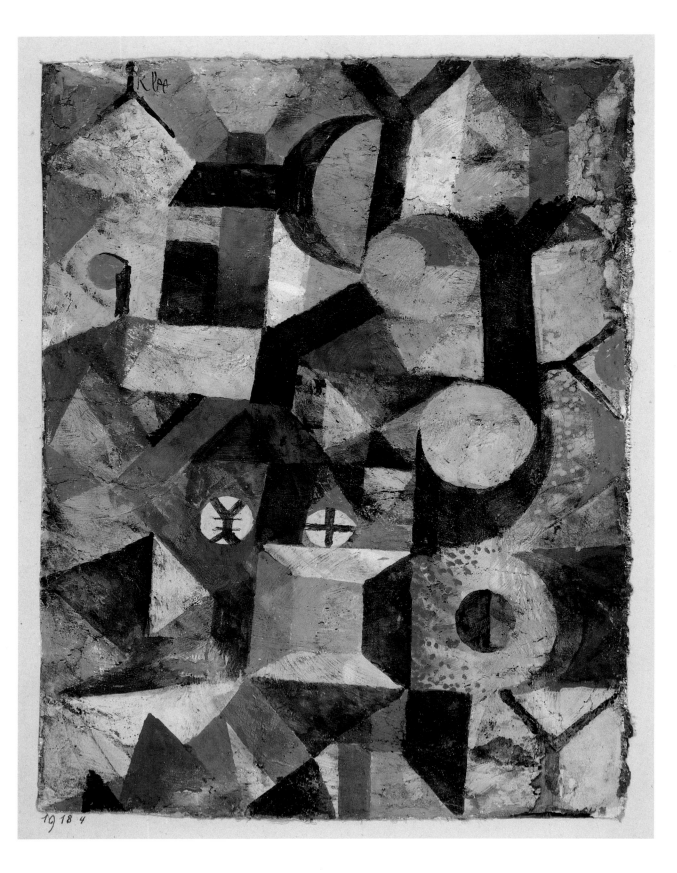

Composition with the Yellow Half-Moon and the Y
Komposition mit dem gelben Halbmond und dem Y
1918

Gouache and watercolor on gesso on cloth mounted on light
cardboard; 8¾ × 6⅝″ (22.2 × 16.8 cm). Signed, in black
ink (upper left): *Klee*. Dated and numbered, on the light
cardboard, in brown ink (lower left): *1918 4*. Recorded
in Klee's oeuvre catalogue as: *Komp. m. dem gelben Halbmond
und dem Y.*

The first months of 1918 were most productive ones for Klee. With the
Army paymaster away, Klee was in charge of the office every night, and
he could work at leisure. His walks and the subtle colors of the late
winter in the country provided inspiration: "I walked in the river bed
[Lech] and since I was wearing rubber boots, I was able to wade through
the water in many places. I found the most beautiful polished stones. I
took along a few washed-out tiles. It is just a short step from this to
plastic form."[1]

Klee sought inspiration in the out-of-doors for his abstractions,
even if the latter, then, might suggest completely different forms. Thus
here they evoke the overlapping colored-glass shards of a kaleidoscope
too broken to create symmetry. On the lower left blue triangles are about
to form a star. Elsewhere one sees black crescents, a square in perspec-
tive, circles, two Ys, and the yellow half-moon of the title.

1 *Briefe*, II, p. 901.

Tomcat's Turf
Revier eines Katers
1919

Watercolor, gouache, and oil on gesso on two sections
of cloth mounted on light cardboard; (lower
section) 3½ × 5⅝″ (8.8 × 14.3 cm); (upper
section) 4⅞ × 5½″ (12.4 × 14 cm). Signed,
in black ink (lower section, upper right): *Klee*.
Dated and numbered, on the light cardboard, in black ink
(lower left): *1919 49*. Recorded in Klee's oeuvre
catalogue as: *Revier eines Katers volkstümliches
Aquarell Flugzeugleinen kreidegrundiert* (Tomcat's
Turf; popular watercolor, airplane linen primed with
chalk).

Fig. 8. Reconstruction of *Tomcat's Turf*

Animals often appear in Klee's work. Some are pure inventions, and
others are real creatures—fish, birds, and cats—whose elusive and
graceful qualities caught Klee's fancy.

Cats played a large role in the artist's private life. He kept them,
photographed them (see fig. 9), wrote about them, and even signed a
letter of October 5, 1922, with the inky paws of his tomcat, Fritzi.

In *Tomcat's Turf*, sky and landscape are reduced to large, loosely
brushed, rough cubic planes. We see a moored boat, a busy watermill, a
red sun, and the letters "B." and "F." Does the letter "F." stand for
Fritzi's name?

Klee liked to cut up his compositions and then rearrange them, just
as he did here (see page 124). By switching the upper and lower parts (fig.
8), Klee also turned the laws of nature upside down. Now the mouse,
high up in the green fields, defies the cat, down below in the blue sky.

1919.49.

Fig. 9. Fritzi at Possenhofen, 1921.
Photograph Paul Klee. Collection
Felix Klee

Fig. 10. Felix Klee, *Fritzi*, 1919. Pencil
on paper; 7⅝ × 10⅝" (19.2 × 26.9 cm).
The Museum of Modern Art, New York.
Gift of Mrs. Donald B. Straus

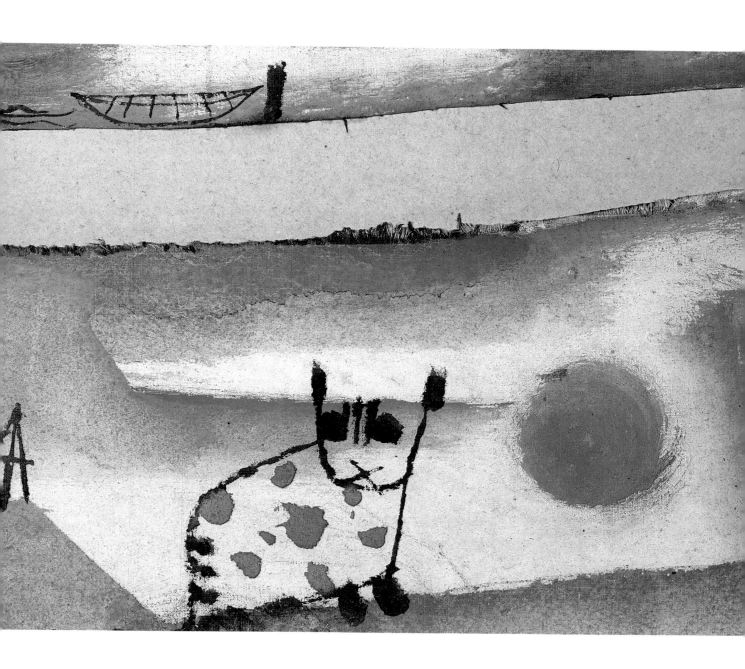

Southern Gardens
Südliche Gärten
1919

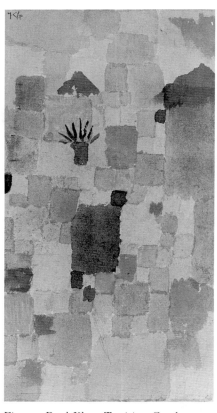

Fig. 11. Paul Klee, *Tunisian Gardens*,
1919. Watercolor on paper mounted on
light cardboard; 9⅜ × 5⅛"
(24 × 13 cm). Private collection

Watercolor, pen and black ink, and transferred
printing ink on two sheets of laid paper mounted
on light cardboard; 9½ × 7⅜" (24.4 × 18.7 cm).
Signed, in black ink (lower left): *Klee*. Inscribed,
on the light cardboard, in black ink (lower left): *1919.80
Südliche Gärten*; in pencil (lower left): *S.Kl.*
Recorded in Klee's oeuvre catalogue as: *Tunesische
Gärten*.

Klee's impressions from his visit to Tunisia in 1914 remained vivid in his
mind and eye for a long time. In this watercolor, painted five years later,
he once again evokes the sun-flooded gardens of St. Germain, the Euro-
pean colony near Tunis. Here, however, nature no longer dictates his
choice of colors. These are bright and luminous, with two plantlike
forms in contrasting black.

The group of seven watercolors to which this work belongs—all
approximately the same height but of slightly different widths—is solely
based on the gardens at St. Germain.[1] Two were painted directly on site
(see page 61), the other five were conjured up from Klee's memory.

Southern Gardens and *Tunisian Gardens* (fig. 11) formed a single
watercolor until Klee took his scissors and separated them. Not content
with that, he also cut off a strip from *Tunisian Gardens*' right edge and
glued it to the right edge of *Southern Gardens*.[2]

1 Klee made many watercolors of St.
Germain. According to Suter-Raeber, in
1914 alone he painted twelve watercolors of
this place. Nine of them depict various sites
at St. Germain and were painted in situ.
Three others were executed a few weeks
later after his return to Bern. See Regula
Suter-Raeber, "Paul Klee: Der Durchbruch
zur Farbe und zum abstrakten Bild," *Paul
Klee: Das Frühwerk 1883–1922*, compiled by
Armin Zweite, exhibition catalogue
(Munich: Städtische Galerie im
Lenbachhaus, 1979–80), pp. 132–33.

2 I am grateful to Wolfgang Kersten, Paul
Klee Stiftung in the Kunstmuseum Bern, for
this information.

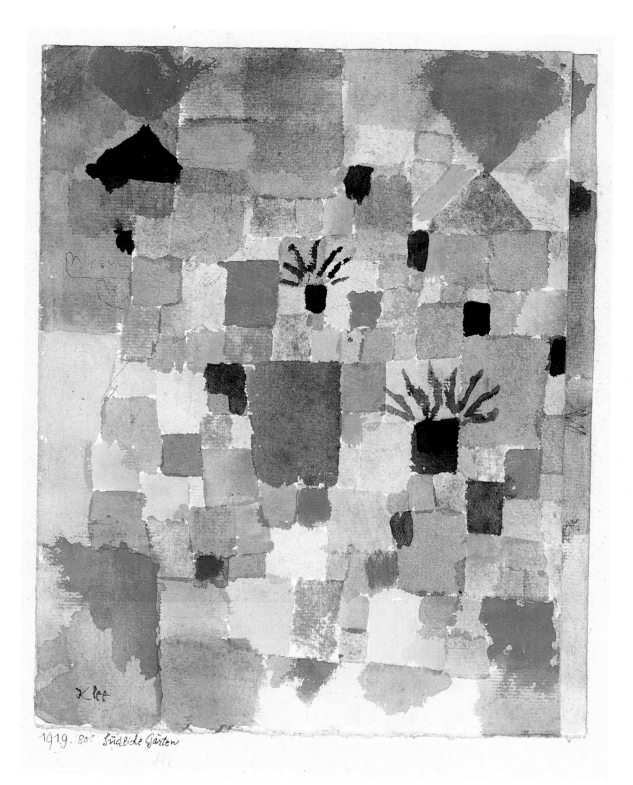

Klee

1919. 80: Südliche Gärten

Black Columns in a Landscape
Landschaft mit den schwarzen Säulen
1919

Watercolor, pen and black ink on wove paper mounted
on light cardboard; 8 × 10⅞″ (20.4 × 26.3 cm).
Signed, in black ink (lower right): *Klee*. Dated
and numbered, on the light cardboard, in brown ink
(lower left): *1919 144*. Recorded in Klee's oeuvre
catalogue as: *Landschaft m. d schwarzen Säulen.*

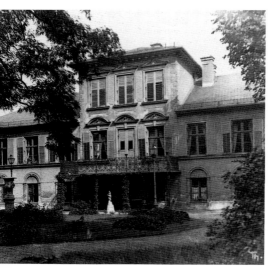

Fig. 12. Schlösschen Suresnes, Wer-
neckstrasse 1, Munich, at the turn of the
century. Photograph Stadtarchiv
München

Klee was able to return to civilian life in Munich for the Christmas
holidays in 1918, and his final release from the German Army occurred
in February 1919. The Klees' dark apartment at Ainmillerstrasse 32/II
was somewhat cramped. It consisted of a large room in which Lily gave
piano lessons, a living room, and a bedroom. Klee painted in the kitchen.
In the spring of 1919, however, he rented a large studio in the eigh-
teenth-century palais Suresnes in the Werneckstrasse in Schwabing,
Munich's artists' quarter.

Suresnes had been built in 1715–17.[1] In the next two centuries, the
palais had changed hands more than twenty times. When Klee moved
into it, the building had been split up into rental units.[2] The once splen-
didly furnished interior, the French formal garden, the chestnut grove,
the fountain, and sculptures were all in a state of gentle neglect. When it
rained, Klee collected the water in buckets. According to Felix Klee,
Suresnes, its park as well as the nearby Englischer Garten, served as
inspiration for this watercolor.[3] It depicts Ionic columns, a large chestnut
leaf, a thin black cross, a small red pavilion, and a boat on the River Isar,
which flows through Munich.

Today Suresnes serves as the guest house for the Catholic Academy
of the State of Bavaria.

1 Max Xavier Ignaz von Wilhelm,
secretary to Elector Max Emmanuel of
Bavaria, built Suresnes on the model of the
château de Suresnes, west of Paris. While in
exile in France from 1713 to 1715 during
the War of the Spanish Succession, Max
Emmanuel had enchanted Parisian society
with his lavish parties. In 1720 Schwabing
was a small village of no more than forty
houses owned mostly by farmers and
fishermen.

2 While Klee lived at Suresnes, it was
owned (1878–1924) by the Schüler family,

respectively by Emil Schüler, a factory
owner from St. Johann on the Saar River;
by Karl Schüler, the director of the
Südbahngesellschaft, Vienna; and by Oskar
Schüler and Co. See Michael Schattenhofer,
Schloss Suresnes in Schwabing (Munich,
1982), p. 49.

3 Felix Klee, *Paul Klee/12 aquarelles*,
translated by Pierre-Henri Gonthier (Paris:
Berggruen & Cie, 1964), text to pl. 2.

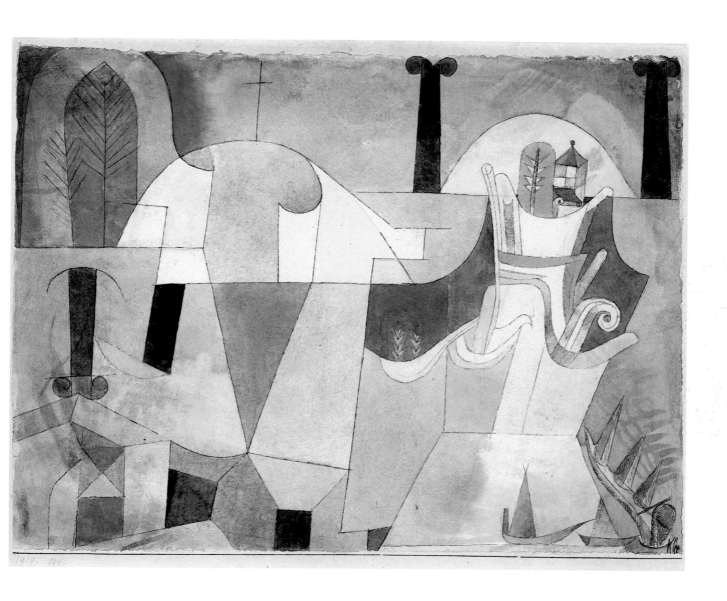

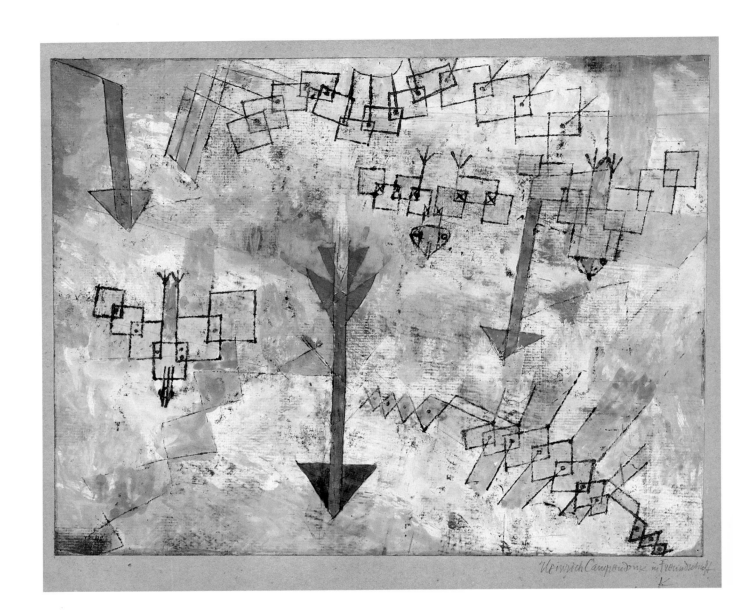

Birds Swooping Down and Arrows
Herabstossende Vögel und Luftpfeile
1919

Watercolor and transferred printing ink on
gesso on laid paper mounted on light cardboard;
8⅜ × 10½″ (21.3 × 26.7 cm).
Dated and numbered, on the light cardboard,
in brown ink (lower left): *1919 201*. Inscribed, in
pencil (lower right): *Heinrich Campendonk in
Freundschaft/K.* (Heinrich Campendonk in friendship/K.)
Recorded in Klee's oeuvre catalogue
as: *Herabstossende Vögel und Luftpfeile*.

Are they birds? Are they planes? Of course not! They are bird-planes.
We learn this from a pencil drawing (see fig. 13) from which Klee copied
part of this watercolor, and which dates from 1918, when he was sta-
tioned at the pilots' school in Gersthofen. The artist's inspiration, no
doubt, was the sight of airplanes constantly flying above him.

The composition of this pencil drawing is unresolved. It might have
begun as a playful exercise with rectangles. Then, after the artist linked
one rectangle to another, added dots, bird feet, and odd shapes with
eyes, the rectangles turned into birds or flying machines.

In this watercolor, as in more than 240 others executed between
1919 and 1925, Klee used a special kind of transfer technique.[1] He
covered a sheet with black oil paint and then placed it between a drawing
(fig. 13) and a blank sheet of paper. With a stylus he retraced those
outlines of the drawing that he wanted to reproduce on the sheet of

1 Marie-Françoise Haenggli-Robert of the
Paul Klee Stiftung in the Kunstmuseum
Bern supplied an itemized listing by year of
Klee's transfer drawings between these
dates.

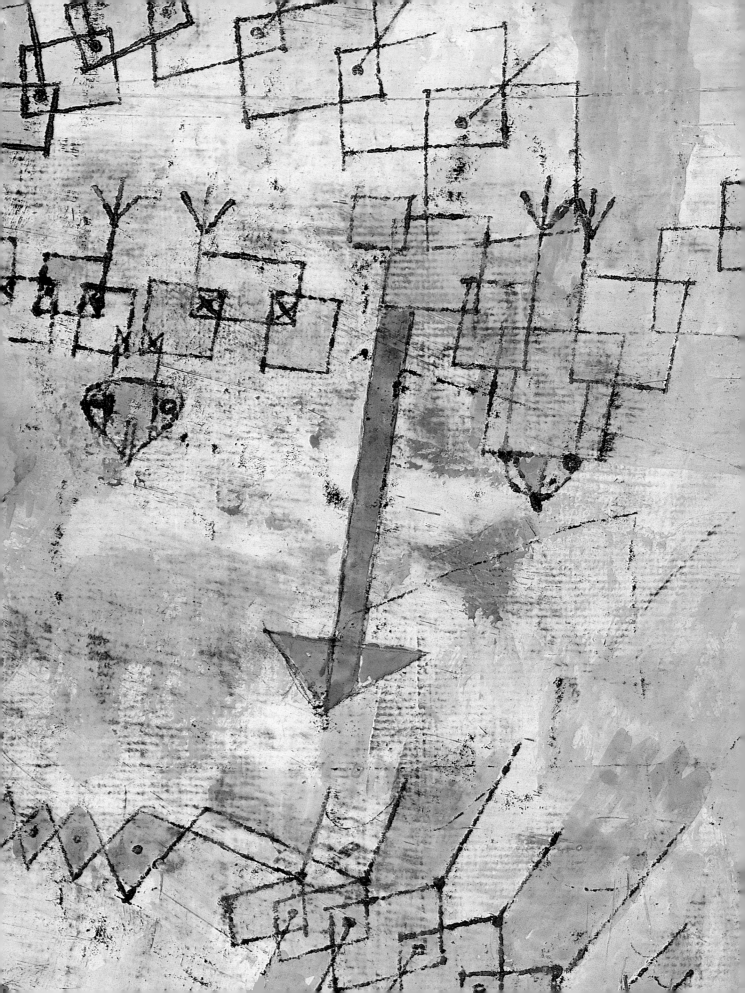

paper. In this case he deleted the forms appearing left of center in the drawing. The "transferred" drawing now has the desired effects, namely soft and blurred lines and, through the pressure of his hand and friction, blots and traces of black oil paint. Now Klee could add color or any other embellishment to the new work, while he kept his original drawing. Here he added three colored arrows that indicate the direction of flight. This method of working allowed Klee to use a single drawing as the model for several watercolors. Color no longer had to be confined within sharp contours and could be applied more generously.

Klee regarded his drawings as his best source of inspiration. Because he reused their motifs often, sometimes many years later, he preferred not to sell them. Klee's use of this transfer technique coincided with his association with the dealer Hans Goltz in Munich. Twice, beginning in 1919, Klee entered into a three-year contract with Goltz. It was Goltz who told him that colored sheets sold better. After 1925, when his second contract with Goltz expired, Klee made only a few transfer drawings.

This work was dedicated to his friend Heinrich Campendonk (1888–1957), a fellow member of the Blue Rider group, whose naively exaggerated, neoprimitive painting reflects his enthusiasms for Bavarian painting on glass and for folk art, and with whom Klee corresponded throughout World War I.

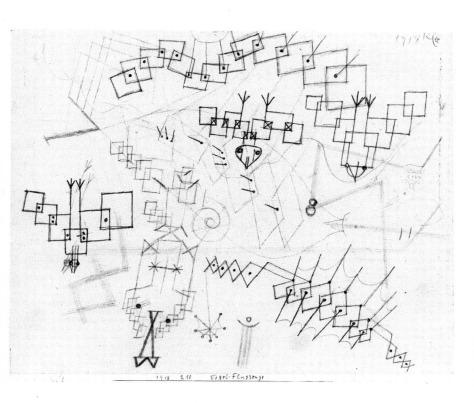

Fig. 13. Paul Klee, *Bird-Planes*, 1918. Pencil and incised lines on paper mounted on light cardboard; 8⅝ × 10¾" (21.8 × 27.4 cm). Private collection, Bern

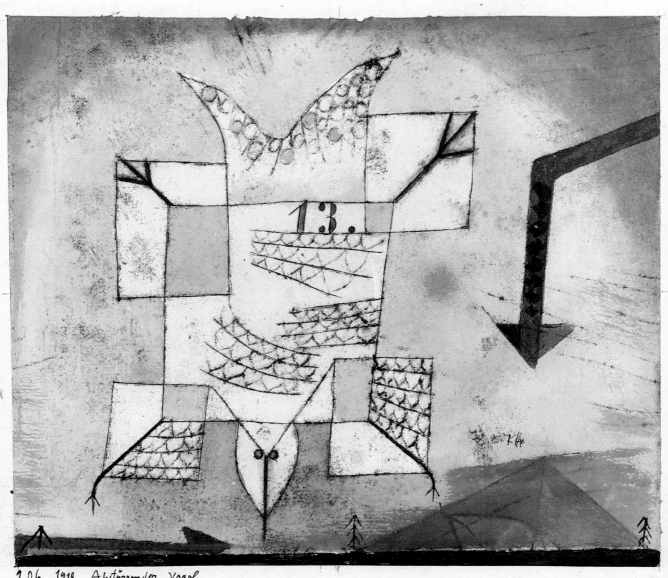

206. 1919 Abstürzender Vogel

Falling Bird
Abstürzender Vogel
1919

Watercolor, transferred printing ink, and pen and black ink on laid paper bordered with black ink mounted on light cardboard; 6⅜ × 7⅜" (16.2 × 18.7 cm). Signed, in black ink (lower right): *Klee.* Inscribed, on the light cardboard, in black ink (lower left): *206.1919 Abstürzender Vogel.* Recorded in Klee's oeuvre catalogue as: *Abstürzender Vogel.*

Fig. 14. Paul Klee, *Falling and Gliding Bird*, 1919. Crayon and incised lines on paper mounted on light cardboard; 11 × 8⅝" (28 × 22 cm). Private collection, France

This watercolor appears as a sequel and close-up to the preceding and contemporary work, *Birds Swooping Down and Arrows*, 1919 (see page 94). When Klee was stationed at the flying school in Gersthofen from 1917 to 1918, he had ample opportunity to witness airplane crashes. He usually responded to them with cynicism, as during the week he witnessed three fatal casualties and wrote in his diary: "This week we had three fatal casualties; one man was smashed by the propeller, the other two crashed from the air! Yesterday, a fourth man came ploughing with a loud bang into the roof of the workshop. He had been flying too low, caught on a telephone pole, bounced on the roof of the workshop, turned a somersault, and collapsed upside down in a heap of wreckage. People came running from all sides; in a second the roof was black with mechanics in working clothes. Stretchers, ladders. The photographer. A young man being pulled out of the debris and carried away unconscious. Loud cursing at the bystanders. First-rate movie effects. . . ."[1]

One year later, in 1919, Klee seemed to recapture these accidents in this haunting image. The large bird, copied from the upper bird in the drawing *Falling and Gliding Bird*, 1919 (fig. 14), comes hurtling down, within seconds of a fatal crash in a desolate landscape. It has four feet, two tails, square wings, and some sort of a coat of mail, and it might be a hybrid between a flattened dinosaur, a plane, and a kite. Bad omens abound, such as the black number thirteen, perhaps a reminder that Klee during his stay at Schleissheim, preceding that at Gersthofen, painted numbers on airplanes. Equally ominous is the bent black arrow, a feature that later recurred in many of Klee's works.

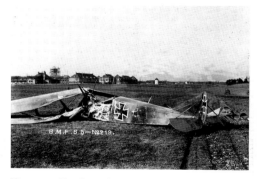

Fig. 14a. Fatal airplane crash of bombardier Georg Schmidt, March 8, 1918, Airport Gersthofen, Fifth Royal Bavarian Air Force Flying School. Photograph Bayerisches Hauptstaatsarchiv IV, Munich

1 *Diaries*, pp. 387–88.

The Hypocrites
Heuchlerpaar
1919

Watercolor and transferred printing ink on laid
paper bordered with metallic foil mounted on
light cardboard; 5¾ × 9⅜″ (14.6 × 23.8 cm).
Signed, in black ink (lower right): *Klee*. Inscribed,
on the light cardboard, in black ink (lower left):
1919.213. Heuchlerpaar. Recorded in Klee's oeuvre
catalogue as: *Heuchlerpaar*.

Two beasts lock in a strange mating ritual. Being hypocrites, they also
feign depth of emotion. The male animal has a large round head and the
eyes of a cat. He is fitted with a small curled tail and a curious heavy
appendage. He pretends "Selbst Hingabe" (self-devotion). These words,
at least, are inscribed on the two yellow banners at the lower left (Klee
wrote "Selbst" [self] upside down). Meanwhile, the female crocodile
promises "Tiefe des Herzens" (depth of heart) as her yellow tongue
waves between her open jaws. As if to underline the irony, the "Tiefe"
(depth) is measured like a ribbon on a yardstick against an arrow point-
ing not toward—but away—from the heart. The couple's eyes are well
matched. The cat's eyes of the male are impenetrable with their thin
black pupils. As for the eyes of the crocodile, the value of the tears they
might shed is well known.

Here is one of the few instances of the obscene in Klee's work.
However, it has been relegated to the realm of the unreal.

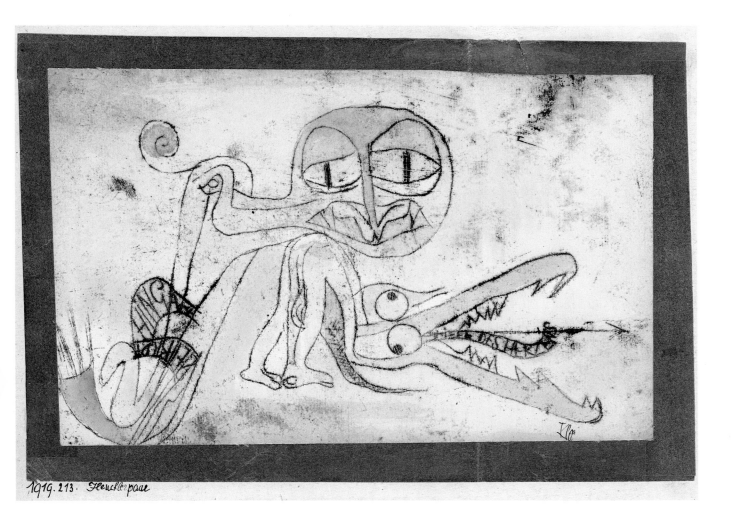

1919. 213. Heuchlerpaar

Lady Inclining Her Head
Dame mit geneigtem Haupt
1919

Watercolor and transferred printing ink on laid
paper mounted on light cardboard; 11⅛ × 5¾″
(28.3 × 14.6 cm). Signed and dated, in black ink
(lower right): *Klee 1919*. Numbered, in pencil (lower
right): *222*. Dated and numbered, on the light
cardboard, in brown ink (lower left): *1922 222*.
Recorded in Klee's oeuvre catalogue as: *Dame mit
geneigtem Haupt (orange u. gelb)*.

Female nudes are relatively rare in Klee's art. Fewer than forty works
show this motif among his nearly 10,000 paintings, drawings, and water-
colors. This figure excludes his early studies after the nude of 1899 and
1903–1905 and his satirical etchings and drawings of 1903–1906 and
1907–1908. His nudes in the latter group show the deformed and worn-
out bodies of fools and sinners, like some nudes depicted in medieval art.

Perhaps Klee satirizes vanity in this cruel watercolor: the dolled-up
hair, the necklace, the painted face, and the would-be alluring posture of
a lady well past her prime.

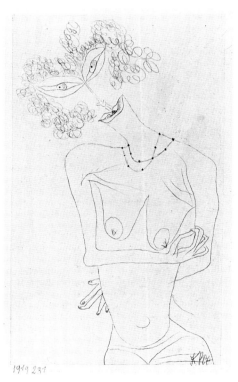

Fig. 15. Paul Klee, *Naked Lady with
Necklace and Curly Hair*, 1919. Pencil and
incised lines on paper mounted on light
cardboard; 10¾ × 6¼″ (27.3 × 15.9 cm).
Paul Klee Stiftung, Kunstmuseum Bern

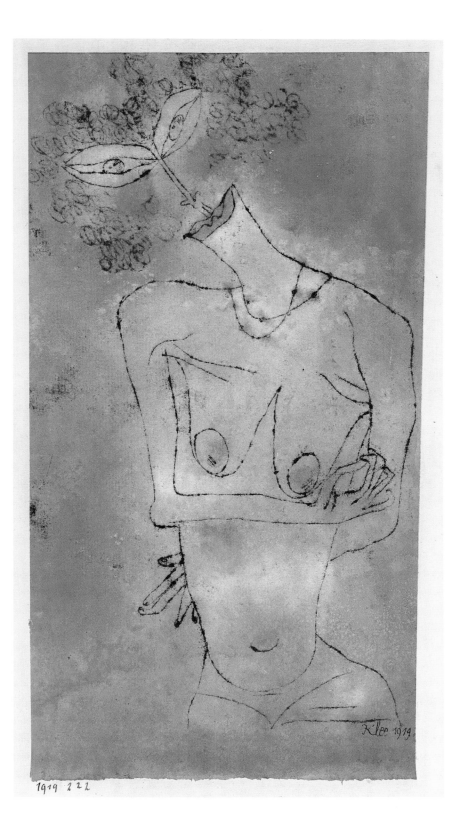

Klee 1919

1919 222

Theater-Mountain-Construction
Bühnen-Gebirgs-Konstruktion
1920

Oil, gouache, pen and black ink on wove paper mounted on light cardboard; 13 × 16½″ (33 × 41.9 cm). Signed, dated, and numbered, in black ink (lower right): *Klee 1920 28*. Inscribed, on the light cardboard, in brown ink: *1920/28 Bühnen-Gebirgs-Konstruktion*. Recorded in Klee's oeuvre catalogue as: *Landschaftliche Holzarchitectur oder Bühnengebirgs-Konstruktion* (Wooden Architecture in the Manner of a Landscape or Mountainous Theater-Construction).

A fantastic stone quarry might be the scene of Klee's "mountainous theater-construction." First the artist painted on paper in oil the colors of the rainbow and highlighted them with white gouache. Then he drew with pen and ink the configurations of black parallel lines that cover the entire surface of the sheet. These striations of various widths, lengths, and angles seemingly form plateaus and gorges, terraces and mountains, apparently hewn out of crystalline rock.

In his studio in the eighteenth-century palais Suresnes in Munich's artists' quarter, Schwabing, in 1919, Klee first began to paint seriously in oil. A photograph made by the artist in 1920 shows this work in the Suresnes studio (fig. 16). It appears in a white frame at the far left of the photograph, partly cut by the photograph's edge.

Fig. 16. Paul Klee's studio in Schlösschen Suresnes, Werneckstrasse 1, Munich, 1920. Photograph Paul Klee. Collection Felix Klee

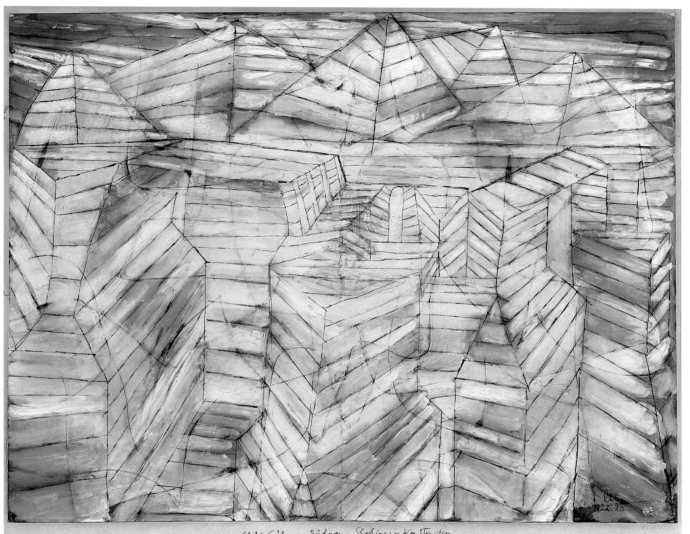

1920/28 Bühnen – Gebirgs – Konstruction

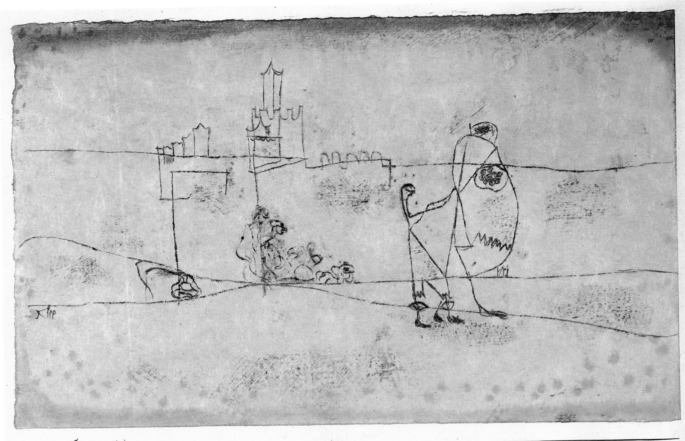

1920/35 Scène aus Kairuan

Episode at Kairouan
Szene aus Kairuan
1920

Watercolor and transferred printing ink on wove
paper mounted on light cardboard; 6⅞ × 10⅞″
(17.5 × 27.6 cm). Signed, in black ink (lower left):
Klee. Inscribed, on the light cardboard, in black
ink (lower left): *1920/35 Scene aus Kairuan*. Recorded
in Klee's oeuvre catalogue as: *Scene aus Kairuan
(nach der Bleist.zchn 1914)* [Episode at Kairouan
(after the pencil drawing of 1914)].

The high point of Klee's 1914 Tunisian journey was a stay of three days
at Kairouan, one of Tunisia's oldest Arab cities whose ancient quarter is
encircled by a 33-foot-high wall. Surrounded by salt marshes, it lies
about 80 miles south of Tunis. Founded in 670, Kairouan once served as
the capital and religious center of North Africa. Its Great Mosque of Sidi
Okba was first built about that same year. Many other mosques were
built during the Turkish occupation, which lasted from 1574 to 1650.
Regarded as one of the four gates of Paradise, Kairouan denied entry to
Christians and Jews. Spending "one's last days within its walls," says
Baedeker, and being "buried in hallowed earth outside its gates, seemed
to believers the height of bliss."[1]

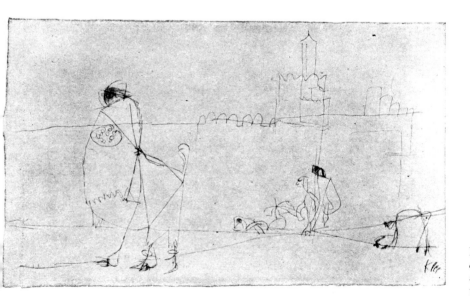

Fig. 17. Paul Klee, *Woman with Child
and Small Group of People*, 1914. Pencil
and incised lines on paper. Whereabouts
unknown

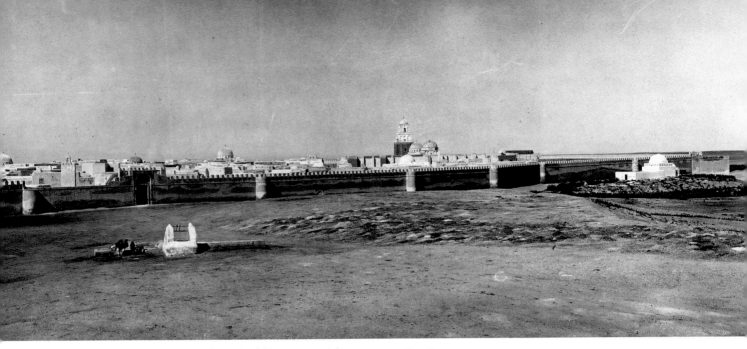

Fig. 18. Kairouan at the turn of the century. Photograph Roger-Viollet, Paris

Klee fell completely under Kairouan's spell. He wrote in his diary: "The essence of *A Thousand and One Nights*, which is, however, ninety-nine percent real. What an aroma, how penetrating, how intoxicating, and at the same time simple and clear. Nourishment, the most real and substantial nourishment as well as delicious drink. Food and intoxication. Scented wood is burning. Home?"[2]

The following day Klee made the now-famous entry in his diary: "Color possesses me. I don't have to pursue it. It will possess me always. I know it. That is the meaning of this happy hour: Color and I are one. I am a painter."[3] Klee revised and edited his diary between 1904 and 1921. Thus, he could have replaced these overly rhapsodic passages with simpler ones when his ecstasy had worn off after the trip, but he chose not to do so.[4]

Klee's visit to Tunisia has become the most written-about trip of any artist, excepting perhaps Goethe's travels in Italy and the imaginary ones of Dante in the *Inferno*. Perhaps this fame rests partly on these frequently quoted passages from Klee's diary, which has in itself become so widely read and famous.

Klee painted this watercolor six years after his visit to Kairouan, and some years later (in 1923) he painted *Episode Before an Arab Town* (see page 171) and (in 1931) the larger *Episode B at Kairouan* (see page 236). Both the 1920 and 1923 watercolors—but not the 1931 work—were transferred from the same pencil drawing, *Woman with Child and Small Group of People*, 1914 (see fig. 17), that Klee had executed on site during his 1914 visit.

On April 17, 1914, Klee noted in his diary: "In the morning, painted again outside the town, close to the wall, on a sand hill."[5] Klee cast the scene of this picture, which he probably observed on that morning of April 17, in limpid morning light. Here chimerical figures of people mingle with camels. The tower of one of the city's many mosques dominates the surrounding flat salt marshes.

This work and the two later watercolors represent mirror-images of the earlier 1914 drawing, the location of which is unknown. Sketching quickly what was happening in front of him, Klee no doubt actually saw a couple walking toward the left. When looking at this drawing six years later in 1920, preparing to copy it for this watercolor, Klee might have felt that its motion toward the left was awkward. In order to reverse the image in his watercolor, he had to copy the drawing from its reverse side. We can only assume that either the paper of the drawing was very thin or that Klee retraced the drawing's outlines with a sharp pen in order to see and trace the image from the back of the drawing. Perhaps he slightly shifted the paper while working. That would explain why some of the outlines of the drawing and the later watercolors do not quite match.

A photograph taken at the beginning of this century shows how Kairouan and its ramparts looked during Klee's visit there (fig. 18).

1 Karl Baedeker, *The Mediterranean* (Leipzig, London, and New York: Karl Baedeker, 1911), p. 373.

2 *Diaries*, p. 297.

3 *Ibid.*

4 Klee actually made these euphoric remarks about color not in Tunisia in 1914, but seven years later, in 1921, while revising this part of his diary in Munich between 1918 and 1921. See Wolfgang Kersten, "Paul Klee: . . . 'ich und die Farbe sind eins.' Eine historische Kritik," *Kunst-Bulletin des Schweizerischen Kunstvereins*, no. 12 (December 1987), pp. 10–14.

5 *Diaries*, p. 297.

Fig. 19. August Macke (on donkey) and Paul Klee before the gates of Kairouan, Tunisia, April 1914. Collection Felix Klee

Redgreen and Violet-Yellow Rhythms
Rotgrüne und violettgelbe Rhythmen
1920

Oil and ink on cardboard; 14¾ × 13¼"
(37.5 × 34 cm). Signed and numbered (center left):
Klee 1920 38. Recorded in Klee's oeuvre catalogue
as: *Kubischer Aufbau (mit kobaltviolettem Kreuz)*
[Cubist Construction (with cobalt-violet cross)].

Klee did not embrace abstraction in sheer pursuit of some deep spiritual goal, as did Kandinsky and Mondrian. Instead, as his titles playfully indicate, he just tried to keep reality at bay. When the artist began to work earnestly in oil in 1919, he painted a series of small works, mostly on cardboard, that had as their subject matter magic landscapes or gardens. Here the little fir trees placed on a sort of Cubist ground evoke some enchanted forest. In his oeuvre catalogue, as indicated above, Klee entitled this picture *Cubist Construction (with cobalt-violet cross)*. He must have painted the cross out because it is nowhere to be seen.

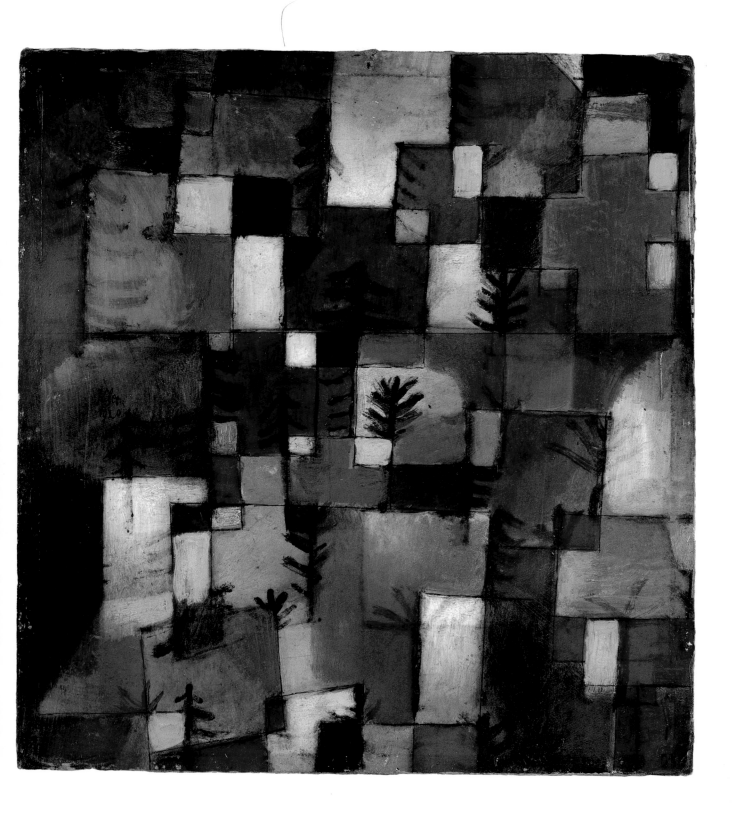

Rider Unhorsed and Bewitched
Abgeworfener und verhexter Reiter
1920

Pen and black ink on wove paper mounted on light
cardboard; 7⅝ × 8⅜″ (19.4 × 21.3 cm).
Signed, in black ink (upper left): *Klee*. Dated
and numbered, on the light cardboard, in black ink
(lower left): *1920.62*. Recorded in Klee's oeuvre
catalogue as: *Abgeworfener und verhexter Reiter*.

The rider with the large, odd-shaped head, buttoned suit, teeny-weeny
feet, and long penis seems a distant cousin of Humpty-Dumpty. Like a
spider in a web, he is caught in the fine threads making up a strange
landscape that might be at the bottom of the sea, in a desert, or on some
distant star.

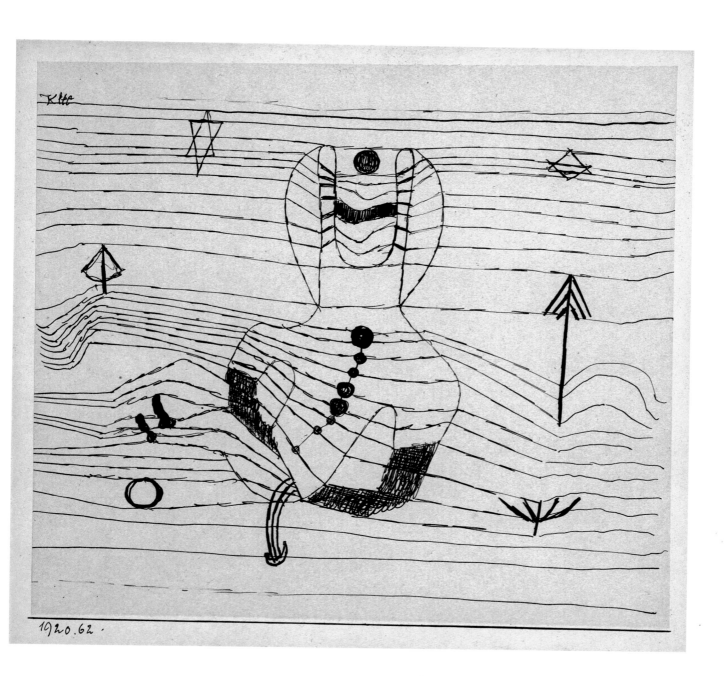

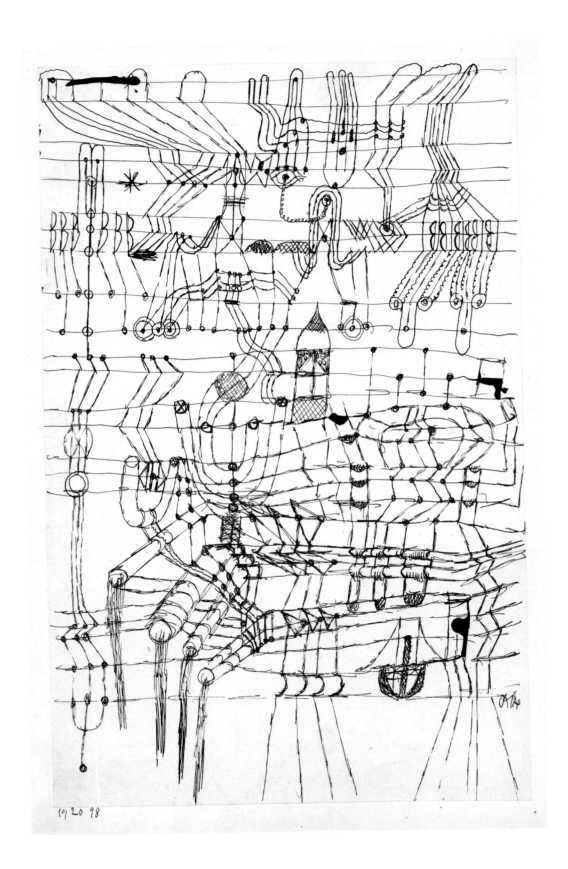

1920 98

Drawing Knotted in the Manner of a Net
Zeichnung in der Art eines Netzes geknüpft
1920

Pen and black ink on wove paper mounted on light
cardboard; 12¼ × 7½″ (31.1 × 19.1 cm). Signed,
in black ink (lower right): *Klee.* Dated and numbered,
on the light cardboard, in black ink (lower left):
1920 98. Recorded in Klee's oeuvre catalogue as:
Zeichnung in der Art eines Netzes geknüpft.

Together with *Rider Unhorsed and Bewitched* (see page 113), this work
belongs to a group of five drawings—all of 1920—in which the black
lines might be compared to yarn threads. Here the lines form a fan-
tastical "net" that seems "knotted" by a possessed sailor. Some things
nautical, some not can be recognized in the intricate pattern. The letter
"B" and its reversed form appear in the upper registers, and in the lower
ones are an anchor, a railing, and some strange plumbing. A touch of the
Orient is added by the cupola-topped window that adorns the center of
the drawing.

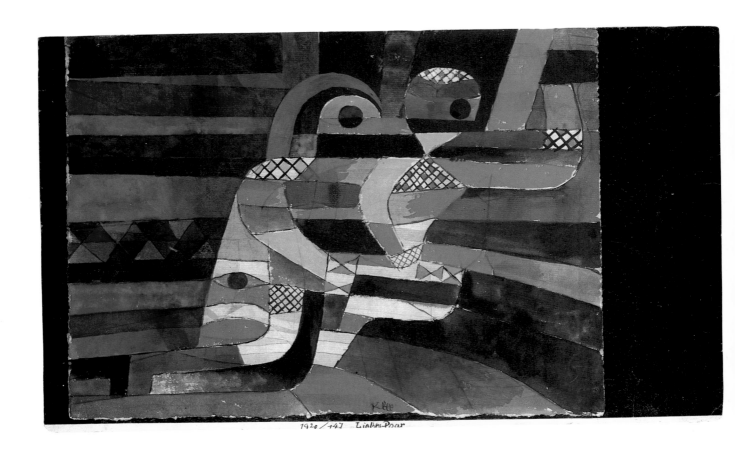

1920/147 Liebes-Paar

Lovers
Liebespaar
1920

Gouache and pencil on laid paper mounted on shiny
black paper mounted on light cardboard; 9¾ × 16″
(24.8 × 40.6 cm). Signed, in black ink
(bottom center): *Klee*. Inscribed, on the light
cardboard, in black ink: *1920/147 Liebes Paar*.
Recorded in Klee's oeuvre catalogue as: *Liebespaar,
erotisches Aquarell monumentalen Stils* (Lovers,
Erotic Watercolor in Monumental Style).

It would be an exaggeration to state that overt eroticism played a large
part in Klee's art. In his writings and letters, he is also extremely discreet
on the subject of sex. In the diary that he kept from 1898 to 1918, he
referred to the topic only once. In the summer of 1901, when touching
upon the anxieties that "sexual helplessness" had earlier produced, he
talks about the need for "purification," "emotional equilibrium," and his
recent engagement, all in one breath.[1]

In the hundreds of letters that Klee wrote to Lily between 1900 and
1940, he broaches erotic matters also only once. In a letter of April 17,
1932, he makes a distinction between human relationships involving
either eroticism, bondage, or selective affinities, or a combination of all
three. It is then that he calls their own union, both past and present,
erotic.[2] We become aware of the eroticism in Klee's art mainly through
the titles that he gave to his works, rather than through the images
themselves. In these cases, however, Klee relegates eroticism to the
realm of irony or reduces it to the whimsical sexual acts of strange little
figures and animals, as in the group of six ink drawings whose inventory
numbers immediately precede that of the *Lovers*.[3] The large-eyed pair—
there is a curiously placed third eye for good measure—is set against a
background of red and black bands. Despite their proximity, they do not
embrace. In fact, the male figure on the left appears in hot pursuit of the
female figure, who has a pointed torso and outstretched arm. The vari-
ous diamond-shaped patterns might denote their garments. Klee left a
wide strip of black cardboard, on which the watercolor is pasted, visible
on the right. In that way the lovers are placed in the middle of the
composition.

1 *Diaries*, pp. 55–56. Actually, Klee's first
entry dates from 1897.

2 *Briefe*, II, p. 1,187.

3 See Klee's 1920 works with inventory
numbers from 138 through 143, with such
titles as *Homosexual Game (In a Lesbian
Key)*, 1920.139; *Maenadic Fright (Erotic
Drawing)*, 1920.141; and *Going Limp
(Erotic Drawing)*, 1920.142.

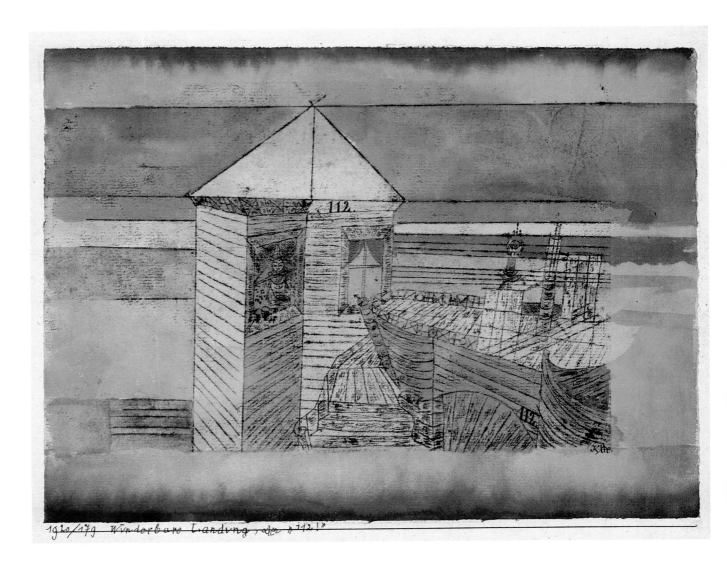

1920/179 Wunderbare Landung, der »112!«

Miraculous Landing, or the "112!"
Wunderbare Landung, oder „112!"
1920

Watercolor, pen and black ink, and transferred printing
ink on laid paper mounted on light cardboard;
9¼ × 12½" (23.5 × 31.8 cm). Signed, in black ink
(lower right): *Klee*. Inscribed, on the light cardboard,
in black ink (lower left): *1920/179 Wunderbare Landung,
oder „112!"* Recorded in Klee's oeuvre catalogue as:
Wunderbare Landung oder „112"

A boat of the type of Noah's Ark—the "112"—is moored to a boathouse.
Only a meandering gangplank separates the two. The number "112" is
painted just below the roof. The girl in the left window shows no sign of
surprise at the scene. Her eyes are closed—perhaps everything exists
only in her imagination. Or perhaps in that of the sailor on the bridge of
the boat, who with yet another number "112!" above his head longs for
his sweetheart at home.

In the drawing (fig. 20) from which Klee transferred this water-
color, both the boat and the house extend farther to the right and to the
left. By eliminating some of these elements in the watercolor, Klee may
have wished to make the central image more evocative, even heighten-
ing its unreality.

The earthy, golden colors are far removed from things nautical!
Instead they bring to mind an image that Klee had evoked some two
years earlier in his diary: "The storm on the wheat fields was captivating;
I'll paint a ship sailing on waves of rye. . . ."[1]

Klee never painted that picture, but this one seems just as miracu-
lous.

1 *Diaries*, p. 398.

Fig. 20. Paul Klee, *Drawing for "Mirac-
ulous Landing, or the '112!,'"* 1920. Pen
and ink and incised lines on paper
mounted on light cardboard; 7¼ × 11⅛"
(18.6 × 28.4 cm). Paul Klee Stiftung,
Kunstmuseum Bern

Phantom Perspective
Perspektiv-Spuk
1920

Pen and violet ink and incised lines on wove
paper mounted on light cardboard; 7⅜ × 11⅛″
(18.7 × 28.3 cm). Signed, in black ink (lower
right): *Klee*. Inscribed, on the light cardboard, in
black ink (lower left): *1920/189 Perspective-Spuk
(zu 1920/174)*. Recorded in Klee's oeuvre catalogue
as: *Zeichnung zu 1920/174 (Perspective-Spuk)*
[Drawing for 1920/174 (Phantom Perspective)].

This drawing forms the basis for the watercolor (see page 122) that was
adapted from it. They exemplify the rare and fortunate instance in which
both are in the same collection. As explained on pages 95–97, Klee
traced with a stylus the outlines of a drawing that he wished to re-
produce, using paper covered with black oil paint as a carbon placed on a
blank sheet of paper. He then added color to the new drawing. Under
strong raking light the marks left by the stylus become visible (fig. 21).

Klee numbered his works each year in sequence beginning with
number one. In this case the drawing evidently precedes the watercolor.
However, the inventory number of the drawing (1920.189) is higher than
that of the watercolor (1920.174). The explanation is that Klee only peri-
odically—perhaps every seven or ten days—pasted his works on pre-
pared supports and dated, numbered, and entitled them. In the case of
this drawing—and others in The Berggruen Klee Collection—Klee did
not do it in strictly chronological sequence.

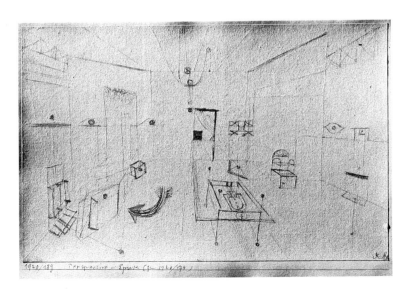

Fig. 21. Paul Klee, *Phantom Perspective*,
1920. Image shown under raking light.
Photograph Margaret Holben Ellis

120

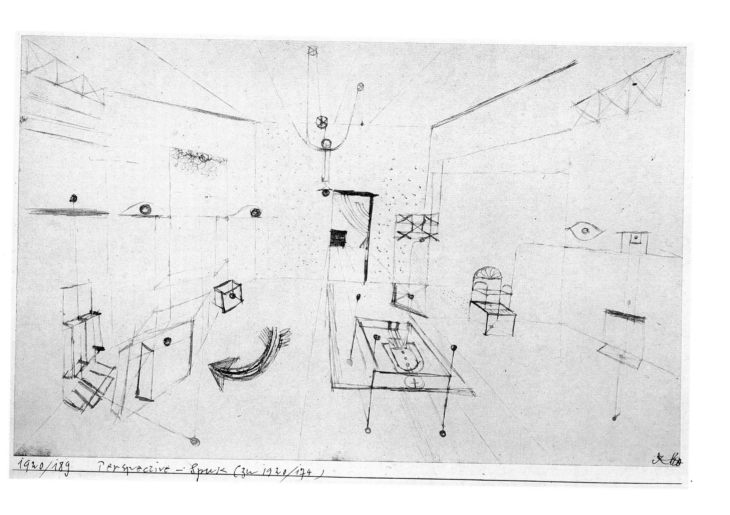

1920/189 Perspective – Spuk (zu 1920/174)

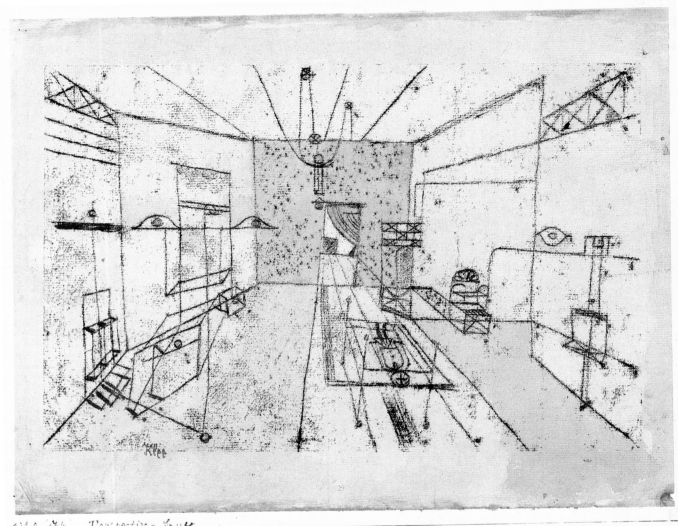

1929 174 Perspectiv-Spuk

Phantom Perspective
Perspektiv-Spuk
1920

Watercolor and transferred printing ink on laid
paper mounted on light cardboard; 9½ × 12″
(24.1 × 30.5 cm). Signed, in gray ink (lower left):
Klee. Inscribed, on the light cardboard, in black
ink (lower left): *1920/174 Perspectiv-Spuk.*
Initialed, in pencil (lower right): *q.* Recorded
in Klee's oeuvre catalogue as: *Perspectiv-Spuk.*

This interior scene seems a cross between a gym, an operating room, and
Spalanzani's laboratory in Act I of Jacques Offenbach's opera *Les Contes
d'Hoffmann* (1881), where the doll Olympia is invented. There are three
large watchful eyes. Thin metal furniture, which anticipates by forty
years that of Diego Giacometti (1902–85), the brother of Alberto (1906–
66), is scattered everywhere. The lines of perspective dominate every-
thing. Converging toward a vanishing point behind the curtained door,
these lines have just shot in, or are about to suck out, the room's only
human figure, who lies flattened like a puppet on an iron bed.

Klee copied all forms of the ink drawing (see page 121) onto this
transfer watercolor (see pages 95–97 for the description of this tech-
nique), except the large curved arrow.

Incidentally, this watercolor, finely tuned in pale pistachio and old
rose, was the very first picture purchased by Heinz Berggruen as a young
man in 1937.

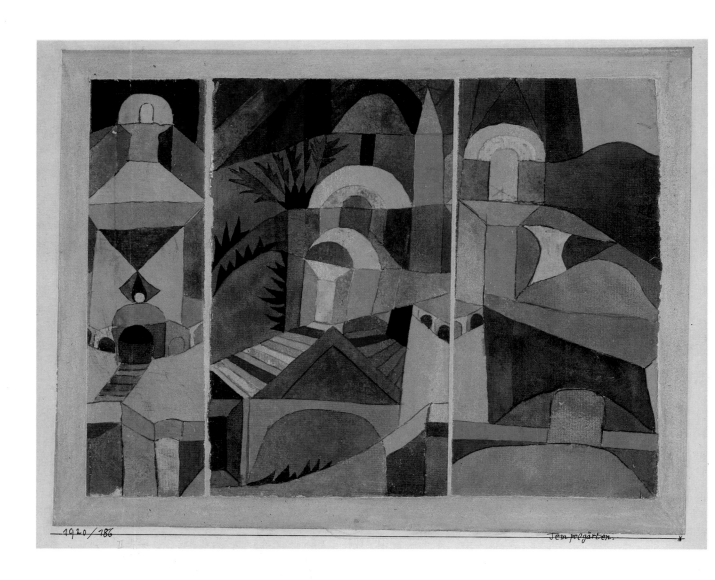

1920/186 Tempelgärten.

Temple Gardens
Tempelgärten
1920

Gouache and traces of black ink, possibly transfer,
on three sheets of laid paper mounted on wove paper
mounted on light cardboard; 7¼ × 10¼″ (18.4 ×
26.7 cm). Signed, in black ink (upper right): *Klee.*
Dated and numbered, on the light cardboard, in black
ink (lower left): *1920/186*; in pencil (lower left):
II; titled, in black ink (lower right): *Tempelgärten.*
Recorded in Klee's oeuvre catalogue as: *Tempelgärten (auf
gelb gegründet)* [Temple Gardens (on yellow ground)].

Once again Klee appears to recall impressions from his visit to Tunisia in
April 1914. This watercolor has the brilliance of a stained-glass window
on a sunny day. Stairways lead to the doors of various garden pavilions.
Palm trees peek over sections of high walls, and here and there are
domed towers.

As mentioned earlier (see page 86), Klee sometimes liked to re-
arrange his compositions with scissors. Perhaps in this instance, Klee

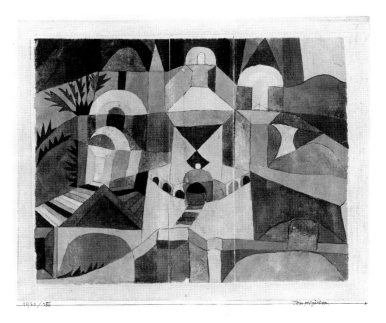

Fig. 22. Paul Klee, Reconstruction of
Temple Gardens, 1920

thought that the original work (see fig. 22) looked too symmetrical. Therefore, he cut it into three sections and moved the center one to the left. Now the site depicted in *Temple Gardens*, which earlier was only pleasantly full of the "angles and corners" he had admired in Kairouan, has truly become labyrinthine.

From 1925 on, and retroactively, Klee established a price system for his past and present works, rating them from "I" to "X." "I" represented the lowest price and "X" the highest. He noted these numbers, clearly visible in pencil, on the lower left on the support of his watercolors. This work was graded "II."

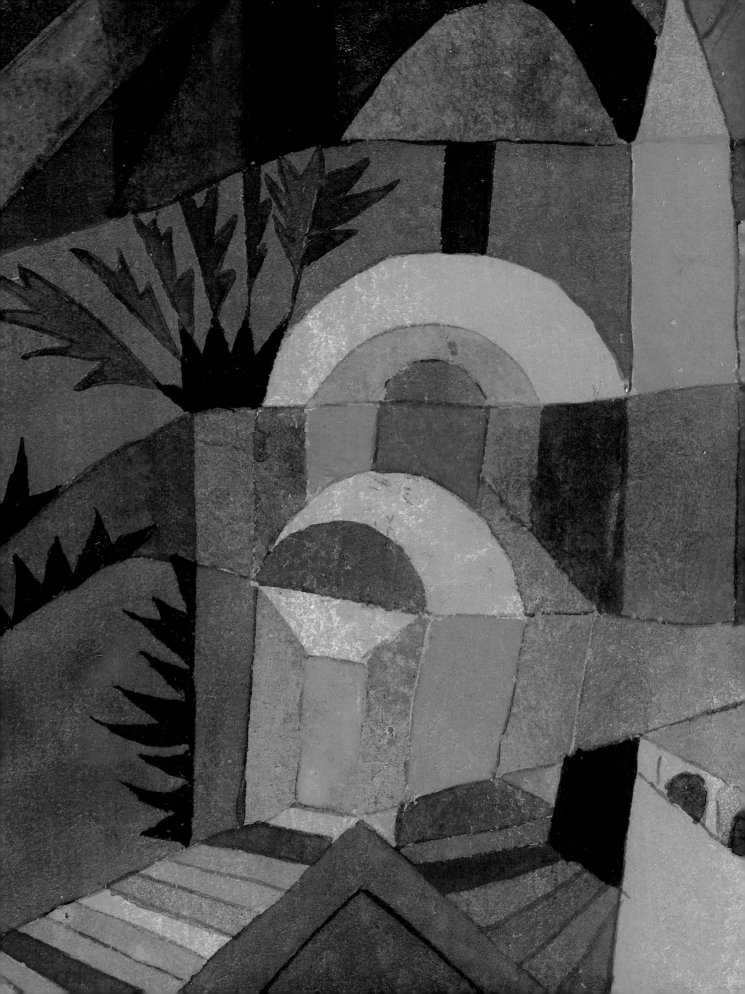

Where the Eggs and the Good Roast Come From
Wo die Eier herkommen und der gute Braten
1921

Watercolor and transferred printing ink on laid
paper mounted on light cardboard; 6⅛ × 11⅜″
(15.6 × 28.9 cm). Inscribed, in black ink (lower
right): *Alle diese Bilder hat der Onkel Klee gemacht.*
Inscribed, on the light cardboard, in black ink
(lower left): *1921/6 Wo die Eier herkomen und der
gute Braten (für Florina-Irene).* Recorded in Klee's
oeuvre catalogue as: *Wo die Eier herkomen und der
gute Braten (für Kind Galston).*

There's no mistake about it, chickens lay eggs and pigs make good
roasts. As in a children's picture book, Klee shows where these delicious
foods come from. The hard-boiled egg has "egg" written on it, and the
pig with the bristly back is identified as the "good roast." In keeping with
this image, Klee wrote playfully on the lower right: "It was Uncle Klee
who made all these pictures."

 Klee dedicated and gave this watercolor, which he copied from an
earlier drawing (fig. 23), to his godchild Florina-Irene Galston at her
christening.[1] Florina-Irene, who died at a very early age, was the daugh-
ter of Gottfried Galston (1879–1950), a painter, pianist, and friend of
Klee's. The Galstons lived across the hall from the Klees at Ainmiller-
strasse 32/II in Munich.

1 Conversation with Felix Klee,
Switzerland, July 1, 1985.

Fig. 23. Paul Klee, *Rooster and Pig*, 1920.
Ink and pen and incised lines mounted
on light cardboard; 2¾ × 8⅛″
(7 × 20.5 cm). Private collection

guter Braten

Alle diese Bilder
hat der Onkel Klee gemacht.

1921/6 Wo die Eier herkommen und der gute Braten. (für Florina-Irene)

Adam and Little Eve
Adam und Evchen
1921

Watercolor and transferred printing ink on laid
paper mounted on light cardboard; 12⅜ × 8⅝"
(31.4 × 21.9 cm). Signed, in black ink (lower right):
Klee. Inscribed, on the light cardboard, in black
ink (lower left): *1921/12 Adam und Evchen*. Recorded
in Klee's oeuvre catalogue as: *Adam und Evchen*.

Klee somewhat expanded the story of the creation of man. His Eve, after
growing from Adam's rib, stays right there. She also remains a child.
Evchen looks like a schoolgirl with flaxen hair tied in a braid. Adam is a
broad-faced, grown man who sports earrings and a mustache.

By placing the figures against a shallow ground with a reddish
curtain, Klee seems to set the oddly matched pair on a puppet-theater
stage.

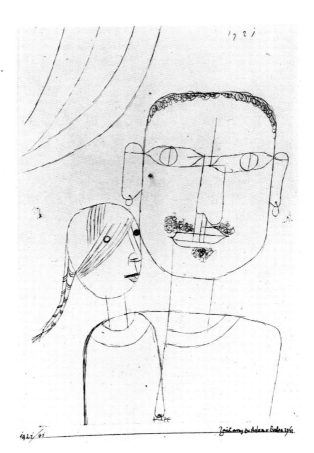

Fig. 24. Paul Klee, *Drawing for "Adam
and Little Eve,"* 1921. Pen and ink and
incised lines on paper mounted on light
cardboard; 11¼ × 7¼" (28.5 × 18.5 cm).
Private collection

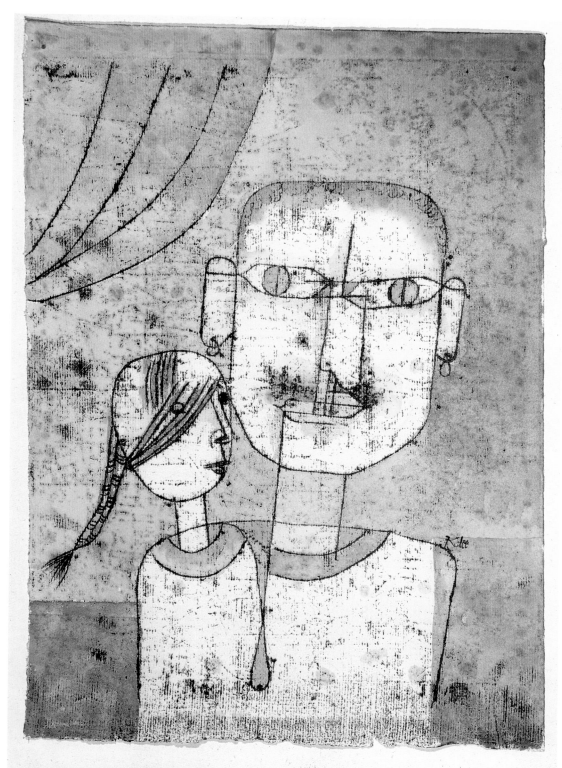

1921/12 Adam und Evchen

Fig. 25. Paul Klee, *Drawing for "Tale à la Hoffmann,"* 1918. Pen and ink and incised lines on paper mounted on light cardboard; 11¼ × 8⅝″ (28.8 × 21.9 cm). Private collection

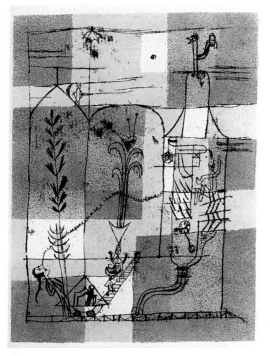

Fig. 26. Paul Klee, *Tale à la Hoffmann,* 1921. Color lithograph (yellow and violet on black stone); 13⅞ × 10⅜″ (35.4 × 26.3 cm). Paul Klee Stiftung, Kunstmuseum Bern

Tale à la Hoffmann
Hoffmanneske Geschichte
1921

Watercolor, pencil, and transferred printing ink on laid paper bordered with metallic foil mounted on light cardboard; 12¼ × 9½″ (31.1 × 24.1 cm). Signed, in black ink (lower right): *Klee.* Inscribed, on the light cardboard, in black ink: *1921/18 Hoffmañeske Geschichte.* Watermark (lower right): monogram. Recorded in Klee's oeuvre catalogue as: *Hoffmañeske Geschichte.*

Klee loved the tales of the German poet and writer E. T. A. Hoffmann (1776–1822), who was nicknamed "Ghost Hoffmann" in his own country. Reading Hoffmann again in early December 1918 might have inspired Klee to execute that same year the drawing (fig. 25) from which, three years later, in 1921, the artist copied this transfer watercolor as well as a transfer color lithograph (fig. 26).[1]

Tale à la Hoffmann appears to be loosely based on the poet's best-known lyrical fairy tale, *The Golden Pot* (1814), a magical story that switches back and forth between high fantasy and everyday life in Dresden. It tells the trials of the pure and foolish young Anselmus and his efforts to gain entry to Atlantis, the heaven of poetry. The tree from which Anselmus first heard fateful voices speaking to him might thus be on the left. The odd, tubelike construction on the right perhaps represents the glass bottle in which Anselmus found himself briefly imprisoned. The tale's repeated references to time are reflected in the two clocks, and the vessel in the center may stand for the golden pot with the fantastic lily that gives the story its name.

1 The lithograph is included in *Bauhaus-Drucke. Neue europäische Graphik. Erste Mappe. Meister des Staatlichen Bauhauses in Weimar* (Weimar, 1921). This portfolio contains 14 lithographs, including Klee's *Tale à la Hoffmann,* a second lithograph by him, and works by Feininger, Itten, Marcks, Muche, Schlemmer, and Schreyer. The Metropolitan Museum of Art has a copy of this portfolio.

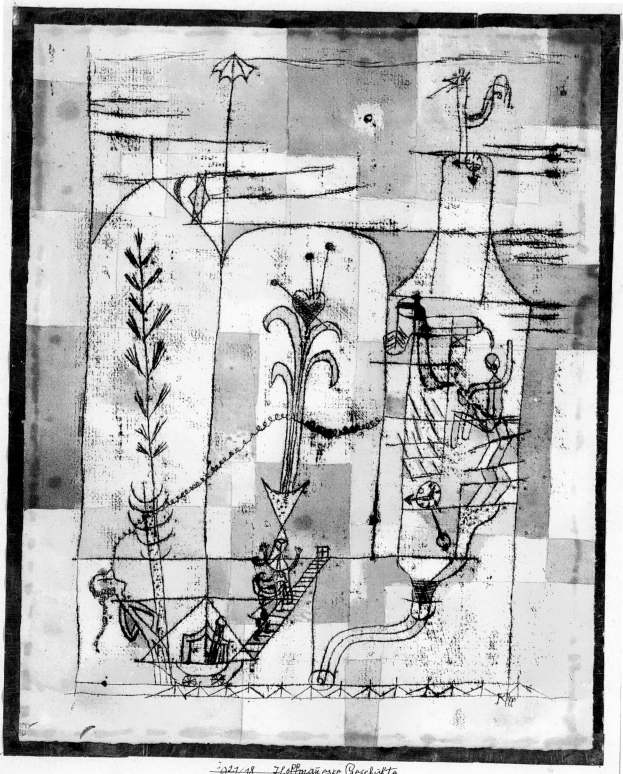

1921/18 Hoffmañeske Geschichte

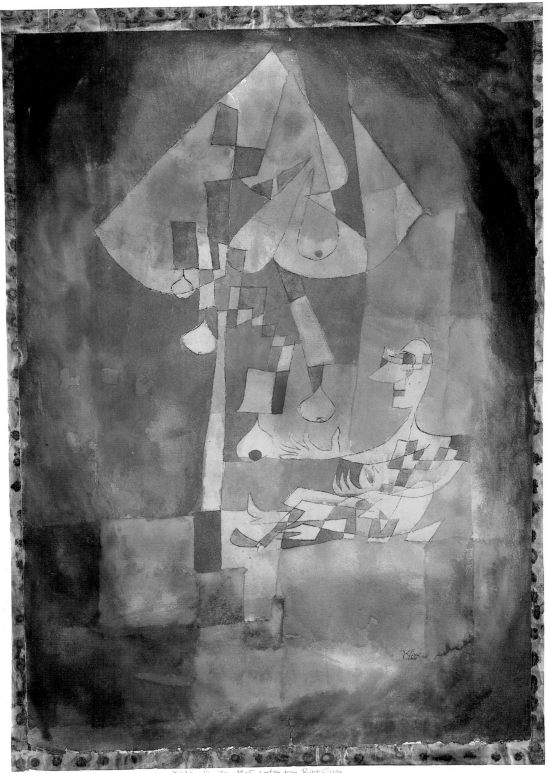

1921 19 Der Mann unter dem Birnbaum

The Man Under the Pear Tree
Der Mann unter dem Birnbaum
1921

Watercolor and transferred printing ink on laid
paper bordered with metallic foil mounted on light
cardboard, 14⅜ × 9¾″ (36.5 × 24.8 cm). Signed,
in black ink (lower right): *Klee.* Inscribed, on the
light cardboard, in black ink: *1921/19 Der Mañ unter
dem Birnbaum.* Recorded in Klee's oeuvre catalogue as:
Der Mann unter dem Birnbaum.

The bald, bespectacled man beneath the pear tree does not even look up.
Ripe fruit will just fall into his lap. Does Klee depict a lucky man who
harvests a rich crop without working? Or does he mock the sexual yearn-
ings of someone no longer young? The red-dotted pears suggest breasts,
as does the silhouette of the fruit-bearing part of the tree. Perhaps that is
why both tree and figure are rendered in the same hot reds, oranges, and
yellows, and why the man is wearing a diamond-patterned fool's dress.[1]

Klee copied the image of this watercolor from a pencil drawing (fig.
27). Eight years later he made a slightly larger pen-and-ink copy of it, in
mirror-image, which he dedicated to his dealer, Alfred Flechtheim
(1878–1937), on the latter's fiftieth birthday (fig. 28). Now the pears, or
breasts, appear to have turned into punching bags—probably a reference
to Flechtheim's fondness for boxing matches.

1 For a different interpretation, which
suggests that this man is Klee's dealer Hans
Goltz who "reaps" success with Klee's works
(i.e., they are the "ripe fruit"), see Stefan
Frey and Wolfgang Kersten, "Paul Klees
geschäftliche Verbindung zur Galerie Alfred
Flechtheim," *Alfred Flechtheim: Sammler
Kunsthändler Verleger*, compiled by Stephan
von Wiese and Monika Flacke-Knoch,
exhibition catalogue (Düsseldorf:
Kunstmuseum, 1987), pp. 82–86.

Fig. 27. Paul Klee, *Drawing for "The
Man Under the Pear Tree,"* 1920. Pencil
and incised lines on paper mounted on
light cardboard; 11 × 7⅛″
(28.1 × 18 cm). Paul Klee Stiftung,
Kunstmuseum Bern

Fig. 28. Paul Klee, *Untitled,* 1928. Pen
and ink on paper mounted on light card-
board; 11⅜ × 9¼″ (29 × 23.5 cm).
Whereabouts unknown

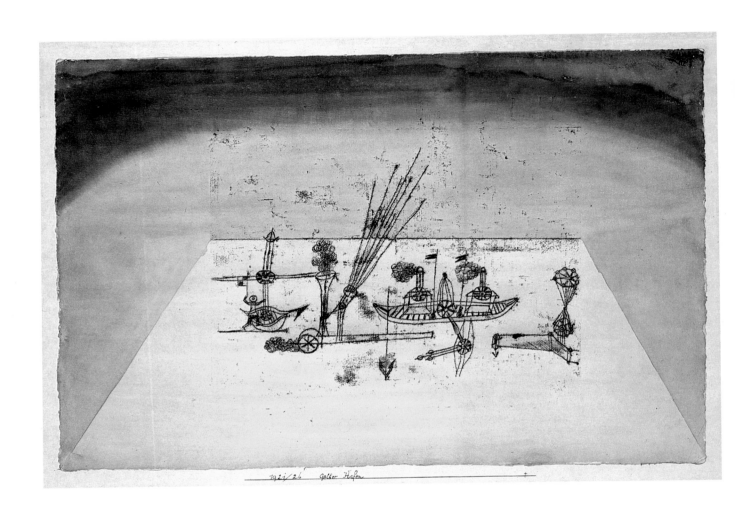

1921/26 Gelber Hafen

Yellow Harbor
Gelber Hafen
1921

Watercolor and transferred printing ink on laid
paper mounted on light cardboard; 12½ × 19″
(31.8 × 48.3 cm). Signed, in black ink (upper right):
Klee. Inscribed, on the light cardboard, in brown
ink: *1921/26 Gelber Hafen †*. Watermark: MBN (FR.
Recorded in Klee's oeuvre catalogue as: *Gelber Hafen †*.

Klee's harbor appears to be a yellow cloth covering a table on which
mechanical toys engage in a battle at sea. Under the overcast verdigris
sky many whimsies occur. A strange cannon stands on a stretch of pier,
having belched one cloud of smoke behind and just now puffing another
into the air. It explodes skyward from a second, smaller barrel, which is
attached by a pulley lock. A man with a checkered flag hops aboard a
small boat shaped like a half walnut. Its spiky bow points toward a large
ship with two flags and two smoking stacks. The latter is propelled by
two wheels, one above board and one below. Yet it is also moored, if the
arrow pointing downward is its anchor. On the right floats another in-
vention: two wheels whose sets of eight spokes connect with lines form-
ing an hourglass shape. All in all, Klee implanted here five pairs of
wheels and two sets of pulley locks.

Curiously, the image is proportionately much smaller in the water-
color than in the drawing (fig. 29) from which it was copied.

Fig. 29. Paul Klee, *Drawing for "Yellow
Harbor,"* 1920. Pen and ink and incised
lines on paper mounted on light card-
board; 7¾ × 11¼″ (19.8 × 28.7 cm).
Mr. and Mrs. Harvey R. Plonsker,
Glencoe, Ill.

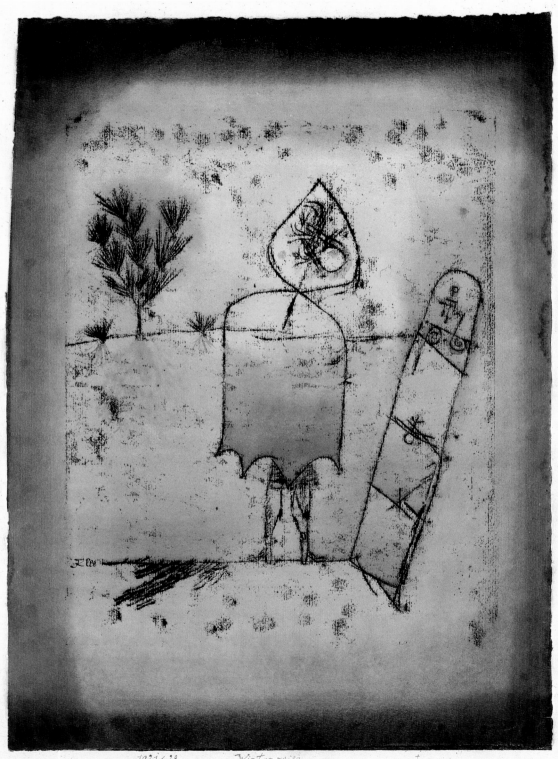

Klee

Winter Journey
Winterreise
1921

Watercolor and transferred printing ink on laid
paper bordered with black ink mounted on light
cardboard, 15⅝ × 11″ (39.3 × 27.9 cm). Signed
(lower left): *Klee*. Inscribed, on the light
cardboard, in brown ink: *1921/28 Winterreise †*.
Recorded in Klee's oeuvre catalogue as: *Winterreise †*.

Klee borrowed the title of this watercolor from the 1827 song cycle *Winter Journey* (*Winterreise*) by Franz Schubert (1797–1828). Composed one year before Schubert died of syphilis, the songs reflect the composer's premonition of and preoccupation with death. The twenty-four songs describe a rejected suitor's flight through a frozen landscape to madness and the grave.

In Klee's *Winter Journey*, the travels of the hooded little man, with spindly legs poking out from his cape, end before a tombstone bearing indecipherable runes. On the horizon of the barren winter landscape stand a lone pine tree and two small bushes.

According to the artist's son, Felix, this melancholic work relates to the death of the painter's mother, Ida Marie Klee (1855–1921), on March 15 of the same year. As Felix Klee tells it, a strange thing happened on that day. After brewing himself his usual afternoon tea in his studio, the artist dozed off in his armchair. In his sleep his mother entered the room, winked at him, and disappeared. When the news of her death reached him several hours later, Klee was not surprised.[1] As a sign of mourning, Klee put here, as in six other works from this time (see page 136), a little cross in ink to the right of the title. He also painted dark borders around these pictures.

Fig. 30. Paul Klee, *Drawing for "Winter Journey,"* 1921. Pen and violet ink and incised lines on paper mounted on light cardboard; 11¼ × 8⅞″ (28.5 × 22.6 cm). Paul Klee Stiftung, Kunstmuseum Bern

1 Felix Klee, *Paul Klee/12 aquarelles*, translated by Pierre-Henri Gonthier (Paris: Berggruen & Cie, 1964), text to pl. 7.

Cold City
Kalte Stadt
1921

Watercolor on laid paper mounted on maroon wove
paper mounted on light cardboard; 8¼ × 11⅝″
(21 × 29.5 cm). Signed, in brown ink (lower right):
Klee; inscribed, on the light cardboard, in brown
ink (lower left): *1921/66 Kalte Stadt*. Recorded in
Klee's oeuvre catalogue as: *Kalte Stadt
Aquarell/(aus gelb u.- violett)* [Cold City Watercolor
in (Yellow and Violet)].

In 1937, this watercolor was confiscated from the Mannheim Kunsthalle.
As one of thousands of works of modern art designated as "degenerate
art" by the National Socialists in Germany, it was taken to Berlin and
put up for sale. Much to Lily Klee's relief, by early 1940 this work had
found—through the New York art dealer Curt Valentin—a "home" with
an assistant of The Museum of Modern Art in New York.[1]

Klee began to teach at the Bauhaus in Weimar on January 10, 1921.
Walter Gropius (1883–1969), its founding father, had appointed him to
this position late in 1920. Klee did not come to the Bauhaus an unknown
artist—quite to the contrary. In April 1920 Hans Goltz had organized a
large retrospective of Klee's work at his gallery, Neue Kunst, in Munich.
By 1921 three monographs on the artist had been published, and Klee's
own essay for *Schöpferische Konfession*, an anthology of artists' writings
edited by Kasimir Edschmid, had appeared the previous year.[2]

The Bauhaus (1919–33), this cradle of modern design, strove for a
synthesis between crafts and arts, with the latter directly tied to architec-
ture. Thus every Bauhaus student also learned a craft in workshops
taught by both artists and craftsmen. As we know from his letters to his
wife, Lily, Klee kept aloof from the daily affairs of the Bauhaus, looking
upon its pioneering philosophies and zealous efforts with amused de-
tachment.[3] The attitude that he described in a letter to his son, Felix, on
April 19, 1921, probably applied—more or less—to his entire ten-year
stay (1921–31) at the school, first in Weimar and then in Dessau, where
the Bauhaus moved in 1925: "Life and all these goings on in Weimar do
not concern me. I work, and talk to nobody during the entire time. On
Thursday, the master council will meet. I shall visit Feininger once, and
perhaps see Itten. That is the future."[4]

Although Klee kept pretty much to himself and rarely ever voiced
his opinion in the master council meetings, he was greatly esteemed by
students and faculty alike. He participated in all the school's musical

1 Undated letter (c. 1940) from Lily Klee
to Curt Valentin. The Curt Valentin Papers,
The Museum of Modern Art Library, New
York.

2 For exhibition and literature history,
see the bibliography. Klee's untitled essay in
Schöpferische Konfession, vol. XIII of the art
book series *Tribüne der Kunst und Zeit*, ed.
Kasimir Edschmid (Berlin: Erich Reiss
Verlag, 1920), pp. 28–40, is partially
translated as "Opinions on Creation," in
Paul Klee, edited by Margaret Miller (New
York: The Museum of Modern Art, 1945),
pp. 10–13.

3 *Briefe*, II, p. 970–71, 973, 975, 1,016,
1,019, 1,100, 1,139, 1,140.

4 *Ibid.*, p. 976.

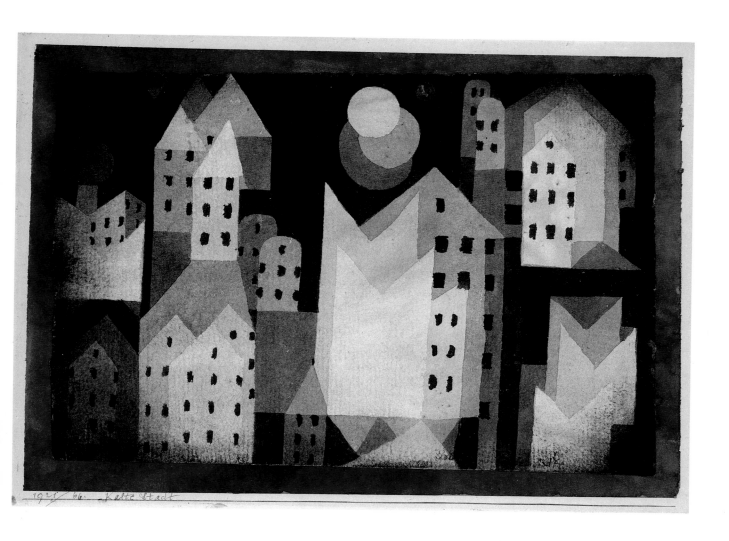

1921/66. Kalte Stadt

events, and he kept up friendships with such other Bauhaus masters as Feininger, Schlemmer, Muche, and especially Kandinsky, who later was his neighbor in Dessau. Perhaps, more importantly, the Bauhaus represented financial security to the artist.

The Bauhaus workshops were elective, and Klee was assigned to the least important ones, bookbinding in 1922 and painting on glass in 1922 to 1923. Only four students, for instance, enrolled in his bookbind-

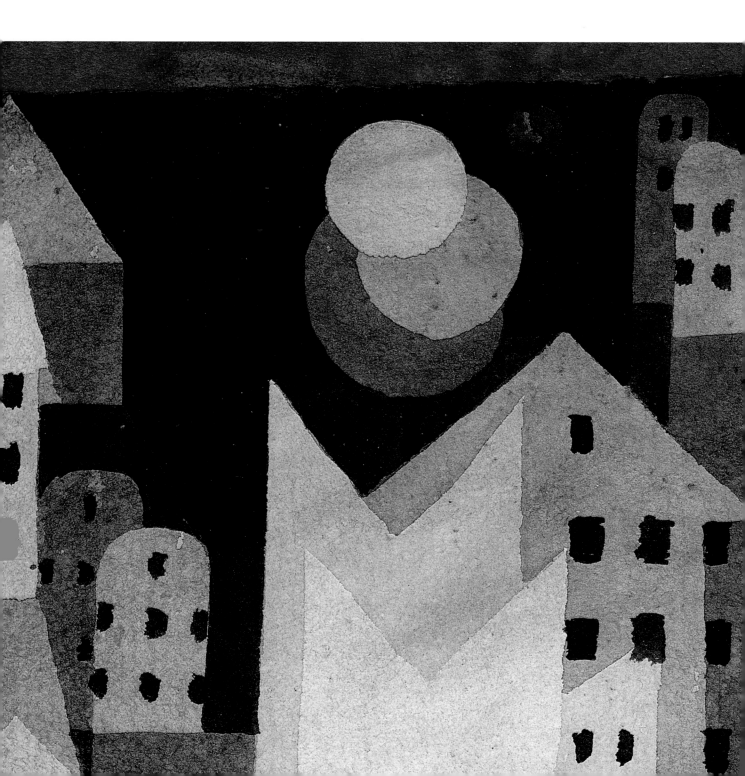

ing class. By contrast, his course on composition, a mandatory one, was so popular that he had to reduce the number of students from 45 to 30.

"Today I had my first lecture, and the extraordinary thing happened, I talked freely for two hours with people. First I discussed several paintings and watercolors" [by students]. "Then I handed around ten of my own watercolors and discussed them in depth vis-à-vis their formal elements and compositional connections. But I was just too careless in using up all my material, so that for next Friday I have to paint new sample pictures."[5]

Not surprisingly, the pictures Klee painted during his tenure at the Bauhaus relate from time to time to the subject of his courses. His so-called color-gradation pictures of 1921 to 1923 correspond to his preoccupation with color theory at that time.

Unlike Goethe, Runge, Delacroix, and Kandinsky, upon whose color theories he based his own, Klee was also concerned with the interaction between colors. He called the relationship between complementary colors that diametrically face each other across the gray center of the color wheel "diametrical movement." In practice, this "movement" or gradation occurs when complementary colors—for example, red and green—are gradually mixed until they fuse into gray. The same result can be reached with watercolors by "glazing" (the layering of two colors). That is just what Klee did. However, he never mixed two colors to such a degree that they turned into gray. "In the last watercolors I try to build up the tonality strictly with two colors, not just from feelings."[6]

Klee's glazing method is simple. A picture ground is divided into echoing forms or stripes. The gradations are added by covering these forms with layer upon layer of translucent watercolor wash—using first one and then the other of the two colors—always reserving one form in each layer. Movement from light to dark is thus created.[7]

Klee always specified in his oeuvre catalogue the two colors he chose for a work. Therefore, we know that in *Cold City*, one of the earliest works of the color-gradation series, the artist used yellow and violet.

A full moon, groups of houses, and geometric structures stacked one behind the other seemingly float on a flat black ground. Here the layering of violet and yellow washes results in forms colored umber and dark yellow to pale yellow in the background and forms remaining white in what appears to be the foreground. All these hues, ranging from clear yellow to dirty brown-yellow, are not what are usually called "cold" colors. Rather, the forbiddingly impersonal metropolis depicted here conveys the impression of coldness to which the title refers. In Klee's nighttime city everything is reversed as in a photographic negative. We do not see dark houses with here and there a lighted window. Instead, the façades are illuminated, and all the windows are pitch black.

5 *Ibid.*, p. 977.

6 *Ibid.*, p. 975.

7 See the chapter on "Order in the Realm of Color" in Christian Geelhaar, *Paul Klee and the Bauhaus*, translator unknown (Greenwich, Conn.: New York Graphic Society, 1973), pp. 35–43. The above information is taken from this volume, as is that in entries on pp. 145, 158, 163, and 173–74.

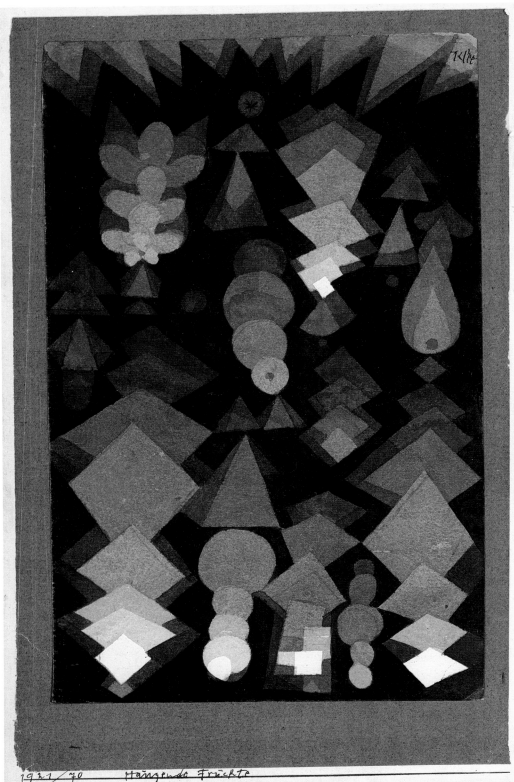

1921/70 Hängende Früchte

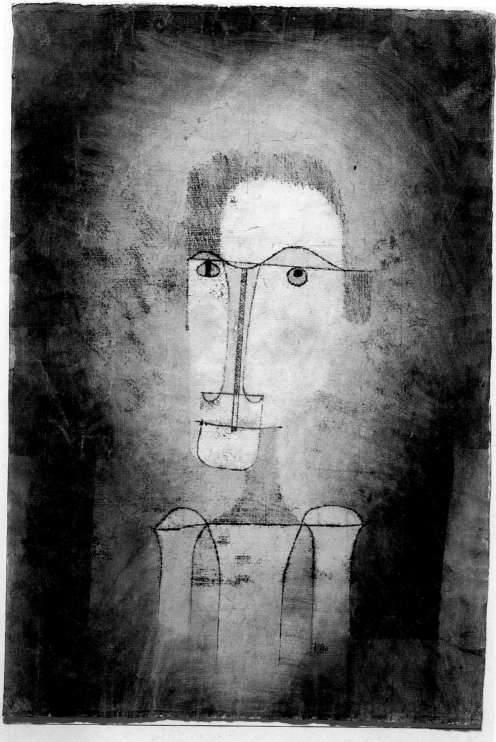

1921/136 Bildnis eines Gelben

Mural from the Temple of Longing ↖ Thither ↗
Wandbild aus dem Tempel der Sehnsucht ↖ Dorthin ↗
1922

Watercolor and transferred printing ink on gesso on cloth mounted on light cardboard; 10⅝ × 14¾" (27 × 37.5 cm). Signed, in black ink (lower left): *Klee*. Dated and numbered on the light cardboard, in brown ink (lower left): *1922/30*. Titled on the light cardboard, in brown ink (lower right): *Wandbild aus dem Tempel der Sehnsucht ↖ dorthin ↗*. Recorded in Klee's oeuvre catalogue as: *"Wandbild aus dem Tempel der Sehnsucht „ dorthin."*

Klee adapted this watercolor from a drawing (fig. 36) that looks quite different. Thin black geometric configurations seemingly advance and recede in space between wavy horizontal lines. The short diagonals—those that indicate the recession in space in the drawing—become the stems of the thick black arrows in the watercolor. The space in the watercolor, in turn, becomes as two-dimensionally flat as the "mural" referred to in the title. While long-shafted arrows indicate calamity in Klee's work (see pages 94, 98, and 251), the chubby ones here refer to friendlier matters. Their meaning might be related to Klee's lecture on the arrow as projectile and as indicator of movement, which he gave on April 3, 1922.[1] As always, Klee enlivened his topic with poetic and philosophic comparisons. In a somewhat farfetched analogy, Klee's arrow—it has the word "dorthin?" ("thither") written beneath it in a diagram in his notes for this lecture (fig. 37)—stands for man's ability to "measure the spiritual and cosmic despite his physical helplessness."[2]

Thus this spirited composition of frolicking arrows might actually turn out to be a "mural" from a "temple of longing" toward the "cosmos" or the "spiritual."

Otto Ralfs (1892–1955), a businessman and collector from Brunswick who founded the Klee Gesellschaft in 1925, purchased this watercolor in 1923.

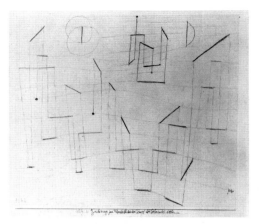

Fig. 36. Paul Klee, *Drawing for "Mural from the Temple of Longing ↖ Thither ↗,"* 1922. Pencil and incised lines on paper mounted on light cardboard; 9⅜ × 10¼" (24 × 26 cm). Private collection

1 Klee, *Beiträge zur bildnerischen Formlehre*, edited by Jürgen Glaesemer (Basel: Benno Schwabe & Co., 1979), p. 127. Facsimile of original manuscript of 1921–22.

2 *Ibid.*

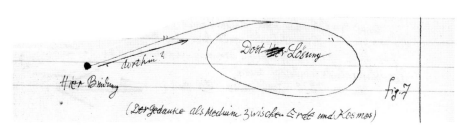

Fig. 37. Paul Klee, *Diagram from "Beiträge zur bildnerischen Formlehre,"* 1921–22

Suspended Fruit
Hängende Früchte
1921

Watercolor and pencil on textured paper mounted on green wove paper mounted on light cardboard, 9¾ × 6″ (24.8 × 15.2 cm). Signed, in black ink (upper right): *Klee*. Inscribed, on the light cardboard, in black ink (lower left): *1921/70 Hängende Früchte*. Recorded in Klee's oeuvre catalogue as: *Hängende Früchte Aquarell (Karmin/grün)* [Hanging Fruit watercolor (carmine/green)].

"The lecture yesterday went very well, once again I was totally prepared so that I didn't have to worry about saying something that is not quite correct."[1] At the Bauhaus, Klee structured his classes meticulously. His teaching seems to have been inspiring, and he attracted students who compared him to a poet illuminating his verses yet never giving a clue as to how to write them. His teaching, in fact, did evolve into the formulation of a theory of art that Klee expressed in his pedagogical writings (more than 3,000 pages) and in diagrams and drawings accumulated during the decade of his association with the Bauhaus (1921–31).[2]

 Suspended Fruit belongs to the group of color-gradation pictures of 1921 to 1923 (as does *Cold City* on page 141). In these watercolors Klee created space through the spread-out stack of colored forms that seemingly wax or wane from foreground to background. Klee also created "movement" (he called it "diametrical movement") by "glazing." (This technique is explained on page 143.)[3]

 As we know from Klee's oeuvre catalogue, he used a combination of carmine (red) and green in this picture. The layering of both colors, with one form always spared in each layer, results here in a motion from front to back, as well as from light to dark. The effect, however, is not really one of suspended fruit, but of cascading decks of geometric shapes, with here and there fruit and flowers, all spilling from a cornucopia whose jagged lip is visible at the top.

1 *Briefe*, II, p. 982.

2 Only a fraction of Klee's notes for his classes has been published. A small part was published by Klee himself; see his *Pedagogical Sketchbook*, translated and introduced by Sybil Moholy-Nagy (New York: Praeger, 1953). Another larger part was published posthumously as *Paul Klee: The Thinking Eye*, edited by Jürg Spiller, translated by Ralph Manheim (New York: George Wittenborn; London: Lund Humphries, 1961) and *Paul Klee Notebooks, Volume 2: The Nature of Nature*, edited by Jürg Spiller, translated by Heinz Norden (New York: George Wittenborn, 1973).

3 See Note 7 in entry for *Cold City* on page 143 for Klee's color-gradation theories.

All Souls' Picture
Allerseelen Bild
1921

Watercolor and transferred printing ink on two sheets
of laid paper bordered with black ink mounted on
light cardboard; 12 × 17⅞″ (30.5 × 45.4 cm).
Signed, in black ink (lower right): *Klee*. Inscribed,
on the light cardboard, in black ink: *1921/113
Allerseelen Bild*. Recorded in Klee's oeuvre catalogue
as: *Allerseelenbild*.

A photograph taken in 1921 of Klee in Possenhofen on Lake Starnberg
in Bavaria shows him seated and working on this picture, which lies on a
facing chair (fig. 31). Beside him naps his tomcat, Fritzi.

 Floating against a muted violet ground is a large unwieldy shape in
thin black lines with festoons of little meandering patterns and tufts of
color. At once ephemeral and solemn, it evokes both hoar-frosted tree
leaves and windowpanes in winter, as well as funerary ornaments in
provincial cemeteries. Just the thing on the occasion of All Souls' Day.

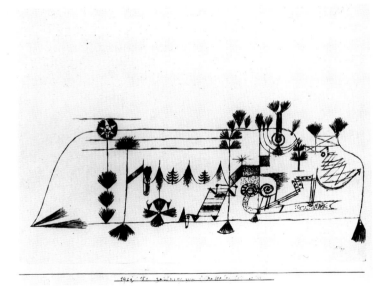

LEFT
Fig. 31. Paul Klee at Possenhofen, 1921.
Photograph Felix Klee

ABOVE
Fig. 32. Paul Klee, *Drawing for "All
Souls' Picture,"* 1921. Pen and ink and
incised lines on paper mounted on light
cardboard; 8⅝ × 11″ (22 × 28 cm).
Private collection, Paris

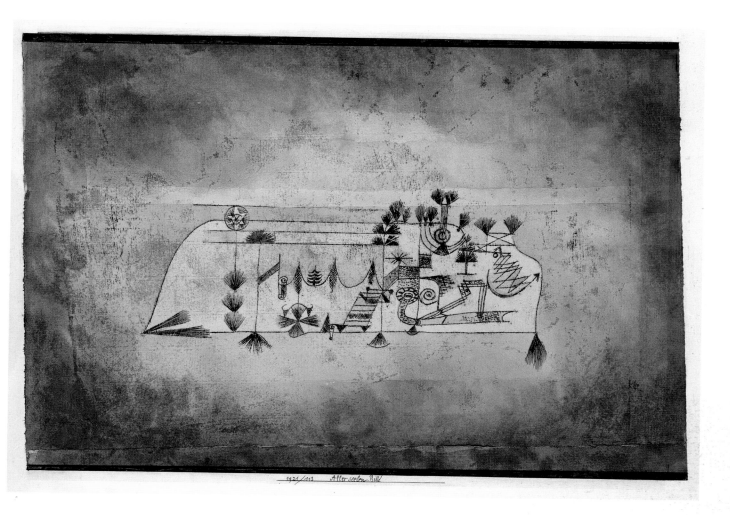

1921/113 Aller seelen Bild

Fig. 33. Paul Klee, *Drawing for "The Pathos of Fertility,"* 1921. Pencil with incised lines and stippling on notepaper mounted on light cardboard; 11⅛ × 8¾" (28.3 × 22.3 cm). The Galka E. Scheyer Blue Four Collection, Norton Simon Museum, Pasadena

Fig. 34. Rudolf Jordan, *Pilot's Examination,* 1842. Lithograph by Paul Rohrbach

The Pathos of Fertility
Das Pathos der Fruchtbarkeit
1921

Watercolor and transferred printing ink on laid paper bordered with black ink mounted on the verso of a lithograph by Paul Rohrbach, printed by Louis Zoellner, Berlin; 14⅞ × 12" (37.8 × 30.5 cm). Signed, in black ink (lower left): *Klee.* Inscribed, on the secondary support, in black ink: *1921/130 Das Pathos der Fruchtbarkeit.* Recorded in Klee's oeuvre catalogue as: *Pathos der Fruchtbarkeit.*

Klee liked to visit the flea market in Munich, the Auer Dult, where he bought old picture frames. He would repaint them, or not, and put his own works in them. If he found old prints in the frames he bought, he would simply turn the prints over and use their blank side. *The Pathos of Fertility*, for instance, is mounted on the reverse of a lithograph by Paul Rohrbach of Rudolf Jordan's 1842 genre painting *Pilot's Examination* (fig. 34).

Klee never flatteringly depicted either women or men. His etchings and drawings of 1903–1906 and of 1907–1908, which satirize human desires and false morality, show deformed features and bodies. He depicted his wife, Lily, as sensuously attractive only once in his work—in the photographs he took of her in 1903, when they were still engaged (see page 25). In 1907, when she became pregnant, she also fell victim to his caricaturing pen and brush.

Here Klee shows a pregnant woman who literally turns into a flowerpot, supported by open and bent legs. The sprouting plant in her belly and her ardent posture with outstretched arms and tilted head anticipate Picasso's paintings of his sleeping mistress, Marie-Thérèse Walter, executed some ten years later. Marie-Thérèse's earthy sensuousness is evoked by plants or flowers that sinuously grow from her placid body. If these are Picasso's most erotic pictures, this work seems only pathetic.

148

1921/130 Das Pathos der Fruchtbarkeit

Portrait of a Yellow Man
Bildnis eines Gelben
1921

Watercolor and transferred printing ink, pen and black
ink on laid paper mounted on light cardboard; 17½
× 11¾" (44.5 × 28.9 cm). Signed, in black ink
(lower right): *Klee*. Inscribed, on the light cardboard,
in black ink: *1921/36 Bildnis eines Gelben*. Recorded
in Klee's oeuvre catalogue as: *Bildnis eines Gelben*.

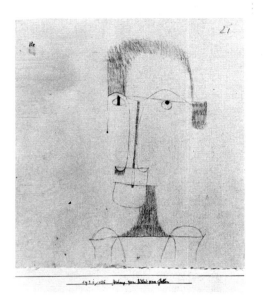

Fig. 35. Paul Klee, *Drawing for "Portrait of a Yellow Man,"* 1921. Pencil and stenciled lines on paper mounted on light cardboard; 11¾ × 10⅜" (29.8 × 26.2 cm). Private collection, Bern

Klee began teaching at the Bauhaus in Weimar in January 1921. During the next nine months his wife, Lily, and his son, Felix, remained in Munich. Alternately, Klee stayed at the boardinghouse Haus zur Sonne in Weimar for two weeks and then returned to his family in Munich for two weeks. Klee wrote to Lily on January 13, 1921: "For breakfast I bought myself a fine sausage and a cheese. I fixed up the studio so much that I was able to paint for the first time today. This large room is still completely empty and will, for the time being, remain so. It is ten by eleven feet and has fine walls to hang pictures on. Until now I have not bought a single piece of furniture since I could get hold of the most essential things here at the Bauhaus. It's just like in the army because one can buy neither easels nor drawing boards. Fine 'specialty shops' they are! . . . Instead, one can get here in the Bauhaus all sorts of trifles, cardboard, paper, canvas, paint etc. etc. . . ."[1]

Later that year, in October, Klee rented a four-room apartment at Am Horn 53 in Weimar, high above Goethe's summerhouse, into which he moved with his wife and son. While at the Bauhaus, Klee painted pictures that related to the theories that he discussed in his classes and others that were pure fantasy, as, for instance, this *Portrait of a Yellow Man*.

This picture is not the portrait of a man from China, as the title suggests, but of a man with yellow hair, a yellow suit, and as glum a mien as one might encounter in the portraits of stern ancestors. Brow, upper lip, and shoulder line are indicated by four horizontal and two vertical lines. Sinuous lines around these form the eyebrows, the nostrils, the chin, and a pair of padded shoulders. A tuft of yellow hair hangs down above the right, catlike eye into a long face with rouged and contourless cheeks. In the sense of the word, Klee playfully drew here what in German is called a Männeken Strich (A little man made out of lines).

1 *Briefe*, II, p. 969.

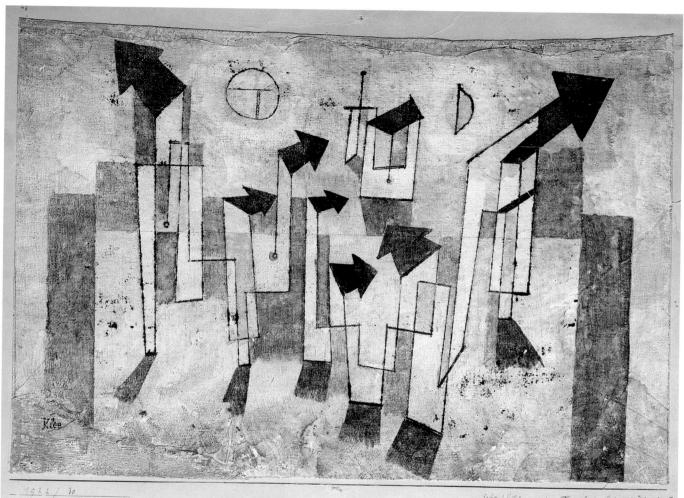

Klee

Wandbild aus dem Tempel der Sehnsucht "dorthin"

The Chair-Animal
Das Stuhltier
1922

Watercolor and transferred printing ink on laid
paper bordered with brown gouache mounted on light
cardboard; 13⅜ × 19⅝″ (34 × 49.8 cm). Signed,
in black ink (lower left): *Klee*. Inscribed, on the light
cardboard, in brown ink: *1922/45 Das Stuhltier*; in
pencil (lower left): *S.Kl*. Recorded in Klee's oeuvre
catalogue as: *Das Stuhltier*.

Overlapping open rectangles, on wheels, are set within sparkling blue
fireworks effects. Four gray narrow strips have feet. These feet evoke
human legs sticking out from funny animal costumes often featured in
variety shows. A tail is on the left, and for the head Klee substituted a
straight, ornamental chair backrest. Why not? In Klee's fantasy universe
a four-legged "chair-animal" is probably nothing unusual.

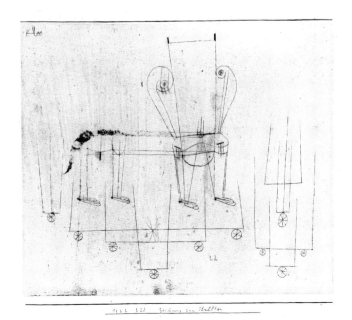

Fig. 38. Paul Klee, *Drawing for "The
Chair-Animal,"* 1922. Pen and ink and
incised lines on paper mounted on light
cardboard; 10⅞ × 11¾″ (27.5 × 30 cm).
Bauhaus Archiv, Museum für Gestaltung,
Berlin

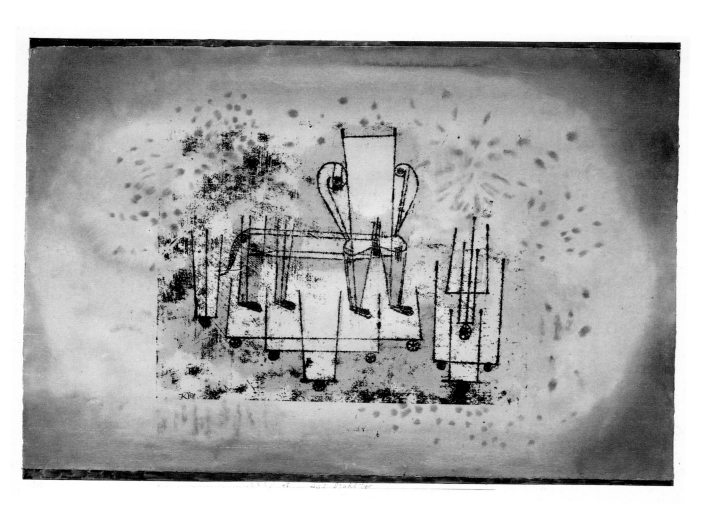

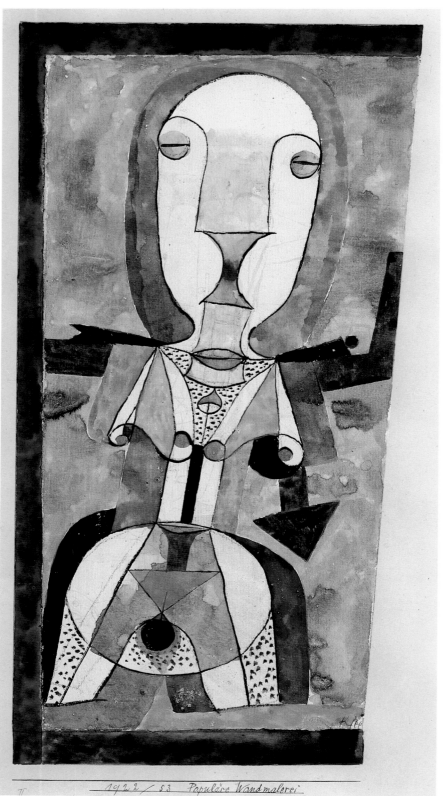

1922/53 Populäre Wandmalerei

Popular Wall-Painting
Populäre Wandmalerei
1922

Gouache and pencil on laid paper bordered with blue and gray gouache mounted on light cardboard; 13¾ × 6¼″ (34.9 × 15.9 cm). Signed, in brown ink (lower right): *Klee*. Inscribed, on the light cardboard, in brown ink: *1922/53 Populäre Wandmalerei*; in pencil (lower left): *II*. Recorded in Klee's oeuvre catalogue as: *Populäre Wandmalerei*.

Klee's Bauhaus years (1921–31) were his most productive ones. Forty-eight works in The Berggruen Klee Collection—just over one half—date from this period. Perhaps as a respite between works that reflected his pedagogical theories, Klee would paint pictures that were funny. *Popular Wall-Painting* appears to be one of these.

An odd assortment of abstract shapes in muted earth colors connects in order to form a creature half-human and half-animal on a sheet of paper that narrows toward the bottom, somewhat as in a game the Surrealists invented in 1925 called "Cadavre Exquis" ("Exquisite Corpse"). In this game the first player would draw the head of a human, an animal, or an insect on the top of a sheet of paper, fold it over to hide what had been drawn, and then pass the sheet to the next player, who would draw the upper part of a body, and so on.

The enormous head might be that of a mournful dog or a cowardly lion, and the body seems stuck into a Baroque papier-mâché costume. Are we faced with male or female exhibitionism? It is difficult to say because of the shape of the blotch of red at what appears to be the crotch of this creature—one of the few pictures in which Klee emphasizes the sexual, albeit in his usual cryptic manner.

Here is a Klee whimsy as seemingly easy to understand as a poster or smutty graffiti. Yet is it as folksy and pleasing as its title suggests?

The Firmament Above the Temple
Gestirne über dem Tempel
1922

Watercolor, pencil, and pen and black ink on wove paper bordered with olive-green gouache and brown ink mounted on light cardboard; 5½ × 10⅞" (14 × 27.6 cm). Signed, in black ink (upper right): *Klee*. Dated and numbered, on the light cardboard, in brown ink (lower left): *1922/58*; titled, in brown ink (lower right): *Gestirne über dem Tempel*. Recorded in Klee's oeuvre catalogue as: *Tempel mit schwarzen Gestirnen (grün/orange Stufung)* [Temple with black stars (green/orange color gradation)].

This watercolor is one of Klee's so-called color-gradation pictures (see pages 141 and 144), with differences, however. One difference is that forms have been reduced to more or less parallel bands. Another is that Klee chose to work with what he called "false color pairs," i.e., such secondary colors as green and orange, green and violet, and violet and orange. Mixed in equal parts, the colors of these pairs turn into gray with shades of either yellow, blue, or red. When Klee applied his special glazing method in 1921, he started out with a blank form, one not covered with color. Of the chosen two complementary colors, only one—the one that was applied first—remained in its pure state. Meanwhile, in this 1922 group of pictures, Klee first introduced both colors of the false color pair before mixing them. Of course, Klee never mixed his two colors in equal parts because he was not interested in gray; it was the "color gradation" before that stage that interested him.[1]

Here, for example, Klee chose as the "false color pair" green and orange. He first covered the entire surface of the sheet with an orange wash—except for the section reserved for the green, which he left empty. Then he applied the green wash, but he did not touch the two small orange sections. In this way both the green and the orange first appear in their pure states. Klee continued in this fashion, alternating between green and orange washes, yet always sparing one section for each coating of color. Klee discussed these false color pairs at length in his lecture on color theory given on November 28, 1922, one of his two lectures on this subject.[2] On that occasion he told his students that during the past summer he had experimented with false color pairs in separate pictures and that he had found these works "lacking in total effect."[3] This may have influenced him to add a bit of fantasy at the top of the picture—the moon, the sun, and square stars.

1 See Note 7 in entry for *Cold City* on page 143 for Klee's color-gradation theories.

2 Jürg Spiller, ed., *Paul Klee: The Thinking Eye*, translated by Ralph Manheim (New York: George Wittenborn; London: Lund Humphries, 1961), p. 483.

3 *Ibid.*

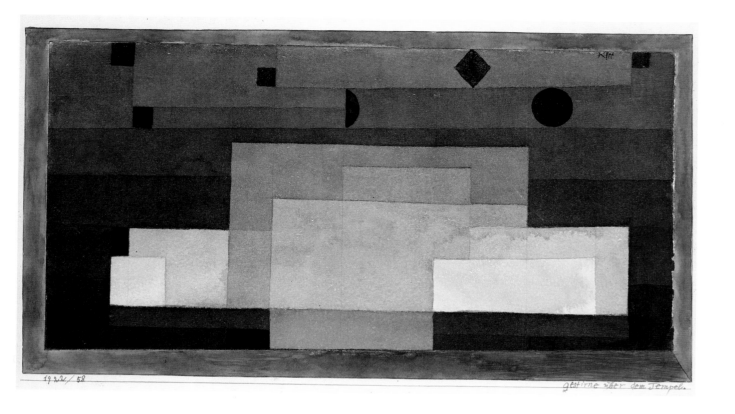

1932/58 gestirne über dem Tempel.

Tower in Orange and Green
Turm in Orange und Grün
1922

Watercolor, pen and black ink, and pencil on wove paper bordered with black ink mounted on light cardboard; 10⅞ × 5⅜″ (27.6 × 13.7 cm). Signed, in black ink (center): *Klee*; dated and numbered, on the light cardboard, in brown ink (lower left): *1922/72*. Titled, in brown ink (lower right): *Turm in orange u. grün*. Recorded in Klee's oeuvre catalogue as: *Turm in orange und grün (fern ein blauer Halbmond)* [Tower in orange and green (far away a blue half-moon)].

This watercolor, although in a vertical format, is nearly identical in size, composition, and color to *The Firmament Above the Temple*, 1922 (see page 159).[1] Because both the orange and the green have stronger hues here, these colors combine to make a darker picture. Although these two works look like exercises in geometry, Klee wanted the luminous orange and green horizontal bands in *The Firmament Above the Temple* to be seen as a temple. Instead, the vertical ones in this watercolor become a tower. In order to embellish this rather sober color experiment, he added the blue half-moon barely visible at the upper right.

1 The companion work is *Green-Orange Gradation with Black Half-Moon* (1922); watercolor on paper mounted on light cardboard; 11¾ × 15½″ (29.9 × 39.4 cm). Fogg Art Museum, Harvard University, Cambridge, Mass.

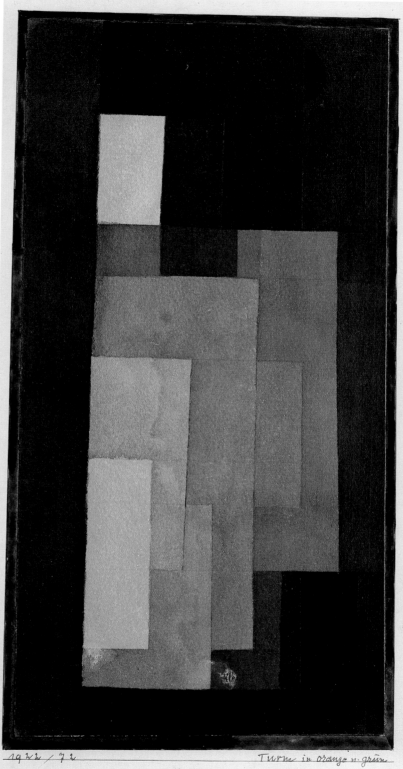

1924 / 72 Turm in orange u. grün

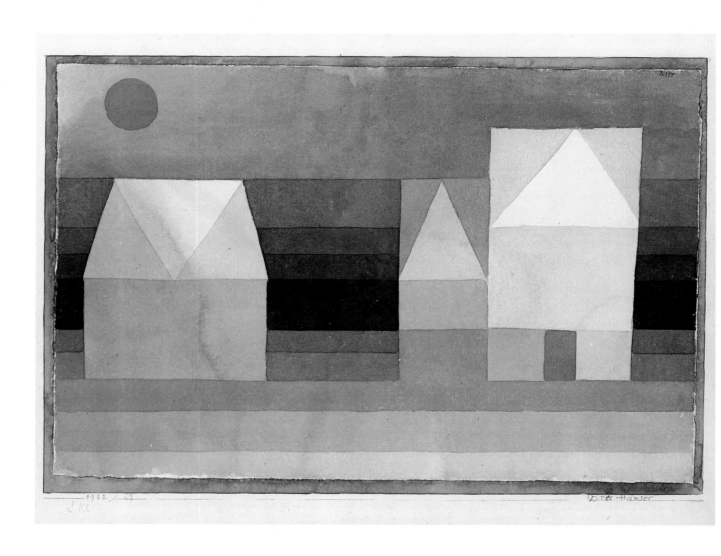

1922/59 Drei Häuser

Three Houses
Drei Häuser
1922

Watercolor on laid paper bordered by violet watercolor
mounted on light cardboard; 7⅞ × 11⅞″ (20
× 30.2 cm). Signed, in black ink (upper right):
Klee. Dated and numbered, on the light cardboard,
in brown ink (lower left): *1922/59*; in pencil (lower
left): *S.Kl.*; titled, in brown ink (lower right):
Drei Häuser. Recorded in Klee's oeuvre catalogue as:
Drei Häuser (grün violette Stufung) [Three Houses
(green violet color gradation)].

Three Houses is the third watercolor in The Berggruen Klee Collection in
which Klee experimented with what he called "false color pairs" (see
pages 159 and 161). In this work Klee chose violet and green. When
mixed in equal parts, these two colors turn into a bluish sort of gray.

Klee first introduced both colors in the three gabled structures.
Then, starting from the top as well as from the bottom of the picture, he
covered the striped surfaces in alternate layers of violet and green
washes. The strongest concentration of both colors, in the center, turns
into a very dark bluish gray.

In a landscape, the horizon is usually a light color, which gives an
effect of distance. So it is here. In this strangely poetic setting, the middle
area is dark. It is as if the three houses stood at the edge of a black canal,
at dawn or dusk, illuminated by a green moon.

The Last Adventure of the Knight Errant
Des irrenden Ritters letztes Abenteuer
1922

Pen and black and brown ink on paper mounted on
light cardboard; 11¼ × 8⅜″ (28.6 × 21.3 cm).
Signed, in brown ink (lower center): *Klee*. Dated,
in pencil (upper right): *1922 7/12*. Inscribed,
on the light cardboard, in brown ink: *1922/86 Des
irrenden Ritters letztes Abenteuer*. Recorded in
Klee's oeuvre catalogue as: *des irrenden Ritters
letztes Abenteuer*.

Our errant knight's earlier adventures were probably happier. There he
is, at the right, with a balloon-shaped head and a stick-figure body in the
shape of a jack-in-the-box. Caught like an insect in a spider's net, which
seems spun out of wrought-iron musical symbols, he is about to disap-
pear, heart and all, into the round well toward which all the little arrows
and lines converge.

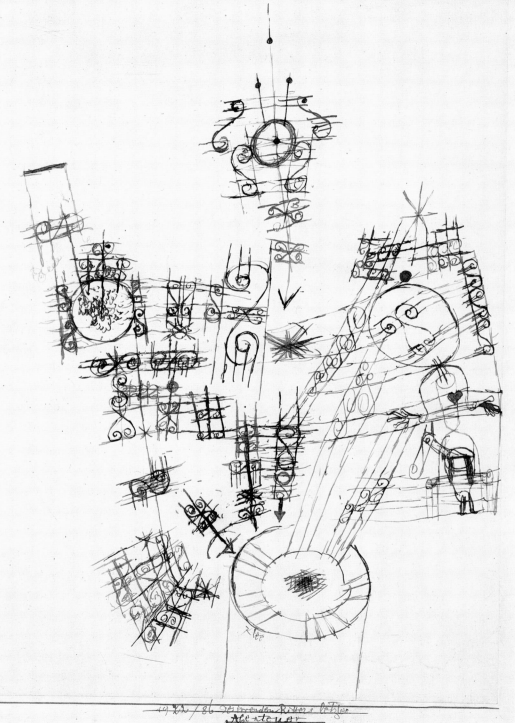

1922/86 Des werdenden Ritters letztes
Abenteuer

Window Display for Lingerie
Schaufenster für Damenunterkleidung
1922

Pen and black ink and watercolor on two sheets of laid paper bordered with black ink mounted on light cardboard; 16½ × 10⅝″ (41.9 × 27 cm). Signed, in black ink (upper right): *Klee.* Inscribed, on the light cardboard, in black ink: *1922/125 Schaufenster für Damenunterkleidung*; in pencil (lower left): *V.* Watermark (left): *JWZ*; watermark (right): swirled monogram. Recorded in Klee's oeuvre catalogue as: *Schaufenster für Damenunterkleidung.*

The window of Anna Wenne's "specialty" lingerie shop promises "fixed prices," possibly an allusion to postwar runaway inflation. In view of the modish merchandise offered and the hoped-for international clientele, the entrance to the shop is indicated both in German ("Eingang") and in

Fig. 39. Eugène Atget, *Boulevard de Strasbourg, Corsets,* c. 1912. The Museum of Modern Art, New York. Study Collection 84.69

1922/125 Schaufenster für Damen unterkleidung

French ("Entrée"). The effect of seeing the lingerie display through a reflecting glass pane seems to chop up and flatten the space behind into a cubic grid, all the while dismembering the dummies into marionettes. Dressed up in fashionable 1920s gear—ankle boots and pot hats—they display the shop's specialties: corsets, floppy pants, and garter belts.

The display in this picture brings to mind the Surrealists' delight in old-fashioned shop windows, featuring strange-looking dummies and wares, which they passed on their random promenades through Paris, and also Eugène Atget's photographs of similar subjects (see fig. 39). Actually, no one named Anna Wenne lived or owned or operated a lingerie shop in either Weimar or Munich while Klee lived and painted in both cities during the 1920s.[1]

The name Anna Wenne appears in the artist's works only one more time, namely in a watercolor dating from 1923, in which Klee painted, over variously sized colored squares and rectangles, the words "Paul Ernst," "Ei," and "Anna Wenne."[2] Perhaps Klee's Anna Wenne is as fictitious as Kurt Schwitters's Anna Blume, the heroine of his poem "An Anna Blume," which achieved instant and notorious fame when it was published in 1919.[3]

1 I am grateful to Volker Wahl, now the director of the Nationale Forschungs- und Gedenkstätten der Klassischen deutschen Literatur, Goethe- und Schiller- Archiv, Weimar, for this information. He kindly checked Weimar's directories for this period. Similarly, the Einwohneramt, Munich, informed me in a letter dated February 2, 1986, that no person by that name had lived there.

2 This work is entitled *A Centrifugal Memory Sheet*, 1923. Watercolor on newspaper mounted on light cardboard; 21½ × 16⅜″ (54.7 × 41.7 cm). Private collection, Lucerne.

3 "An Anna Blume," *Der Sturm* 10, no. 5 (August 1919), p. 72. It is also included in the anthology of prose pieces and poems entitled *Anna Blume. Dichtungen* (Hannover: Paul Steegermann, 1919).

Episode Before an Arab Town
Szene vor einer arabischen Stadt
1923

Watercolor and transferred printing ink on laid
paper with gray and green gouache and black ink
mounted on light cardboard; 8⅞ × 12″ (22.5 ×
30.5 cm). Signed, in black ink (center, left side):
Klee. Inscribed, on the light cardboard, in black
ink: *1923 /// 53. Scene vor einer arabischen
Stadt*. Recorded in Klee's oeuvre catalogue as:
Scene vor einer arabischen Stadt.

The impact of Klee's trip to Tunisia in 1914 remained so strong that
things Oriental cropped up in the artist's works and in their titles for the
rest of his life. In 1923, nine years after his memorable visit, Klee picked
up once again a pencil drawing (see fig. 17) that he had executed on site
during his visit to Kairouan from April 15–17, 1914, to adapt it—in
mirror-image—for a second watercolor. Whereas the earlier watercolor,
Episode at Kairouan, 1920 (see page 106), might represent early morn-
ing, here we see sky and landscape saturated by the deep red of what
might be the reflection of a North African sunset.

This glimmering red, ranging from orange to violet, well conveys
the sense of the Orient that Klee had described in his diary as "the
essence of *A Thousand and One Nights*, which is, however, ninety-nine
percent real,"[1] and that by 1923 had become a memory. In 1914, how-
ever, his visit to Kairouan had proven to be so overwhelming that Klee
had intended to depart before his two companions, August Macke and
Louis Moilliet: "I packed my few things; my train leaves at 11 in the
morning. The other two will follow later, on the same afternoon or the
next day. Today I had to be alone; what I had experienced was too
powerful. I had to leave to regain my senses."[2] In the end, however,
Macke and Moilliet did leave with him, because as Klee wrote: ". . . they
too have had their experience."[3]

1 *Diaries*, p. 297.

2 *Ibid.*, p. 298.

3 *Ibid.*

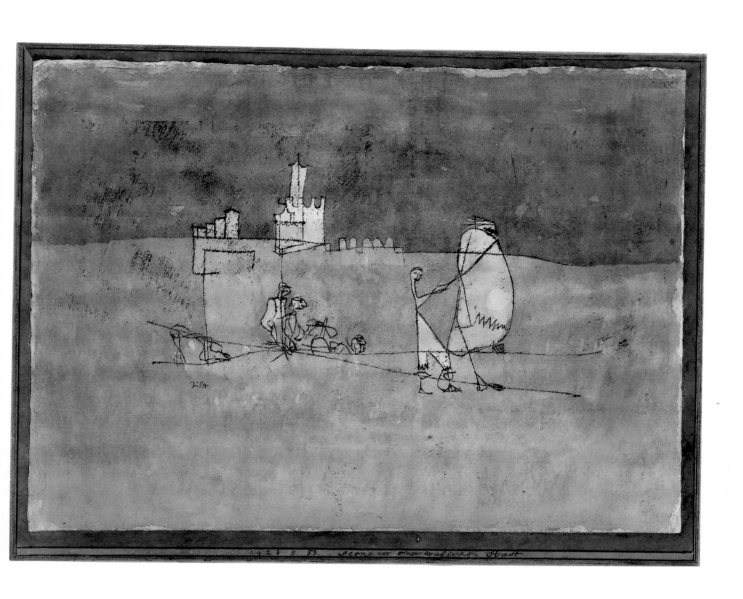

1923 // 53. Scene vor einer arabischen Stadt

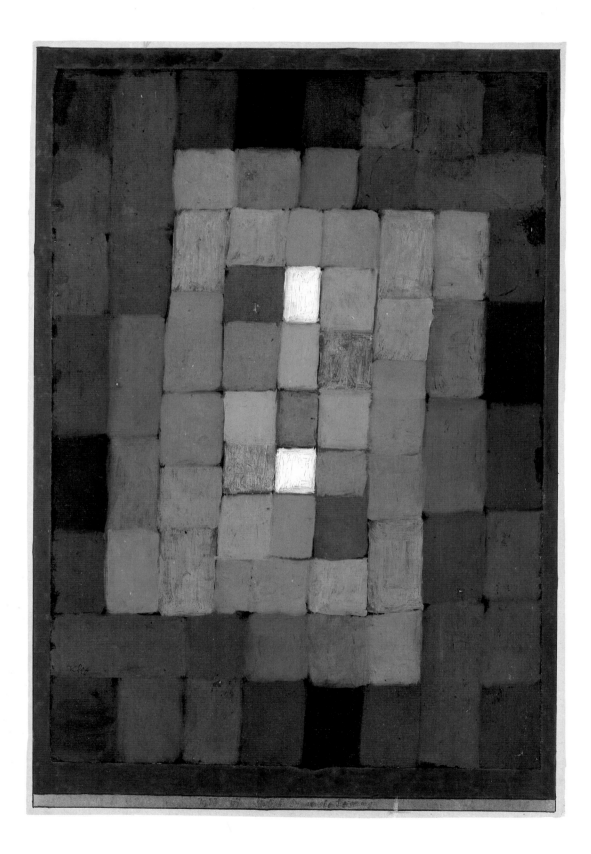

Static-Dynamic Gradation
Statisch-Dynamische Steigerung
1923

Oil and gouache on wove paper bordered with maroon
gouache, gray watercolor, and black ink mounted on
light cardboard; 15 × 10¼″ (38.1 × 26.1 cm).
Signed, in black ink (lower left): *Klee*; inscribed,
on the light cardboard, in black ink: *1923 /// 67
Statisch-Dynamische Steigerung*. Recorded in Klee's
oeuvre catalogue as: *Farbsteigerung vom Statischen
ins Dynamische* (Color Gradation from the Static to
the Dynamic).

"To paint well means only this: to put the right colors in the right spot."[1]
Besides offering this aphorism in his second Bauhaus course, Klee also
changed the usual color circle into a color sphere. Its lower pole was
black and its upper one white, with the gray area in the middle of the
axis. Longitudinally, the sphere could thus be divided, as an orange, into
sections of all the colors of the rainbow, including the intermediate ones,

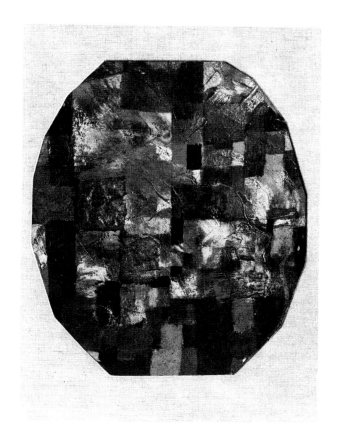

Fig. 40. Paul Klee, *Hommage à Picasso*,
1914. Oil on board; 13¾ × 11½″
(34.9 × 29.2 cm). Whereabouts unknown

ranging from very light (white) at the top to very dark (black) at the bottom.

Whereas the color circle offered only a limited choice of intensities of colors, the color sphere with its gradations to light and dark offered a multitude of choices. Klee used these colors in his so-called magic square pictures, which he began in 1921 and painted until the end of his career.[2]

These works have their roots in the Tunisian watercolors (see pages 61 and 65) of 1914 in which Klee first divided the picture into colored cubic squares and in his famous painting *Hommage à Picasso* of the same year (see fig. 40). Not unlike their distribution on Klee's color sphere, here and in many others of this series, outer dark colors surround pure luminous ones in the center. In this work Klee devised a systematic movement, progressing from dark-hued brownish, the so-called static squares, toward the clear-colored ones, which by virtue of the contrasts they offer, Klee called "dynamic."

1 "Begriff der Gestaltung," *Pädagogischer Nachlass* (Paul Klee Stiftung, Bern), ms. 1, p. 3, cited in Christian Geelhaar, *Paul Klee and the Bauhaus*, translator unknown (Greenwich, Conn.: New York Graphic Society, 1973), footnote 19, p. 48. See his chapter "Paintings of Squares" from which the following information is taken, pp. 44–49.

2 Will Grohmann, *Paul Klee*, translator unknown (New York: Harry N. Abrams, 1954), p. 213.

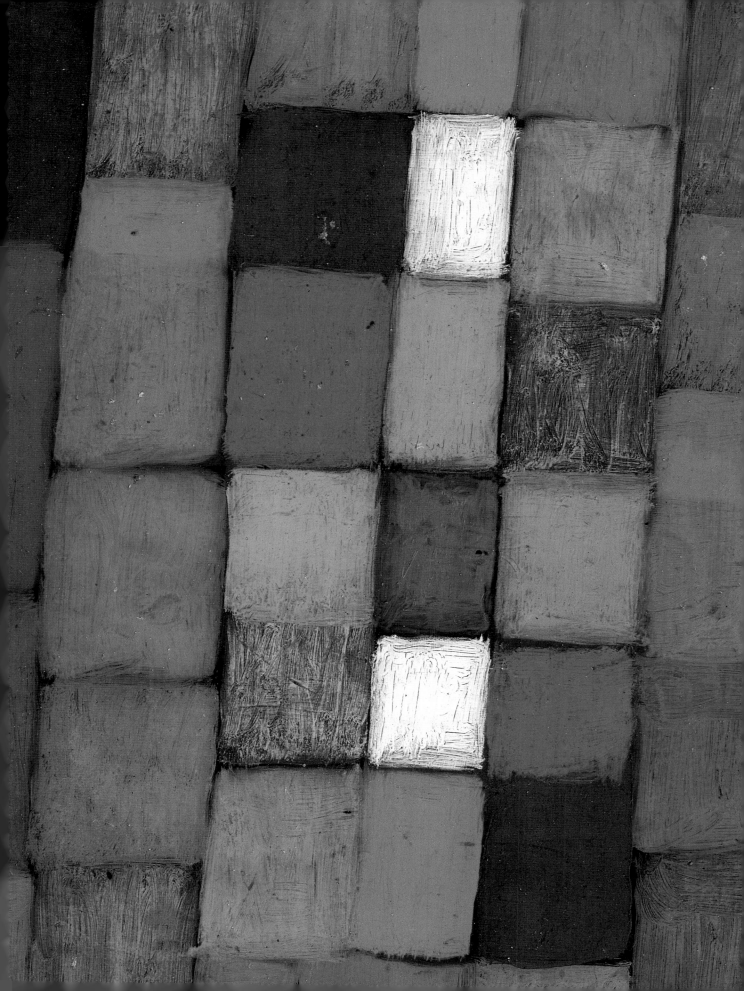

Abstract Trio
Abstraktes Terzett
1923

Watercolor and transferred printing ink on wove
paper bordered with brown, gray gouache, and black
ink mounted on light cardboard; 12½ × 19¾"
(32.1 × 50.2 cm). Signed, in black ink (extreme upper right):
Klee. Inscribed, on the light cardboard, in black ink:
1923 88 Abstractes Terzett; in pencil
(lower left): *VII*. Recorded in Klee's oeuvre catalogue as:
Abstractes Terzett.

Here is a good example of one's susceptibility to Klee's evocative titles.
The artist copied the image of this watercolor from a smaller pencil
drawing, which he called *Theater of Masks*, 1922 (fig. 41). Thus one looks
for masks—albeit abstract ones—in the drawing. But in the watercolor
these same three sprightly forms might represent as well the abstract
sound patterns of three voices or three instruments. Or are they the three
performers?

Music played a great role in Klee's life. His letters from Munich
written between 1898 and 1901 to his parents in Bern are filled with
impressions of the operas and concerts that he attended. In fact, in their
knowledgeably pungent and humorously down-to-earth way, these let-
ters probably offer the best record of Munich's musical life in those
years.

Klee was an accomplished violinist himself, and music making was
his daily food. In 1902 he joined the Bernische Musikgesellschaft as a
violinist during its subscription series of performances. As a married
man from 1906 onward, he played duets at home with his wife, Lily, a
pianist. Chamber-music gatherings at friends' and at the Bauhaus were
frequent happy events.

Klee's favorite composers were Bach, Mozart, and Beethoven. His
passion for music is reflected in the titles of some of his works. According
to his son, Felix, of the 9,146 works Klee recorded in his oeuvre cata-
logue, more than 500 refer to the theater, to masks, or to music.[1]

Alfred H. Barr, Jr., who was the first director of New York's Mu-
seum of Modern Art, bought this watercolor from J. B. Neumann in
1930 and kept it in his collection for fifty years.

Fig. 41. Paul Klee, *Theater of Masks*,
1922. Pencil and incised lines on paper
mounted on light cardboard; 8¾ × 11¼"
(22.3 × 28.6 cm). Formerly Galerie
Rosengart, Lucerne

1 Felix Klee, *Paul Klee: His Life and Work
in Documents*, translated by Richard and
Clara Winston (New York: George Braziller,
1962), p. 138.

Ventriloquist and Crier in the Moor
Bauchredner und Rufer im Moor
1923

Watercolor and transferred printing ink on laid
paper bordered with black and blue ink mounted on
light cardboard; 15¼ × 11″ (38.7 × 27.9 cm).
Signed, in black ink (upper right): *Klee*. Inscribed,
on the light cardboard, in black ink: *1923.103
Bauchredner und Rufer im Moor*; in black ink (lower
left): *VIII*. Recorded in Klee's oeuvre catalogue as:
Bauchredner (Rufer im Moor).

This work, with its humor and grotesque fantasy, may strike many viewers as the quintessential "Klee." Imaginary beasts float within a transparent ventriloquist who appears to be all belly—except, of course, for a pair of legs, tiny arms, and a sort of head without a mouth.

Klee had executed the drawing (fig. 42) from which this watercolor was copied two years earlier in 1921. It is very similar in style to *Drawing for "The Pathos of Fertility,"* 1921 (see fig. 33). If the pot of flowers in the woman's belly refers to budding life in her womb, then the little creatures inside the ventriloquist might symbolize the odd noises and voices that seem to come from there. Yet why the ventriloquist stands on a small gangplank in a swamp and cries is anybody's guess. The swamp is indicated by the background grid of warm earth colors that turns dark toward the center and against which the figure, as part of this grid, stands out like a light-colored bubble in clear reds and blues. As if attracted by the animal sounds above him, a stray fish is about to enter a net dangling from the lower part of the ventriloquist's anatomy—perhaps to join the menagerie within.

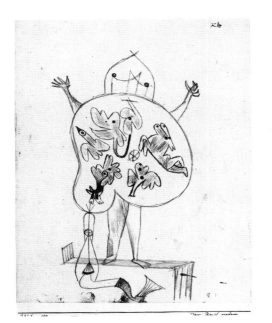

Fig. 42. Paul Klee, *The Ventriloquist*,
1921. Pencil and incised lines on paper
mounted on light cardboard; 11⅛ × 8¾″
(28.3 × 22.3 cm). Paul Klee Stiftung,
Kunstmuseum Bern

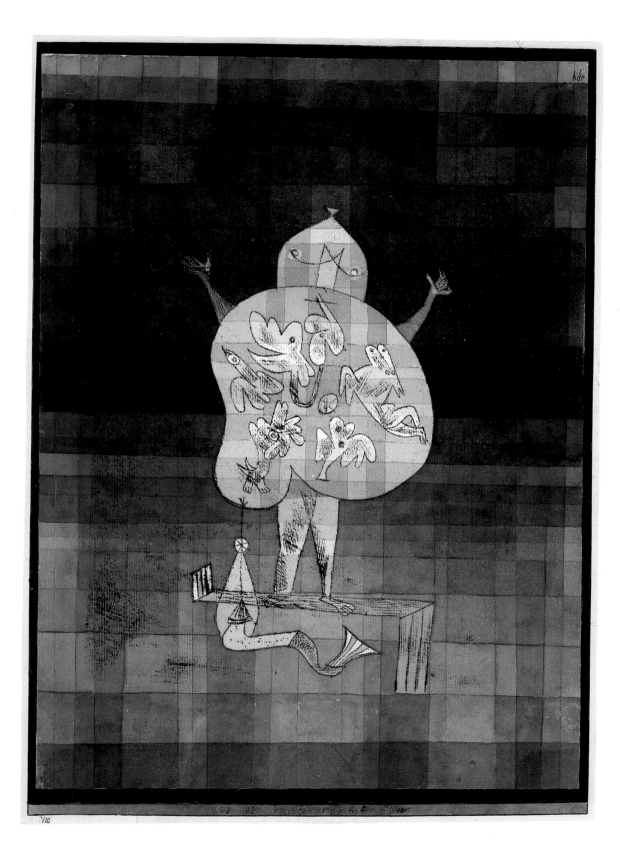

The Barbed Noose with the Mice
Die Stachel-Schlinge mit den Mäusen
1923

Watercolor and gouache on laid paper bordered with
violet, maroon, and gray gouache mounted on light
cardboard; 9 × 12⅛″ (22.9 × 30.8 cm). Signed, in
brown ink (upper left): *Klee*. Inscribed, on the
light cardboard, in black ink: *1923 105 Die
Stachel-Schlinge mit den Mäusen*. Recorded in Klee's
oeuvre catalogue as: *Die Stachelschlinge mit d. Mäusen*.

Klee once wrote in a letter: "My compositions are but the scenes of my
thoughts."[1] Judging by a composition such as this one, he had not, shall
we say, any ordinary person's thoughts. In this work the light-colored
swirl covered with red thorns, the treading wheel, and the translucent
green pattern, all set against a dark ground, probably evoked in Klee's
mind a mazelike noose in which four black mice get lost.

1 *Briefe*, I, p. 144.

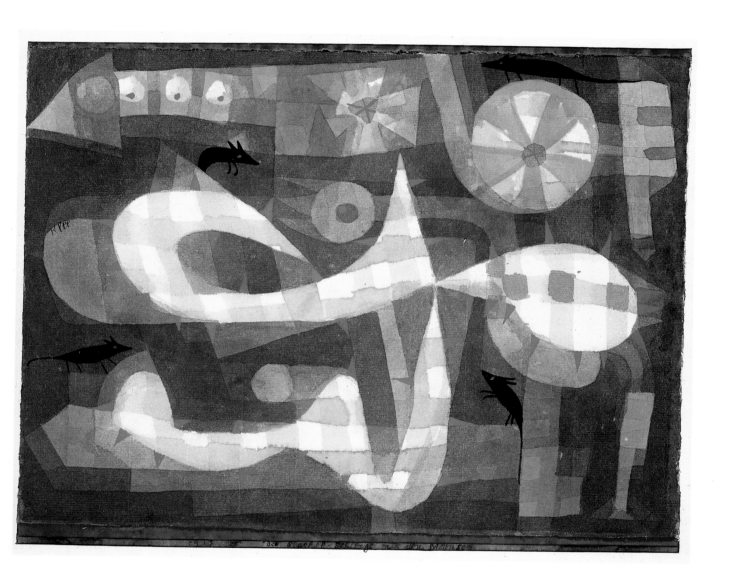

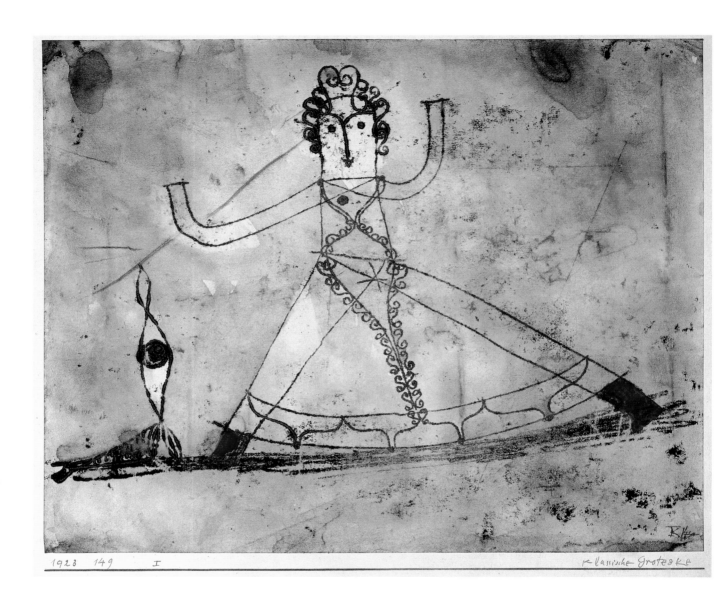

1923 149 I klassische Groteske

Classical Grotesque
Klassische Groteske
1923

Watercolor and transferred printing ink on wove
paper mounted on light cardboard; 9 × 11″
(22.9 × 27.9 cm). Signed, in brown ink (lower right):
Klee. Dated and numbered, on the light cardboard,
in brown ink (lower left): *1923 149*; in black ink
(lower left): *I*; titled, in brown ink (lower right):
Klassische Groteske. Recorded in Klee's oeuvre
catalogue as: *Klassische Groteske*.

An initial reaction to this work might be one of slight disappointment
after reading its title. Klee conjured up much stranger images than this
one—so why would he call this figure in ornate period dress and hairdo
a "classical grotesque"?

Klee very likely used this word ("grotesque") in its traditional
positive meaning, as representing, according to *Webster's*, "distortion or
exaggeration of the natural or the expected."[1] This is just what Klee's
lady conveys with long tubes in lieu of arms and with booted legs spread
in an almost acrobatic position. The suspended large eye on a fish's tail
seems an appropriate companion.

1 *Webster's Third New International
Dictionary of the English Language*
(Springfield, Mass.: G. & C. Merriam
Company, Publishers, 1971), p. 1,002.

Strange Garden
Seltsamer Garten
1923

Watercolor on gesso on cloth bordered with red
and green gouache and black ink mounted on light
cardboard; 15¾ × 11⅜″ (40 × 28.9 cm). Signed,
in black ink (upper left): *Klee.* Dated and numbered,
in black ink (lower left): *1923 160*; in pencil (lower
left): *S.Kl.*; titled, in black ink (lower right):
Seltsamer Garten. Recorded in Klee's oeuvre catalogue
as: *Seltsamer Garten.*

In his life and in his art, Klee liked to evoke gardens—but never an
ordinary kind of vegetable patch. Referring to their future life together,
Klee wrote to his fiancée, Lily Stumpf, on October 5, 1901: "Why should
we make out of ourselves a little garden of white flowers and keep watch
all day from its fence? Our garden will be the wide open world, not the
fighting one. To sow many different kinds of seeds."[1]

In his art Klee conjures up the gardens of faraway and strange
places, of fairy tales, and, as here, gardens budding with strange flora
and fauna. This one grows all kinds of faces of humans and birds, masks
both friendly and solemn, a sun, a star, flowers, plants, peacock wings,
imaginary winged creatures, eyes, mouths, and sexual orifices and parts.
Once before, in Klee's 1913 etching *Garden of Passion* (fig. 43), the
garden had served as a congenial spot for the pursuit of various frolick-
ings.

With images surrounded by small furry hatchings and drawn with a
very thin brush, this watercolor resembles a finely interwoven, exotic
piece of fabric.

1 *Briefe*, I, p. 152.

Fig. 43. Paul Klee, *Garden of Passion*,
1913. Etching; c. 10¼ × 14⅜″
(26 × 36.5 cm). Private collection, Bern

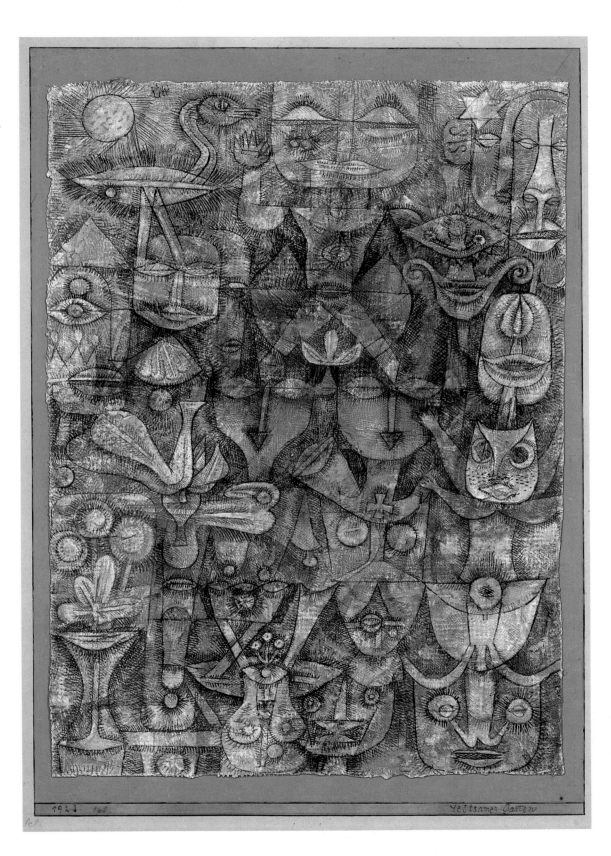

Klee

1923 160. Seltsamer Garten

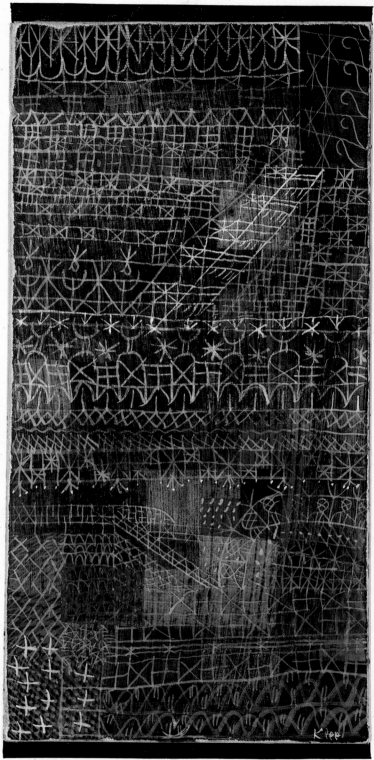

1924 125 „Structural I "

Structural I

Structural I

1924

Gouache on cardboard bordered with black ink mounted
on light cardboard; 11¼ × 5½" (28.6 × 14 cm).
Signed, in white gouache (lower right): *Klee*. Dated
and numbered, on the light cardboard, in black ink
(lower left): *1924 125*; titled, in black ink (lower
right): *"Structural I."* Recorded in Klee's oeuvre
catalogue as: *Structural I.*

This watercolor is one in a series of twelve all painted in 1924 that all
show similar motifs. Over a muted colored ground Klee painted—with a
very fine brush—a white screen that seems spun out of lace, irregularly
at that. Arranged in friezelike fashion, with here and there a diagonal or
curved band, it also brings to mind the latticework of grated windows
that Klee would have seen on his visit to Tunisia in 1914 (fig. 44).

Fig. 44. Window in Kairouan, 1982.
Photograph Roger-Viollet, Paris

Medicinal Flora
Officinale Flora
1924

Watercolor and transferred printing ink on textured wove paper bordered with blue gouache and black ink mounted on light cardboard; 11⅜ × 15⅜″ (28.9 × 39.1 cm). Signed, in black ink (lower left): *Klee.* Inscribed, on the light cardboard, in black ink: *1924 140 Officinale Flora*; in pencil (lower left): *S.Cl.* Recorded in Klee's oeuvre catalogue as: *officinale Flora.*

Klee had been interested in botany since his childhood. His son, Felix, still preserves in his collection at least twelve works, dating from between 1927 and 1931, in which Klee had mounted dried and pressed flowers and plants on black paper (fig. 45). Klee had gathered these flowers and plants during his walks through the countryside. One or two of these works, with groups of clover leaves, were of special meaning to the artist. "Klee" means "clover" in German.

Klee is probably the only modern artist—or one of a few—who chose medicinal plants for a flower still life.

Fig. 45. Paul Klee, *Four Pressed Plants*, 1931. 19¼ × 12¾″ (48.9 × 32.4 cm). Collection Felix Klee

Fig. 46. Paul Klee, *Drawing for a Garden Picture*, 1923. Pencil and stenciled lines on paper; 9½ × 12″ (24.2 × 30.5 cm). Whereabouts unknown

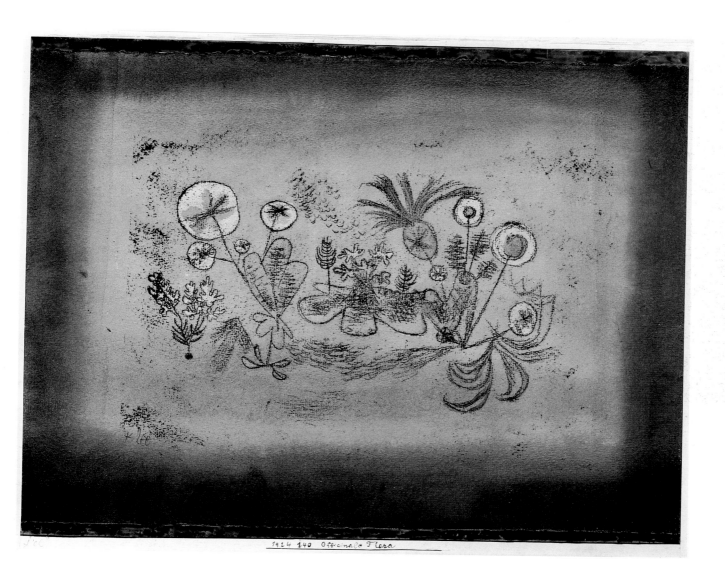

Klee

1924 140 Officinale Flora

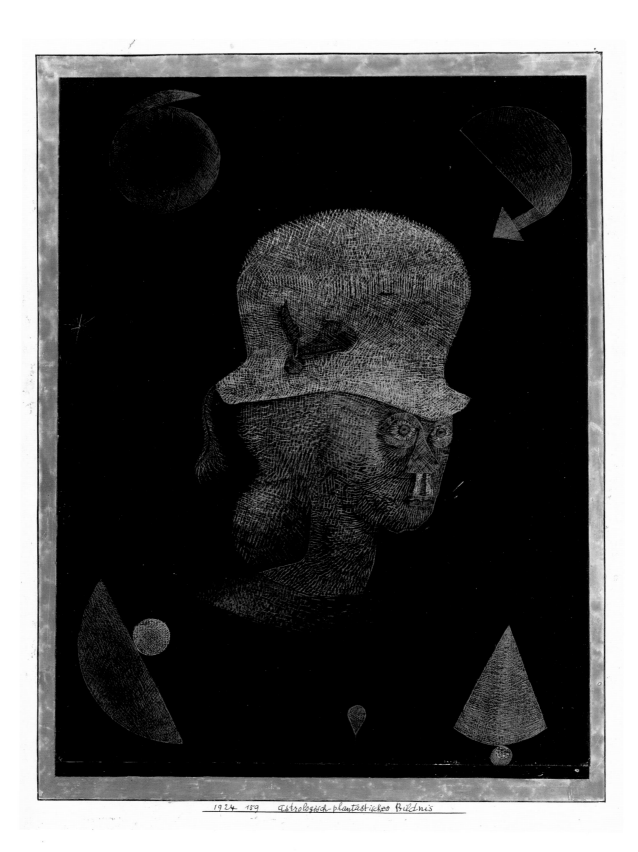

1924 159 Astrologisch-phantastisches Bildnis

Astrological Fantasy Portrait

Astrologisch-phantastisches Bildnis

1924

Gouache on laid paper bordered with black ink and gray gouache mounted on light cardboard; 12⅜ × 9⅜″ (31.4 × 23.8 cm). Signed, in red gouache (center left): *Klee*. Inscribed, on the light cardboard, in black ink: *1924 159 Astrologisch-phantastisches Bildnis*. Watermark (lower right): MBM. Recorded in Klee's oeuvre catalogue as: *astrologisch-phantastisches Bildnis*.

Klee's was not a life of drama—there were no scandals, divorces, or mistresses. His was the quiet and regulated existence of a modest German bourgeois; he indulged, it seems, in nothing more than fine meals. If little of his life ever found its way into Klee's art, from time to time something personal did sneak into it. According to her son, Felix, Lily Klee was very interested in astrology, much to the amusement of her son and husband. It is well within this spirit of gentle mockery that Klee composed here a portrait in the manner of a strange playing card, suggesting its use in divination rites. The woman wears a tousled and feathered helmetlike hat, and she is surrounded in all four corners by planets and other astrological paraphernalia. Her extraterrestrial pursuits probably make her look as insubstantial as an X-ray.

A Pride of Lions (Take Note!)
Löwengruppe (zu beachten!)
1924

Brush, pen and black ink, and watercolor on laid
paper mounted on light cardboard; 8¼ × 15″
(21 × 38.1 cm). Signed and titled, in black ink
(center right): *Löwengruppe (zu beachten!) Klee.*
Dated and numbered, on the light cardboard, in black ink: *1924 193.*
Watermark: *JWZ*; swirled monogram. Recorded in
Klee's oeuvre catalogue as: *Löwengruppe (zu beachten!).*

It would be difficult not to "take note" of these four lions! There is little
else in the picture.

Klee's instruction to take note, which he jotted down as part of the
title at right center, is akin to that given to a group of tourists not to
overlook an interesting architectural detail on a cluttered cathedral fa-
çade. Klee's irony turns this rather unremarkable watercolor into an
amusing one. These toy beasts, the ancestors of Alexander Calder's wire
circus lions of the mid-1920s, actually have the posture and bearing of
real lions.

This pride of lions had appeared earlier, in 1923, in Klee's water-
color, *Lions, Take Note of Them!* (fig. 47), as part of a circus ring com-
plete with lion tamer and two performers. In this work Klee literally took
the lions out-of-doors by placing them on a pale yellow ground and by
adding a big red sun and some undulating ink lines that suggest a hilly
desert.

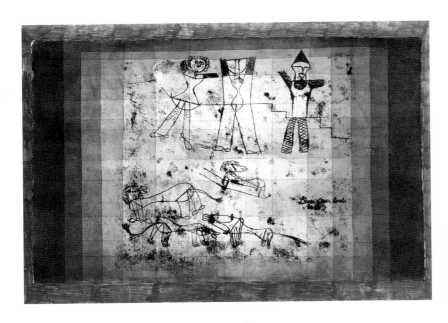

Fig. 47. Paul Klee, *Lions, Take Note of
Them!*, 1923. Watercolor and transferred
printing ink on paper mounted on light
cardboard; 14⅛ × 20⅛″ (36 × 51.2 cm).
Kunstsammlung Nordrhein-Westfalen,
Düsseldorf

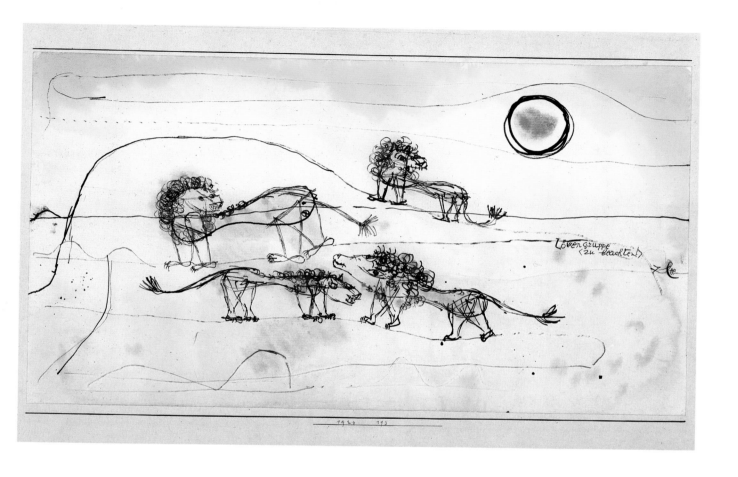

Löwengruppe
(zu beachten)

Klee

1924 193

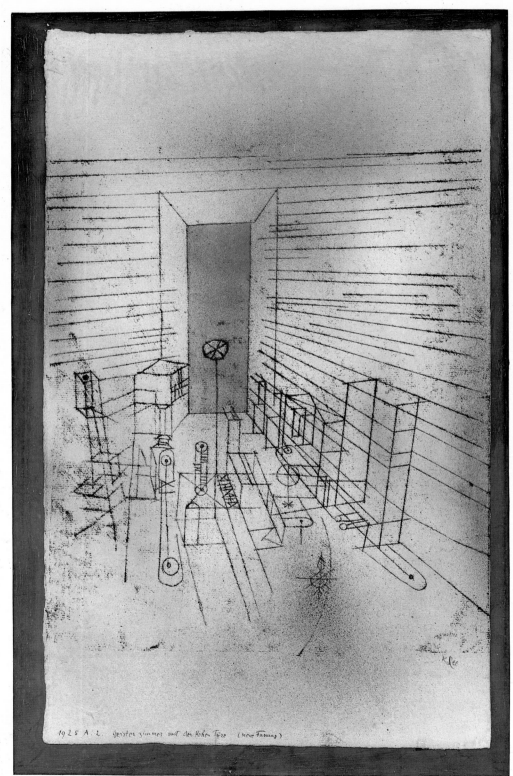

1925 A.2. Geister Zimmer mit der Hohen Türe (neue Fassung)

Ghost Chamber with the Tall Door (New Version)

Geisterzimmer mit der hohen Türe (Neue Fassung)
1925

Sprayed and brushed watercolor and transferred
printing ink on laid paper bordered with gray gouache
and black ink mounted on light cardboard; 19⅛ x
11⅝″ (48.7 × 29.4 cm). Signed, in black ink
(lower right): *Klee.* Inscribed, in black ink: *1925
A. 2. Geisterzimmer mit der hohen Türe (neue
Fassung)*; in black ink (lower left): *VIII.*
Recorded in Klee's oeuvre catalogue as: *Geisterzimmer
mit der hohen Türe (neue Fassung).*

In the early 1920s Klee painted a series of ghost chambers with eerie
lines of perspective that reduce everything to skeletal transparency (see
pages 121 and 122). As Klee rarely used perspective, he applied it in these
works—always interiors—solely to show its delusive effects, a theory he
also told his students in his Bauhaus lecture on the subject on November
28, 1921.[1] He demonstrates that perspective can be playful in this water-
color of an orange room cluttered with black wire utensils and with a tall

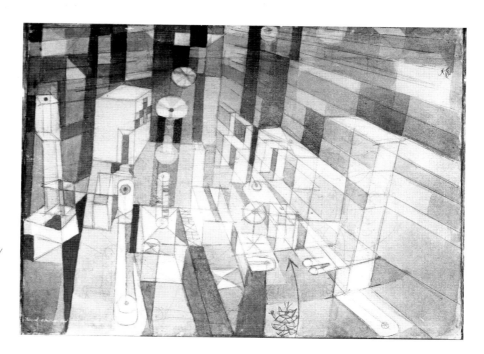

Fig. 48. Paul Klee, *Room Perspective Red/
Green*, 1921. Watercolor and pencil on
paper mounted on colored papers
mounted on light cardboard; 8⅓ × 10½″
(21.3 × 26.7 cm). The Galka E. Scheyer
Blue Four Collection, Norton Simon
Museum, Pasadena

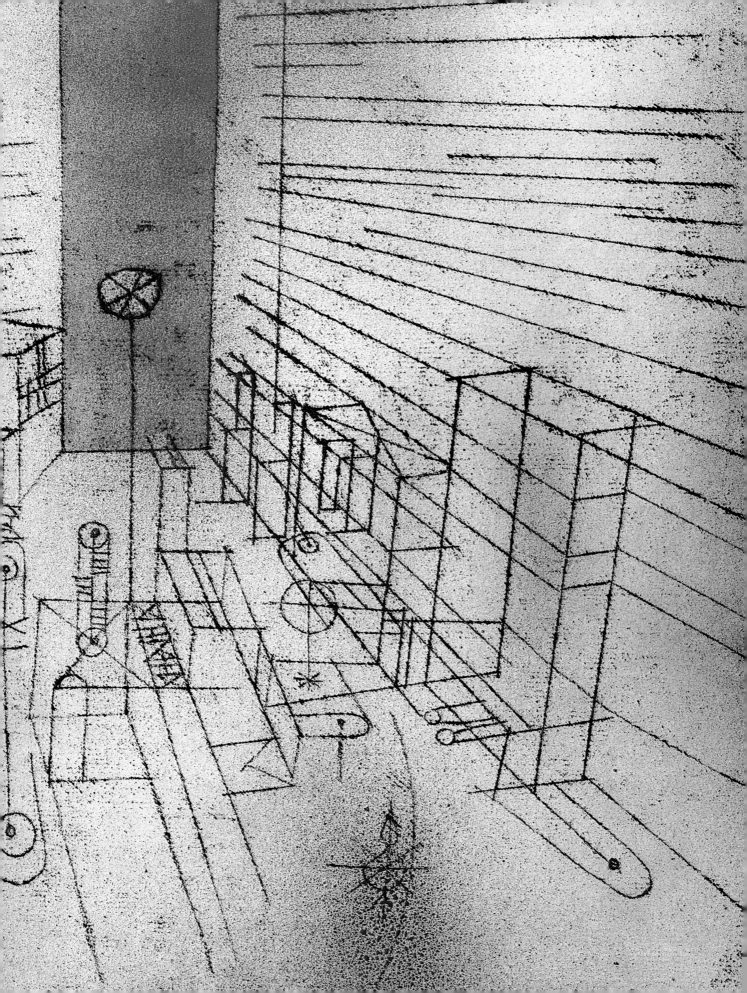

violet door from which seemingly radiate the black perspectival lines. It is a "new" version of exactly the same room Klee had painted four years earlier, in 1921, and had titled *Room Perspective with the Dark Door* (fig. 48a). The only difference is that the door in this work appears to be slightly narrower and taller. Klee also added a certain drama to the title.[2]

Although not obvious at first glance, the same black-wire utensils also appear in the watercolor *Room Perspective Red/Green* (fig. 48), which Klee painted shortly after the "original" version of this work in 1921.[3] These three works are fine examples of Klee's playful treatment of perspective. The dimensions of most of the objects are identical in all three paintings, which must have been copied from the same lost drawing. However, in *Room Perspective Red/Green* Klee copied only a tiny replica of the door (left center) that dominates the composition of the other two. Thus, in one work, the door is dwarfed by "monumental" clutter, while in the others it looms so large that it dwarfs everything around it. This reversal of scale reminds one of Lewis Carroll's Alice, who, after swallowing that fateful potion and cake, grows so tall and then so small that she either towers over her surroundings or is towered over by them. This is one of the seventeen works by Klee that were included in the exhibition *Degenerate Art* held in Munich in 1937.

1 Jürg Spiller, ed., *Paul Klee: The Thinking Eye*, translated by Ralph Manheim (New York: George Wittenborn; London: Lund Humphries, 1961), pp. 133ff.

2 Klee probably sold the "original" version of this work right after he had painted it in 1921 and painted this "new" version in 1925.

3 We can only assume that Klee painted *Room Perspective with the Dark Door* first, because its inventory number (21) is lower than that of *Room Perspective Red/Green* (46).

Fig. 48a. *Paul Klee; Room Perspective with the Dark Door*, 1921. Watercolor and transferred printing ink on paper mounted on light cardboard; 18⅞ × 12⅜" (48.0 × 31.5 cm). Private collection, Switzerland

In Memory of an All-Girl Band
Zur Erinnerung an eine Damenkapelle
1925

Pen and black ink and pencil on laid paper bordered
with metallic paint and black ink mounted on light
cardboard; 7⅝ × 9⅝″ (19.4 × 24.6 cm). Signed,
in black ink (upper right): *Klee.* Inscribed, in
black ink (upper left): *Zur Erinnerung an eine Damenkapelle
1925 A. 3.*; in pencil (upper right): *192.* Recorded in
Klee's oeuvre catalogue as: *Zur Erinnerung an eine
Damenkapelle.*

All-girl bands were *the* thing in the 1920s. They did not offer serious
music but played in dance halls in the evenings and, in Germany, also in
dance cafés in the afternoons. They evoke glitter, the demimonde, fri-
volity, humor, sex, a sense of androgynism, and a touch of slapstick
comedy—all things that were captured so well in Billy Wilder's classic
film *Some Like It Hot* (1959). Klee himself never frolicked to an all-girl
band, yet he surely must have been amused by the unconventional nov-
elty of these musicians.

Klee chose to present here only three players from one of these
bands, and he lined them up like puppets in a Punch and Judy show. It is
even difficult to tell what instruments the girls are actually playing. Are
they manning a xylophone? Who knows? Or is the bulky lady with the
hat in the center scratching on a fiddle? A second unmanned violin with
bow floats above her to the right. Her two companions might be singers.
All together, there are some thirty variously sized circles and ovals in this
composition. Perhaps Klee drew these first, doodling along, and only
later filled in the wispy figures, using the circles and ovals as a mouth,
eyes, sound holes, vocal chords, drums, and breasts, as well as the top of
a hat.

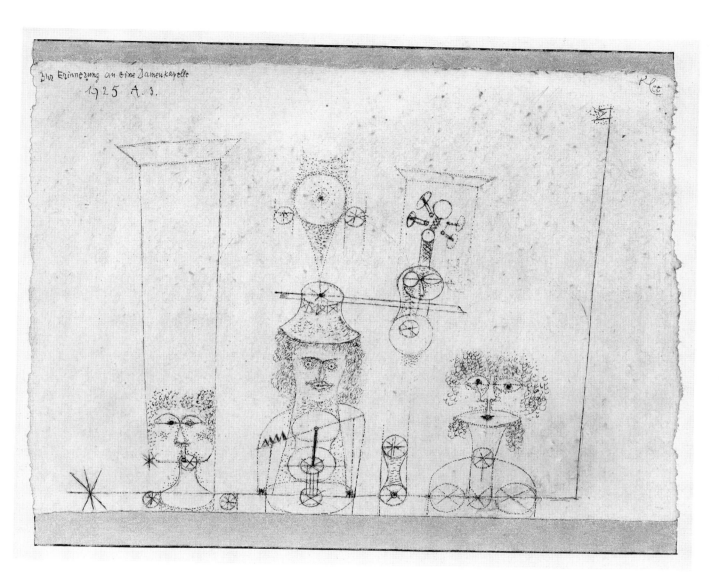

Zur Erinnerung an eine Damenkapelle
1925 A. 3.

View of a Fortress
Ansicht einer Burg
1925

Sprayed watercolor and transferred printing ink on laid paper mounted on light cardboard; 8⅝ × 14⅛″ (21.9 × 35.9 cm). Signed, in black ink (lower right): *Klee.* Dated and numbered, on the light cardboard, in black ink (lower left): *1925.7.*; titled, in black ink (lower right): *Ansicht einer Burg.* Recorded in Klee's oeuvre catalogue as: *Ansicht einer Burg.*

Sprawling over several buildings, towers, and a moat, this geometric fortress might have been forged out of thin black iron rods. Klee copied it from an earlier drawing (fig. 49), which he had executed in the latter part of 1924. At that time he was still completely under the spell of his visit to Sicily the past summer. In several letters to his wife, Lily, who was visiting Munich, he expressed his love of the island. He wrote from Weimar on November 1, 1924: "Here everyone is in feverish activity in anticipation of the great crisis about to happen in eight days. I am still so filled with Sicily that it hardly touches me."[1]

Such was Klee's infatuation with Italy that he ignored much of what was happening around him, including the "great crisis," the Bauhaus's closing in Weimar, due to political pressure, in December 1924. Some days later Klee wrote again to Lily: "I experience nothing, don't even want to. I carry the mountains and the sun of Sicily within me. Everything else is boring."[2] Filled as he was with his Sicilian experience, it is quite possible that Klee represented in this watercolor one of the medieval fortified villages that he had seen perched on mountaintops during his Sicilian visit.

1 *Briefe*, II, p. 995.

2 *Ibid.*, p. 997.

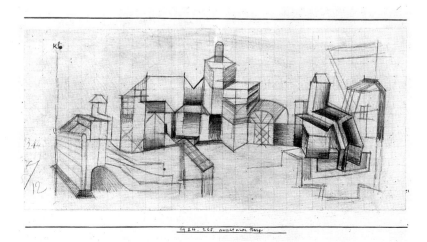

Fig. 49. Paul Klee, *Drawing for "View of a Fortress,"* 1924. Pencil and stenciled lines on graph paper mounted on light cardboard; 5⅛ × 10½″ (13 × 26.8 cm). Private collection, Bern

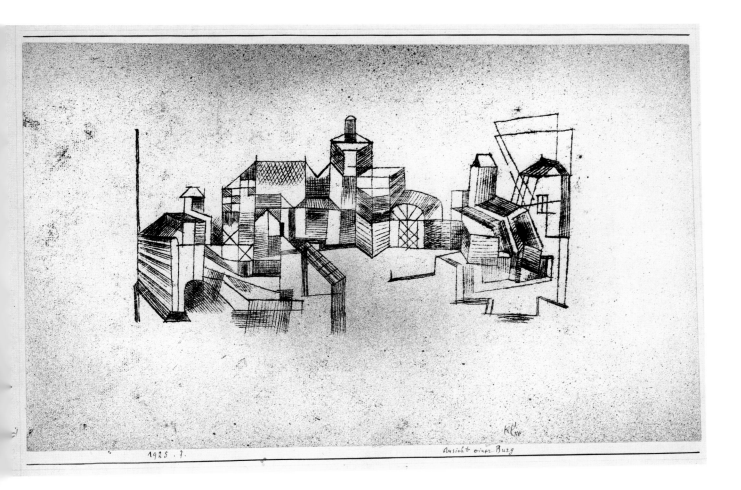

1925 . 7. Ansicht einer Burg

May Picture
Maibild
1925

Oil on cardboard; 16⅝ × 19½″ (41.6 × 49.5 cm).
Inscribed (on reverse): *1925 c.-null Maibild Klee.*
Recorded in Klee's oeuvre catalogue as: *Maibild abstract.*

Ever since its founding in Weimar in 1919, the Bauhaus had been regarded with suspicion by the National Socialists and by others in Thüringia. For example, the craftsmen's unions felt threatened by the Bauhaus workshops with their emphasis on industrial design and on modern technology. Thus, in December 1924, the Bauhaus closed its doors in Weimar under pressure. However, in the spring of 1925, the Bauhaus reopened in Dessau, where it was welcome. It was probably that spring, in May, that Klee signed and dated this painting, which he called *May Picture.* Actually, it had been completed the previous year, as it can be seen in a photograph that he took in 1924 of his Weimar studio. It sits on an easel on the far left in the photograph (fig. 50).

Close comparison of the photograph and the painting shows that, after the photograph was taken, Klee changed some of the light-colored squares in the lower right corner of the painting to the muted blue and gray ones in the final version. This work is one of Klee's Magic Square series. As mentioned earlier (see page 68), these pictures derive from the 1914 Tunisian watercolors in which he had fractured the landscape into squares. They are also related to Klee's preoccupation with the laws of color, prompted by his teaching at the Bauhaus.

The squares in this painting might be viewed as odd-shaped stones—in all the colors of the rainbow, to say nothing of various shades of gray—assembled to form an abstract mosaic.

Fig. 50. Klee's studio at the Bauhaus,
Weimar, 1924. Photograph Paul Klee.
Collection Felix Klee

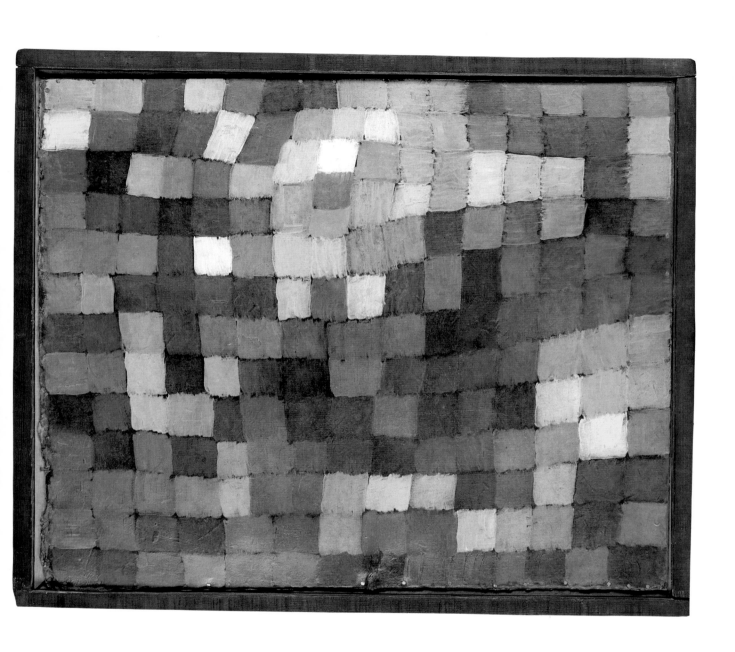

Oriental Pleasure Garden
Orientalischer Lustgarten
1925

Oil on cardboard; 15¾ × 20½″ (40 × 52 cm).
Signed, numbered, and dated, in black paint (lower
right): *Klee 1925 d 1*. Recorded in Klee's oeuvre
catalogue as: *Orientalischer Lustgarten*.

In 1925 Otto Ralfs (1892–1955), a businessman and collector from
Brunswick, formed the Klee Gesellschaft (Klee Society). For a monthly
fee of fifty Reichsmarks,[1] each of some fifteen members was entitled to
select at Christmas a watercolor by Klee. In addition, as a token for his
loyalty, each member also received a lithograph or a drawing by Klee.
This arrangement greatly benefited Klee's financial situation. It also
made possible his trip to Egypt in 1928–29, and it helped to support his
son and to pay the medical bills of his ailing wife.

 Although Klee signed and dated this painting only in 1925, it can be
seen one year earlier in a photograph that he took of his studio in
Weimar in 1924 (see fig. 50). This painting appears high on the wall on
the far left. It looked somewhat different then. Several dark spots in its
upper region, visible in the photograph, were later overpainted with
orange and yellow dots.

Fig. 51. Paul Klee, *Memory of Cairo II*,
1928. Pencil on paper mounted on light
cardboard; 8¼ × 13″ (21 × 33 cm).
Private collection

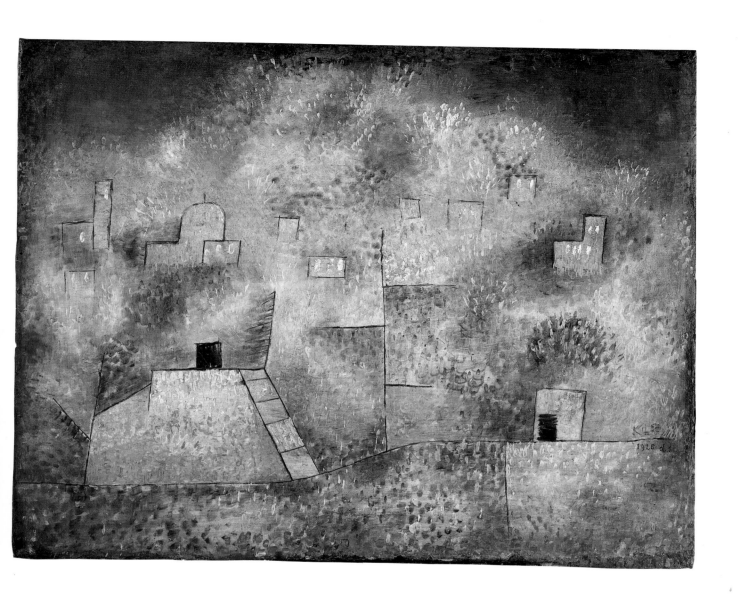

In this painting Klee evoked once again his visit to Tunisia in 1914. Just as in his related—but later—pencil drawing entitled *Memory of Cairo II*, 1928, here only a few black lines indicate the Islamic architecture (see fig. 51). In the drawing the atmosphere shimmering over the city is simulated by innumerable short, feathery pencil strokes. The brushwork of colored dots and strokes in the painting relates to this technique in style. Rather than suggesting gardens in bloom, these dots and strokes seem to illuminate the scene like sparkling fireworks.

This picture anticipates Klee's divisionist paintings by about five years (see pages 239–47).

1 Fifty Reichsmarks, about $12.50 at the time, would perhaps be equivalent to about $250.00 today.

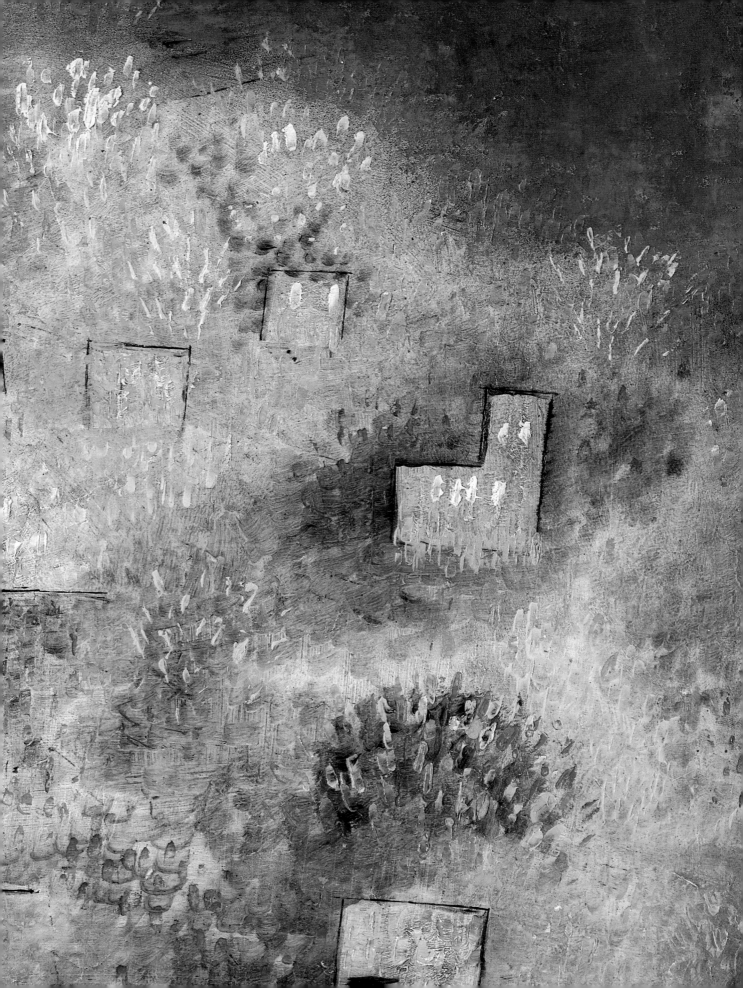

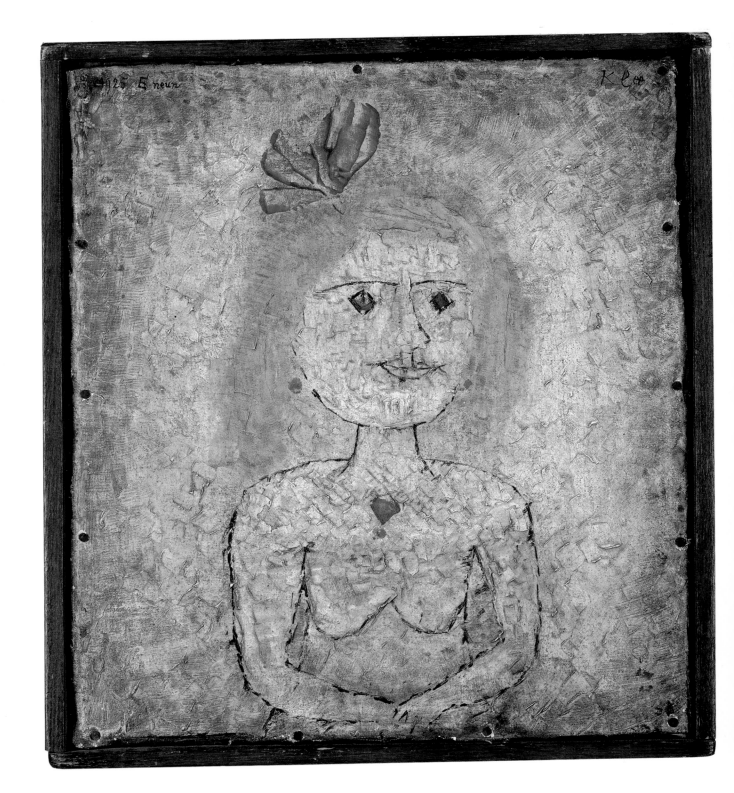

Small Portrait of a Girl in Yellow
Kleines Mädchen Bildnis in Gelb
1925

Gypsum and oil on canvas; 9½ × 8¼″ (24.1 ×
21 cm). Signed, in black paint (upper right): *Klee*;
dated and numbered, in black paint (upper left):
1925 E neun. Also inscribed (on reverse): *1925 E
neun kl Mädchen Bildnis in gelb Klee*. Recorded in
Klee's oeuvre catalogue as: *kl. Mädchenbildnis in Gelb*.

It seems doubtful that anyone actually posed for this picture because
Klee, from about 1915 onward, never worked after nature or the model.
Additionally, this painting is one in a series of at least 18 "portraits" that,
all produced in 1925, form a gallery of caricatures. They satirize men,
vicars, women, and young girls, all outfitted with strange headgear,
beards, crooked mouths, pale eyes, or red or blond hair. Some of these
"portraits"—these have initials in their titles—might refer to specific
people.

All the "portraits" except this one are on paper or cardboard, and
they are characterized by quirky, short pencil or pen-and-ink strokes.
Klee imitated this style with a speckled brush in *Small Portrait of a Girl
in Yellow*. The splendid, big red bow, stuck to the girl's head as on a gift
package, prevents her figure from being swallowed up by the dirty
monochrome pink and ocher ground. Her diamond-shaped green eyes
and round red earrings stand out against it, as does her green and red
pendant, which rests on a décolletage seemingly covered by yellow fish
scales. Not only is this area the only yellow one, to which the title refers,
but also, odder still, the girl appears naked below it.

Bird Landscape
Vogellandschaft
1925

Watercolor and transferred printing ink on laid paper
mounted on light cardboard; 12⅝ × 19″ (32.1 ×
48.3 cm). Signed, in black ink (lower left): *Klee*.
Inscribed, on the light cardboard, in black ink:
1925 "U neun" Vogellandschaft. Watermark: swirled
monogram, *FRANCE*. Recorded in Klee's oeuvre catalogue
as: *Vogellandschaft*.

When the Bauhaus moved to Dessau in the spring of 1925, Klee com-
muted every other week from his home in Weimar to his classes in
Dessau. There he lived in a room he rented from his Bauhaus colleague
Wassily Kandinsky in the latter's flat at Moltkestrasse 7. From July 1926
on, they shared a house at Bergkühner Allee 6–7, one of the three
houses that Gropius had built for the Bauhaus form masters.[1]

Klee had a busy schedule. As he told his parents in a brief note on
June 26, 1925: "Best wishes from the new place where I started my
classes. I live a life of shuttling to and fro, one week Weimar, one week
Dessau."[2] Dessau is a two-hour train ride or 80 miles north of Weimar.

Klee copied this watercolor from a drawing entitled *Travel Bird*,
1925 (fig. 52). This term is jokingly applied in Germany to someone who
travels a lot, and thus the title might be an allusion to Klee's own way of
life at that time. Be that as it may, the traveling bird and its bird's-eye
view of the landscape, seen from high up on a telegraph wire in the
drawing, all but disappear behind the feathery pink clouds in this water-
color. Perhaps this accounts for the change of title.

1 The two other houses were shared by
László Moholy-Nagy/Lyonel Feininger and
by Georg Muche/Oskar Schlemmer. Walter
Gropius lived in a single house. The name
of the Bergkühner Allee was later changed
to Stresemann Allee. This information
comes from Felix Klee, *Paul Klee: His Life
and Work in Documents*, translated by
Richard and Clara Winston (New York:
George Braziller, 1962), p. 55.

2 *Briefe*, II, p. 1,000.

Fig. 52. Paul Klee, *Travel Bird*, 1925.
Pen and ink on paper mounted on light
cardboard; 4½ × 8¾″ (10.8 × 22.2 cm).
Private collection

1925 Uani Vogel Landschaft

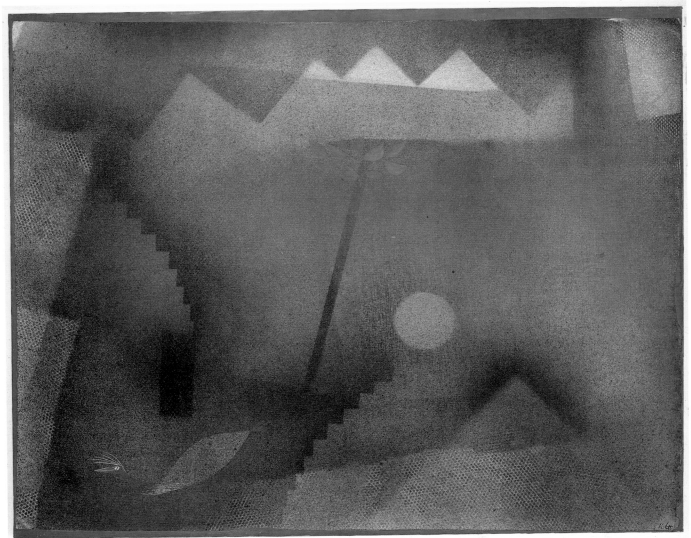

1926 V 8 abwandernder Vogel K. Gtt

Bird Wandering Off
Abwandernder Vogel
1926

Sprayed (with masks) and brushed gouache on wove
paper bordered with gray gouache mounted on light
cardboard; 14¾ × 18⅝″ (37.5 × 47.3 cm). Signed,
in black ink (lower right): *Klee*. Inscribed, on the
light cardboard, in black ink: *1926 V.8. abwandernder
Vogel*. Recorded in Klee's oeuvre catalogue as:
abwandernder Vogel.

Klee's birds do not fly, at least not those in The Berggruen Klee Collection. They either fall from the sky (see page 98) or, as here, wander off somewhere. In this picture an elegant bird with long thin red legs stalks down steep steps.

Both *Bird Wandering Off* and its companion, *View of a Landscape*, 1926 (fig. 53), are related to an earlier work entitled *Mountains in Winter* (fig. 54), painted in 1925, in which mountains and a moon or sun appear as if seen in a fog. Was Klee reminiscing in these pictures—and if so, what regions were evoked in this dreamworld that forms the background of all three? The mountains are perhaps the Alps that rise one hour's travel south of Munich, an area Klee crossed several times in 1924 and again in 1926 on his way to and from Italy.

These three pictures look like the negatives of color photographs. Klee created this effect by placing variously shaped forms on an absorbent ground and, using these forms as stencils, by spraying watercolor over them. He probably knew Man Ray's Aerograph pictures (1919), in which the American Dadaist similarly "blew" forms with a spray gun onto a sheet of paper. Klee adopted this spray method while at the Bauhaus in 1924. It is one more example of his never-ending readiness to adopt or invent new techniques.

BELOW LEFT
Fig. 53. Paul Klee, *View of a Landscape*,
1926. Gouache and air brush on paper
mounted on light cardboard; 11¾ × 19⅛″
(29.8 × 46.3 cm). Louise and Walter
Arensberg Collection, Philadelphia Museum of Art, Philadelphia

BELOW
Fig. 54. Paul Klee, *Mountains in Winter*,
1925. Sprayed gouache on paper mounted
on light cardboard; 11¼ × 14⅝″
(28.7 × 37 cm). Hermann und Margrit
Rupf Stiftung, Kunstmuseum Bern

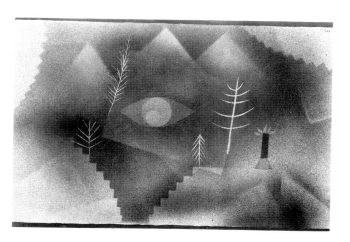

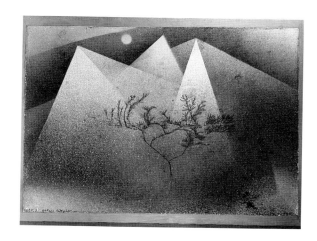

Collection of Figurines
Figurinen Sammlung
1926

Oil on canvas, 10⅜ × 9⅝″ (26.4 × 24.4 cm).
Signed, in orange paint (upper right): *Klee 26
Y 8.* Recorded in Klee's oeuvre catalogue as:
Figurinensam̄lung.

The Bauhaus celebrated the inauguration of its new school building,
designed by Walter Gropius, in Dessau on December 4 and 5, 1926.
Klee, who was always rather detached about what was happening
around him, wrote from Dessau to his wife, Lily, who was visiting
Munich, on November 3, 1926: "The Bauhaus prepares the inaugura-
tion of the new school building, thank God, I have little to do with it."[1]
On November 14 he wrote to her: "I start to slip back into the daily
round. The visit to Italy [September 6—October 18] now, in a distant
glow, quite belongs to the past. That is good, because otherwise, in this
contrastingly 'pleasureless' place, one would just start thinking along
'pleasureless' lines. It would be useless. It is better to just work and to let
an ideal reality slowly emerge. I have started my classes, it was with a
desperate effort that I dragged myself over to the new building, and
when I stood in front of the class, I just pulled myself together and did
my best."[2] By 1926 Klee had become somewhat weary of the Bauhaus.

During the last days of 1926 Klee painted this small picture.[3] Its
large and simply drawn forms render it quite monumental in reproduc-
tion. Klee used only hues of primary colors for these figures, vessels, and
other objects of primitive design. The colors fuse into each other inde-
pendently of the contours. Exactly in the center of the composition, Klee
linked the three figurines by their mouths and eyes: the thick-lipped
mouth of what might be a chess figure of a king or an African mask, the
eye-shaped body of a long-legged figure—perhaps the chess figure of a
pawn—and the pair of eyes of a bird. Like so many of Klee's birds, this
one seems to come hurtling down to a fatal crash.

1 *Briefe*, II, p. 1,013.

2 *Ibid.*, p. 1,016.

3 Klee's oeuvre catalogue for 1926 lists
250 items (watercolors, drawings, and
paintings). This painting is no. 248.

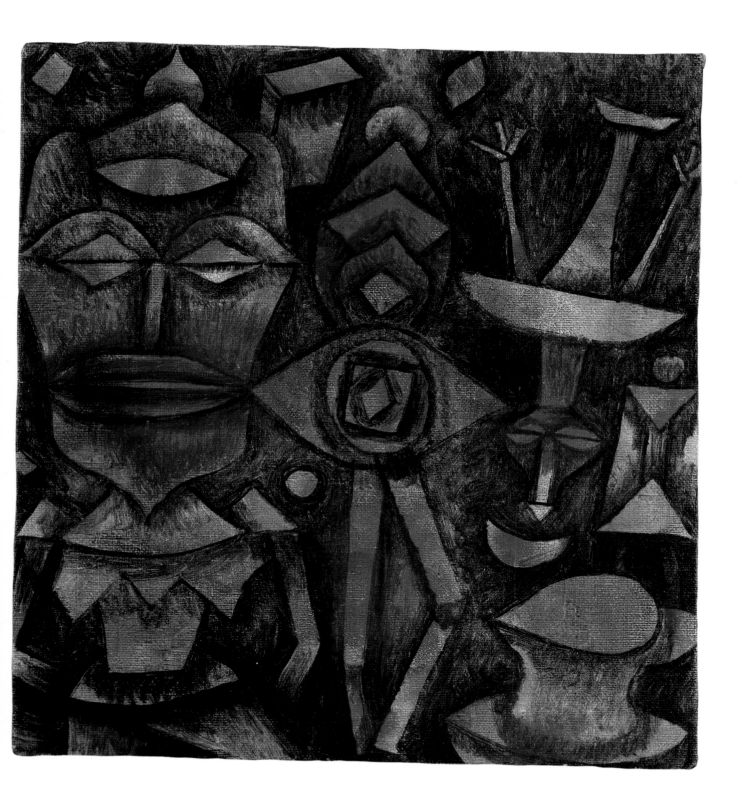

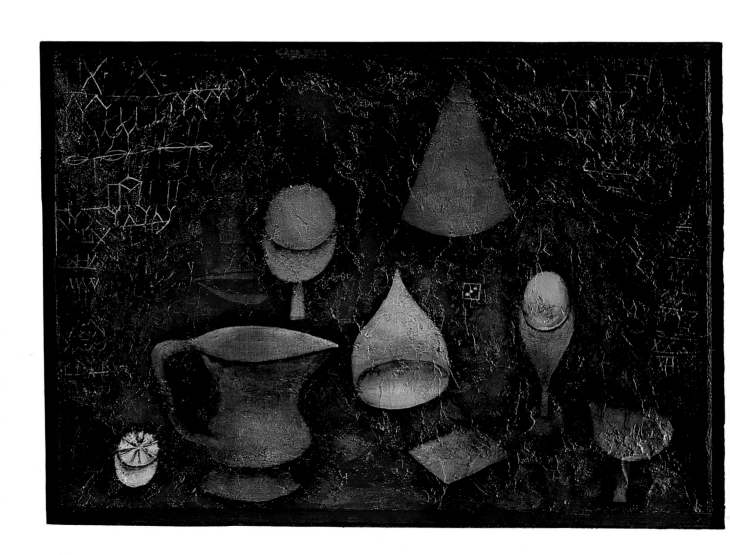

Still Life
Stilleben
1927

Oil on gypsum construction; 18⅞ × 25¼"
(47.9 × 64.1 cm). Signed, dated, and numbered, in red
paint, on the stretcher (upper left): *Klee 1927 K 8*.
Recorded in Klee's oeuvre catalogue as: *Stilleben
(Töpfe, Frucht, Osterei, Gardinen etc.)* [Still
Life (Jars, Fruit, Easter Egg, Curtains etc.)].

Klee must have liked this work because, as he did in such cases, he
underlined its title when he recorded it in his work catalogue. As in a
playful exercise to show that "less is more," Klee simplified forms and
used only primary colors and their complementaries. The cone, goblet,
half lemon, pitcher, cut onion, piece of paper, Easter egg and cup, and
chalice and dice showing the figure three are arranged equally distant
from each other as upon a stage. The painted pattern of the lacy curtains
seems incised with a sharp instrument into the uneven, dark red, crusty
surface. One might be looking at a picture painted on mat stone. In fact,
Klee painted this work on a thick slab of gypsum that he had reinforced
with chicken wire and then encased in a deep wooden frame.

Still Life once belonged to Galka E. Scheyer (1889–1945), a former
German art student and pupil of Alexei von Jawlensky, who had become
an art enthusiast. In 1924 she had been instrumental in founding the
group called *Die Blaue Vier* (*The Blue Four*), comprising Feininger,
Jawlensky, Kandinsky, and Klee. Its purpose was to widen the audience
for these artists abroad, especially in the United States, to which Scheyer
traveled in May 1924 with a collection of their paintings and watercolors.
She lived in California until her death, actively promoting their work
through lectures, exhibitions, and sales.

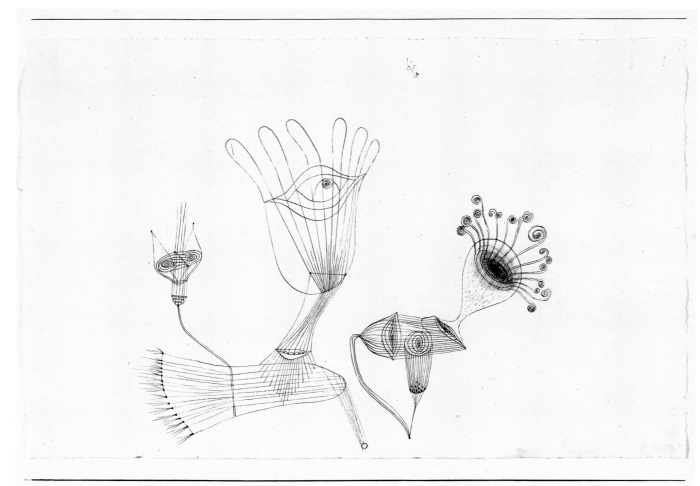

1927 No 18. unter Wasser

Under Water

Unter Wasser

1927

Pen and black ink on laid paper mounted on light
cardboard; 11¾ × 17¾″ (30.2 × 45.1 cm). Signed,
in black ink (top center): *Klee*. Dated and numbered,
on the light cardboard, in black ink (lower left):
1927 Oe. 10.; titled (lower right): *unter Wasser*.
Recorded in Klee's oeuvre catalogue as: *Flora (unter
Wasser)*.

While vacationing on the French island of Porquerolles, Klee wrote to
his wife, Lily, on August 6, 1927: "I went swimming nearly every day, it
is very amusing, one sees crabs, sea anemones, hermit-crabs, pretty
snails and tiny ones, underwater flora and above water flora, simply
wonderful."[1] The island lies only a short distance from the coast south-
east of Toulon. Klee remained there from the end of July until mid-
August, when he proceeded to Corsica. He liked Porquerolles's climate
and its colors, and he patiently suffered both the many "little people"
who crowded his *pension* and the island's mediocre food, which he did
not find up to the standards of Italian cuisine. "The natives are nice and
friendly. The 'little people' who stay in this *pension* are rather odd, as
those people always are, but they are less offensive than those in Ger-
many. Only the waiters and the chambermaids are really fine, but, alas,
they are the ones who have to wait on the others."[2]

 At the beginning of September Klee returned to Dessau. As so often
happened, his impressions of the exotic and colorful places he had vis-
ited that summer lingered on in his mind. These impressions included
those formed during his dips in the water at Porquerolles, where the
flora, both under and above the water, had so enchanted him. During
the next few months, Klee executed a group of fourteen pen-and-ink
drawings with undulating botanical forms that seem spun out of thin
threads and, in this drawing, suggest jellyfish. Even though he referred
variously to the forms in these works as "fruits," "blossoms," "flowers,"
"seeds," and "bouquets," they are a kind of flora that grows only in
Klee's universe.

1 *Briefe*, I, p. 1,058.

2 *Ibid.*, pp. 1,055–56.

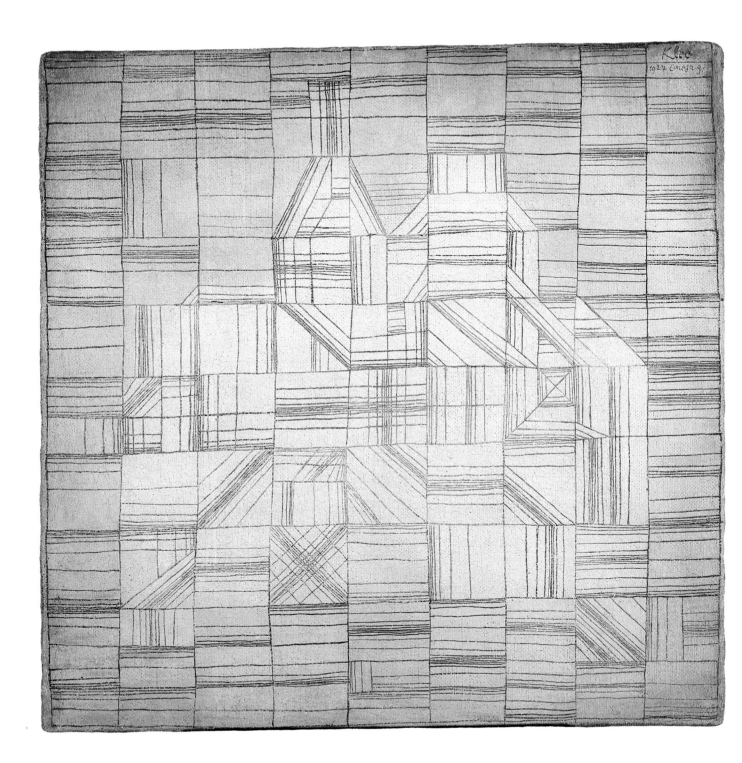

Variations (Progressive Motif)
Variationen (Progressives Motiv)
1927

Oil and watercolor on canvas; 16 × 15¾" (40.6 ×
39.4 cm). Signed, dated, and numbered, in
black paint (upper right): *Klee 1927 Omega 9*.
Recorded in Klee's oeuvre catalogue as: *Variationen
(progressives Motiv)*.

Klee gridded this small canvas in such a way that the design looks like
slightly irregular graph paper or a pattern of parquetry boards. Due to a
variation in the same motif—horizontally striped, light blue squares on
the outside versus ivory-shaded ones with diagonal and crisscross lines
toward the center—there emerges a subtly patterned image that antici-
pates Minimalist painting by about forty years. As in the related drawing,
Architecture by Variations, 1927 (fig. 55), Klee created an architectural
structure that looks like tracery, in this case seemingly seen against a
pale blue sky.

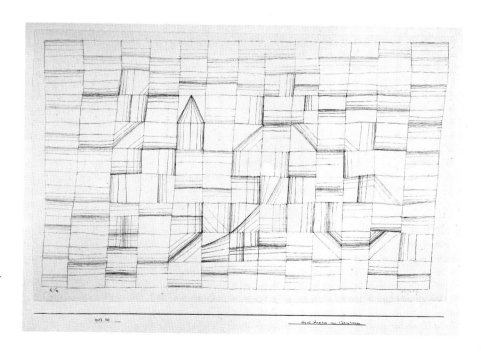

Fig. 55. Paul Klee, *Architecture by Vari-
ations*, 1927. Ink on paper mounted on
light cardboard; 13¾ × 20⅞"
(35 × 53 cm). Paul Klee Stiftung,
Kunstmuseum Bern

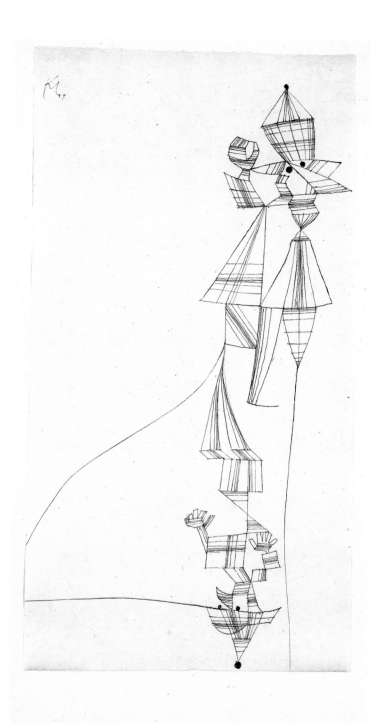

1927 311 figurinen invalider Helden

Statuettes of Disabled War Heroes
Figurinen invalider Helden
1927

Pen and black ink on laid paper mounted on light cardboard; 10½ × 5⅜″ (26.7 × 13.7 cm). Signed, in black ink (upper left): *Klee.* Inscribed, on the light cardboard, in black ink: *1927 311 figurinen invalider Helden.* Recorded in Klee's oeuvre catalogue as: *figurinen invalider Helden.*

This work belongs to a group of three ink drawings that depict various stick figures that seem made out of thin black wire. Their pattern of parallel or crisscross lines is similar to the one Klee used in *Variations,* painted the same year (see page 220). *Statuette of One Who Staggers,* 1927 (fig. 56), shows a hurly-burly man with a top hat and a large mustache swinging to and fro. This work, which looks like an asymmetrical playing card, and *Statuette of a One-Armed Officer,* 1927 (fig. 57), represent whimsical, birdlike creatures missing arms or legs, probably lost in some battle.

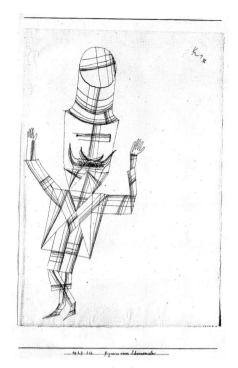

Fig. 56. Paul Klee, *Statuette of One Who Staggers,* 1927. Pen and ink on paper mounted on light cardboard; 14½ × 9¼″ (36.9 × 23.5 cm). Private collection

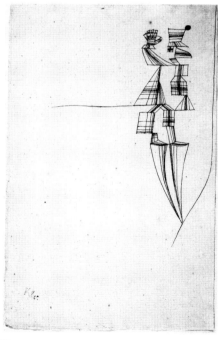

Fig. 57. Paul Klee, *Statuette of a One-Armed Officer,* 1927. Pen and ink on paper mounted on light cardboard; 10½ × 6⅝″ (26.6 × 16.9 cm). Sprengel Museum, Hannover

Monuments at G.
Denkmäler bei G.
1929

Gypsum and watercolor on canvas; 27⅜ × 19¾"
(69.5 × 50.2 cm). Signed and dated, in black ink
(upper right): *Klee 1929*. Signed and titled (on
the reverse): *DENKMÄLER BEI G. - Klee*. Recorded
in Klee's oeuvre catalogue as: *Denkmäler bei G.*

December 26, 1928: "Giza in the morning. Then I ate a small pigeon."[1]
So reads Klee's pocket diary for that day. The artist visited Egypt from
December 24, 1928, until January 10, 1929, staying seven days in Cairo
and the rest of the time in Luxor and Aswân. On December 26, the day
after Christmas, Klee also wrote to his wife, Lily: "Arabic culture is old.
But anybody expecting rich sounds and fine patinas gets it all wrong.
Dirt, sickness and again dirt make up this nation. Horrible poverty
clashes with the richness of the country and that of certain castes; there
exists no sense of time, of initiative, or sense of responsibility. Is this still
the high culture which expressed itself in art? Can it be that the descen-

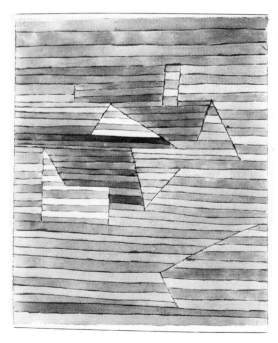

Fig. 58. Paul Klee, *Oasis KSR*, 1929.
Watercolor on paper mounted on light
cardboard; 12 × 9⅝" (30.5 × 24.5 cm).
Private collection, Bern

Fig. 59. The pyramids at Giza, Egypt.
Photograph Roger-Viollet, Paris

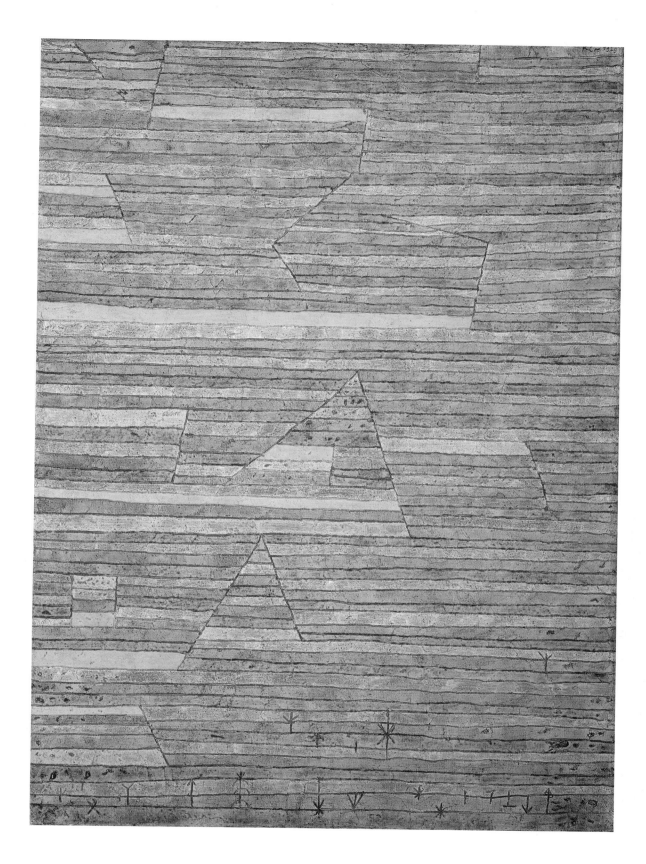

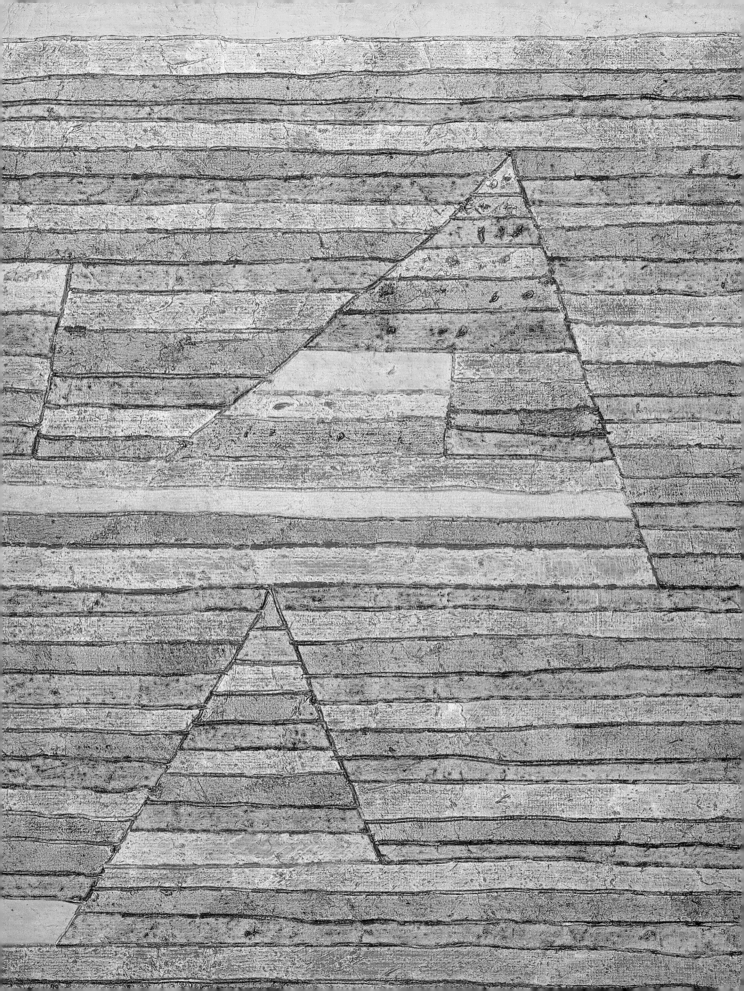

dants of a high culture consist of just a bunch of bandits who can behave more wildly than the Bavarians? I returned from my first visit to Tunisia in 1914 with different impressions and am convinced that Tunisia is purer. The mosques of Kairouan show, indeed, that Tunisia was always purer. In comparison the Cairo mosques are kitsch, practically all of them, even the ones with **. On the other hand, the whole confusion here of Europe—Orient—Africa is simply stupefying in its magnificence."[2]

Shortly after his return from Egypt to Dessau in 1929, Klee painted a group of four small watercolors (see fig. 58) with motifs similar to those in this painting. Thin horizontal stripes cover the entire surface from edge to edge and from top to bottom with here and there vertical or diagonal lines and acute or wide angles interrupting their flow and coloring. The latter denote dunes, shifts in altitude, or architectural accents in a desert that stretches monotonously toward infinity.

In *Monuments at G.*, painted a few weeks after this group of North African watercolors, the two sharp angles probably represent two of the three pyramids at Giza (dating from 2900–2750 B.C.). At the time of Klee's visit, the small provincial town of Giza, which lies southeast of Cairo, was only an hour away by electric tram from the Egyptian capital. Although Klee did not mention it in his letters, he might have climbed to the top of Giza's highest pyramid, the Pyramid of Cheops. As Baedeker tells us, it is from there that one has a striking view: "desolation . . . yellowish brown tracts of sand . . . barren cliffs . . . ," "the two huge colorless monuments," and the Sphinx toward the west, south, and northwest, contrasted, toward the east, by "rich arable land," the "glittering river," and "luxurious blue-green vegetation."[3]

This painting was for many years in the collection of Mies van der Rohe, the architect and director of the Dessau and the Berlin Bauhaus from 1930 to 1933.

1 *Briefe*, II, p. 1,080.

2 *Ibid.*, p. 1,074. **refer to two stars in Karl Baedeker's travel guide *Egypt and the Sudan* (Leipzig: Karl Baedeker, 1914), the first German edition of which dates from 1897. Klee used this edition or a later one.

3 Karl Baedeker, *Egypt and the Sudan* (Leipzig: Karl Baedeker, 1914), p. 129.

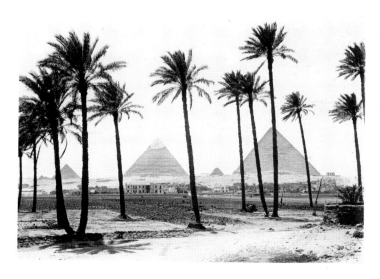

Fig. 60. The pyramids at Giza, Egypt.
Photograph Roger-Viollet, Paris

227

Great Hall for Singers
Sängerhalle
1930

Watercolor and gouache on gesso on laid paper mounted on light cardboard; 10¾ × 18⅞" (27.3 × 47.9 cm). Signed, in black ink (upper right): *Klee*. Dated and numbered, on the light cardboard, in black ink (lower left): *1930 C. 9.*; in pencil (lower left): *S.Cl.* and *IX*; titled in black ink (lower right): *Sängerhalle*. Recorded in Klee's oeuvre catalogue as: *Sängerhalle*.

In Dessau on April 18, 1930, Klee playfully asked: "What do I prefer? to be an artist who exhibits internationally but does not sell, or to show only in my native city and sell?"[1] He posed this question after a New York exhibition at J. B. Neumann's gallery, New Art Circle, in January 1930 had produced no sales. Matters picked up later during the year, however, when his works sold in Hollywood, in Paris, in Düsseldorf, and even in New York.[2]

The years 1928 to 1930 were eventful ones for Klee. In 1928 the architects Walter Gropius and Marcel Breuer and the designer Herbert Bayer resigned from the Bauhaus. Hannes Meyer became its new director until 1930, when he was replaced by Mies van der Rohe.[3] In 1929 Klee celebrated his fiftieth birthday. In March he contacted the Staatliche Kunstakademie Düsseldorf (Düsseldorf Academy) about obtaining a teaching position. In 1930 Klee gave a year's notice of his intention to

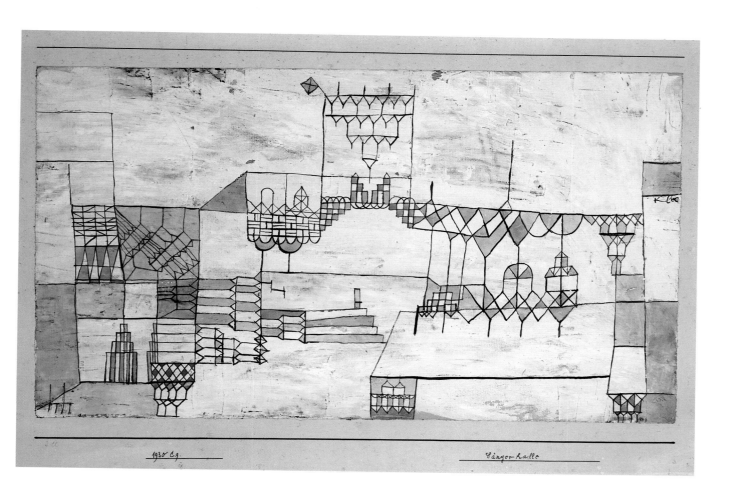

1930 Cg. Sänger-halle

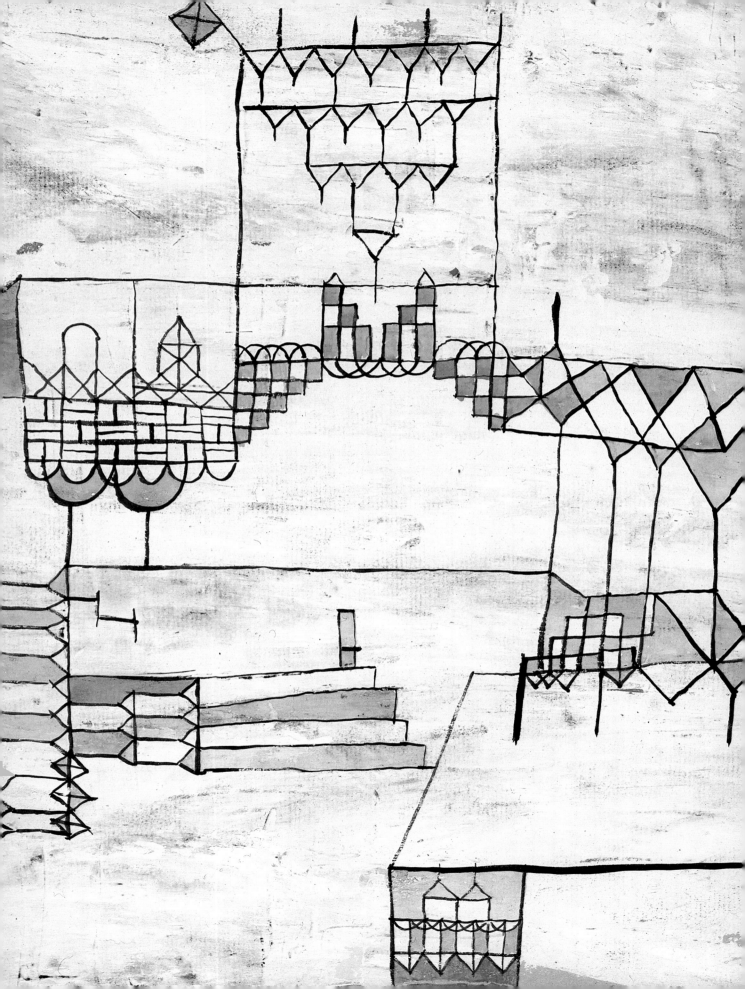

leave the Bauhaus as of April 1931. Lily Klee spent the months between March and October 1930 in a sanatorium in Lucerne. During this time, as during their six-year courtship, one can learn much about Klee's daily life from his frequent and so often facetious letters to his wife. In one letter he complained that although he painted with his left hand, he could not write with it. So he had to use his right one, which he disliked.[4] In September 1930 the Bauhaus closed for two months due to the opposition of many students to Hannes Meyer's summary dismissal. Klee was relieved of his lectures and could devote himself completely to his work; he was rather delighted by the turn of events.

The title of this watercolor somewhat misleadingly conjures up medieval singing competitions à la Richard Wagner's *Die Meistersinger von Nürnberg* (1862–67). It is painted in a lacework line that frequently appears in Klee's pictures of gardens, landscapes, and architectural structures (see pages 186 and 251). It rather reminds one of the colorful cabins, piers, and graceful little pavilions that clutter the six-mile-long coastline between Viareggio and Forte dei Marmi on the Ligurian coast of Italy. Klee had commented upon them during his stay at Viareggio during the last ten days of August 1930. He had been impressed and enchanted by the elegance and "modishness" of the large bathing resort of Viareggio, which lies about fifteen miles northwest of Pisa. The top of its famous tower, though here it does not lean, might be the one in the lower left of Klee's watercolor.

1 *Briefe*, II, p. 1114.

2 Apparently, Galka Scheyer sold several Klees from the exhibition she organized of the Blue Four at the Braxton Gallery, Hollywood (March 1–15, 1930), as did Alfred Flechtheim in Düsseldorf after the Klee show at his gallery (February 15–March 10, 1930). On July 1, Klee wrote to his wife that J. B. Neumann had sold some of his works in New York and that two of his watercolors had found a buyer in Paris. See *Briefe*, II, pp. 1125, 1132.

3 Meyer was the father of Livia Meyer, who in 1982 became the second wife of Klee's son, Felix.

4 *Briefe*, II, 1105.

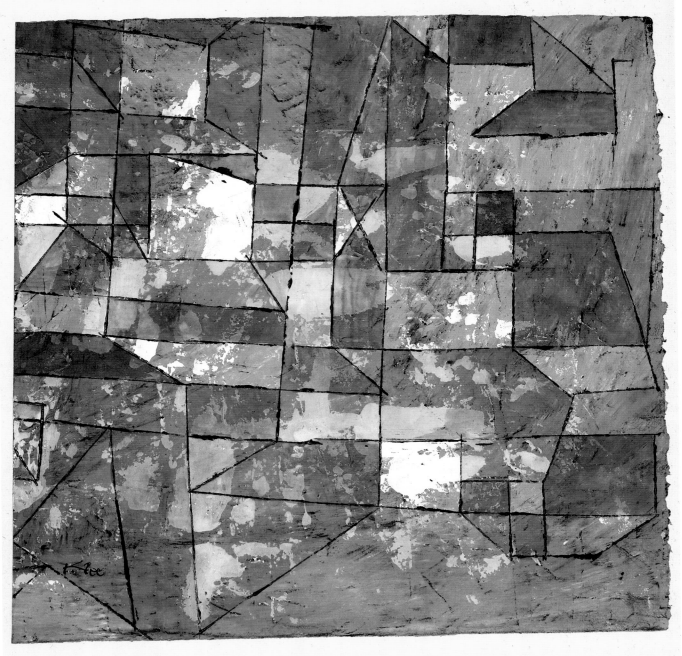

CLV

1930 C. 10 Norddeutsche Stadt

North German City
Norddeutsche Stadt
1930

Gouache and watercolor on gesso on wove paper mounted on light cardboard; 12⅞ × 13¼" (32.7 × 33.7 cm). Signed, in black ink (lower left): *Klee*. Dated and numbered, on the light cardboard, in black ink (lower left): *1930 C. 10*; in pencil (lower left): *Cl. V*; titled, in black ink (lower right): *Norddeutsche Stadt*. Recorded in Klee's oeuvre catalogue as: *norddeutsche Stadt*.

Klee signed and dated this watercolor and the preceding one, *Great Hall for Singers* (see page 229), at exactly the same time in 1930. How do we know? Because the inventory numbers of both works follow in exact sequence. Between the two pictures occurred a switch in mood from airy southern out-of-doors to overcast northern metropolis. Because Klee particularly experimented in this picture with watercolor, it seems worthwhile to describe his method. He coated the entire sheet with a buff-colored gesso containing undissolved pockets of black pigment. To this ground he then applied drips and spatters of white gesso. While the gesso was still damp, he drew on it, with a pen, the black lines of the geometric design that he then filled with pink, yellow, violet, and gray watercolor. He left some areas uncovered, such as those that still show the white spatters of gouache and the underlying buff-colored gesso.[1] The result is a speckled look that suggests peeling paint, grime, and the wear and tear of stone walls, asphalt streets, and roof tiles.

When Klee was a resident of Munich (1898–1901 and 1906–21), he rarely ventured north. Only after 1925, when the Bauhaus moved to Dessau, about seventy miles southwest of Berlin, did Klee often visit the Prussian capital to see exhibitions and friends and to buy materials. As he mentioned in a letter, the trip to Berlin gave him that "little push" that might inspire "one or the other good picture."[2]

1 Margaret Holben Ellis, Consulting Conservator of Prints and Drawings, The Metropolitan Museum of Art, provided this technical information.

2 *Briefe*, II, p. 1,100.

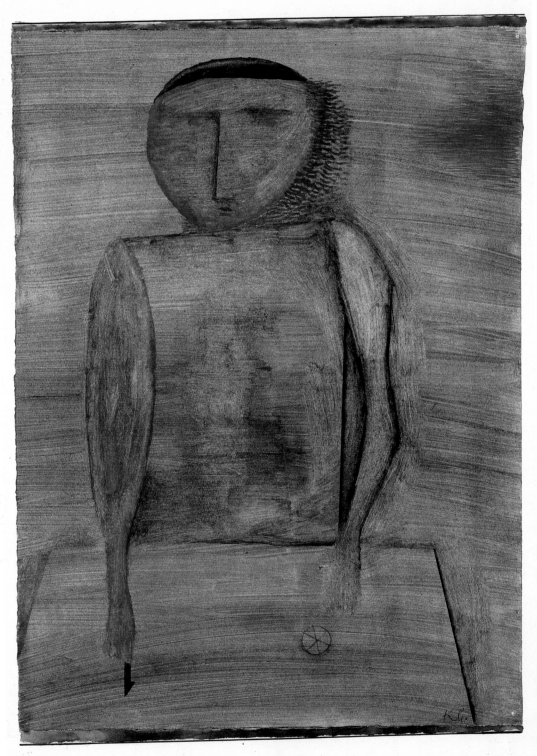

1930 F. 4 Doctor

Doctor
Doktor
1930

Watercolor, gouache, and oil wash on wove paper bordered with brown and gray gouache and black ink mounted on light cardboard; 19⅛ × 13⅛" (48.6 × 33.3 cm). Signed, in black ink (lower right): *Klee*. Inscribed, on the light cardboard, in black ink: *1930 F. 4 Doctor*; in pencil (lower left): *V*. Recorded in Klee's oeuvre catalogue as: *Doctor*.

Does Klee look upon his doctor with sympathy or dislike? This work is one of a series of three watercolors done at the same time that represent large and bulky figures (figs. 61 and 62). About 1930 Klee began working on a larger scale. As he humorously wrote to his son, Felix, who was then an aspiring stage director in Breslau: "I paint pictures, but there is not enough light to tell if they are really any good. It must be like this during a mild December at the North Pole. So that one can see them more clearly, I make them larger. And now a magnifying glass becomes obsolete."[1]

A rather unpleasant brownish sauce seems to cover the figure, the table, and the background in the *Doctor*. A black skullcap sits on an expressionless big red face with a large nose and a tiny mouth. An unshaven beard, or perhaps dark hair, flutters off the left cheek.

Black arrows pointing down always convey something ominous in Klee's oeuvre. Perhaps they are a reminiscence of his service in the German Army during World War I when he was posted to a flying school where aspiring pilots often crashed to their death. Here, placed at the end of the doctor's mangled and misshapen red arm, a black arrow sliced lengthwise suggests a scalpel. And what is the round object on the table? Probably a pill.

1 *Briefe*, II, p. 1,115.

Fig. 61. Paul Klee, *The Roll*, 1930. Watercolor with parts of gesso on paper mounted on light cardboard; 14⅛ × 10⅝" (36 × 27 cm). Private collection

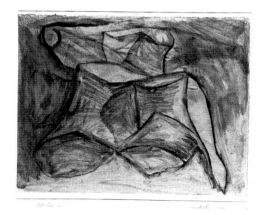

Fig. 62. Paul Klee, *Job*, 1930. Watercolor with parts of gesso on paper mounted on light cardboard; 14⅞ × 18¾" (37.7 × 47.7 cm). Private collection, Bern

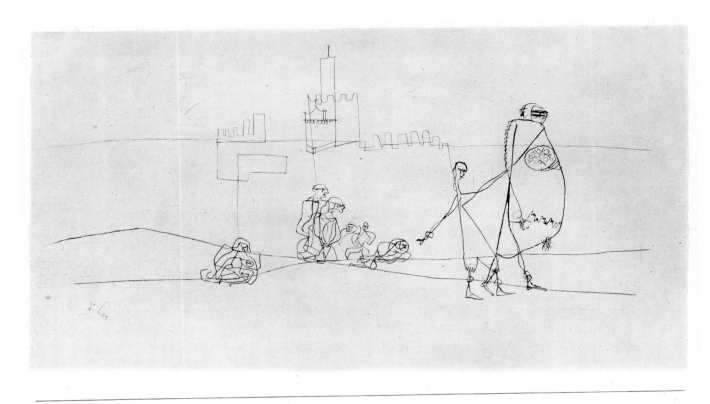

1931 K 8 Scene B aus Kairuan (Nachzeichnung)

Episode B at Kairouan

Szene B aus Kairuan

1931

Pen and blue, brown, and black ink on laid paper
mounted on light cardboard; 11⅞ × 22¼″ (30.2 ×
56.5 cm). Signed, in blue ink (lower left): *Klee*.
Inscribed, on the light cardboard, in black ink:
1931 K 8 Scene B aus Kairuan (nach Zeichng. v. 1914).
Recorded in Klee's oeuvre catalogue as: *Scene B aus
Kairuan (nach Zchg. 1914)* [Scene B at Kairouan
(after a drawing of 1914)].

This drawing forms the last work in The Berggruen Klee Collection that
deals with the artist's trip to Tunisia in 1914. Kairouan certainly made a
lasting impression on Klee. He had visited the little town that lies about
80 miles south of Tunis from April 15 to 17, 1914, during his two-week-
long visit to Tunisia. Then, six years after that visit, and again three after
that, he copied in mirror-image two watercolors—*Episode at Kairouan*,
1920 (see page 106) and *Episode Before an Arab Town*, 1923 (see page
171)—from a pencil drawing that he had executed on site in 1914 (see fig.
17). For this picture, painted in 1931, seventeen years after his visit to
Kairouan, he pulled out his original drawing once again. However, Klee
did not want to copy it, but rather to use it as a model for this larger and
somewhat freely adapted work.

This drawing is again a mirror-image of the 1914 original. The
architecture remains the same, but the figures of the group of people in
the background appear more defined. Klee also added bits of color. Fine
green lines trace the figure of the powerful woman dragging a child on
the right, and green and red squiggles enliven the bouquet of flowers
stuck on the woman's bulky figure.

In the same year, 1931, Klee invoked Kairouan in yet another
work—also after a 1914 original drawing—entitled *Scene A at Kairouan
(After a Drawing of 1914)* (fig. 63). There was good reason indeed why
Kairouan should have had such a special meaning to Klee. Not only had
he chosen this spot for his famous words: "Color and I are one. I am a
painter," but also, in 1921, Wilhelm Hausenstein's book on Klee, bear-
ing the evocative title *Kairuan oder eine Geschichte vom Maler Klee und
von der Kunst dieses Zeitalters (Kairuan or A Tale of the Painter Klee and
the Art of This Century)*, was published. His life, up to his climactic visit
to Kairouan, was herein narrated in the style of a poetic, if factual, fairy
tale, much to Klee's delight.

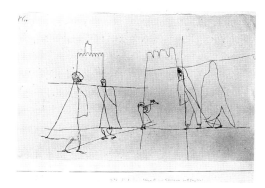

Fig. 63. Paul Klee, *Scene A at Kairouan
(After a Drawing of 1914)*, 1931. Pen and
ink on paper mounted on light cardboard;
11¾ × 18⅞″ (30 × 48 cm). Private
collection

Boy in Fancy Dress
Kostümierter Knabe
1931

Gouache and watercolor on laid paper mounted on light cardboard; 23½ × 17¾" (59.7 × 45.1 cm). Signed, in black ink (upper left): *Klee*. Dated and numbered, on the light cardboard, in brown ink (lower left): *1931 W. 6.*; in pencil (lower left): *VII*; titled, in brown ink (lower right): *Costümierter Knabe*. Recorded in Klee's oeuvre catalogue as: *costümierter Knabe*.

On April 1, 1931, Klee's contract with the Bauhaus in Dessau formally expired. In October he started to teach at the Düsseldorf Academy. His class, on the technique of painting, was small: "At the moment, I have four pupils, but not everybody needs to know that."[1]

Klee felt much at ease in Düsseldorf. "Life here is easy and friendly."[2] He also commented in his letters to his wife, Lily, on the relative cheerfulness of the people he saw on the streets. Klee rented rooms from a widow at Goltsteinstrasse 5. For the next two years he commuted every two weeks between Düsseldorf and his house in Dessau, keeping studios in both cities. According to his son, Felix, Klee worked in Dessau in a more "severe, constructive style" and in Düsseldorf in a "pointillistic, loose mosaic style."[3] Klee's merry "Pointillism" was different from the method of Georges Seurat and his followers, who broke down the imagery of their paintings into tiny dots of pure color. Klee's works, rather, seem "built up" with row upon row of blocklike units of colors chosen without regard to optical laws.

Klee practically lived in his studio at the Academy in Düsseldorf, working there from 8 A.M. to 8 P.M., except on Sundays, when the building was not heated. His studio was known for its delicious odors because Klee, who was a gourmet, prepared fine and elaborate meals on his two small spirit stoves.

This watercolor was painted in Klee's Düsseldorf studio. The odd little creature with a large head and tiny feet distantly evokes Oskar Schlemmer's costumes for the lifesize puppets in his *Triadic Ballet* (1922). This creature leans on a table that is supported by only one leg (see fig. 64, which shows the later and smaller version, *Boy at a Table*,

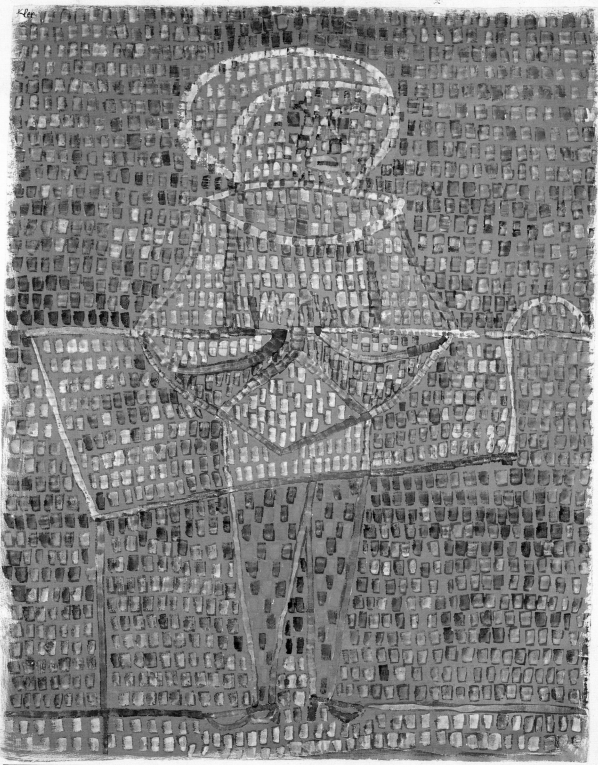

Klee

VII 1931 W.6. Costümierter Knabe

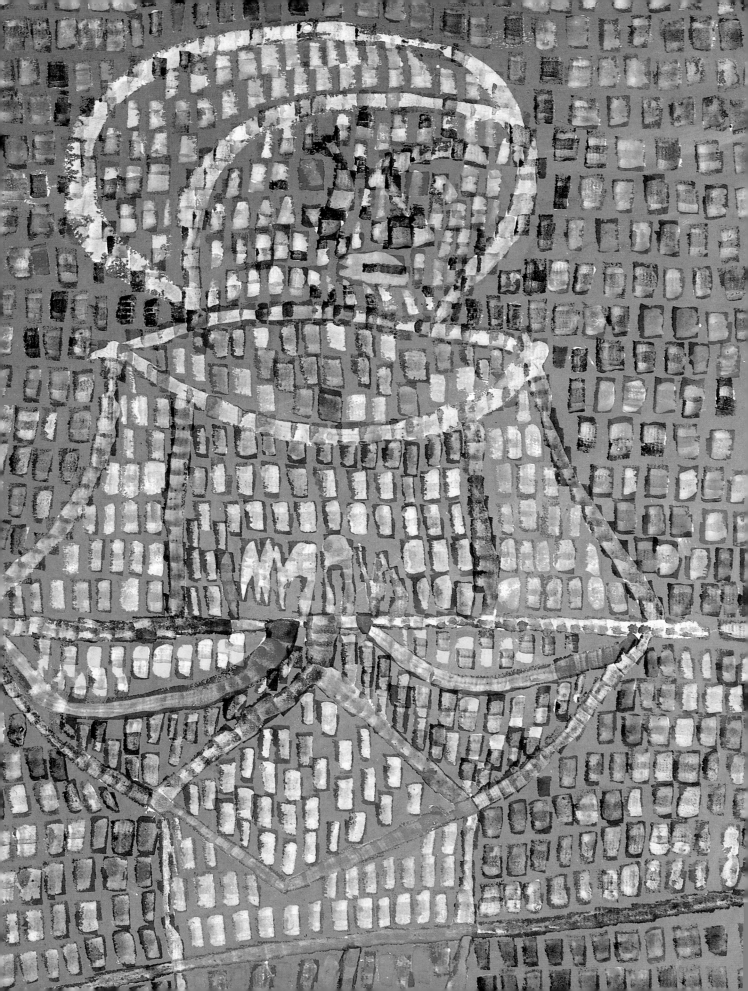

1932). The image seems constructed of a multitude of colored mosaic stones. In order to get a shimmering "stain" effect, Klee coated the entire white sheet with a gouache of opaque gray. Using a flat, square brush, he next painted in the horizontal rows of little squares and the figure in white gesso. Over these he then applied watercolor in all colors.[4]

If the colored squares appear to be placed at random, they are not. Klee precisely planned their placement. Thus the picture's four sides each have forty squares. Given the greater number of squares contained within the figure of the boy and within the table, one can assume that Klee minutely laid out the design for 1,600 to 1,700 colored squares.

1 *Briefe*, II, p. 1,162.

2 *Ibid.*, p. 1,156.

3 *Ibid.*, p. 1,153. In his commentaries to Klee's letters, Felix writes that Klee worked on a smaller scale in Dessau and on a larger one in Düsseldorf, explaining that the former was caused by the lack of space and the intimacy of his studio in Dessau, whereas, in the artist's own words, "Düsseldorf encourages large formats." *Briefe*, II, p. 1,222.

4 This technical information was provided by Margaret Holben Ellis, Consulting Conservator of Prints and Drawings, The Metropolitan Museum of Art.

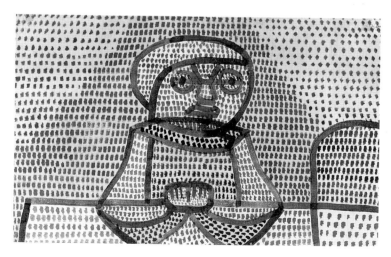

Fig. 64. Paul Klee, *Boy at a Table*, 1932. Watercolor with ink underdrawing on paper mounted on light cardboard; 11⅞ × 18⅞″ (30.2 × 47.9 cm). The Galka E. Scheyer Blue Four Collection, Norton Simon Museum, Pasadena

Athlete's Head
Athleten Kopf
1932

Watercolor, gouache, and pencil on laid paper mounted on light cardboard; 24¾ × 18⅞" (62.9 × 47.9 cm). Signed, in black ink (lower right): *Klee*. Dated and numbered, on the light cardboard, in black ink (lower left): *1932. 11.*; titled, in black ink (lower right): *Athleten-Kopf*; in pencil (lower left): *VI*. Recorded in Klee's oeuvre catalogue as: *Athleten Kopf*.

"Yesterday I had cauliflower and a veal cutlet, pink on the inside. Over the cauliflower lots of butter and grated cheese. Such a meal stimulates me mentally. Afterwards I feel especially healthy and not at all sleepy."[1] During his bimonthly, two-week-long stays in Düsseldorf, nearly every letter that Klee wrote to his wife, Lily, in Dessau describes in detail the fine meals cooked daily on his two little spirit stoves at the Academy. Because his studio-kitchen in Düsseldorf was also the workshop of his so-called Pointillist works, one can assume that it was there that he painted this watercolor.

Klee covered the entire sheet with more than four thousand little squares of rust, violet, and gray, executed in watercolor. These squares were set in even horizontal lines and were applied with a flat, square brush. Then Klee coated the surface with several applications of gray wash, once or twice (or not at all) in the areas of the head and shoulders of the figure that he had earlier indicated in pencil.[2] Below his mop of hair, the thick-necked and thick-headed fellow has hardly any forehead, which gives him a definite air of obtuseness. This is all in keeping with Klee's attitude toward sports. He thought that people don't use their heads while doing sports. Thus athletes probably don't have much of one to begin with. With a few blue lines Klee then added the features that characterize the athlete's face: a tight mouth, a grotesque large nose, and watchful little eyes.

1 *Briefe*, II, p. 1,175.

2 This technical information was provided by Margaret Holben Ellis, Consulting Conservator of Prints and Drawings, The Metropolitan Museum of Art.

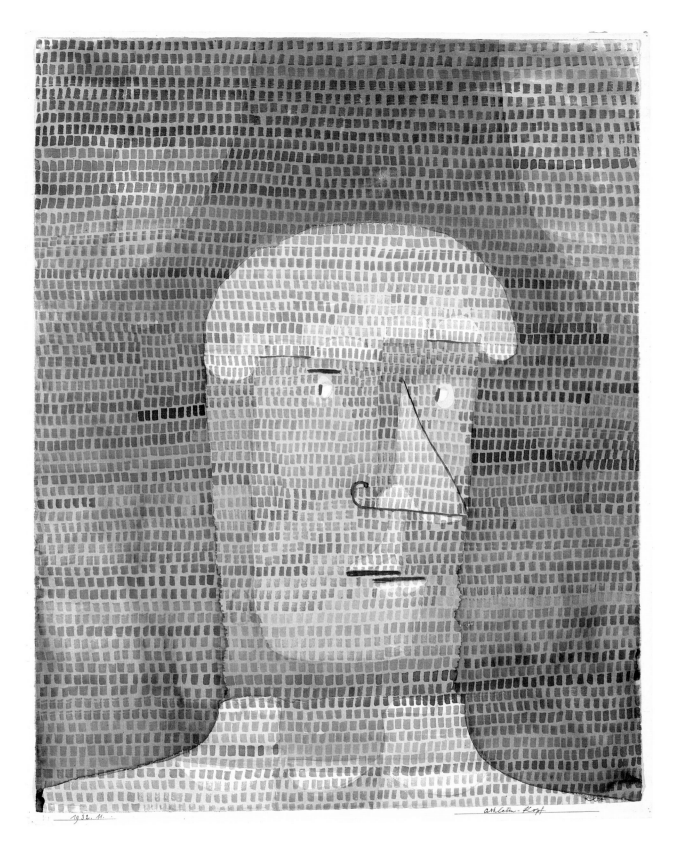

1932. M. athleten-Kopf

Clarification
Klärung
1932

Oil on canvas; 27¾ × 37⅞″ (70.5 × 96.2 cm). Signed,
in black paint (upper right): *Klee*. Signed and inscribed
(on reverse): *1932. M. 6. Klaerung Klee*. Recorded in
Klee's oeuvre catalogue as: *Klaerung*.

Klee liked Düsseldorf. "Even if Düsseldorf does not harbor all the ge-
niuses that are found in Dessau, one senses the artistic saturation and
one feels at home. Conservative minds also grapple intensely with the
New, and being often more honest than the Modernists, that makes
them sometimes more interesting."[1] Klee's well-being was reflected in
greater productivity. He had previously painted or drawn an average of
between 250 and 300 works a year, but during 1932 he produced 344
and the next year 482 works.

Clarification is a finely thought-out painting. Due to the very small
size of the dots of color, the foreground turns into a transparent screen
through which one can see the background. The separate entities of
background and foreground, each with its own design, form one harmo-

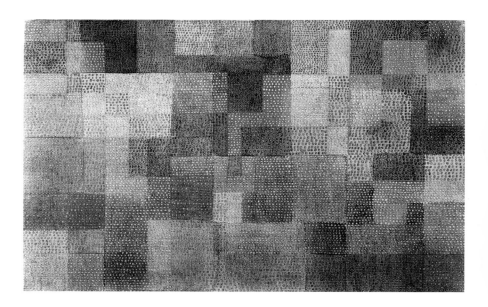

Fig. 65. Paul Klee, *Polyphony*, 1932.
Tempera on canvas; 21⅛ × 41¾″
(66.5 × 106 cm). Emanuel Hoffmann
Stiftung, Kunstmuseum Basel

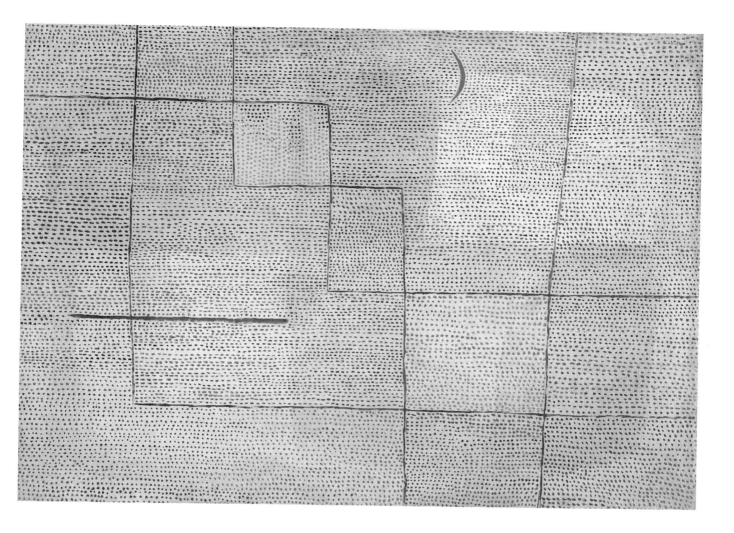

nious theme. Klee divided the ground into large areas of buff and grays, over which he drew the brown geometric design and the green crescent. Then he covered the entire surface with thousands of tiny color dots in even horizontal rows. The dots vary in color imperceptively along the way, yet switch again to only red, orange, or yellow in the brown rectangles. Only in the small yellow rectangle at the upper left do the rows of colors "move against the grain," vertically instead of horizontally.

Klee called one of the pictures he painted in this technique *Polyphony*, 1932 (see fig. 65). Similarly, Klee created here a composition that, just like a musical one, is composed, as *Webster's* defines "polyphony," of "simultaneous and harmonizing" but "individual parts."[2]

1 *Briefe*, II, p. 1,167.

2 *Webster's Third New International Dictionary of the English Language* (Springfield, Mass.: G. & C. Merriam Company, Publishers, 1971), p. 1,760.

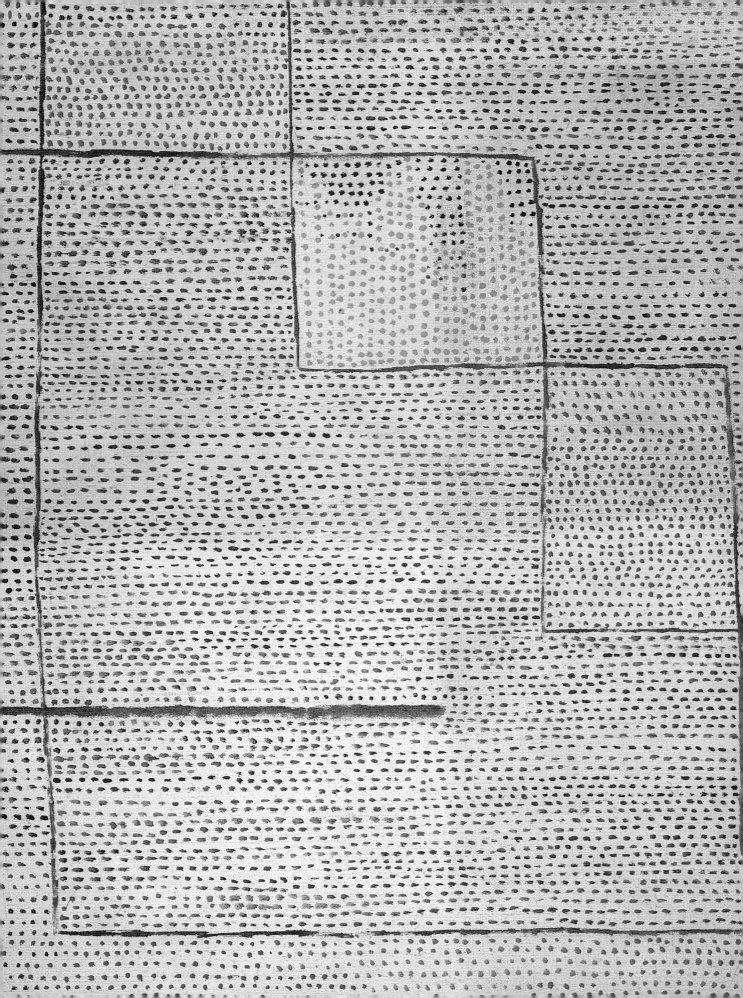

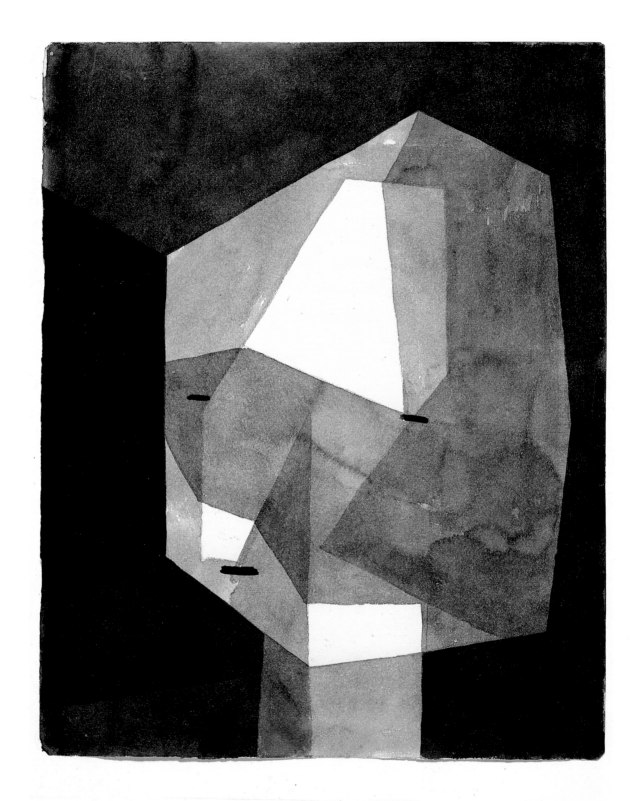

1935 K2 grob.geschnittener Kopf

Rough-Cut Head

Grobgeschnittener Kopf

1935

Black ink wash and pencil on wove paper mounted on
light cardboard; 12¼ × 9½″ (31.1 × 24.1 cm).
Signed, in pink chalk (upper left): *Klee*. Inscribed,
on the light cardboard, in brown ink: *1935 K 2
grobgeschnittener Kopf*; in pencil (lower left):
II. Recorded in Klee's oeuvre catalogue as:
grobgeschnittener Kopf.

In May 1933 the National Socialists, who had come to power in January
1933, suspended Klee from his teaching position at the Düsseldorf Acad-
emy. He was dismissed that fall. Earlier, in March, they had searched his
house in Dessau. In December Klee returned with his wife to his native
Bern. It had been 27 years since Klee had left Bern to marry and live in
Munich. Now he came back to Bern as a renowned artist, yet one who
had no large following in Switzerland. As Klee told a friend, he might be
world famous, but he would still have to find people interested in his
art.[1]

Klee lived in a modest three-room apartment at Kistlerweg 6 in a
residential quarter of Bern, about 15 minutes by tram from the center.
He never owned a car.

In 1935 the first signs of Klee's fatal illness appeared, which in
1936 was diagnosed as scleroderma, a disease that, through malfunction
of the connective tissue, leads to a shrinking of the skin and of the
internal organs.

Klee painted this watercolor in 1935. As if hewn from stone in flat
geometric planes in various shades of black, the monumental head has
only tiny slits for eyes and mouth. It appears somber and foreboding.

1 Ludwig Grote, ed., *Erinnerungen an
Paul Klee* (Munich: Prestel Verlag, 1959),
p. 106.

Stricken City
Betroffene Stadt
1936

Gypsum and oil on canvas; $17\frac{3}{4} \times 13\frac{7}{8}''$ (45.1 × 35.2 cm). Signed and inscribed (on the reverse): *1936 K. 2. betroffene Stadt*. Recorded in Klee's oeuvre catalogue as: *betroffene Stadt*.

During 1936 Klee worked little. Only five "panel paintings," five "polychromatic sheets," and fifteen "monochromatic sheets"—to use his own designations—are recorded in his oeuvre catalogue.[1] That year his illness was diagnosed as scleroderma, a slow and fatal disease that caused his death in 1940. Due to, no doubt, Klee's personal hardship and the increasing gravity of the political situation in Europe, more somber themes predominate in his work.

In *Stricken City* Klee once again used the lacework lines that he had earlier adopted for depictions of gardens, landscapes, and architectural structures (see pages 186 and 229). Here he incised those lines, in various shades, into the still moist gypsum ground he had earlier coated with raw umber. Actually, the lines look reddish because the small elevations on either side of their grooves retained the burnt sienna that Klee, as a final toning, had rubbed over the surface in various lighter and darker shades.[2] This crusty surface anticipates Jean Dubuffet's graffiti work of the 1950s.

Klee's city looks like a medieval fortified town perched atop a mountain with fields extending below. Calamity hovers above in the form of a thick black arrow. As mentioned earlier (see page 99), black arrows pointing downward represent bad luck in Klee's work. This meaning dates back to World War I when the painter was stationed at a flying school in Gersthofen, near Augsburg, where he witnessed many young pilots crashing to their death. Klee later transformed these crashing airplanes into birds whose fatal hurtling down is symbolized by a black arrow.

1 Stefan Frey of the Paul Klee Stiftung in the Kunstmuseum Bern checked these classifications (meaning paintings, watercolors, and drawings) in Klee's oeuvre catalogue for the year 1936.

2 Lucy Belloli, Conservator of Paintings, The Metropolitan Museum of Art, provided this technical information.

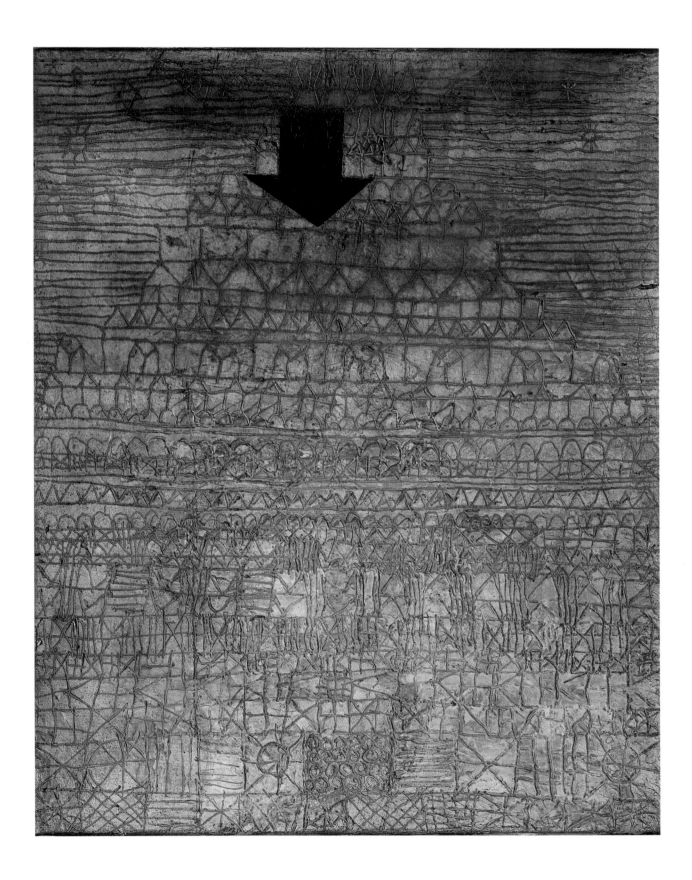

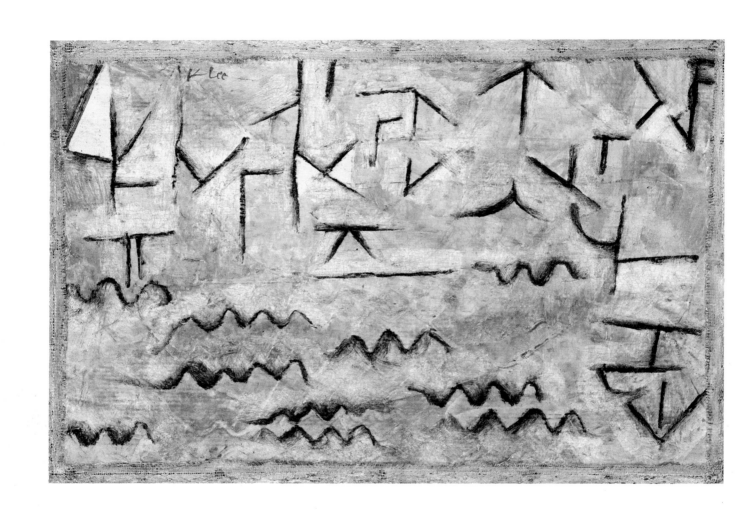

The Rhine at Duisburg
Der Rhein bei Duisburg
1937

Gypsum, oil, and charcoal on cardboard; 7¼ ×
10¾″ (18.4 × 27.3 cm). Signed, in red paint
(upper left): *Klee.* Signed and inscribed (on reverse):
1937 R. 5. der Rhein bei Duisburg Klee. Recorded in
Klee's oeuvre catalogue as: *der Rhein bei Duisburg.*

Here is a description of Klee in the late 1930s: "In the years just preced-
ing the war, one could pass in the afternoon, on the lonely roads of the
Elfenau [residential section of Bern], or sometimes in the crowded col-
onnaded streets of Bern, a man of medium, rather slight stature. He
walked by slowly, nearly hesitantly, and looked at what passed by with a
faraway gaze. Judging by his correct and careful dress, he might have
been a scholar or a citizen in a high position. Somewhat in contrast to
this attire were the graceful features in his pale, nearly translucent face.
Yet even more so were the strange, always pensive, yet expressive eyes
that were like those of an augur. His head was sometimes slightly in-
clined, as if weighing something, and as if a smile of cognition were
about to appear. A floating, magical presence within the crowd."[1]

 In this pictogram a seascape, boats, a shoreline, and rippling waves
of water have been abbreviated into outlines set against muted tones of
mauve, green, peach, rose, and buff. Klee drew open geometric forms for
the houses and boats in the upper half of the picture. Just as in Cubist
"passages," one color plane blends into the other. Meanwhile, the Rhine
River is shown as squiggly lines. Klee had already adopted these hiero-
glyphlike symbols in *Secret Characters* (fig. 66) and *Harbor Scene* (fig.
67), both dating from 1937. A later variation of these signs appears in
Comedians' Handbill, 1938 (see page 255).

 The Rhine at Duisburg may evoke the happy years Klee spent in
Düsseldorf (1931–33), which, about twenty miles south of Duisburg, also
lies on the Rhine. But the word "Duisburg" is shorter than "Düsseldorf"
and may have sounded better to Klee, preoccupied as he was with the
ring of words.

1 "Zur Entstehung der Paul Klee-
Stiftung," *Ausstellung der Paul Klee-Stiftung,*
exhibition catalogue (Bern: Kunstmuseum,
1947), p. 3. This introduction is signed
"Klee-Gesellschaft, Bern." Its members
were Werner Allenbach, Rolf Bürgi,
Hans Meyer-Benteli, and Hermann Rupf.

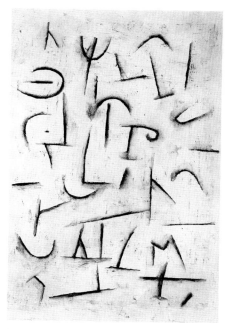

Fig. 66. Paul Klee, *Secret Characters,*
1937. Gesso and charcoal on white gesso
chalk ground on paper mounted on light
cardboard; 19 × 13″ (48.3 × 33 cm).
Collection Edgar Kaufmann, New York

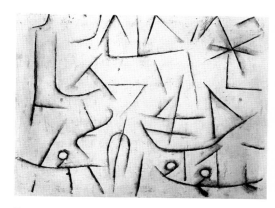

Fig. 67. Paul Klee, *Harbor Scene,* 1937.
Gesso and charcoal on white gesso chalk
ground on paper mounted on light card-
board; 13½ × 19½″ (34.4 × 49.6 cm).
Private collection, New York

Comedians' Handbill
Werbeblatt der Komiker
1938

Fig. 68. Paul Klee, *Alphabet I*, 1938.
Gouache on newsprint mounted
on light cardboard; 21¼ × 13½"
(53.9 × 34.4 cm). Paul Klee Stiftung,
Kunstmuseum Bern

Gouache on newsprint mounted on light cardboard;
19⅛ × 12⅝" (48.6 × 32.1 cm). Signed, in black
ink (upper right): *Klee*. Dated and numbered, on the
light cardboard, in black ink (lower left): *1938 E 2*;
titled, in black ink (lower right): *Werbeblatt der
Komiker*. Recorded in Klee's oeuvre catalogue as:
Werbeblatt der Komiker.

In tune with the motto "the medium is the message," Klee designed this
handbill on a sheet of newspaper that he had covered with caramel-
colored gouache. Correcting here and there the figures' contours, he
filled the spaces between them with bone-colored gouache. Touches of
white and pink gouache add animation. Here in these thick-stemmed,
black pictographs, Klee takes his abbreviated black figures from the
previous year (see page 252 and figs. 66 and 67) one step further. Jumping
into our eyes as boldly as an advertisement, these signs symbolize synco-
pated movement, frolicking creatures, and stick figures. A heart-shaped
thing with hat points with long-tongued hands on the left; a bespectacled
face below a high cylinder stares on the lower left; and a long-legged
figure jumps in the center. Almost fifty years later the German and
American painters R. A. Penck and Keith Haring painted similar images.

Klee distilled his merry symbols into letters in later works in this
series entitled *Alphabet I* and *Alphabet II*, both dating from 1938 (figs. 68
and 69), leaving the newspaper print clearly visible.

Fig. 69. Paul Klee, *Alphabet II*, 1938.
Gouache on newsprint mounted on light
cardboard; 19¼ × 13" (49 × 33 cm).
Paul Klee Stiftung, Kunstmuseum Bern

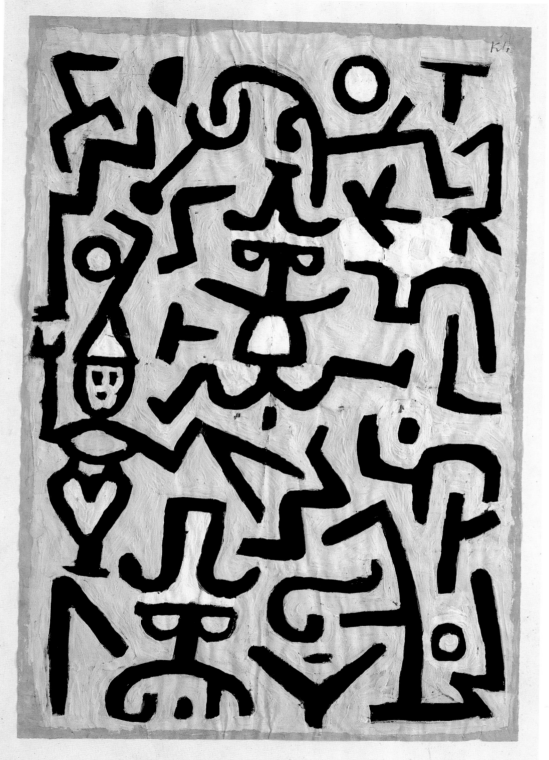

1938 E2 Werbeblatt des Komikers

Little Hope
Wenig Hoffnung
1938

Plaster and watercolor on burlap mounted on light
cardboard; 15½ × 17½" (39.4 × 44.5 cm).
Signed, in rose gouache (upper left): *Klee*. Dated
and numbered, on the light cardboard, in brown ink
(lower left): *1938 qu 14*; titled, in brown ink
(lower right): *wenig Hoffnung*; in pencil (lower right): *VIII*.
Recorded in Klee's oeuvre catalogue as: *wenig Hoffnung*.

As a consequence of scleroderma, Klee's fatal illness, he had to give up
his favorite pastime—playing the violin. However, after the first attack of
his illness had passed in 1935, Klee was able to rally his strength and
return to painting. If in 1936 he recorded only twenty-five items in his
oeuvre catalogue, in 1938 Klee produced 489 works, surpassed by more
than 1,200 in 1939! "The production, with escalating speed, grows into
escalating proportions. I can hardly keep up with such prodigies [works].
They simply jump out. A certain adjustment occurs because drawings
predominate. Anyway, 1,200 items for the year 1939 is a record achieve-
ment."[1]

Klee's work changed. Line became heavy, form broad and genera-
lized, scale larger, and colors simpler. All are related to the fact, proba-
bly, that Klee worked more rapidly, aware that he had not much time left
to live.

In *Little Hope* he first drew the outlines of the head, shoulder,
comb, and arm on the burlap. When covering these forms with plaster
and turquoise watercolor, he left the contours untouched. Thus they
stand out, thick and raw, in dark relief. Contrasting with the girl's de-
murely inclined head and closed eyes is the purple mane of her tousled
hair.

1 *Briefe*, II, p. 1,295.

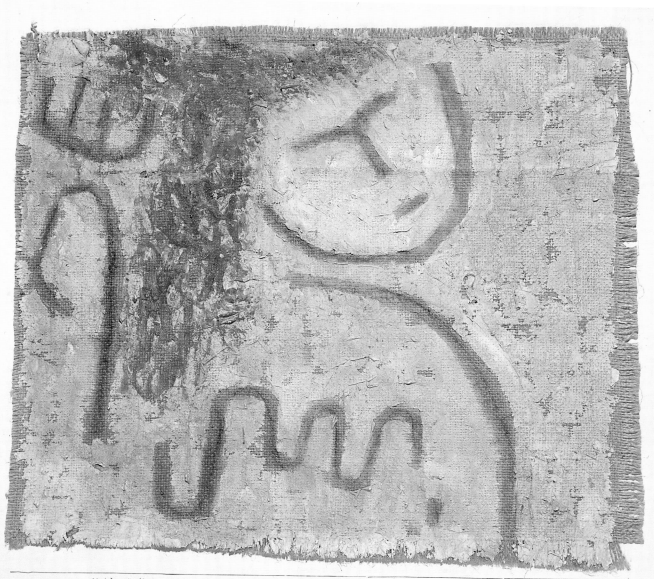

1938 g 14 Wenig Hoffnung

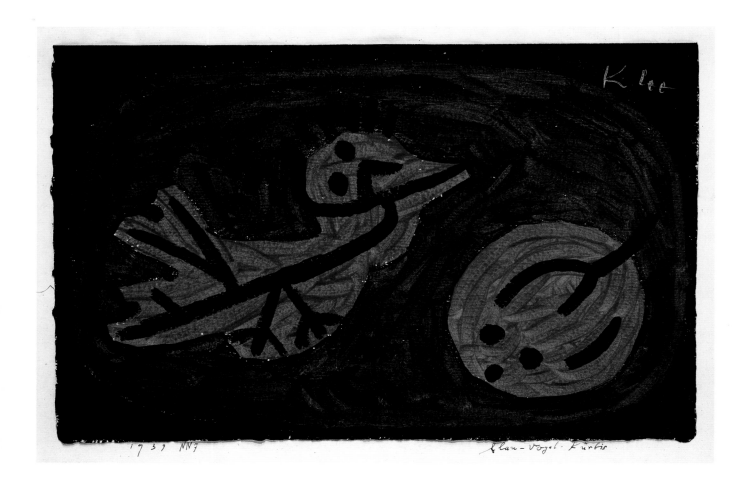

Klee

1939 NN7 Blau-Vogel-Kürbis

Blue-Bird-Pumpkin

Blau-Vogel-Kürbis

1939

Gouache on laid paper mounted on light cardboard;
11 × 17″ (27.9 × 43.2 cm). Signed, in light orange
gouache (upper right): *Klee*. Dated and numbered,
on the light cardboard, in brown ink (lower left):
1939 N N 7; titled, in brown ink (lower right):
blau-Vogel-Kürbis. Recorded in Klee's oeuvre
catalogue as: *blau-Vogel-Kürbis*.

This is not a design for a Picasso ceramic plate.

Klee admired Picasso. After visiting an exhibition of that painter's
works at the Kunsthaus Zürich in October 1932, Klee wrote to his wife,
Lily: "The Picasso exhibition was a new revelation, and the latest pic-
tures with their strong colors were a great surprise. He even outdoes
Matisse. The formats are mostly larger than anticipated. Many of the
funny bathing pictures win through their subtle painting. All in all: the
painter of today."[1]

Klee met Picasso on a trip to Paris in the fall of 1933. He recorded
his visit to the painter on October 26 in his pocket diary, with no com-
ment, however. One of the eagerly awaited events during Klee's last
years in Bern was a visit from Picasso in November 1937. Here again,
little is known of the visit, only that Picasso complimented Klee on his
work. Apparently, Klee quite often referred to this visit and is recorded as
having said: "He [Picasso] liked them [his pictures]. However, for me it
is important to watch out that his style does not sneak up on me, because
he is a great and very strong personality. It can easily happen that one
adopts, unconsciously, things one accepts. But everyone has to follow his
own path."[2] Klee need not have worried. Instead of copying Picasso, he
seems to have anticipated here a style that Picasso himself would only
employ seven years later, when from 1946 onward he created ceramics.

The simple title promises no more and no less: a blue bird and a
blue pumpkin, one of which is either too small or too large for this
playful juxtaposition. Thick black lines indicate the structures of bird
and fruit; black dots delineate the eyes and pits.

If Klee painted a blue pumpkin, he signed his name in the color of a
real pumpkin.

1 *Briefe*, II, p. 1,189.

2 Ludwig Grote, ed., *Erinnerungen an
Paul Klee* (Munich: Prestel Verlag, 1959),
p. 54.

Angel Applicant
Engel Anwärter
1939

Black ink, gouache, and pencil on wove paper
mounted on light cardboard; 19¼ × 13⅜″
(48.9 × 34 cm). Signed, in black ink (bottom center):
Klee. Inscribed, on the light cardboard, in brown
ink: *1939 U U 16 Engel-Anwärter*. Recorded in
Klee's oeuvre catalogue as: *Engel-Anwärter*.

It seems doubtful that this angel applicant, resembling the offspring of a
bulldog and a Halloween mask, will ever reach heaven. In 1939 Klee
composed 29 works that feature angels, having in earlier years only
sporadically depicted them. His angels were not the celestial kind but
hybrid creatures beriddled with human foibles and whims. Klee's angels
are "forgetful," "still female," "ugly," "incomplete," or "poor"—as the
titles he gave these pictures indicate.

Suffering from an incurable illness and sensing himself hovering
between life and death, Klee possibly felt a kinship with these outsiders.
In this work he covered a sheet of newspaper with black gouache on
which he then drew the outlines of the figure and of the crescent moon
with a thick, soft graphite pencil. Then he filled in these forms with a
thin white wash. It is the black ground peeking through the white pig-
ment that gives this creature its ghostly shimmer. Klee used a thin
opaque pink wash for both the background and the creature's nostrils.

Klee's angels appear wrapped in large, billowing sailcloth that
stretches, over the extended wings, to the edges of the composition.
Perhaps, because the applicant is not yet a full-fledged angel, his spiky
fins are not fit for flying.

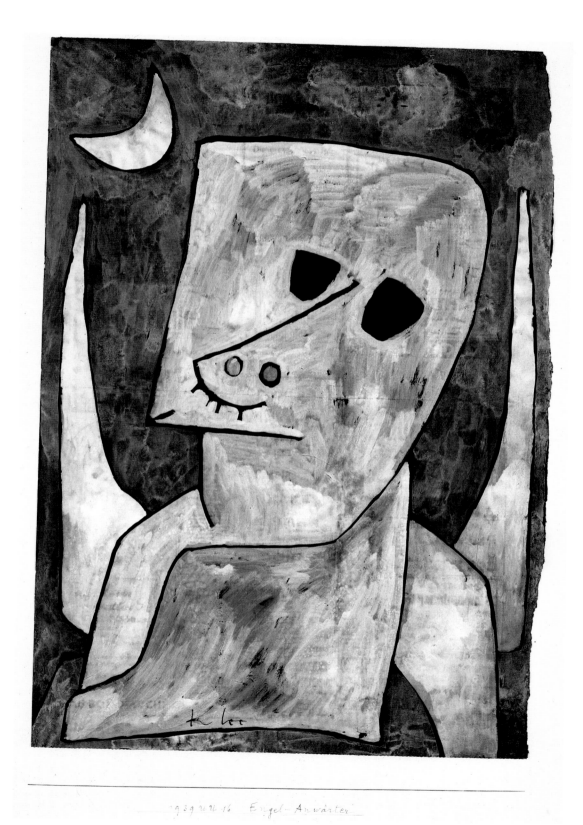

1939 u 16 Engel-Anwärter

Girl in Mourning
Mädchen in Trauer
1939

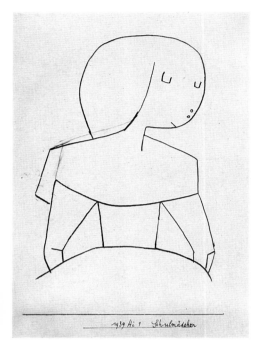

Fig. 70. Paul Klee, *Schoolgirl*, 1939.
Crayon on note paper mounted on light
cardboard; 11⅝ × 8⅛″ (29.5 × 20.8 cm).
Paul Klee Stiftung, Kunstmuseum Bern

Gouache, pastel, and charcoal on wove paper mounted on
light cardboard; 23¾ × 17½″ (60.3 × 44.5 cm).
Signed, in black ink (upper right): *Klee*. Dated and
numbered, on the light cardboard, in black ink (lower
left): *1939 J K 10*; titled, in black ink (lower right):
Mädchen in Trauer. Recorded in Klee's oeuvre catalogue
as: *Mädchen in Trauer*.

A friend who visited Klee in Bern before World War II recalled the
painter's circumstances as follows: "The apartment was very modest in
contrast to those of Dessau and Düsseldorf. I could not help feeling that
his financial situation was not the most promising. There were only three
rooms, one of which he used as a studio. Although, according to my
impressions, the light was not very good, he seemed to have chosen it
because it had a balcony. He could have the illusion of being out-of-
doors, and also had a fine view of the Bernese Oberland [mountains].
The room was very small. He only had a very small working area. Most
of the room was covered with books and portfolios. Despite the lack of
space he created at this time his largest pictures."[1]

References to human emotions, often of a melancholic nature,
were also new in his work. However, this translucent buff-colored girl,
whom in an earlier crayon drawing he had simply called *Schoolgirl*, 1939
(fig. 70), does not really look sad. It is the thick black line making up the
girl's contours—evoking the black-edged note paper that Germans are so
fond of using when writing condolence letters—that probably inspired
Klee to choose this title.

1 Ludwig Grote, ed., *Erinnerungen an
Paul Klee* (Munich: Prestel Verlag, 1959),
p. 106.

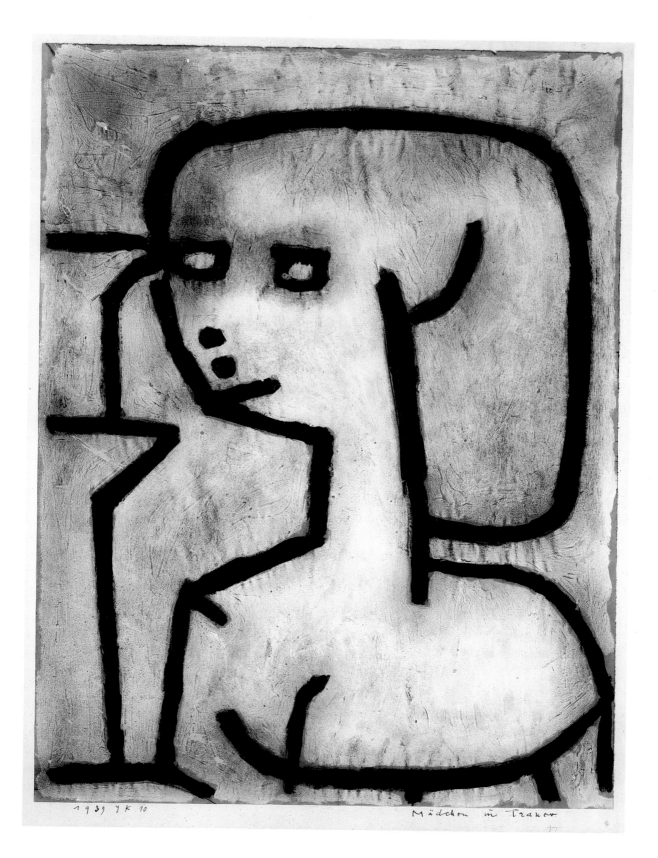

1939 J K 10 Mädchen in Trauer

The Hour Before One Night
Die Stunde vor einer Nacht
1940

Gouache on wove paper mounted on light cardboard;
11⅝ × 16⅜″ (29.5 × 41.6 cm). Signed, in
brown ink (upper left): *Klee*. Dated and numbered,
on the light cardboard, in brown ink (lower left):
1940 L 17; titled, in brown ink (lower right):
die Stunde vor einer Nacht. Recorded in Klee's
oeuvre catalogue as: *die Stunde vor einer Nacht*.

Hans Klee (1849–1940), the artist's German father, never bothered to
apply for Swiss citizenship, although he spent his adult life, from
1875–1940, in Switzerland. Paul Klee, consequently, was born German.
After having returned to Bern for good in 1933, Klee applied for Swiss
citizenship. However, since such matters cannot be rushed in Switzer-
land, Klee's request was ready for approval only a few weeks after he had
died in Muralto-Locarno on June 29, 1940. Until Klee went to Orselina-
Locarno in May 1940 to stay in a sanatorium, he had worked steadily
that year, producing some 366 works between January and May.

Here Klee, seemingly cursorily and rapidly, painted the black bars
of an irregular grid over rough patches of red, blue, and burnt sienna
gouache. Because this watercolor belongs among Klee's last works, its
title might be seen as full of forebodings—but it is not, really. A related
work from exactly the same time in which the black foreground grid is in
one piece, not "broken" as here, is simply called *The Carpet*, 1940
(fig. 71).

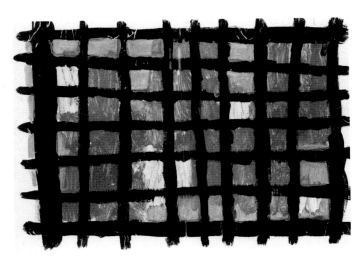

Fig. 71. Paul Klee, *The Carpet*, 1940.
Gouache on paper mounted on
light cardboard; 11⅝ × 16⅜″
(29.5 × 41.7 cm). Private collection, Bern

264

1940 L17 die Stunde vor einer Nacht

Two Newly Discovered Versos

Verso of **Small Portrait of a Girl in Yellow**
(Page 209)
1925 or earlier

Gypsum and oil on canvas; 9½ × 8¼" (24.1 × 21 cm).

When the cardboard backing was removed from *Small Portrait of a Girl in Yellow*, a new work by Klee was discovered on the other side. In shades of red and blue, it represents a monolithic architectural form, perhaps a façade of an imaginary basilica, in which other architectural elements, such as an archway, domes, rectangles, and squares, are set. The top of the work appears to have been cut off.

Klee did not seem to have thought this composition very important. However, being thrifty, he used it as support for another work.

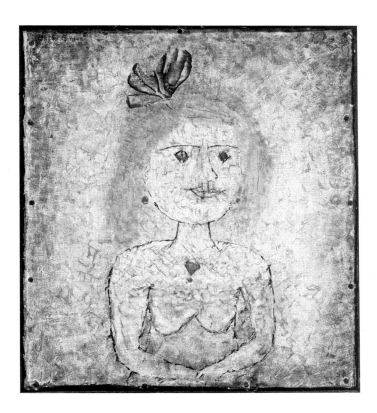

Small Portrait of a Girl in Yellow
Kleines Mädchen Bildnis in Gelb 1925
Gypsum and oil on canvas;
9½ × 8¼" (24.1 × 21 cm)

Verso of Stricken City
(Page 250)
1936 or earlier

Gypsum and oil on canvas; 17¾ × 13⅞″ (45.1 × 35.2 cm).

Klee left this painting incomplete. Then he reduced its size, covered it with yellow paint, placed a stretcher on it, turned it on its other side, and painted *Stricken City*, all within the spirit of never letting anything go to waste.

Ordinarily, one expects to find unprimed canvas on the back of a painting. Thus the layer of mat yellow paint with indications of brushwork beneath suggested the existence of another painting. A new photographic technique called infrared reflectography, which penetrates the top levels of a painting to reveal underdrawings or earlier compositions, proved that our hunch was right. The removal of the yellow paint layer then brought to light this "work in progress," which offers a rare glimpse into Klee's working method.[1] For example, it is evident that the artist did not first map out his composition in pencil, but drew his forms with quite a thick brush directly onto the gesso-primed canvas. The spiky, round, and curvilinear forms—in candy-colored pink, mauve, and baby blue, either crosshatched or not—appear rather unwieldy. The overall effect is one of blandness. Perhaps that is why Klee abandoned this work.

1 Lucy Belloli, Conservator of Paintings, and Maryan W. Ainsworth, Senior Research Associate, The Metropolitan Museum of Art, discovered this painting.

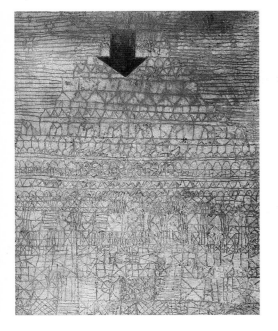

Stricken City
Betroffene Stadt 1936
Gypsum and oil on canvas;
17¾ × 13⅞″ (45.1 × 35.2 cm)

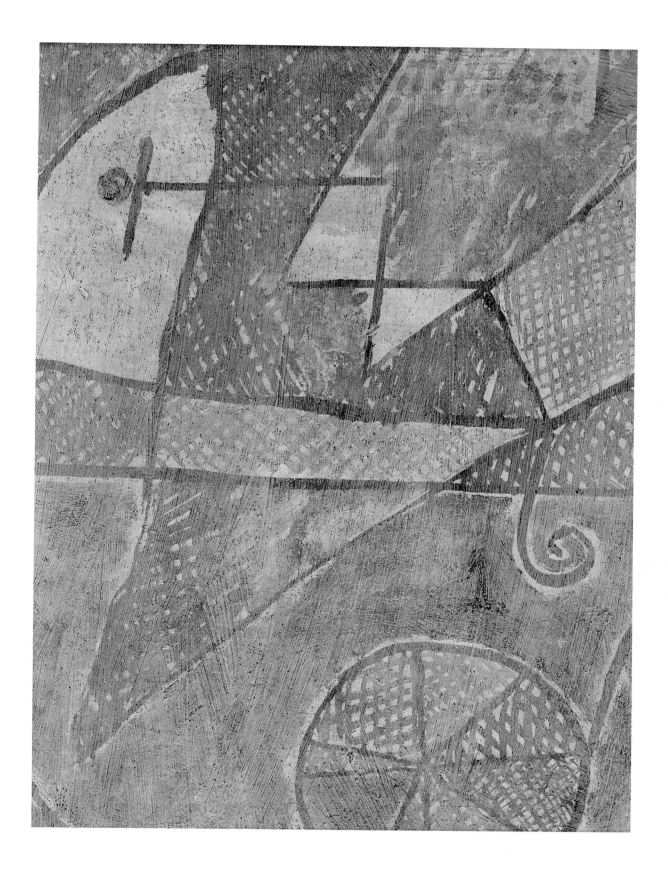

Provenance, Exhibitions, and Bibliographic References

Page 56
Junkerngasse in Bern, 1893

PROVENANCE
Curt Valentin, Buchholz Gallery, New York; G. David Thompson, Pittsburgh; Heinz Berggruen, 1977.

EXHIBITION
New York, 1985.

BIBLIOGRAPHY
Rewald, 1985, ill. p. 52.

Page 59
Sketch of Felix Klee, 1908

PROVENANCE
Mr. and Mrs. Heissler, Strasbourg, 1915; Sale, London, Sotheby's, December 7, 1983, no. 316; Heinz Berggruen, 1983.

EXHIBITION
Munich, 1920, cat. no. 261.

BIBLIOGRAPHY
Der Ararat, 1920, no. 261, p. 24.

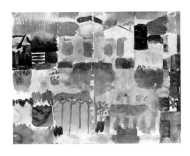

Page 60
Garden in St. Germain, The European Colony Near Tunis, 1914

PROVENANCE
Lily Klee, Bern; Douglas Cooper, Argilliers, France, 1945 (gift of Lily Klee); Heinz Berggruen, 1956.

EXHIBITIONS
London, 1945–46, cat. no. 20; Paris, 1948, cat. no. 47; Brussels, 1958, cat. no. 8a; New York, 1967, cat. no. 19, ill. p. 31; Basel, 1967, cat. no. 24; Paris, 1969–70, cat. no. 19, ill. p. 4; Turin, 1971, ill. p. 227; Saint-Paul, 1977, cat. no. 8; Munich, 1979–80, cat. no. 267, ill. p. 417; New York, 1987, ill. p. 137; Cleveland, 1987, ill. p. 137; Bern, 1987–88, cat. no. 52, ill.

BIBLIOGRAPHY
Grohmann, 1954, ill. p. 125; Fisher, 1966, pl. 4; Burnett, 1977, ill. p. 322; Duvignaud, 1980, ill. p. 65; Jordan, 1984, ill. p. 127.

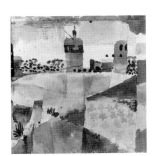

Page 64
Hammamet with Its Mosque, 1914

PROVENANCE
Rudolf Probst, Dresden and Mannheim, before 1939; Baron J. B. Urvater, Brussels; Galerie Beyeler, Basel, 1963; Heinz Berggruen, 1963.

EXHIBITIONS
Munich, 1920, no. 89; Amsterdam, 1957, cat. no. 8; Brussels, 1958, cat. no. 8; London, 1958, cat. no. 39; New York, 1967, cat. no. 18, ill. p. 29; Basel, 1967, cat. no. 22, ill.; Paris, 1969–70, cat. no. 17, ill. p. 4; Düsseldorf, 1967, ill. p. 11; Turin, 1971, ill. p. 228; Saint-Paul, 1977, cat. no. 7, ill. p. (35); Munich, 1979–80, cat. no. 264, ill. p. 142; New York, 1985.

BIBLIOGRAPHY
Der Ararat, 1920, no. 89, p. 22; Langui, 1957, no. 55, ill.; Felix Klee, 1964, pl. 1; Amman, 1965, ill.; Grohmann, 1967, p. 74, ill. p. 75; Messer, 1968, ill. p. 11; Chevalier, 1971, ill. p. 6; Messer, 1972, ill. p. (73); Miyajima, 1976, ill. p. 86; Ohoka, 1976, ill. p. 74; Arnason, 1977, ill. p. 272; Abadie, 1977, ill. p. 35; Triska, 1980, fig. 6; Duvignaud, 1980, ill. p. 62; Tower, 1981, fig. 24; Haxthausen, 1981, ill. p. 659; Geelhaar, 1982, ill. p. 22; Güse, 1982, ill. pp. 56 and 142; Jordan, 1984, ill. p. (58); Larson, 1985, ill. p. 98; Rewald, 1985, ill. p. 52; Grohmann, 1987, ill. p. 151; Kersten, 1987, p. 13, ill. pp. 12 and 13.

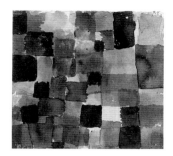

Page 68
Untitled, 1914

PROVENANCE
Hans Goltz, Neue Kunst, Munich,
May–June 1920; Ida Bienert, Dresden
and Munich; Sale, Bern, Gutekunst und
Klipstein, November 27, 1948, no. 156;
Galerie Saqqarah, Gstaad; Sale, London,
Sotheby's, July 3, 1974, no. 170; Heinz
Berggruen, 1974.

EXHIBITIONS
Munich, 1920, cat. no. 70; Berlin, 1920,
no. 87; Tokyo, 1981, cat. no. 2, ill. p. 24.

BIBLIOGRAPHY
Der Ararat, 1920, no. 70, p. 22; Triska,
1979, ill. p. 48; Güse, 1982, ill. p. 195;
Glaesemer, 1984, fig. a, ill. p. 169.

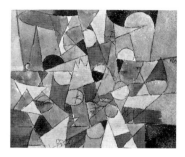

Page 70
Untitled, 1914

PROVENANCE
Curt Valentin, Buchholz Gallery, New
York; Katherine Dreier and Rose Fried,
New York, 1949; Wallace K. Harrison
and Abramovitz, New York; Harold Dia-
mond, New York; Heinz Berggruen, 1981.

EXHIBITIONS
Munich, 1920, cat. no. 84; Munich, 1921,
cat. no. 35; New York, 1954–55, cat. no.
27; Cambridge, Mass., 1955, cat. no. 31.

BIBLIOGRAPHY
Der Ararat, 1920, no. 84, p. 22.

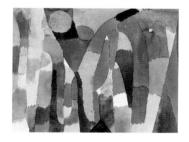

Page 72
Movement of Vaulted Chambers,
1915

PROVENANCE
Estate of Paul Klee, Bern; Galerie Rosen-
gart, Lucerne, 1949; Jan Heyligers,
Amsterdam, 1949; Mark Hendrickx,
Brussels; Heinz Berggruen; Marianne
Feilchenfeldt, Zürich; Heinz Berggruen,
1963.

EXHIBITIONS
Munich, 1979–80, cat. no. 282, ill.
p. 424; New York, 1985; Canberra, 1986,
ill. p. 42.

BIBLIOGRAPHY
Grohmann, 1954, no. 31, ill. p. 388; Felix
Klee, 1960, p. 194; Felix Klee, 1963, ill.
p. (36).

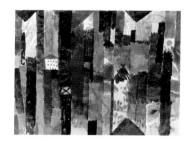

Page 75
Before the Town, 1915

PROVENANCE
Herwarth Walden, Der Sturm, Berlin,
Oct. 1919; Dr. Max Fischer, Berlin;
Robert Connelly, New York; Sale, New
York, Sotheby's, May 22, 1981, no. 84;
Heinz Berggruen, 1981.

EXHIBITIONS
Dresden, 1919, cat. no. 162; New York,
Buchholz Gallery, March 23–April 23,
1938, no. 6; Paris, 1948, cat. no. 219;
Brussels, 1948, cat. no. 219.

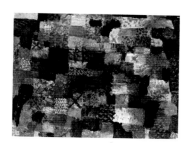

Page 77
Deep Pathos, 1915

PROVENANCE
Sold in Frankfurt am Main, 1917; Siegfried Adler, Montagnola, Switzerland, 1968/69; Heinz Berggruen, 1976.

EXHIBITIONS
Basel, 1916, cat. no. 49; Munich, 1916, cat. no. 103 (as *Abstractes Aquarell*); exhibition traveled to Frankfurt am Main and Wiesbaden, 1917.

BIBLIOGRAPHY
Werckmeister, 1979–80, p. 185.

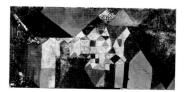

Page 79
Municipal Jewel, 1917

PROVENANCE
Hans Goltz, Neue Kunst, Munich, 1917; Ida Kerkovius, Stuttgart; Kurt Leonardt, Stuttgart; Jacques Benador, Geneva; Heinz Berggruen, 1972.

EXHIBITIONS
Munich, 1917, no. 103; Tokyo, 1981, cat. no. 3, ill. p. 22; New York, 1984, cat. no. 53, ill. p. 64; New York, 1985.

Page 80
Libido of the Forest, 1917

PROVENANCE
Hans Goltz, Neue Kunst, Munich, Feb. 1921; Heinrich Stinnes, Cologne; Sale, Bern, Gutekunst und Klipstein, June 20–22, 1938, no. 519; Karl von Schleider, Denver; Curt Valentin, Buchholz Gallery, New York, 1948; F. C. Schang, New York, 1954; Heinz Berggruen, 1981.

EXHIBITIONS
Berlin, 1917, cat. no. 24; Munich, 1918, cat. no. 78; Munich, 1920, cat. no. 124; New York, 1939, no. 7; Cincinnati, 1942; Denver, 1950, on loan for 5–6 months.

BIBLIOGRAPHY
Der Ararat, 1920, no. 124, p. 22; Wedderkop, 1920, ill.; Glaesemer, 1979, fig. a, ill. p. 140; Henry, 1976, p. 71 and fig. 132, ill. p. 285; Henry, 1977, fig. 3, ill. p. 118.

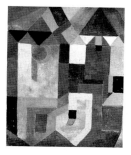

Page 82
Colorful Architecture, 1917

PROVENANCE
Hans Goltz, Neue Kunst, Munich, May–June 1920; Ida Fuld, Frankfurt am Main; Siegfried Adler, Montagnola, Switzerland, 1975; Heinz Berggruen, 1976.

EXHIBITIONS
New York, 1985; Canberra, 1986, ill. p. 42.

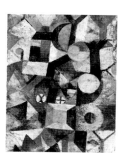

Page 85
Composition with the Yellow Half-Moon and the Y, 1918

PROVENANCE
Professor Oscar Müller-Widmann, Basel; Aenne Abels, Cologne; Heinz Berggruen, 1968.

EXHIBITIONS
Dresden, 1918, no. 17; Copenhagen, 1918, no. 64; Berlin, 1919, no. 65; Paris, 1969–70, cat. no. 26; Berlin, 1974, cat. no. 47, ill. p. 53; Munich, 1979–80, cat. no. 335, ill. p. 455.

BIBLIOGRAPHY
Jordan, 1984, fig. 67, ill. p. 67.

Page 86
Tomcat's Turf, 1919

PROVENANCE
Hans Goltz, Neue Kunst, Munich, May–June 1920; Motomachi Gallery, Tokyo; Sale, London, Christie's, December 1, 1981, no. 363 (bought in); Heinz Berggruen, 1981.

EXHIBITION
Munich, 1920, cat. no. 200.

BIBLIOGRAPHY
Der Ararat, 1920, no. 200, p. 23.

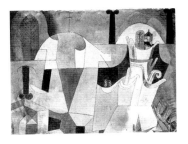

Page 90
Southern Gardens, 1919

PROVENANCE
Lily Klee, Bern; Douglas Cooper, Argilliers, France; Heinz Berggruen, 1956; Erika Brausen, London; Heinz Berggruen, 1962.

EXHIBITIONS
London, 1945–46, cat. no. 35; London, 1946, cat. no. 11; Saint-Paul, 1977, cat. no. 21, ill. p. (46); London, 1978, cat. no. 3.18, ill. p. 70.

BIBLIOGRAPHY
Grohmann, 1967, p. 84, ill. p. 85; Carpi, 1973, ill. p. 19; Abadie, 1977, ill. p. (46); Duvignaud, 1980, ill. p. 53; Triska, 1980, fig. 22; Güse, 1982, ill. p. 63; Grohmann, 1987, ill. p. 59.

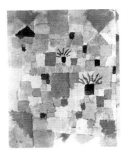

Page 92
Black Columns in a Landscape, 1919

PROVENANCE
Hans Goltz, Neue Kunst, Munich; Erna and Curt Burgauer, Küsnacht, Zürich; Heinz Berggruen, 1963.

EXHIBITIONS
Munich, 1920, cat. no. 221; Zürich, 1955, p. 21 (no number); Bern, August 11–November 4, 1956, cat. no. 422; Berlin, 1974, cat. no. 50, ill. p. 112; Munich, 1979–80, cat. no. 388, ill. p. 490; New York, 1985.

BIBLIOGRAPHY
Der Ararat, 1920, no. 221, p. 23; Zahn, 1920, ill. p. 60; Giedion-Welcker, 1954, fig. 58, ill. p. 84; Felix Klee, 1964, pl. 2.

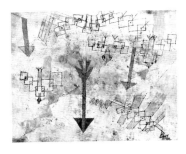

Page 95
Birds Swooping Down and Arrows, 1919

PROVENANCE
Heinrich Campendonk, Seeshaupt, Bavaria, 1919; Reiner Bornefeld, Antibes; Sale, Hamburg, Hauswedell & Nolte, June 2–4, 1977, no. 774; Heinz Berggruen, 1977.

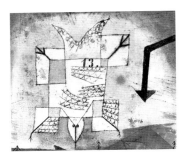

Page 99
Falling Bird, 1919

PROVENANCE
Hans Goltz, Neue Kunst, Munich; César de Hauke, Paris; Heinz Berggruen, 1970.

EXHIBITIONS
Munich, 1920, cat. no. 230; Berlin, 1921, cat. no. 928; Munich, 1979–80, cat. no. 403, ill. p. 498.

BIBLIOGRAPHY
Der Ararat, 1920, no. 230, p. 23; Zahn, 1920, ill. p. 73; Rosenthal, 1979, fig. 42, ill. p. 244; Rosenthal, 1980, ill. p. 93.

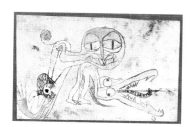

Page 100
The Hypocrites, 1919

PROVENANCE
Moderne Galerie Heinrich Thannhäuser,
Munich; Galerie Alfred Flechtheim,
Berlin; James J. Sweeney, New York;
M. Knoedler & Co., Inc., New York,
1959; Heinz Berggruen, 1960.

EXHIBITIONS
New York, 1948, cat. no. 38, ill.; Frank-
furt am Main, 1968, cat. no. 37, ill. and
on the cover.

Page 102
Lady Inclining Her Head, 1919

PROVENANCE
Werner Vowinckel, Cologne-Marienburg;
Ewald Rathke, Frankfurt am Main;
Heinz Berggruen, 1981.

EXHIBITIONS
Düsseldorf, 1930, cat. no. 64 (as *Frau*);
Düsseldorf, 1931, cat. no. 129 (as *Frau*);
London, October–November 1959, cat.
no. 67; Cologne, 1979, cat. no. 21, ill.
p. 162 (as *Weiblicher Akt*); Munich,
1979–80, cat. no. 405, ill. p. 501 (as *Roter
Akt [Dame mit geneigtem Haupt]*).

Page 104
Theater-Mountain-Construction,
1920

PROVENANCE
Dr. Hugelshofer, Zürich; Heinz Berg-
gruen; Sale, Bern, Galerie Kornfeld,
June 23–25, 1982, no. 379; Heinz Berg-
gruen, 1982.

EXHIBITIONS
Munich, 1925, cat. no. 3; Zürich, 1929,
cat. no. 49; New York, 1985.

Page 107
Episode at Kairouan, 1920

PROVENANCE
Marianne von Werefkin, Ascona; André
Breton, Paris; Simone Kahn, Paris; Heinz
Berggruen, 1981.

EXHIBITIONS
Munich, 1920, cat. no. 248; New York,
1936–37, cat. no. 233; Paris, 1969–70,
cat. no. 38, ill. p. 7; New York, 1985;
Canberra, 1986, ill. p. 45.

BIBLIOGRAPHY
Der Ararat, 1920, no. 248, p. 24.

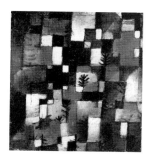

Page 110
Redgreen and Violet-Yellow
Rhythms, 1920

PROVENANCE
Hans Goltz, Neue Kunst, Munich, April
1921; Paul Erich Küppers, Hannover;
Sophie Küppers Lissitzky, Novosibirsk,
U.S.S.R.; Carlo Kos, Klagenfurt, 1955;
Sale, London, Sotheby's, July 2–3, 1974,
no. 92; Heinz Berggruen, 1974.

EXHIBITIONS
Munich, 1920, cat. no. 29 (as *Rotgrüne
und violettgelbe Rhythmen*); Munich,
1979–80, cat. no. 411, ill. p. 506.

BIBLIOGRAPHY
Der Ararat, 1920, no. 29, p. 21.

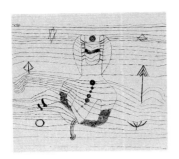

Page 112
Rider Unhorsed and Bewitched, 1920

PROVENANCE
Curt Valentin, Buchholz Gallery, New York; Benjamin Baldwin, East Hampton, 1935; Donald Young, Chicago; Xavier Fourcade, New York, 1982; Heinz Berggruen, 1983.

BIBLIOGRAPHY
Grohmann, 1934, no. 15, p. 18; Grohmann, 1954, ill. p. 159; Gonthier, 1964, ill. on the cover; Henry, 1976, fig. 172, ill. p. 304; Rosenthal, 1979, fig. 98, ill. p. 301.

Page 115
Drawing Knotted in the Manner of a Net, 1920

PROVENANCE
Estate of Paul Klee, Bern; Galerie Rosengart, Lucerne, 1948; Ruth Vollmer, New York, 1952; The Museum of Modern Art, New York, 1982; Hirschl & Adler Modern, New York, 1983; James Goodman Gallery, New York, 1983; Heinz Berggruen, 1983.

Page 117
Lovers, 1920

PROVENANCE
Hans Goltz, Neue Kunst, Munich, Dec. 1920; Baron J. B. Urvater, Brussels; Galerie Rosengart, Lucerne, 1965; Stephan Hahn Gallery, New York, 1971; Heinz Berggruen, 1975.

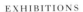

EXHIBITIONS
Amsterdam, 1957, cat. no. 28, ill.; Brussels, 1957, cat. no. 28, ill.; Otterlo, 1957, cat. no. 58; London, 1958, cat. no. 42; Essen, 1969, cat. no. 47, ill. p. 61; Paris, 1969–70, cat. no. 42, ill.

BIBLIOGRAPHY
Langui, 1957, no. 58, ill.

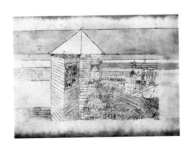

Page 119
Miraculous Landing, or the "112!," 1920

PROVENANCE
Wilhelm Hausenstein, Munich, March 1921 (as a gift from Klee); Baron J. B. Urvater, Brussels; Galerie Beyeler, Basel, 1961; Heinz Berggruen, 1963.

EXHIBITIONS
Bern, 1947, cat. no. 231; Amsterdam, 1957, cat. no. 29, ill.; Brussels, 1957, cat. no. 29, ill.; Otterlo, 1957, cat. no. 59; London, 1958, cat. no. 43; Basel, 1963, cat. no. 15, ill. p. 17; Paris, 1971, cat. no. 2; Saint-Paul, 1977, cat. no. 30, ill. p. 49; London, 1978, cat. no. 8.17; Cologne, 1979, cat. no. 31, ill. p. 168; New York, 1985; Canberra, 1986, ill. p. 45.

BIBLIOGRAPHY
Langui, 1957, no. 59, ill.; Ueberwasser, 1963, ill. p. 550; Felix Klee, 1964, pl. 5; Ferrier, 1971, ill. p. 95; Abadie, 1977, ill. p. 49.

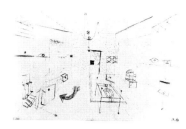

Page 120
Phantom Perspective, 1920

PROVENANCE
Private collection, Switzerland; Sale, Bern, Kornfeld und Klipstein, June 8, 1961, no. 54; Heinz Berggruen, 1961.

EXHIBITIONS
Düsseldorf, 1967, ill. p. 25; Frankfurt am Main, 1968, cat. no. 39, ill.; Paris, 1969–70, cat. no. 164, ill.; Paris, 1971, cat. no. 4; Saint-Paul, 1977, cat. no. 31, ill. p. 61; New York, 1985.

BIBLIOGRAPHY
Glaesemer, 1979, fig. b, ill. p. 146.

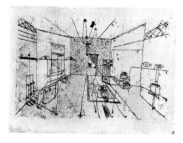

Page 123
Phantom Perspective, 1920

PROVENANCE
Hans Goltz, Neue Kunst, Munich, Dec. 1921; Private collection, Chicago; Heinz Berggruen, San Francisco, 1937.

EXHIBITIONS
Berlin, 1921, cat. no. 924; Paris, 1925, cat. no. 16; Frankfurt am Main, 1968, cat. no. 39, ill.; Paris, 1971, cat. no. 5; Saint-Paul, 1977, cat. no. 31, ill. p. 61; London, 1978, cat. no. 8.18; New York, 1985; Canberra, 1986, ill. p. 44.

BIBLIOGRAPHY
Courthion, 1953, pl. 19; Felix Klee, 1964, pl. 4; UNESCO, 1965, no. 656, ill. p. 236; Ferrier, 1971, ill. pp. 38–39; Abadie, 1977, ill. p. 61.

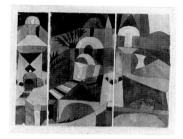

Page 125
Temple Gardens, 1920

PROVENANCE
Estate of Paul Klee, Bern; Galerie Rosengart, Lucerne, 1947; Lorenzo Montano, Lugano, 1947; Danilo Lebrecht, Geneva, 1950s; Private collection, Geneva; Sale, London, Christie's, November 30, 1976, no. 66; Heinz Berggruen, 1976.

EXHIBITIONS
Basel, 1941, cat. no. 163; Saint-Paul, 1977, cat. no. 32, ill. p. 40; Cologne, 1979, cat. no. 32, ill. p. 181; Munich, 1979–80, cat. no. 436, ill. p. 525; New York, 1985.

BIBLIOGRAPHY
Abadie, 1977, ill. p. 40; Kersten, 1987, pp. 64–65, ill. pp. 64 and 65.

Page 128
Where the Eggs and the Good Roast Come From, 1921

PROVENANCE
Florina-Irene Galston, Munich, 1921; Dean J. A. McClain, Jr., Duke University, Durham, N.C., 1951; J. B. Neumann, New Art Circle, New York; F. C. Schang, New York, 1955; Heinz Berggruen, 1972.

EXHIBITIONS
Durham, N.C., 1951, no. 6; New York, 1967, cat. no. 40, ill. p. 41; Basel, 1967, cat. no. 45, ill.

BIBLIOGRAPHY
Kagan, 1983, fig. 47, ill. p. 107.

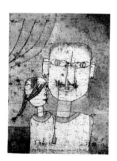

Page 130
Adam and Little Eve, 1921

PROVENANCE
Alexei von Jawlensky, Wiesbaden, 1921; Richard Doetsch-Benzinger, Basel; Sale, Bern, Kornfeld und Klipstein, May 24, 1962, no. 126 (archive and part of collection of J. B. Neumann. However, this work was not part of Neumann's collection); Norman Granz, Beverly Hills; Sale, New York, Sotheby's, November 2, 1978, no. 141; Heinz Berggruen, 1978.

EXHIBITIONS
Geneva, 1959, cat. no. 7; Paris, 1969–70, cat. no. 46, ill.; Paris, 1971, cat. no. 15; Cologne, 1979, cat. no. 36, ill. p. 169.

BIBLIOGRAPHY
Felix Klee, 1963, ill. p. (41); Ferrier, 1971, ill. pp. 50–51.

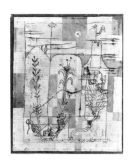

Page 132
Tale à la Hoffmann, 1921

PROVENANCE
Hans Goltz, Neue Kunst, Munich; Curt
Valentin, Buchholz Gallery, New York;
Nelson A. Rockefeller, New York, 1952;
Alfred H. Barr, Jr., New York, 1952 (gift
from Rockefeller); E.V. Thaw & Co., Inc.,
New York, 1978; Heinz Berggruen, 1979.

EXHIBITIONS
New York, 1987, ill. p. 167; Cleveland,
1987, ill. p. 167; Bern, 1987–88, cat. no.
103, ill. p. 179.

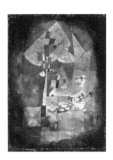

Page 135
The Man Under the Pear Tree,
1921

PROVENANCE
Lily Klee, Bern; Rolf Bürgi, Belp, Bern;
Heinz Berggruen, 1957.

EXHIBITIONS
Munich, 1921, cat. no. 93; London,
1945–46, cat. no. 49; London, 1946, cat.
no. 14; Bern, August 11–November 4,
1956, cat. no. 446; Paris, 1971, cat. no. 12,
ill. and on the cover.

BIBLIOGRAPHY
Felix Klee, 1964, pl. 6; Ferrier, 1971, ill.
p. 46; Glaesemer, 1973, ill. p. 259.

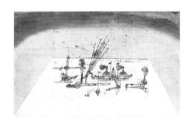

Page 137
Yellow Harbor, 1921

PROVENANCE
Curt Valentin, Buchholz Gallery, New
York; Nelson A. Rockefeller, New York,
1950; Heinz Berggruen, 1977.

EXHIBITIONS
Munich, 1921, cat. no. 99; Wellesley,
Mass., 1950; Palm Beach, 1951, no. 19;
New York, 1969, p. 132.

BIBLIOGRAPHY
Miller, 1981, ill. p. 114.

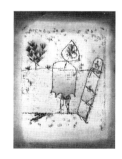

Page 139
Winter Journey, 1921

PROVENANCE
Dr. and Mrs. Eric Ponder, U.S.A., 1951;
Gustav Kahnweiler, London; Heinz Berg-
gruen, 1962.

EXHIBITIONS
Munich, 1921, cat. no. 101; Brussels,
Galerie "L'Époque," 1928, cat. no. 15;
Palm Beach, 1951, cat. no. 17; Paris, 1971,
cat. no. 13.

BIBLIOGRAPHY
Spiller, 1962, ill. p. 26; Felix Klee, 1964,
pl. 7; Henry, 1976, fig. 319, ill. p. 377;
Glaesemer, 1984, ill. p. 13.

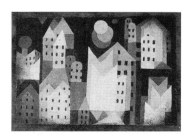

Page 140
Cold City, 1921

PROVENANCE
Hans Goltz, Neue Kunst, Munich; Städ-
tische Kunsthalle Mannheim, 1925–37;
confiscated in 1937 as "degenerate art"
and taken to Berlin; Curt Valentin,
Buchholz Gallery, New York (between
1937–40); Elodie E. Osborn, Salisbury,
Conn., 1940; E. V. Thaw & Co., Inc., New
York, 1974; Heinz Berggruen, 1974.

EXHIBITIONS
Munich, 1921, cat. no. 117; Düsseldorf,
1922, cat. no. 733; Mannheim, 1924;
Mannheim, 1927, no. 151; Mannheim,
1933, no. 8; New York, Buchholz Gal-
lery/Willard Gallery, 1940, no. 24;
Munich, 1979–80, cat. no. 445, ill. p. 531;
New York, 1985; Düsseldorf, 1987, cat.
no. 31, ill. p. 33.

BIBLIOGRAPHY
Grohmann, 1929, no. 17, ill. p. 10; Crevel,
1930, ill. p. 22.

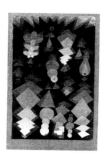

Page 145
Suspended Fruit, 1921

PROVENANCE
Galka E. Scheyer, Hollywood (after 1924); Sale, Stuttgarter Kunstkabinett, Roman Norbert Ketterer, May 10–12, 1950, no. 1488; Curt Valentin, Buchholz Gallery, New York; Clifford Odets, New York, 1951; Heinz Berggruen, 1965.

EXHIBITIONS
Waltham, Mass., 1960, cat. no. 7; Denver, 1963, no. 16, ill. on checklist; Paris, 1969–70, cat. no. 52, ill.; Paris, 1971, cat. no. 11; Berlin, 1974, cat. no. 52, ill. p. 115; Munich, 1979–80, cat. no. 446, ill. p. 531.

BIBLIOGRAPHY
Grohmann, 1954, ill. p. 165; San Lazzaro, 1957, no. 34, ill. p. 263; Ferrier, 1971, ill. pp. 54–55; Henry, 1976, fig. 126, ill. p. 282; Verdi, 1985, fig. 103, ill. p. 114.

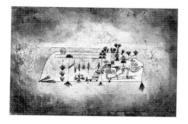

Page 146
All Souls' Picture, 1921

PROVENANCE
Madame Tak van Bortvliet, The Hague; Jan W. E. Buys, The Hague; C. L. Fischer, Nunspeet, The Netherlands; Stiftung Bô Yin Râ, Lugano; Sale, Amsterdam, Sotheby's, November 15, 1976, no. 267; Heinz Berggruen, 1976.

EXHIBITIONS
Saint-Paul, 1977, cat. no. 37, ill. p. 62; Cologne, 1979, cat. no. 47, ill. p. 163; Munich, 1979–80, cat. no. 452, ill. p. 537.

BIBLIOGRAPHY
Abadie, 1977, ill. p. 62.

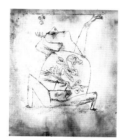

Page 148
The Pathos of Fertility, 1921

PROVENANCE
Galka E. Scheyer, Hollywood (after 1924); Nierendorf Galleries, New York; Estate of Karl Nierendorf; The Solomon R. Guggenheim Museum, New York, 1948; Ernst Beyeler, Basel, 1971; Heinz Berggruen, 1974.

EXHIBITIONS
San Francisco, 1941, no. 17; New York, 1947, no. 26; Basel, 1973, cat. no. 17; Tokyo, 1981, cat. no. 8, ill. p. 35.

BIBLIOGRAPHY
Barrière, 1974, ill. p. 109.

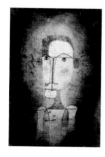

Page 150
Portrait of a Yellow Man, 1921

PROVENANCE
"Die Gesellschaft für Förderung deutscher Kunst des 20. Jahrhunderts," Neuss am Rhein, 1921–22; Family of Johannes Geller, Neuss am Rhein, 1924–55; Sale, Stuttgarter Kunstkabinett, Roman Norbert Ketterer, December 1, 1955, no. 1387; Heinz Berggruen, 1955.

EXHIBITIONS
Düsseldorf, 1930, cat. no. 77 (as *Antlitz des Gelben*); Saarbrücken, 1930, cat. no. 108; Paris, 1959, ill.; Paris, 1971, cat. no. 10.

BIBLIOGRAPHY
Grohmann, 1958, pl. 3; Felix Klee, 1964, pl. 8; Fisher, 1966, pl. 21; Ferrier, 1971, ill. p. 50.

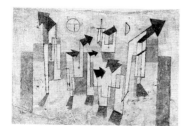

Page 152
Mural from the Temple of Longing ↖ Thither ↗, 1922

PROVENANCE
Otto Ralfs, Brunswick, 1923 (bought directly from the artist); Private collection, Jersey Island; Private collection, London; Grabowski Gallery, London; Sale, London, Christie's, March 30, 1981, no. 65; Heinz Berggruen, 1981.

EXHIBITIONS
Munich, 1922, cat. no. 152; Berlin, 1928, cat. no. 50a; Berlin, 1930, no. 32; Hannover, 1931; Duisburg, 1974–75, fig. 27, ill. p. 34; New York, 1985; New York, 1987, ill. pp. 67 and 175; Cleveland, 1987, ill. pp. 67 and 175; Bern, 1987–88, cat. no. 112, ill. pp. 16 and 187.

BIBLIOGRAPHY
Grohmann, 1924, ill. p. 790; Grohmann, 1929, no. 19, ill. p. 11; Willrich, 1937, fig. 38, ill. p. 87; Spiller, 1961, ill. p. 406; Güse, 1982, p. 67; Glaesemer, 1987 (New York), ill. p. 67; Glaesemer, 1987 (Bern), ill. p. 16.

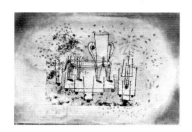

Page 154
The Chair-Animal, 1922

PROVENANCE
Nierendorf Galleries, New York; Estate of
Karl Nierendorf, New York; The Solomon
R. Guggenheim Museum, New York,
1948; Roswitha Haftmann, Zürich, 1973;
Heinz Berggruen, 1974.

EXHIBITIONS
Munich, 1922, cat. no. 161; Munich,
1925, cat. no. 60; New York, 1952;
Toronto, 1954, cat. no. 37.

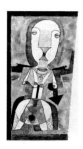

Page 157
Popular Wall-Painting, 1922

PROVENANCE
Estate of Paul Klee, Bern; Rolf Bürgi,
Belp, Bern; Galerie Rosengart, Lucerne,
1953; Jacques Benador, Geneva; James
Wise, Vence, France; Sale, Bern,
Kornfeld und Klipstein, May 27–29,
1964, no. 619; Private collection,
Switzerland; Sale, London, Christie's,

June 30, 1981, no. 131; Heinz Berggruen,
1981.

EXHIBITIONS
Geneva, 1960, cat. no. 26, ill.; London,
1961, cat. no. 5, ill.; Geneva, 1965, cat.
no. 3, ill.; London, Brook Street Gallery,
1966, cat. no. 8, ill.

BIBLIOGRAPHY
Rosenthal, 1979, ill. p. 252.

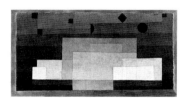

Page 158
The Firmament Above the Temple, 1922

PROVENANCE
Alfred Rose, Hannover; Professor Kurt
Wilhelm, Brunswick, Dortmund,
Jerusalem, and Stockholm, 1927–79;
Galerie Bel'Art, Stockholm, 1979; Private
collection, Switzerland, 1979; Sale,

London, Sotheby's, 1979, no. 155; Heinz
Berggruen, 1979.

EXHIBITIONS
Cologne, 1979, cat. no. 65, ill. p. 214;
New York, 1985; Canberra, 1986, ill.
p. 43.

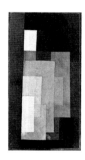

Page 160
Tower in Orange and Green, 1922

PROVENANCE
Estate of Paul Klee, Bern; Galerie Rosen-
gart, Lucerne, 1949; Charlotte Picher
Purcell, Chicago, 1949; Joseph Faulkner,
Chicago; Sale, New York, Sotheby's, No-
vember 6, 1981, no. 542; Heinz Berg-
gruen, 1981.

EXHIBITIONS
Des Moines, 1973, cat. no. 9, ill.; New
York, 1985; Canberra, 1986, ill. p. 43.

BIBLIOGRAPHY
Spiller, 1961, p. 483.

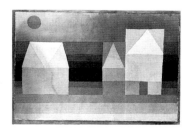

Page 163
Three Houses, 1922

PROVENANCE
Curt Valentin, Buchholz Gallery, New
York; F. C. Schang, New York, 1950;
Heinz Berggruen, 1963.

EXHIBITIONS
Munich, 1925, cat. no. 61; Palm Beach,
1951, cat. no. 20; Minneapolis, 1955, no.
7; Bern, August 11–November 4, 1956,
cat. no. 470; Paris, 1971, cat. no. 17;
Berlin, 1974, cat. no. 55, ill. p. 116; New
York, 1985; Canberra, 1986, ill. p. 43.

BIBLIOGRAPHY
San Lazzaro, 1957, no. 42, ill. p. 265;
Spiller, 1961, p. 483; Felix Klee, 1963, ill.
p. (43); Felix Klee, 1964, pl. 9; Ferrier,
1971, ill. pp. 58–59; Geelhaar, 1973,
p. 36; Henry, 1976, fig. 182, ill. p. 309.

Page 164
The Last Adventure of the Knight Errant, 1922

PROVENANCE
Curt Valentin, Buchholz Gallery, New York; F. C. Schang, New York, 1951; Estate of Victor Babin, Cleveland, 1979; Serge Sabarsky, New York; Heinz Berggruen, 1981.

BIBLIOGRAPHY
Grohmann, 1934, no. 15.

Page 166
Window Display for Lingerie, 1922

PROVENANCE
Curt Valentin, Buchholz Gallery, New York; Frank Perls Galleries, Beverly Hills, 1955; Donald McNeil, Los Angeles; Ronald Feldman, New York; Heinz Berggruen, 1973.

EXHIBITIONS
Wiesbaden, 1924, cat. no. 37; Munich, 1925, cat. no. 70; New York, 1953, cat. no. 8, ill.; New York, 1987, ill. p. 17; Cleveland, 1987, ill. p. 17; Bern, 1987–88, cat. no. 118, ill. p. 190.

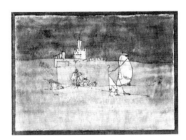

Page 170
Episode Before an Arab Town, 1923

PROVENANCE
Louis Gittler, New York; E. V. Thaw & Co., Inc., New York, 1969; Heinz Berggruen, 1969.

BIBLIOGRAPHY
Ferrier, 1971, ill. p. 71; Abadie, 1977, ill. p. (74); Duvignaud, 1980, ill. pp. 78–79.

EXHIBITIONS
Paris, 1971, cat. no. 29; Saint-Paul, 1977, cat. no. 53, ill. p. (74); Cologne, 1979, cat. no. 94, ill. p. 20; New York, 1985; Canberra, 1986, ill. p. 45.

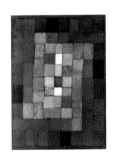

Page 173
Static-Dynamic Gradation, 1923

PROVENANCE
Ida Bienert, Dresden and Munich; Hermann Rupf, Bern; Peter Nathan, Galerie Nathan, Zürich, 1976; Heinz Berggruen, 1976.

EXHIBITIONS
Winterthur, 1952, cat. no. 53; Bern, 1987–88, cat. no. 129, ill. p. 198.

BIBLIOGRAPHY
Grohmann, 1933, p. 21; Awazu, 1968, pl. 13; Nakahara, 1971, pl. 24 and ill. p. 120; Ponente, 1960, ill. p. 68; Kagan, 1977, p. 103; Teuber, 1979–80, p. 284; Triska, 1979, ill. p. 65; Triska, 1980, fig. 27.

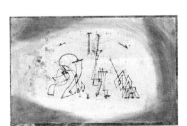

Page 177
Abstract Trio, 1923

PROVENANCE
J. B. Neumann, New Art Circle, New York; Alfred H. Barr, Jr., New York, 1930; E. V. Thaw & Co., Inc., New York, 1980; Heinz Berggruen, 1980.

EXHIBITIONS
Basel, 1929, cat. no. 123; Berlin, Galerie Ferdinand Möller, 1929, cat. no. 118; New York, 1930, cat. no. 3, ill.; New York, 1936, cat. no. 109, ill. p. 181; New York, Buchholz Gallery, 1940, no. 33; New York, 1941, cat. no. 21; Philadelphia, 1944, cat. no. 14.

BIBLIOGRAPHY
Miller, 1945, ill. p. 34; Lanchner, 1987 (New York), ill. p. 99; Lanchner, 1987 (Bern), ill. p. 100.

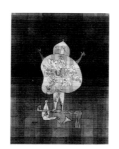

Page 178
Ventriloquist and Crier in the Moor, 1923

PROVENANCE
Lily Klee, Bern; Douglas Cooper, Argilliers, France, 1946; Heinz Berggruen, 1956.

EXHIBITIONS
Munich, 1925, cat. no. 84; Brussels, Galerie "L'Époque," 1928, cat. no. 7; Dresden, 1929, cat. no. 10; Saarbrücken, 1930, cat. no. 7; Hannover, 1931; London, 1945–46, cat. no. 67; London, 1946, cat. no. 23; New York, 1967, cat. no. 63, ill.; Basel, 1967, cat. no. 69; Turin, 1967–68,

cat. no. 96, ill. p. 73; Frankfurt am Main, 1968, cat. no. 42, ill.; Paris, 1969–70, cat. no. 63, ill.; Paris, 1971, cat. no. 24; Cologne, 1979, cat. no. 101, ill. p. 93; New York, 1987, ill. p. 186; Cleveland, 1987, ill. p. 186.

BIBLIOGRAPHY
Einstein, 1926, ill. p. 538; *Cahiers d'Art*, 1945–46, ill. p. 40; Grohmann, 1954, ill. p. 193; Grohmann, 1955, pl. 6, ill.; San Lazzaro, 1957, no. 46, ill. p. 265; Felix Klee, 1964, pl. 11; Lamac, 1965, pl. IX; Ferrier, 1971, ill. p. 98; Nakahara, 1971, pl. 17 and ill. p. 117; Kagan, 1983, fig. 54, ill. p. (113); Laude, 1984, ill. p. 494; Glaesemer, 1984, ill. p. 15.

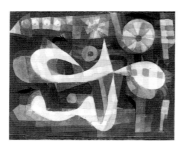

Page 180
The Barbed Noose with the Mice, 1923

PROVENANCE
Curt Valentin, Buchholz Gallery, New York; F. C. Schang, New York, 1950; Heinz Berggruen, 1978.

EXHIBITIONS
Wiesbaden, 1925, cat. no. 65; Munich, 1925, cat. no. 86; Gera, 1925–26, cat. no. 13; Palm Beach, 1951, cat. no. 24, ill.; Minneapolis, 1955, no. 12; Bern, August 11–November 4, 1956, cat. no. 493; Geneva, 1959, cat. no. 5, ill.

BIBLIOGRAPHY
Courthion, 1953, no. 3, ill.; Marchiori, 1960, ill.

Page 183
Classical Grotesque, 1923

PROVENANCE
Sale, Stuttgarter Kunstkabinett, Roman Norbert Ketterer, May 28–29, 1957, no. 463; Mr. and Mrs. John L. Strauss, Chicago; Bud Holland and Grace Hokin, Chicago; Heinz Berggruen, 1973.

EXHIBITIONS
Munich, 1925, cat. no. 104; Chicago, 1962, cat. no. 28.

BIBLIOGRAPHY
Grohmann, 1924, ill. p. 790.

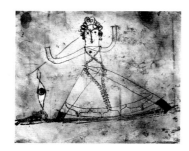

Page 184
Strange Garden, 1923

PROVENANCE
Private collection, Bern (directly from the artist); Galerie Rosengart, Lucerne, 1966; Peter Benzinger, Chicago, 1967; Heinz Berggruen, 1971.

EXHIBITIONS
Bern, 1940, cat. no. 92; Paris, 1971, cat. no. 26; Cologne, 1979, cat. no. 108, ill. p. 211; New York, 1987, ill. p. 199; Cleveland, 1987, ill. p. 199; Bern, 1987–88, cat. no. 136, ill. p. 209.

BIBLIOGRAPHY
Ferrier, 1971, ill. p. 75; Geelhaar, 1973, pp. 59–65, ill. p. 61; Henry, 1976, fig. 53, ill. p. 246.

Page 187
Structural I, 1924

PROVENANCE
G. David Thompson, Pittsburgh; Heinz Berggruen, 1977.

EXHIBITIONS
Munich, 1925, cat. no. 141; Zürich, 1926, cat. no. 80; New York, 1958, cat. no. 55, ill.; New York, 1960, cat. no. 16.

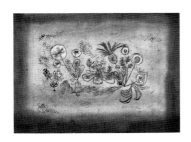

Page 188

Medicinal Flora, 1924

PROVENANCE
Nierendorf Galleries, New York; Estate of
Karl Nierendorf, New York; The Solomon
R. Guggenheim Museum, New York,
1948; Galerie Beyeler, Basel, 1971; Heinz
Berggruen, 1972.

EXHIBITIONS
Dresden, 1926, cat. no. 40; New York,
1947, no. 16.

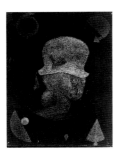

Page 191

**Astrological Fantasy Portrait,
1924**

PROVENANCE
Nierendorf Galleries, New York; Estate of
Karl Nierendorf, New York; The Solomon
R. Guggenheim Museum, New York,
1948; Roswitha Haftmann, Zürich, 1973;
Heinz Berggruen, 1974.

EXHIBITIONS
New York, 1987, ill. p. 200; Cleveland,
1987, ill. p. 200.

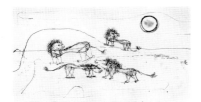

Page 192

**A Pride of Lions (Take Note!),
1924**

PROVENANCE
Otto Ralfs, Brunswick; Curt Valentin,
Buchholz Gallery, New York, 1946;
Clifford Odets, New York; J. B. Neu-
mann, New Art Circle, New York, 1953;
E. & A. Silberman Galleries, Inc., New
York; Saidenberg Gallery, Inc., New

York, 1955; Robert F. Woolworth, San
Francisco, 1957; Sale, New York,
Sotheby's, May 19, 1966, no. 2; James
Shapiro, New York; Heinz Berggruen,
1979.

EXHIBITIONS
Munich, 1925, cat. no. 175, ill.; Berlin,
1930, cat. no. 38; New York, 1955, cat.
no. 16; Tokyo, 1981, cat. no. 13, ill. p. 38.

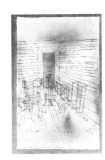

Page 195

**Ghost Chamber with the Tall
Door (New Version), 1925**

PROVENANCE
Folkwang Museum, Essen (by 1929);
Curt Valentin, Buchholz Gallery, New
York, c. 1938; Davidson Taylor, New
York; Sale, New York, Sotheby's, April
26, 1972, no. 101; Heinz Berggruen, 1972.

EXHIBITIONS
Dresden, 1926, cat. no. 49; Essen, 1928,
cat. no. 500; New York, Buchholz Gal-

lery, 1940, no. 12; New York, Buchholz
Gallery/Willard Gallery, 1940, cat. no. 49;
Paris, 1974, cat. no. 616, ill. p. 33; New
York, 1985; Canberra, 1986, ill. p. 44.

BIBLIOGRAPHY
Waldstein, 1929, no. 533, p. 47;
Grohmann, 1954, p. 233; Grohmann,
1957, ill. p. 18; Glaesemer, 1979, fig. d,
ill. p. 146; Schuster, 1987, p. 166, ill.
p. 167.

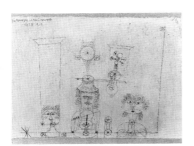

Page 198

**In Memory of an All-Girl Band,
1925**

PROVENANCE
Curt Valentin, Buchholz Gallery, New
York; Edgar Kaufmann, Jr., New York;
Saidenberg Gallery, Inc., New York,
1976; Heinz Berggruen, 1976.

EXHIBITIONS
Gera, 1925–26, cat. no. 18; New York, 1950,
cat. no. 31; New York, 1987, ill. p. 204;
Cleveland, 1987, ill. p. 204; Bern,
1987–88, cat. no. 156, ill. p. 228.

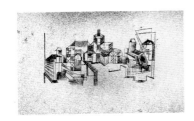

Page 200
View of a Fortress, 1925

PROVENANCE
E. V. Thaw & Co., Inc., New York; Heinz
Berggruen, 1962.

EXHIBITIONS
Paris, 1971, cat. no. 45; New York, 1985.

Page 202
May Picture, 1925

PROVENANCE
Alexei von Jawlensky, Wiesbaden; Estate
of Alexei von Jawlensky, Wiesbaden; Lisa
Kümmel, Wiesbaden; Private collection,
Germany, 1944; Heinz Berggruen, 1971.

EXHIBITIONS
Zürich, 1926, cat. no. 32; Wiesbaden,
1929, cat. no. 17; Paris, 1971, cat. no. 48.

BIBLIOGRAPHY
Triska, 1980, fig. 28; Geelhaar, 1982, ill.
p. 45.

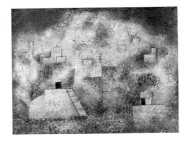

Page 204
Oriental Pleasure Garden, 1925

PROVENANCE
Theodor Werner, Berlin, 1953; Marlbor-
ough Fine Art Limited, London; Sidney
Janis Gallery, New York, 1958; Heinz
Berggruen, 1959; Peter Benzinger, Chi-
cago, 1965; Stephen Hahn, New York,
1973; Heinz Berggruen, 1974.

EXHIBITIONS
Zürich, 1926, cat. no. 21; Wiesbaden,
1926, cat. no. 12; Wiesbaden, 1929, cat.
no. 16; New York, 1939, no. 13; Han-
nover, 1952, cat. no. 55; Lucerne, 1953,
cat. no. 276; London, Summer, 1959, cat.
no. 36, ill. p. 53; Chicago, 1962, cat. no.
20; Saint-Paul, 1977, cat. no. 69, ill.
p. (88); London, 1978, cat. no. 9.29, ill.
p. 212; New York, 1985; Canberra, 1986,
ill. p. 40; New York, 1987, ill. p. 210;
Cleveland, 1987, ill. p. 210; Bern,
1987–88, cat. no. 158, ill. p. 224.

BIBLIOGRAPHY
Abadie, 1977, ill. p. (90); Duvignaud,
1980, ill. p. (14).

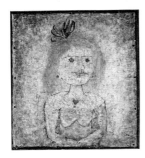

Page 209
Small Portrait of a Girl in Yellow, 1925

PROVENANCE
Galka E. Scheyer, Hollywood; Richard
Sisson, New York, c. 1944; E. V. Thaw &
Co., Inc., New York, c. 1960; F. C.
Schang, New York; Heinz Berggruen,
1970.

EXHIBITIONS
Zürich, 1926, cat. no. 28; Wiesbaden,
1926, cat. no. 21; Palm Beach, 1951, cat.
no. 31; New York, 1955, cat. no. 18; New
York, 1967, cat. no. 78, ill. p. 67; Paris,
1971, cat. no. 42; Saint-Paul, 1977, cat.
no. 68, ill. p. 92; Cologne, 1979, cat. no.
161, ill. p. 250.

BIBLIOGRAPHY
San Lazzaro, 1957, ill. p. 96; Ferrier,
1971, ill. p. 31; Abadie, 1977, ill. p. 92.

Page 210
Bird Landscape, 1925

PROVENANCE
Galerie Alfred Flechtheim, Berlin; Curt
Valentin, Buchholz Gallery, New York;
Estella Katzenellenbogen, Los Angeles
(after 1945); Marianne and Walter F.
Feilchenfeldt, Zürich, 1976; Eberhard W.
Kornfeld, Bern; Heinz Berggruen, 1976.

EXHIBITIONS
Düsseldorf, 1931, cat. no. 172; Tokyo,
1981, cat. no. 19, ill.

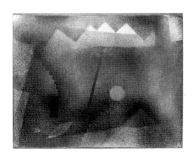

Page 213
Bird Wandering Off, 1926

PROVENANCE
Rolf Bürgi, Belp, Bern; Galerie Beyeler, Basel, 1973; Private collection, Switzerland, 1974; Thomas Gibson, London, c. 1980; Heinz Berggruen, 1980.

EXHIBITIONS
Paris, 1927, no. 5; Berlin, Galerie Alfred Flechtheim, 1929, cat. no. 71; Bern, 1931, cat. no. 28; Bern, 1937, no. 40; Bern, February 4–April 2, 1956, cat. no. 550; Hamburg, 1956–57, cat. no. 210; Basel, 1973, cat. no. 34, ill.; New York, 1987, ill. p. 218; Cleveland, 1987, ill. p. 218; Bern, 1987–88, cat. no. 170, ill. p. 231.

BIBLIOGRAPHY
Walterskirchen, 1975, ill. p. 43.

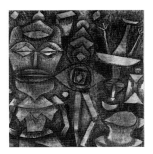

Page 214
Collection of Figurines, 1926

PROVENANCE
Nierendorf Galleries, New York; Estate of Karl Nierendorf, New York; The Solomon R. Guggenheim Museum, New York, 1948; Galerie Beyeler, Basel, 1972; Ronald Feldman, New York, 1972; Heinz Berggruen, 1974.

EXHIBITIONS
Hollywood, 1930, cat. no. 20.

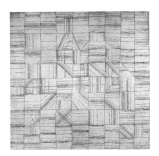

Page 217
Still Life, 1927

PROVENANCE
Galka E. Scheyer, Hollywood; Marjorie Eaton, San Francisco; Mrs. Adolph Mack, San Francisco; Mrs. de Schulthess, Los Angeles; Heinz Berggruen, 1959.

EXHIBITIONS
San Francisco, 1931, cat. no. 30; San Francisco, 1940, cat. no. 160; San Francisco, 1941; Paris, 1971, cat. no. 55; New York, 1987, ill. p. 230.

BIBLIOGRAPHY
The Museum of Modern Art, 1941, ill. and on the cover; *Du*, 1948, ill.; Ferrier, 1971, ill. pp. 86–87; Geelhaar, 1973, pp. 107–8, ill. p. 109.

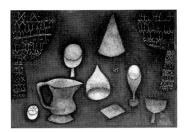

Page 219
Under Water, 1927

PROVENANCE
Galerie Beyeler, Basel; Galerie Otto Stangl, Munich; Ernst Fischer, Krefeld, c. 1962–64; Sale, Bern, Kornfeld und Klipstein, June 26, 1981, no. 109; Heinz Berggruen, 1981.

EXHIBITIONS
Bern, 1940, cat. no. 228; Düsseldorf, 1967, cat. no. 180; Frankfurt am Main, 1968, cat. no. 49, ill.; Cologne, 1979, cat. no. 221, ill. p. 271.

BIBLIOGRAPHY
Grohmann, 1934, no. 193; Spiller, 1973, ill. p. 134; Wada, 1980, fig. 290, ill. p. 99; Verdi, 1985, fig. 65, ill. p. 73.

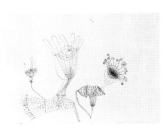

Page 221
Variations (Progressive Motif), 1927

PROVENANCE
Daniel-Henry Kahnweiler, Galerie Simon, Paris, 1933 (directly from the artist); Heinz Berggruen, 1973.

EXHIBITIONS
Berlin, 1928, cat. no. 19; Brussels, Galerie Le Centaure, 1928, no. 25; Paris, 1929, no. 24; Berlin, Galerie Alfred Flechtheim, 1929, cat. no. 77; New York, 1930, cat. no. 20, ill.; Düsseldorf, 1931, cat. no. 38; Frankfurt am Main, 1950, ill. p. 15; Berlin, 1974, cat. no. 62, ill. p. 116; New York, 1987, ill. p. 225; Cleveland, 1987, ill. p. 225; Bern, 1987–88, cat. no. 177, ill. pp. 95 and 237.

BIBLIOGRAPHY
Miller, 1945, ill. p. 40; Kahnweiler, 1950, ill.; San Lazzaro, 1957, no. 67, ill. p. 268; Spiller, 1961, ill. p. 28; Wada, 1980, fig. 400, ill. p. 125; Lanchner, 1987 (New York), ill. p. 95; Lanchner, 1987 (Bern), ill. p. 95.

Page 223
Statuettes of Disabled War
Heroes, 1927

PROVENANCE
Curt Valentin, Buchholz Gallery, New
York; F. C. Schang, New York, 1951;
Galerie Rosengart, Lucerne, 1952; Ruth
Vollmer, New York, 1952; The Museum
of Modern Art, New York, 1982; Hirschl

& Adler Modern, New York, 1983; James
Goodman Gallery, New York, 1983;
Heinz Berggruen, 1983.

BIBLIOGRAPHY
Grohmann, 1934, no. 204.

Page 224
Monuments at G., 1929

PROVENANCE
Daniel-Henry Kahnweiler, Galerie Si-
mon, Paris; Nierendorf Galleries, New
York; Mies van der Rohe, Chicago, 1939;
Private collection, West Germany, 1950;
Heinz Berggruen, 1980.

EXHIBITIONS
Berlin, Galerie Alfred Flechtheim, 1929,
cat. no. 122; New York, 1930, cat. no. 50;
Düsseldorf, 1931, cat. no. 81; Munich,
Bayerische Staatsgemäldesammlungen,
on loan from 1967–80; New York, 1985.

BIBLIOGRAPHY
Glaesemer, 1979, ill. p. 165.

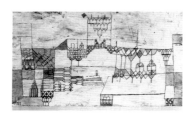

Page 228
Great Hall for Singers, 1930

PROVENANCE
Hannah Bürgi-Bigler, Bern; Rolf Bürgi,
Belp, Bern; Heinz Berggruen, 1979.

EXHIBITIONS
Basel, 1950, cat. no. 44, ill. p. 21; New
York, 1985.

BIBLIOGRAPHY
Cahiers d'Art, 1945–46, ill. p. 54; *Du*,
1948, ill. p. 31; Grohmann, 1954, no. 85,
ill. p. 394; San Lazzaro, 1957, ill. p. 149;
Spiller, 1973, ill. p. 244; Marnat, 1974,
pl. 45; Walterskirchen, 1975, ill. p. 18.

Page 233
North German City, 1930

PROVENANCE
Hans Meyer-Benteli, Bern; Curt Valentin,
Buchholz Gallery, New York; A. James
Speyer, Chicago, early 1940s; Harold Di-
amond, New York; Heinz Berggruen, 1977.

EXHIBITIONS
Bern, 1935, cat. no. 156; Basel, 1935, cat.
no. 102; Lucerne, 1936, cat. no. 119; New
York, 1939, no. 28; Des Moines, 1973,
cat. no. 50, ill.; Cologne, 1979, cat. no.
306, ill. p. 358; New York, 1985.

BIBLIOGRAPHY
p. h., 1935.

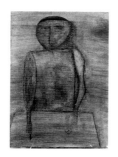

Page 235
Doctor, 1930

PROVENANCE
Hermann Rupf, Bern; Heinz Berggruen,
1955; Galerie Gérald Cramer, Geneva,
1955; Heinz Berggruen, 1976.

EXHIBITIONS
Paris, 1955, ill.; Tokyo, 1981, cat. no. 25,
ill. p. 59.

BIBLIOGRAPHY
Brion, 1955, pl. 41; Cramer, 1956, no. 74,
ill. p. 21.

Page 237
Episode B at Kairouan, 1931
PROVENANCE
Nierendorf Galleries, New York; Estate of Karl Nierendorf, New York; The Solomon R. Guggenheim Museum, New York, 1948; Serge Sabarsky Gallery, New York, 1979; Heinz Berggruen, 1979.

EXHIBITIONS
Bern, 1940, cat. no. 232; New York, 1947, no. 12; New York, 1977, cat. no. 8, ill. p. (41); Tokyo, 1978, cat. no. 24, ill.; Osaka, 1979, cat. no. 13, ill. p. 23; Tokyo, 1981, cat. no. 26, ill. p. 61.

BIBLIOGRAPHY
Güse, 1982, ill. p. 95.

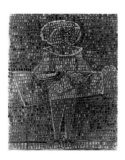

Page 238
Boy in Fancy Dress, 1931
PROVENANCE
Ida Bienert, Dresden and Munich; G. F. Hitchman, Herliberg, Zürich; Private collection, Monaco; Marlborough Fine Art Limited, London, 1966; Otto Preminger, New York; Heinz Berggruen, 1979.

EXHIBITIONS
Lucerne, 1953, cat. no. 291, ill.; Venice, 1954, no. 31; Bern, August 11–November 4, 1956, cat. no. 616; Hamburg, 1956–57, cat. no. 274; London, Marlborough Fine Art Limited, 1966, cat. no. 40, ill. p. 52 and on the cover.

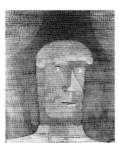

Page 242
Athlete's Head, 1932
PROVENANCE
Nierendorf Galleries, New York; Herman Schulman, New York, 1941; Harold Diamond, New York, 1974; Heinz Berggruen, 1974.

EXHIBITIONS
New York, Nierendorf Galleries, 1938, no. 56; Boston, 1939, cat. no. 63, ill.; New York, Buchholz Gallery/Willard Gallery, 1940, cat. no. 74; New York, 1941, cat. no. 53.

BIBLIOGRAPHY
Read, 1938, ill. p. 32; Nierendorf, 1941, pl. 38.

Page 244
Clarification, 1932
PROVENANCE
Galka E. Scheyer, Hollywood; The Estate of Galka E. Scheyer, 1945; Daniel-Henry Kahnweiler, Galerie Simon, Paris; J. B. Neumann, New Art Circle, New York, c. 1949; Heinz Berggruen; Markus Mizne, London, 1964; Sale, New York, Sotheby's, May 16–17, 1979, no. 285; Heinz Berggruen, 1979.

EXHIBITIONS
Los Angeles, 1940, no. 40; San Francisco, 1941, no. 3; New York, 1944, cat. no. 57; Beverly Hills, 1948, cat. no. 12; Santa Barbara, 1960; Berkeley, 1962, cat. no. 38, ill. p. 27; Jerusalem, 1966, cat. no. 39.

BIBLIOGRAPHY
Neumann, 1949.

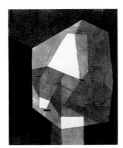

Page 249
Rough-Cut Head, 1935
PROVENANCE
Hermann Rupf, Bern; Daniel-Henry Kahnweiler, Galerie Simon, Paris, 1937–40; J. B. Neumann, New Art Circle, New York; F. C. Schang, New York; Heinz Berggruen, 1981.

EXHIBITIONS
Frankfurt am Main, 1950, no. 19; New York, 1953, cat. no. 40; Minneapolis, 1955, no. 33; Bern, August 11–November 4, 1956, cat. no. 661; New York, 1957, no. 30; Waltham, Mass., 1960, cat. no. 30; Pasadena, 1967–68, cat. no. 144, ill. p. 95; New York, 1985.

BIBLIOGRAPHY
Cooper, 1949, pl. 28; Grohmann, 1955, pl. 28; San Lazzaro, 1957, ill. p. 147.

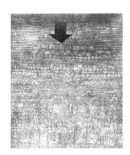

Page 250
Stricken City, 1936

PROVENANCE
W. Loeffler, Zürich; Heinz Berggruen, 1976.

EXHIBITIONS
Bern, 1940, cat. no. 47; Zürich, 1943, cat. no. 581; New York, 1985; Bern, 1987–88, cat. no. 233, ill. p. 274.

BIBLIOGRAPHY
Giedion-Welcker, 1948, ill. p. (85); Giedion-Welcker, 1952, ill. p. 111; San Lazzaro, 1957, no. 114, ill. p. 275; Giedion-Welcker, 1961, ill. p. (126); Forge, 1961, pl. 8; Felix Klee, 1960, p. 194; Henry, 1976, fig. 215, ill. p. 325; Aichele, 1986, ill. p. 454.

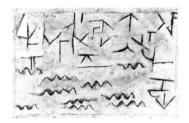

Page 253
The Rhine at Duisburg, 1937

PROVENANCE
J. B. Neumann, New Art Circle, New York; Curt Valentin, Buchholz Gallery, New York; F. C. Schang, New York, 1951; G. David Thompson, Pittsburgh; Rolf E. Stenersen, Oslo; Sale, Munich, Galerie Wolfgang Ketterer, 1968, no. 583; Sale, New York, Sotheby's, April 30, 1969, no. 96; Galerie Beyeler, Basel; Modorati, Monza, Italy, 1970; Sale, London, Sotheby's, December 5, 1979, no. 61; Heinz Berggruen, 1979.

EXHIBITIONS
Zürich, 1940, cat. no. 142; New York, 1950, cat. no. 29; Stockholm, 1961, cat. no. 26; Amsterdam, 1962, cat. no. 77; Tokyo, 1981, cat. no. 29, ill. p. 56.

BIBLIOGRAPHY
Spiller, 1961, ill. p. 290; Rosenthal, 1979, fig. 162, ill. p. 370; Wilhelm Lehmbruck Museum, 1971, ill. p. 6.

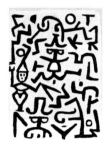

Page 254
Comedians' Handbill, 1938

PROVENANCE
Daniel-Henry Kahnweiler, Galerie Louise Leiris, Paris; Emil G. Bührle, Zürich, 1948–49; Marlborough Gallery, Inc., New York, 1967; Saidenberg Gallery, New York, 1968; Lady Nika Hulton, London; Heinz Berggruen, 1981.

EXHIBITIONS
New York, 1984–85, no. 106.

BIBLIOGRAPHY
Kahnweiler, 1950, ill.; San Lazzaro, 1957, no. 136, ill. p. 277; Awazu, 1968, ill. p. 105; Micko, 1969, pl. 33; Hofstätter, 1969, fig. 38, ill. p. 154; Huggler, 1969, fig. 73, ill.; Rewald, 1985, ill. p. 53; O'Connor, 1986, ill. p. (7).

Page 256
Little Hope, 1938

PROVENANCE
Lily Klee, Bern; Hermann Rupf, Bern; Peter O'Toole, London; Rodriguez Betancourt, Mexico City; Sale, London, Sotheby's, December 5, 1979 (bought in); Heinz Berggruen, 1979.

EXHIBITIONS
Zürich, 1940, cat. no. 55; Bern, 1940, cat. no. 148; Bern, Feb. 4–April 2, 1956, cat. no. 149; Bern, Aug. 11–Nov. 4, 1956, cat. no. 704; Paris, 1961, ill.

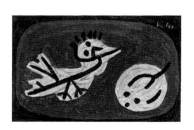

Page 259
Blue-Bird-Pumpkin, 1939

PROVENANCE
Lily Klee, Bern; Douglas Cooper, Argilliers, France, 1946; Heinz Berggruen, 1958.

EXHIBITIONS
Bern, 1940, cat. no. 176; London, 1945–46, cat. no. 126; London, 1946, cat. no. 48; Newcastle upon Tyne, 1950, no. 4.

BIBLIOGRAPHY
Cahiers d'Art, 1945–46, ill. p. 74; Cooper, 1949, pl. 27; Grohmann, 1955, pl. 27; Felix Klee, 1964, pl. 12; Grohmann, 1967, ill. p. 153; Chevalier, 1971, ill. p. (82).

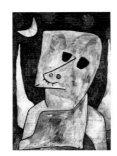

Page 260
Angel Applicant, 1939

PROVENANCE
Charles Nilsson, Sweden; Werner
Rusche, Cologne; Carlo van den Bosch,
Antwerp; Sale, London, Christie's, March
29, 1977, no. 46; Heinz Berggruen, 1977.

EXHIBITIONS
Zürich, 1940, cat. no. 110; Cologne, 1955,
ill.; Brussels, 1957, cat. no. 102c, ill.;
Stockholm, 1961, cat. no. 158, ill.; Stock-
holm, 1963–64, cat. no. 107, ill.; London,
1978, cat. no. 12.79, ill. p. 312; Saint-Paul,
1977, cat. no. 160, ill. p. (153); Tokyo,
1981, cat. no. 31, ill. p. 60.

BIBLIOGRAPHY
Abadie, 1977, ill. p. (153); Hall, 1977,
pl. 48.

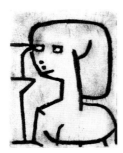

Page 262
Girl in Mourning, 1939

PROVENANCE
Estate of Paul Klee, Bern; Galerie Rosen-
gart, Lucerne, 1947; Hans Arnhold, New
York, 1949; Ellen Gorrissen, New York;
Nina-Maria Gorrissen, New York;
Leonard Hutton Galleries, New York,
1984; Heinz Berggruen, 1984.

EXHIBITIONS
Zürich, 1940, cat. no. 125; New York,
1984, cat. no. 65, ill. p. 74.

Page 264
The Hour Before One Night,
1940

PROVENANCE
Estate of Paul Klee, Bern; Galerie Rosen-
gart, Lucerne, 1952; Baron Floris Car-
selius van Pallandt, The Hague, 1952;
Private collection; Sale, London, Christie's,
December 1, 1981, no. 365; Heinz Berg-
gruen, 1981.

EXHIBITION
Antwerp, 1949, cat. no. 58.

Chronology

This chronology is largely based on the exemplary and detailed chronologies by Christian Geelhaar, *Paul Klee: Das Frühwerk 1883–1922*, compiled by Armin Zweite, exhibition catalogue (Munich: Städtische Galerie im Lenbachhaus, 1979–80), and by Wolfgang Kersten, *Paul Klee als Zeichner 1921–33*, compiled by Peter Hahn, exhibition catalogue (Berlin: Bauhaus-Archiv, 1985). Felix Klee and Wolfgang Kersten checked this version for errors and contributed new facts.

1879
Paul Klee is born on December 18 in Münchenbuchsee, a suburb of Bern. Second child of Hans Klee (1849–1940), a German music teacher, and the Swiss Ida Marie (née Frick, 1855–1921).

1880
The Klees move to Bern, and at the teachers' training college in Bern-Hofwil, Hans Klee teaches singing, piano, organ, and violin until his retirement in 1931. Paul Klee receives first instructions in drawing and coloring from his maternal grandmother, Anna Catharina Rosina Frick (née Riedtmann, 1817–84).

1886–96
Klee attends the Primarschule (1886–90), the Progymnasium (1890–94), and the Literarschule (1894–98). Takes violin lessons from Karl Jahn, a former pupil of the celebrated violinist Joseph Joachim. Makes rapid progress and soon plays with the Bernische Musikgesellschaft (Bernese Music Society) in its subscription concerts. Between 1892 and 1898 fills nine sketchbooks with drawings, most of them copies after illustrated calendars by Emil Lauterburg, landscape drawings by Karl Girardet, illustrations by Friedrich Kallmorgen in the magazine *Vom Fels zum Meer* (*From the Mountain to the Sea*), and illustrations in the magazine *Gartenlaube* (*Gazebo*). From 1895 on Klee draws more and more after nature. Fills the margins of his books and exercise books with caricatures.

1897

The Klees move into their own house at Obstbergweg 6, where Hans Klee lives until his death in 1940. In November Klee begins keeping a diary, discontinuing it in 1918, but editing and revising it from 1904 until about 1921.

1898

Graduates from the Literarschule. Edits with his classmates Hans Bloesch and René Thiessing a satirical student newspaper, *Die Wanze* (*The Flea*), that scandalizes his professors. Moves to Munich in October to study art. His inaptitude in drawing the figure prevents him from being admitted to the Munich Academy and, in preparation, he enrolls at the private drawing school of Heinrich Knirr, an academic painter. During the next two years he lives in various furnished rooms and frequently attends concerts and operas.

1899

During a stay in Burghausen on the River Salzach, he learns the technique of etching from the painter and engraver Walter Ziegler. Spends the summer in Bern. His mother, Ida Klee, becomes permanently paralyzed and spends the rest of her life in a wheelchair. Returns to Munich at the end of October. At a musical soiree in December, he meets his future wife, the pianist Lily Stumpf (1876–1946). They play duos together and solos, as they will on many subsequent occasions.

1900

Has a brief affair with a shopgirl. She bears a son who lives only a few weeks (November 5–29). Spends May through September in Bern. In October finally enrolls in the class of Franz von Stuck at the Academy. Wassily Kandinsky is a fellow student, but they do not meet. Continues to attend sketching classes at Knirr's. Forms a chamber-music quartet with friends that meets weekly.

1901

Leaves von Stuck's class in March. Drops plan to enroll in a sculpture class at the Academy because of being too weary to pass its entrance examination. Attempts first etchings. Concludes his studies in Munich and becomes secretly engaged to Lily Stumpf before returning to Bern at the end of June. Spends summer in Bern and Oberhofen. In October leaves for a six-month stay in Italy with his sculptor friend Hermann Haller. They travel via Milan, Genoa, Pisa, and Leghorn to Rome, where Klee remains until spring. Visits the Sistine Chapel, churches, museums, and ancient ruins and attends many Italian operas.

1902

Regularly attends evening sketching classes after the nude at the Deutscher Künstler Verein (German Artists' Club) in Rome. Visits Naples for two weeks in March and is fascinated by the Pompeian wall paintings in the Museo Nazionale. Excursions to Pompeii, Sorrento, and Amalfi. Back in Rome he is impressed by Rodin's drawings of the nude included in the annual exhibition at the Galleria Nazionale d'Arte Moderna; however, he mistakes them for caricatures. In Florence during the last two weeks of April, Klee spends many hours in the Uffizi and in the painting galleries at the Palazzo Pitti. Prefers art

of the Renaissance and of antiquity to the Baroque, but feels overwhelmed by the art of the past and perceives himself as an epigone. Reacts with caricatures. Returns to Bern in May to remain there, in relative seclusion, until 1906. For the next four years he subjects himself to an autodidactic education as artist and literate, interrupted only by periodic trips to Munich, Berlin, and Paris. In October the Bernische Musikgesellschaft hires him as violinist for one year to play in its subscription concerts in various Swiss cities. Starting in November, Klee's self-imposed "curriculum" consists of attending an anatomy course every day, an evening sketching class after the nude three times a week, and once a week a lecture for artists on anatomy.

1903
Plays in six subscription concerts given by the Bernische Musikgesellschaft during the spring. With his friend Louis Moilliet takes private sketching classes after the nude, sketching first a woman, then a boy. Spends two weeks in Munich. Creates the first five of his eleven-etching series *Inventions* between July and September. Called by him Opus One, they constitute his "critique of the bourgeoisie." Lily Stumpf spends part of the summer in Bern. In the autumn Klee's contract with the Bernische Musikgesellschaft expires. From October 1903 until March 1906 Klee writes opera and concert reviews for the *Berner Fremdenblatt*, published by his friend Hans Bloesch.

1904
In June participates in the V. Schweizerische Tonkünstlerfest (Fifth Swiss Musicians Festival) as a member of the Bern City Orchestra. Lily Stumpf spends part of the summer in Bern. They make excursions to Basel and Geneva, visiting museums and galleries. During his ten-day visit to Munich in October, Klee studies illustrations by Aubrey Beardsley, William Blake, and Goya in the Kupferstichkabinett. Signs another contract with the Bernische Musikgesellschaft for a second season. Creates three new etchings for his series of *Inventions*.

1905
Between January and March creates three more etchings, completing his series of eleven *Inventions*. On February 28, Pablo Casals gives a cello concert in Bern accompanied by the Bernische Musikgesellschaft and an enthusiastic Klee. Visits Paris during the first two weeks in June, accompanied by his friends Bloesch and Moilliet. Spends many hours at the Louvre and at the Musée du Luxembourg; sees the Whistler exhibition at the Palais de l'École des Beaux-Arts; and views the frescos by Puvis de Chavannes in public buildings. He makes no mention of modern French painting in his diary. During the summer in Bern, Klee makes drawings by scratching with a fine steel pen on a blackened glass plate, an experiment that, in the autumn, leads to painting on glass. Visits Munich at the end of October for one week and sees prints by Félicien Rops. Lily Stumpf spends the summer and Christmas in Bern.

1906
Continues with painting on glass. Spends one week during April in Berlin with his friend Bloesch. Sees the centennial exhibition of German art from 1775 to 1875 organized by Hugo von Tschudi at the Nationalgalerie im Kron-

prinzenpalais and visits the Kaiser-Friedrich Museum, the Pergamon-Museum, and the Museum für Volkskunde (ethnology). Attends many theater performances, including Max Reinhardt's production of Shakespeare's *The Merchant of Venice* with scenery by Lovis Corinth. Meets Lily Stumpf in Kassel and returns to Bern via Frankfurt am Main and Karlsruhe. As a former student of Franz von Stuck, Klee is able to include ten of his *Inventions* in the Munich Secession exhibition. It receives a biting review. Meets the draftsman and illustrator Jacques Ernst Sonderegger, who introduces him to the works of Toulouse-Lautrec, Munch, and Ensor. Marries Lily Stumpf in Bern on September 15 and moves to Munich in October. They rent a small three-room apartment at Ainmillerstrasse 32/II in Schwabing, Munich's artists' quarter, and go to many opera performances and concerts. Klee's efforts to contribute illustrations to the satirical magazine *Simplizissimus* fail.

1907

The jury of the spring exhibition of the Munich Secession rejects Klee's *Inventions* and his paintings on glass, as do the editors of the magazine *Kunst und Künstler*. Visits an exhibition of French paintings from Manet to Monet at the Galerie Heinemann in Munich in January. Sees in Manet's works parallels to his own experiments with light and dark masses in his charcoal drawings and his black-and-white landscapes on glass. Spends the summer in Bern. Contributes one colored drawing to the new Swiss satirical weekly *Der Grüne Heinrich* (*The Green Henry*). Birth of his only child, Felix, on November 30. Klee takes care of the household and of Felix, and Lily earns money by giving piano lessons.

1908

Sees the works of van Gogh exhibited in two Munich galleries: at Kunstsalon W. Zimmermann and at Moderne Kunsthandlung Josef Brakl (both March–April 15). From April until June Klee gives correction in the sketching classes after the model at the Debschitz School. In May joins Die Walze (The Roll), the Association of Swiss Graphic Artists. The Munich Secession exhibition includes three of his drawings (May 15–end of October). Spends August until mid-October in Bern. Applies various layers of thin black watercolor on paper in emulation of the different scales of light and dark masses he observes in nature. Rents a small studio at Feilitzschstrasse 3/4II and paints in oil. The *XVI. Zeichnende Künste* exhibition at the Berlin Secession shows six of his drawings (December).

1909

Impressed by the Hans von Marées exhibition at the Munich Secession (January). Severe illness of his son, Felix, lasts from March until May. Shows his drawings to the art historian Julius Meier-Graefe with no result. The jury of the Munich Secession exhibition rejects five of his drawings. Sees at this exhibition (March 2–May 10) eight paintings by Cézanne and calls him his "master par excellence." Spends June through October in Bern and Beatenberg. Plans to illustrate Voltaire's satirical utopian novel, *Candide* (1758). Shows two drawings in the *XIX. Zeichnende Künste* exhibition in the Berlin Secession (November 27, 1909–January 9, 1910).

1910

Works with a pantograph. Continues his experiments with black watercolor as a means to study light and dark masses. During the summer he changes to color, yet uses a subdued palette. Spends July through November in Bern. First one-man exhibition of more than 50 works (from the years 1907 to 1910) at the Kunstmuseum Bern (August), at the Kunsthaus Zürich (October), at the Kunsthandlung zum Hohen Haus, Winterthur (November), and at the Kunsthalle Basel (January 1911). In December Alfred Kubin buys a Klee drawing.

1911

In January Kubin visits Klee in Bern. A friendship and correspondence ensue and continue until Klee's death in 1940. In February Klee establishes a work catalogue of his past and current works, including some dating back to 1893, and maintains it until his death. Begins the illustrations for Voltaire's *Candide*, which will be published in 1920 by Kurt Wolff Verlag in Munich. Heinrich Thannhauser exhibits 30 of Klee's works in his Moderne Galerie in the Arcopalais, Munich (June). Spends the summer in Bern and Beatenberg. In September meets the painter August Macke at his friend Moilliet's in Bern. In October makes the acquaintance of Kandinsky, who lives two doors away from the Klees at Ainmillerstrasse 36. Klee is a founding member of the young artist's group Sema (Sign), to which Kubin belongs as well. Writes reviews of Munich and Zürich art exhibitions and opera performances until December 1912 for the Swiss monthly magazine *Die Alpen* (*The Alps*), edited by his friend Bloesch. Sees the first exhibition of the Blaue Reiter group at Thannhauser's gallery (December 1911–January 1912).

1912

His review of the Blaue Reiter exhibition appears in the January issue of *Die Alpen*. The same issue contains Bloesch's article on Klee entitled "Ein moderner Graphiker" ("A Modern Graphic Artist") with five reproductions of his works. Meets Alexei von Jawlensky and Marianne von Werefkin. Klee joins the Blaue Reiter and exhibits 17 of his works in the group's second exhibition of only works on paper at Hans Goltz's bookshop in Munich (Feb. 12–April). Spends two weeks in Paris with his wife (April 2–18). Visits the studios of Delaunay, Le Fauconnier, and Karl Hofer with a letter of introduction from Kandinsky. Sees the works of Braque, Picasso, and Rousseau in the collection of the German writer Wilhelm Uhde. At Daniel-Henry Kahnweiler's gallery sees pictures by Derain, Vlaminck, and Picasso, and at the firm of Bernheim-Jeune paintings by Matisse. Participates in the first exhibition of the artists' group Sema shown at Thannhauser's Moderne Galerie (April); the exhibition later travels to Dresden. The annual exhibition of graphics (LIA Leipziger Jahres Ausstellung 1912) in Leipzig includes four of his works (April 7–end of June), the Sonderbund exhibition at the Städtische Ausstellungshalle in Cologne shows four works by Klee (May 25–September 30), and the Moderner Bund exhibition at the Kunsthaus Zürich another eight works (July 7–31). In June visits Kubin in Zwickledt, Austria, for a few days. Eleven of his watercolors are included in the inaugural exhibition of Hans Goltz's new gallery, Neue Kunst, on the Odeonsplatz in Munich in October. Enters into a close friendship with Franz Marc. Through Marc he meets Herwarth Walden, the founder of the magazine and gallery Der Sturm in Berlin.

Piper Verlag in Munich rejects Klee's illustrations for *Candide*, which are shown to this firm by Marc.

1913

Über das Licht, Klee's translation of Delaunay's essay *La Lumière*, appears in the January issue of *Der Sturm*. The Moderner Bund exhibition at Neue Kunst Hans Goltz in Munich includes nine works by Klee (March 16–April 4). It is also shown at the Galerie Der Sturm in Berlin (April 26–May 31). Spends the summer in Bern. Sees the collection of Cubist works assembled by the businessman Hermann Rupf in Bern. The Erster Deutscher Herbstsalon exhibition at the Galerie Der Sturm includes 22 of his works (September 20–December 1).

1914

In April spends two weeks in Tunisia with Macke and Moilliet. The Bernese pharmacist Charles Bornand pays for Klee's expenses by purchasing eight of his watercolors. Klee and companions visit Tunis (April 7–10), St. Germain (April 10–13), Sidi-Bou-Said (April 13), Carthage (April 13), Hammamet (April 14), Kairouan (April 15–17), and Tunis (April 17–19). The limpid light of North Africa awakens Klee's sense of color, and he feels he is a painter for the first time. Returns alone via Palermo, Naples, and Rome to Munich. Exhibition at the Galerie Der Sturm, along with Chagall. Exhibits eight of his Tunisian watercolors in the first exhibition of the New Munich Secession (May 30–October 1), founded by the art critic and writer Wilhelm Hausenstein, whose book on Klee will be published in 1921. Klee is a founding member of the New Munich Secession, acting as its secretary from 1918 to 1920. World War I begins on August 1. Marc, Macke, and Campendonk are drafted; Kandinsky, Werefkin, Münter, and Jawlensky leave Germany. Macke dies near Perthes in Champagne on September 27. Klee visits Kandinsky on the Swiss side of Lake Constance in October.

1915

Spring exhibition of the New Munich Secession includes 14 of his works (February 20–end of March). The poet Rainer Maria Rilke visits him. Spends the summer in Bern. Works are now completely abstract. Visits Jawlensky and Werefkin, who live in St. Prex, on Lake Geneva.

1916

Exhibition at the Galerie Der Sturm, along with Albert Bloch (March). Franz Marc dies in the Battle of Verdun on March 4. Klee is drafted into the German Army on March 11 and is sent to the Recruit Depot in Landshut, near Munich. Summer exhibition of the New Munich Secession includes eight of his works (June 1–September 30). Transferred to the Second Reserve Infantry Regiment in Munich on July 20. Assigned to the Workshop Company Air Force Reserve Unit at Schleissheim, near Munich, in August. Paints and repairs numbers and signs on airplanes. During November and December accompanies two military transports, one to Cologne, the other to Cambrai and St. Quentin on the western front.

1917

Accompanies third military transport to Nordholz (near Cuxhaven) in January. Returns via Berlin, where he visits Walden and sees the collection of

Bernhard Koehler. Transferred to the Fifth Royal Bavarian Air Force Flying School in Gersthofen (near Augsburg) as part of the construction squad. In February Klee is assigned to a clerical job in the paymaster's office. Paints and draws during his spare time. Exhibition at the Galerie Der Sturm, along with Georg Muche (February). Many of his works sell. Der Sturm exhibition at the Galerie Dada, Zürich, includes Klee's works (April 9–30). The summer exhibition of the New Munich Secession includes Klee's watercolors, as does the exhibition of Expressionist paintings and watercolors at the Galerie Der Sturm devoted to Klee, Gabriele Münter, and Gösta Adrian-Nilsson (December).

1918

Klee achieves recognition in the art market. An article on Klee by the poet Theodor Däubler appears in the January issue of *Das Kunstblatt*. Twenty-four of his drawings make up volume 3 of the *Sturm Bilderbücher*, published in February. Klee is promoted to corporal in March. The inaugural exhibition of the Bern Kunsthalle contains four of his drawings (October 5–November 3). In November writes final draft of an essay that appears in 1920 in the anthology of artists' writings, *Schöpferische Konfession*, volume 13 of the art book series *Tribüne der Kunst und Zeit* (Berlin: Verlag Erich Reiss), edited by Kasimir Edschmid. Georg Müller Verlag commissions Klee to do the illustrations for Curt Corinth's Expressionist, erotic novel, *Potsdamer Platz oder die Nächte des neuen Messias* (*Potsdamer Square or the Nights of the New Messiah*), published in 1920. Returns to Munich before Christmas; released from the Army until his final discharge in February 1919. Klee joins the groups Rat Bildender Künstler Münchens (Munich Visual Arts Council) and Aktionsausschuss Revolutionärer Künstler Münchens (Munich Revolutionary Artists' Action Committee), the latter a leftist radical group, and both offshoots of the Novembergruppe.

1919

Exhibition at the Galerie Der Sturm, along with Kurt Schwitters and Johannes Molzahn (January). Rents a studio in the eighteenth-century palais Suresnes in Schwabing, Munich's artists' quarter. Works in oil. During May reign of the Räterepublik—Bavaria's short-lived "Soviet Republic" of terror and unrest—following the November 1918 Revolution. Klee enters into a three-year contract with Hans Goltz, which is renewed for another three years in 1922. The Stuttgart Academy of Arts rejects Klee as the successor to Adolf Hölzel, as proposed by Oskar Schlemmer, the Students' Council chairman. Polemic in the press against Klee. In June visits Zürich and makes contact with the Dada group, meets Hans Arp, Hans Richter, and Tristan Tzara. Pays a visit to the composer and pianist Ferruccio Busoni. Spends the summer in Bern. The Staatliche Graphische Sammlung in Munich buys five of his *Inventions*. The architect Walter Gropius founds the Bauhaus School in Weimar, hiring Lyonel Feininger, Johannes Itten, and Gerhard Marcks as teachers.

1920

Large retrospective exhibition of 362 of Klee's works at Hans Goltz's gallery Neue Kunst (May–June). A special issue of the magazine *Der Ararat* serves as catalogue. Kurt Wolff Verlag publishes Voltaire's *Candide* with 26 of Klee's

illustrations, and Georg Müller Verlag brings out Curt Corinth's *Potsdamer Platz* with ten of his illustrations. Two monographs devoted to Klee, one by Leopold Zahn and the other by Hans von Wedderkop, are published in the autumn. Spends the summer in Possenhofen on Lake Starnberg. Visits Jawlensky and Werefkin in Ascona. His essay "Farbe als Wissenschaft" ("The Science of Color") appears in the *Farbensonderheft* (special issue on color) of the *Mitteilungen des Deutschen Werkbundes* (News of the German Workers' Association), along with essays by Kandinsky, Hölzel, and Leonardo da Vinci. End of October appointed to the Bauhaus.

1921

Klee starts teaching at the Bauhaus on January 10. His teaching colleagues include Feininger, Gropius, Schlemmer, Itten, Muche, Adolf Meyer, and Marcks. For the next ten months travels every two weeks from Munich to Weimar, where he teaches for two weeks. Ida Klee, his mother, dies on March 15 in Bern. In April Klee is assigned to give artistic advice, as form master, in the bookbinding workshop, and in May he begins his course on composition with about 30 students. Spends summer in Possenhofen on Lake Starnberg. In October moves into a four-room apartment at Am Horn 33, in Weimar. From November until December 1922 teaches "Beiträge zur bildnerischen Formlehre" ("Lectures on Visual Form"). Klee writes his lectures in a simple exercise book that, in facsimile, will be published in 1979 by Jürgen Glaesemer of the Klee Stiftung in Bern. Hausenstein's monograph *Kairuan oder eine Geschichte vom Maler Klee und von der Kunst dieses Zeitalters* (*Kairouan or A Tale of the Painter Klee and the Art of This Century*) is published.

1922

In April the bookbinding workshop is dissolved. Kandinsky, accompanied by his wife Nina, joins the Bauhaus staff in July. Klee spends the summer in Possenhofen. In November teaches "Farbenlehre" ("Color Theory") and becomes artistic advisor (form master) in the stained-glass workshop.

1923

Itten leaves the Bauhaus, and Moholy-Nagy takes over the preliminary course. Schlemmer inherits the stage workshop from Schreyer, and Albers the technical supervision of the stained-glass workshop. August 15– September 30: Bauhaus week and exhibition. Klee's essay "Wege des Naturstudiums" ("Approaches to the Study of Nature") is published in the accompanying publication *Staatliches Bauhaus—Weimar 1919–23*. During the exhibition meets the collector and businessman Otto Ralfs from Brunswick. In September vacations on Baltrum, an island in the North Sea. Returns via Hannover and visits Schwitters and El Lissitzky. Exhibition at the Nationalgalerie im Kronprinzenpalais, Berlin (October). Teaches "Elementaren Gestaltungsunterricht" ("Basic Composition") from October until February 1924.

1924

First one-man exhibition in the U.S.A. at the Société Anonyme, New York (January 7–February 7). Gives a lecture "Über die moderne Kunst" ("On Modern Art") on January 26 on the occasion of his exhibition at the Kunstverein Jena (January–February), published as a book in 1945. Die Blaue Vier (The Blue Four) group is founded with Klee, Kandinsky,

Feininger, and Jawlensky at the instigation of the art enthusiast Galka E. Scheyer for the purpose of showing their works in the U.S.A., which Scheyer visits in May, to remain there until her death in 1945. Klee visits Sicily in the summer. On December 26 the masters of the Bauhaus send an open letter to numerous daily newspapers in Germany in which they announce their decision to close the Bauhaus in Weimar with the expiration of their contracts on April 1, 1925.

1925

In the spring the Bauhaus reopens in Dessau. Gropius abandons the distinction between "form master" and "master craftsman." The state of Anhalt grants the Bauhaus the status of Institute of Design. The masters, among them Klee, receive the title of professor. Klee starts his classes in June, keeping his apartment and studio in Weimar. For the next year he spends one week in Weimar and one week in Dessau, first in a hotel in Dessau, then as Kandinsky's tenant at Moltkestrasse 7. Second large retrospective exhibition at Hans Goltz's gallery (May–June). His contract with Goltz ends. Klee's *Pädagogisches Skizzenbuch* (*Pedagogical Sketchbook*), an extract of his lecture course of 1921–22, entitled "Beiträge zur bildnerischen Formlehre" ("Lectures on Visual Form"), appears as volume 2 in the series of the Bauhaus books edited by Gropius and Moholy-Nagy. Meets Hindemith. Otto Ralfs founds the Klee Gesellschaft (Klee Society), and the annual contributions paid by its members give Klee an additional monthly income. First exhibition in France at the Galerie Vavin-Raspail, Paris (October 21–November 14). Participates with two works in the first group exhibition of the Surrealists at the Galerie Pierre, Paris (November 14–25). Teaches "Elementaren Gestaltungsunterricht" ("Basic Composition") during the winter semester. Establishes a price system for his past and present works, rating them from I to X. Also designates those he likes with "Sonderklasse" ("S.Kl." or "S.Cl.").

1926

In July moves to Burgkühner Allee 7. Shares with Kandinsky one of the three two-family houses built by Gropius for the Bauhaus professors. In Italy with Lily and Felix from September until mid-October, visiting Genoa, Elba, Pisa, Florence, Ravenna, and Milan. Klee rejects, along with Kandinsky, a proposal by Gropius to reduce their salaries by 10 percent in order to alleviate the financial crisis of the Bauhaus. They agree on a 5 percent cut sometime later. The new building of the Bauhaus, built by Gropius, is inaugurated on December 4–5. Klee teaches a sculpture and painting seminar, an evening drawing class after the nude, and "Grundlehre" ("Theoretical Foundations").

1927

Vacations in Porquerolles, an island off the coast of France, southeast of Toulon, and later visits Corsica. Teaches "Gestaltungslehre für Weberei" ("Textile Composition"), "Formenlehre" ("Theory of Forms"), and a painting workshop.

1928

In March Gropius, Bayer, Breuer, and Moholy-Nagy leave the Bauhaus. Hannes Meyer becomes director of the Bauhaus, April 1. Klee now sells

work mainly through the art dealer Alfred Flechtheim, who has galleries in Berlin and Düsseldorf. Klee spends six days in Berlin and meets Emil Nolde, and also visits the art critic Carl Einstein. Spends time during August in Brittany. Extended voyage to Egypt and Italy (December 17–January 17, 1929), visiting Alexandria (December 24; January 9–10), Cairo (December 24–30), Luxor (December 31–January 6), and Aswân (January 7–8), with excursions to Giza, Karnak, the Valley of the Kings, and Thebes. Returns via Syracuse, Naples, and Milan. His essay "Exakte Versuche im Bereich der Kunst" ("Exact Investigations in the Realm of Art") is published in the February 3 issue of the magazine *Bauhaus. Zeitschrift für Gestaltung*. During the summer teaches "Theory of Forms," "Textile Composition," and studio painting, and during the winter "Theory of Forms," "Textile Composition," studio painting, and "Basic Composition."

1929

In March discussions with the Düsseldorf Academy about teaching there. Joins the Deutscher Künstlerbund (League of German Artists). During the summer visits France and Spain. Meets Kandinsky in Hendaye, near the border between France and Spain on the Bay of Biscay. Exhibitions honoring Klee's fiftieth birthday in various cities: Galerie Neue Kunst Fides, Dresden (February 1 to March), Galerie Georges Bernheim et Cie, Paris (February 1–15), Nationalgalerie im Kronprinzenpalais, Berlin (October 14–November 14), Galerie Alfred Flechtheim, Berlin (October 20–November 15). Will Grohmann's monograph on Klee is published by *Cahiers d'Art* in Paris.

1930

Third one-man exhibition at the Galerie Alfred Flechtheim, Berlin (February 11–March 10). Originally planned to be shown at J. B. Neumann's New Art Circle, New York, the exhibition—owing to lack of space there—is mounted instead at The Museum of Modern Art, New York (March 13–April 2). Klee spends the summer in the Engadine, Switzerland, and in Viareggio, Italy. In May informs the Bauhaus of his intention to leave as of April 1, 1931. Meyer is dismissed as director of the Bauhaus for political reasons on August 1, and Mies van der Rohe takes his place. The Bauhaus closes from September to October 21, reopening with a new schedule of classes.

1931

Klee's contract with the Bauhaus ends on April 1. Spends the summer in Sicily. In October joins the faculty of the Düsseldorf Academy as a professor of painting. Lives in a rented room at Goldsteinstrasse 5 in Düsseldorf and teaches a class on painting technique, having only a handful of students. Keeping his house and studio in Dessau, he travels for the next two years between Dessau and Düsseldorf, staying 14 days in each city. The December issue of the magazine *Bauhaus. Zeitschrift für Gestaltung* is devoted to Klee (vol. 3, no. 4), with contributions by Grohmann, Kandinsky, Grote, and others.

1932

Changes rooms and moves to Mozartstrasse 4 in Düsseldorf, all the while continuing to look for a suitable apartment. Paints Pointillist, merry, mosaic-style pictures in Düsseldorf and continues the Constructivist ones in Dessau.

Visits the Picasso exhibition at the Kunsthaus Zürich. Spends ten days in Venice and Padua. On October 1 the Bauhaus in Dessau is closed by the National Socialists. The school moves to Berlin, reopening the same month.

1933

Adolf Hitler becomes chancellor of Germany on January 30. The National Socialists search Klee's house in Dessau during his absence at the end of March. They confiscate his letters to Lily, who later retrieves them. In April the National Socialists close the Bauhaus in Berlin. Klee finds an apartment at Heinrichstrasse 36 in Düsseldorf. Arranges move from Dessau to Düsseldorf for May 1, when he learns on April 24 of his immediate suspension from the Düsseldorf Academy as of that date, having been classified as a "degenerate artist." On September 22, receives the formal notice of his termination of employment as of January 1, 1934. Fritz Radziwill takes his place. Klee lives from May 1 until December 23 at his new apartment in Düsseldorf. Visits the south of France in October. Returns via Paris. Daniel-Henry Kahnweiler, encouraged by Flechtheim, who leaves Germany, signs a contract with Klee. His gallery in Paris is now called Galerie Simon. In Paris Klee visits Picasso on October 26. Emigrates with Lily to Switzerland at the end of December. They live briefly with his father at Obstbergweg 6 in Bern.

1934

First exhibition in England at the Mayor Gallery, London (January). Exhibition at the Galerie Simon, Paris. Moves into a small furnished apartment at Kollerweg 6 and in the spring into a three-room apartment at Kistlerweg 6, in Elfenau, a residential section of Bern. Meets E. L. Kirchner and renews contact with friends in Bern.

1935

Will Grohmann's book on Klee's drawings of the years 1921–30 appears and, during its distribution to bookshops in Germany, is confiscated by the National Socialists in the spring of 1935. Klee keeps a pocket diary with daily notations of his menu. Exhibition of 273 of his works at the Kunsthalle Bern (February 23–March 24); the exhibition in reduced form is shown at the Kunsthalle Basel (October 27–November 24). In November suffers from bronchitis, then from measles, the beginning of a severe illness.

1936

Klee's illness becomes worse and is diagnosed as scleroderma, an incurable disease. Takes cures with Hermann and Margrit Rupf-Wyss at Tarasp in the canton of Graubünden and at Montana in the canton of Valais, both in Switzerland. Produces only 25 works.

1937

In February Kandinsky visits Klee on the occasion of the former's exhibition at the Kunsthalle Bern. Seventeen of Klee's works are included in the exhibition *Degenerate Art*, which opens July 19 in Munich, at the former building of the Kunstverein, Galeriestrasse 4. One hundred and two of Klee's works are confiscated from German public collections, illegally, because it occurs one year before Goering's decree of August 3, 1938. Curt Valentin of the Buchholz Gallery, New York, cultivates contacts with Klee in

the hope of representing him in the U.S.A. Recovers sufficiently to start working again, producing 264 works during the year. On November 28 Picasso visits Klee in Bern.

1938

Exhibitions in Paris at the Galerie Simon (January 24–February 5) and at the Galerie Balaye et Louis Carré (July). In spring signs contract with Karl Nierendorf in New York. Participates in the Bauhaus exhibition organized at The Museum of Modern Art, New York (December 7, 1938–January 30, 1939).

1939

Visits the exhibition of masterpieces from the Prado Museum shown at the Musée d'Art et d'Histoire in Geneva (June–August). Spends the summer in Faoug on Lake Murten, near Bern. Applies a second time for Swiss citizenship, having been rejected earlier for technical reasons. Produces some 1,300 works, most of them drawings.

1940

Hans Klee, the artist's father, dies in Bern on January 10 at the age of 91. Exhibition of Klee's works made between 1933 and 1940 at the Kunsthaus Zürich in honor of his sixtieth birthday the year before (February 16–March 25). In May moves to a sanatorium in Orselina-Locarno. Enters the hospital Sant'Agnese in Muralto-Locarno on June 8 and dies there on June 29.

Appendix

Deine Lieblingseigenschaften am Manne? _allgem. bildg. u. Haltung_

Deine Lieblingseigenschaften am Weibe? _Gutmütigkeit u. Einfalt_

Deine Lieblingsbeschäftigung? _sehen_

Deine Idee von Glück? _mit Erfolg arbeiten_

Welcher Beruf scheint Dir der beste? _Der der fürchtesten begabten mehr_

Wer möchtest Du wohl sein, wenn nicht Du? _Kutzen Bei mir_

Wo möchtest Du leben? _nicht ohne Freunde_

Wann möchtest Du gelebt haben? _/_

Deine Idee von Unglück? _nicht arbeiten können_

Dein Hauptcharakterzug? _zu sicher, zu rasch (zu meinem Schaden)_

Deine Lieblingsschriftsteller? _die Kürzesten_

Deine Lieblingsmaler und =Bildhauer? _Goya Manet_ ~~—~~

Deine Lieblingscomponisten? _Bach Mozart u Beethoven_

Deine Lieblingsfarbe und =Blume? _u. Alle, wenn sie selbstgewählt sind gemischt_

Lieblingshelden in der Geschichte? _/_

Lieblingsheldinnen in der Geschichte? _/_

Lieblingscharaktere in der Poesie? _dämonische_

Deine Lieblingsnamen? _Lily_

Welche geschichtlichen Charaktere kannst Du nicht leiden? _die gefürchteten_

Welche Fehler würdest Du am ersten entschuldigen? _Druckfehler_

Deine unüberwindliche Abneigung? _früh aufstehen müssen_

Wovor fürchtest Du Dich? _Vor der Jury_

Lieblingsspeise und =Trank? _Guter roter Wein_

Dein Temperament? _zu nach der Gemütsverfassung_

1908 P. K.

Klee's answers to a questionnaire (*right*). Both the origin and purpose of the questionnaire are unknown. Klee was an amateur photographer, and it might have been part of a package of film or development paper he obtained. 1908. Photograph Collection Felix Klee

Your favorite qualities in a man?
education and brains

Your favorite qualities in a woman?
health and refinement

Your favorite occupation?
to see

Your idea of happiness?
to be successful in your work

Which profession do you like best?
the one that brings out your greatest talent

Who would you like to be if not yourself?
a cat in my house

Where would you like to live?
without friends nowhere

When would you like to have lived?

Your idea of unhappiness?
not being able to work

The main facet of your character?
tendency toward being matter of fact, facts in general (facts concerning me)

Your favorite authors?
those of few words

Your favorite painters and sculptors?
Goya, Manet

Your favorite composers?
Bach, Mozart, and Beethoven

Your favorite colors and flowers?
all when well painted/mixed

Your favorite heroes in history?

Your favorite heroines in history?

Your favorite characters in poetry?
the demonic ones

Your favorite name?
Lily

Which character from history do you dislike?
the fake ones

Which errors would you most easily forgive?
misprints

Your greatest, insurmountable dislike?
to have to talk a lot

What are you afraid of?
the jury

Favorite dish or drink?
good red wine

What's your temperament like?
it depends on my frame of mind

1908 P K

Bibliography

Full citations for bibliographic references in
the entries are cited below.

ABADIE, DANIEL. *Paul Klee.* Paris: Maeght Éditeur, 1977.

AICHELE, PORTER K. "Paul Klee's Operatic Themes and Variations." *The Art Bulletin* 68, no. 3 (September 1986): 450–66.

AMMAN, JEAN-CHRISTOPHE. "Die Tunesien-Aquarelle Paul Klees von 1914." *Kunst-Nachrichten* (Lucerne) 2, no. 3 (December 1965).

ARNASON, H. H. *History of Modern Art.* New York: Harry N. Abrams, 1977.

AWAZU, NORIO. *Klee/Kandinsky.* Tokyo: L'Art du Monde, 1968.

BARRIÈRE, GÉRARD. "Paul Klee." *Connaissance des Arts,* no. 266 (April 1974): 104–11.

BRION, MARCEL. *Klee.* Paris: Éditions Aimery Somogy, 1955.

BURNETT, DAVID. "Paul Klee: The Romantic Landscape." *Art Journal* 36, no. 4 (Summer 1977): 322–26.

Cahiers d'Art 20–21 (1945–46): 9–74. Texts on Klee by Christian Zervos, Georges Duthuit, Pierre Mabille, Tristan Tzara, Jean Bousquet, Georges Bataille, Roger Vitrac, Will Grohmann, Victor Hugo, René Char, and Jacques Prévert.

CARPI, PININ. *L'Isda dei quatri margici.* Milan, 1973.

CHEVALIER, DENYS. *Klee.* Translated by Eileen B. Hennessy. New York: Crown Publishers, 1971.

COOPER, DOUGLAS. *Paul Klee.* Harmondsworth, Middlesex: Penguin Books, 1949.

COURTHION, PIERRE. *Klee.* Paris: Fernand Hazan, 1953.

CRAMER, GÉRALD. Galerie Gérald Cramer, Geneva, stock catalogue, no. 10, 1956.

CREVEL, RENÉ. *Paul Klee.* Paris: Gallimard, 1930.

Der Ararat. Zweites Sonderheft: Paul Klee. Special issue as exhibition catalogue. Munich, Neue Kunst Hans Goltz, May–June 1920.

Du 8, no. 10 (October 1948). Special issue devoted to Paul Klee. With contributions by Rolf Bürgi, Max Huggler, Felix Klee, Carola Giedion-Welcker, and Paul Éluard.

DUVIGNAUD, JEAN. *Klee en Tunisie.* Lausanne and Paris: La Bibliothèque des Arts, 1980.

EINSTEIN, CARL. *Die Kunst des 20. Jahrhunderts.* Vol. 16. 3rd rev. ed. Berlin: Propyläen Kunstgeschichte, 1926.

FERRIER, JEAN-LOUIS. *Paul Klee: Les années 20.* Paris: Éditions Denoël, 1971. With a text by René Crevel that was originally published as the introduction to the catalogue of Klee's exhibition at the Galerie Alfred Flechtheim, Berlin, 1928.

FISHER, ROBERT. *Klee.* New York: Tudor Publishing Co., 1966.

FORGE, ANDREW. Introduction and notes to *Klee (1879–1940) (Second Volume).* London: Faber and Faber, 1961.

GEELHAAR, CHRISTIAN. *Paul Klee and the Bauhaus.* Translator unknown. Greenwich, Conn.: New York Graphic Society, 1973.

———. *Paul Klee: Life and Work.* Translated by W. Walter Jaffe. Woodbury, N.Y.; London; and Toronto: Barron's, 1982.

GIEDION-WELCKER, CAROLA. "Bildinhalte und Ausdrucksmittel bei Paul Klee." *Werk* 35, no. 3 (March 1948): 81–89.

———. *Paul Klee.* Translated by Alexander Gode. New York: The Viking Press, 1952.

———. *Paul Klee.* Stuttgart: Verlag Gerd Hatje, 1954.

———. *Paul Klee in Selbstzeugnissen und Bilddokumenten.* Reinbek bei Hamburg: Rowolt Taschenbuch Verlag, 1961.

GLAESEMER, JÜRGEN. *Paul Klee Handzeichnungen I: Kindheit bis 1920.* Bern: Paul Klee Stiftung, 1973.

———. *Paul Klee: The Colored Works in the Kunstmuseum Bern.* Translated by Renate Franciscono. Bern: Kornfeld and Cie, 1979.

———. *Paul Klee Handzeichnungen II: 1921–1936.* With the assistance of Judith Adank and Stefan Frey. Bern: Kunstmuseum, 1984.

———. "Paul Klee and German Romanticism." In *Paul Klee.* Exhibition catalogue, compiled by Carolyn Lanchner, pp. 65–81. New York: The Museum of Modern Art, 1987.

———. "Paul Klee und die deutsche Romantik." In *Paul Klee Leben und Werk.* Exhibition catalogue, compiled by the Paul Klee Stiftung, Kunstmuseum Bern, and The Museum of Modern Art, New York, pp. 13–29. Bern: Kunstmuseum, 1987.

GONTHIER, PIERRE-HENRI, ed. and trans. *Paul Klee Theorie de l'art moderne.* Basel: Benno Schwabe & Co., 1964.

GROHMANN, WILL. "Paul Klee 1923–24." *Der Cicerone* 16, no. 17 (August 1924): 786–98. Reprinted in *Jahrbuch der Jungen Kunst.* Leipzig: Klinkhardt & Biermann, 1924.

———. *Paul Klee.* Paris: Éditions Cahiers d'Art, 1929.

———. *Die Sammlung Ida Bienert Dresden.* Potsdam: Müller & I. Kiepenheuer, 1933.

———. *Paul Klee: Handzeichnungen 1921–1930.* Potsdam and Berlin: Müller & I. Kiepenheuer, 1934.

———. *Paul Klee.* Translator unknown. New York: Harry N. Abrams, 1954.

———. *Paul Klee, 1879–1940.* Munich: Kurt Desch, 1955.

———. "Weimar Bauhaus Dessau." *L'Œil,* no. 28 (April 1957): 12–21.

———. *Paul Klee.* Milan: Silvan Editoriale d'Art, 1958.

———. *Paul Klee.* Translated by Norbert Guterman. New York: Harry N. Abrams, 1967.

GÜSE, ERNST-GERHARD. *Die Tunisreise: Klee, Macke, Moilliet.* Stuttgart: Verlag Gerd Hatje, 1982.

HALL, DOUGLAS. *Klee.* New York: Dutton, 1977.

HAXTHAUSEN, CHARLES WERNER. *Paul Klee: The Formative Years.* New York and London: Garland Publishing, 1981.

HENRY, SARA LYNN. "Paul Klee, Nature and Modern Science, The 1920s." Ph.D. dissertation, University of California, Berkeley, 1976.

———. "Formcreating—Energies: Paul Klee and Physics." *Arts Magazine* 52, no. 1 (September 1977): 118–21. Special issue devoted to Paul Klee.

HOFSTÄTTER, HANS H. *Malerei und Graphik der Gegenwart.* Baden-Baden: Holle Verlag, 1969.

HUGGLER, MAX. *Paul Klee: Die Malerei als Blick in den Kosmos.* Frauenfeld and Stuttgart: Verlag Huber, 1969.

————. *Paul Klee.* Translated by Norbert Guterman. London: Thames & Hudson, 1987.

JORDAN, JIM M. *Paul Klee and Cubism.* Princeton, N.J.: Princeton University Press, 1984.

KAGAN, ANDREW. "Paul Klee's 'Ad Parnassum': The Theory and Practice of Eighteenth-Century Polyphony as Models for Klee's Art." *Arts Magazine* 52, no. 1 (September 1977): 90–104. Special issue devoted to Paul Klee.

————. *Paul Klee/Art & Music.* Ithaca, N.Y.: Cornell University Press, 1983.

KAHNWEILER, DANIEL-HENRY. *Klee.* Paris: Les Éditions Braun & Cie, 1950.

KERSTEN, WOLFGANG. "Paul Klee: Zerstörung der Konstruktion zuliebe?" *Studien zur Kunst- und Kulturgeschichte 5.* Marburg: Jonas Verlag, 1987.

KLEE, FELIX. *Paul Klee: Leben und Werk in Dokumenten.* Zürich: Diogenes Verlag, 1960. Translated by Richard and Clara Winston as *Paul Klee: His Life and Work in Documents.* New York: George Braziller, 1962. Expanded French version published as *Paul Klee par lui-même et par son fils Felix Klee.* Edited by Bernard Gheerbrant. Paris: Les Libraires Associés, 1963.

————. *Paul Klee/12 aquarelles.* Translated by Pierre-Henri Gonthier. Paris: Berggruen & Cie, 1964.

LAMAC, MIROSLAV. *Paul Klee.* Prague, 1965.

LANCHNER, CAROLYN. "Klee in America." In *Paul Klee.* Exhibition catalogue, compiled by Carolyn Lanchner, pp. 83–111. New York: The Museum of Modern Art, 1987.

————. "Klee in Amerika." In *Paul Klee Leben und Werk.* Exhibition catalogue, compiled by the Paul Klee Stiftung, Kunstmuseum Bern, and The Museum of Modern Art, New York, pp. 83–111. Bern: Kunstmuseum, 1987.

LANGUI, ÉMILE. Introduction to *Collection Urvater. Les Grandes Collections Belges.* Exhibition catalogue. Brussels: Éditions de la Connaissance, 1957.

LARSON, KAY. "The Met's Modern Movement." *New York Magazine,* August 26, 1985, p. 98.

LAUDE, JEAN. "Paul Klee." In *"Primitivism" in 20th Century Art.* Edited by William Rubin. Vol. 2. New York: The Museum of Modern Art, 1984.

MARCHIORI, GIUSEPPE. *La Pittura Straniera nelle Collezioni Italiane.* Turin: Edizioni d'Arte Fratelli Pozzo, 1960.

MARNAT, MARCEL. *Klee.* Paris: Fernand Hazan, 1974.

MESSER, THOMAS M. *Paul Klee Exhibition at the Guggenheim Museum: A Post Scriptum.* New York: The Solomon R. Guggenheim Museum, 1968.

————. "Paul Klee at The Baltimore Museum of Art." *Baltimore Museum of Art Annual* IV, no. 12 (1972): 71–79.

MICKO, MIROSLAV. *Expressionismus.* Prague: Obelisk, 1969.

MILLER, DOROTHY C., ed. *The Nelson A. Rockefeller Collection: Masterpieces of Modern Art.* New York: Hudson Hills Press, 1981.

MILLER, MARGARET, ed. *Paul Klee.* 2nd rev. ed. New York: The Museum of Modern Art, 1945. With excerpts from Klee's diary, his untitled essay for *Schöpferische Konfession,* 1920 (as "Opinions on Creation"), and articles by Alfred H. Barr, Jr., Julia and Lyonel Feininger, and James Johnson Sweeney.

MIYAJIMA, HISOA, et al. "Paul Klee—The Mitos of Plastic Thinking." *Monthly Art Magazine Bijutso Techo* (Tokyo) 28, no. 412 (October 1976): 9–112.

MUSEUM OF MODERN ART, THE. Addenda to *Paul Klee.* Exhibition catalogue, by Alfred H. Barr, Jr., et al. New York: 1941.

NAKAHARA, YUSUKE. *Paul Klee.* Tokyo: Shueisha, 1971.

NEUMANN, J. B. *Klee in the U.S.A.* Unpublished ms. New York: The Museum of Modern Art (special collection), c. 1949.

NIERENDORF, KARL, ed. *Paul Klee: Paintings, Watercolors 1913 to 1939.* Introduction by James J. Sweeney. New York: Oxford University Press, 1941.

O'CONNOR, PATRICK. "Paul Klee in New York." *FMR,* no. 25 (March/April 1986): 7–9.

OHOKA, MAKATO. *Klee.* Tokyo: Shinchoska, 1976.

P. H. "Kunsthalle Paul Klee—Hermann Haller." *Berner Tageblatt,* March 7, 1935, unpaginated.

PONENTE, NELLO. *Klee.* Translated by James Emmons. Geneva: Skira, 1960.

READ, HERBERT. "Hommage à Paul Klee: Imagination and Phantasy," *20e Siècle,* no. 4 (December 1958): 30–36.

REWALD, SABINE. "The Berggruen Klee Collection." In *Notable Acquisitions 1984–85.* New York: The Metropolitan Museum of Art, 1985.

ROSENTHAL, MARK LAWRENCE. "Paul Klee and the Arrow." Ph.D. dissertation, University of Iowa, Iowa City, 1979.

————. "The Myth of Flight in the Art of Paul Klee." *Arts Magazine* 55, no. 1 (September 1980): 90–95.

SAN LAZZARO, GUALTIERI DI. *Klee: A Study of His Life and Work.* Translated by Stuart Hood. New York: Frederick A. Praeger, 1957.

SCHUSTER, PETER-KLAUS, ed. *Nationalsozialismus und Entartete Kunst.* Munich: Prestel Verlag, 1987.

SPILLER, JÜRG, ed. *Das bildnerische Denken.* Basel: Benno Schwabe & Co., 1956. Translated by Ralph Manheim as *Paul Klee: The Thinking Eye.* New York: George Wittenborn; London: Lund Humphries, 1961.

————. *Paul Klee.* Berlin and Munich: Gebrüder Weiss Verlag Lebendiges Wissen, 1962.

————. *Unendliche Naturgeschichte.* Basel: Benno Schwabe & Co., 1970. Translated by Heinz Norden as *Paul Klee Notebooks, Volume 2: The Nature of Nature.* New York: George Wittenborn, 1973.

TEUBER, MARIANNE L. "Zwei frühe Quellen zu Paul Klees Theorie der Form. Eine Dokumentation." In *Paul Klee: Das Frühwerk 1883–1922.* Exhibition catalogue, compiled by Armin Zweite, pp. 261–96. Munich: Städtische Galerie im Lenbachhaus, 1979–80.

TOWER, BEEKE SELL. *Klee and Kandinsky in Munich and at the Bauhaus.* Ann Arbor, Mich.: UMI Research Press, 1981.

TRISKA, EVA-MARIA. "Die Quadratbilder Paul Klees—ein Beispiel für das Verhältnis seiner Theorie zu seinem Werk." In *Paul Klee: Das Werk der Jahre 1919–1933.* Exhibition catalogue, compiled by Siegfried Gohr, pp. 43–78. Cologne: Kunsthalle, 1979.

————. "Die Quadratbilder Paul Klees—ein Beitrag zur Analyse formaler Ausdrucksmittel in seinem Werk und seiner Theorie." Ph.D. dissertation, University of Vienna, 1980.

UEBERWASSER, WALTER. "Klee chiffrierte Weltgedanken bei Paul Klee." *Die Kunst und das Schöne Heim* 61, no. 11 (August 1963): 550–55.

UNESCO, ed. *Catalogue de reproductions en couleurs de*

peintures 1860 à 1965. Paris: L'Organisation des Nations Unis pour l'éducation, la science et la culture, 1965.

VERDI, RICHARD. *Klee and Nature*. New York: Rizzoli, 1985.

WADA, SADAO. *Paul Klee and His Travels*. Tokyo: Nantenshi Gallery, 1980.

WALDSTEIN, AGNES. *Museum Folkwang, Moderne Kunst, Malerei, Plastik, Grafik*. Vol. 1, no. 533. Essen: Museum Folkwang, 1929. Reprint 1985.

WALTERSKIRCHEN, KATALIN VON. *Paul Klee*. Translated by Jack Altman. New York: Rizzoli, 1975.

WEDDERKOP, H. VON. *Paul Klee*. Leipzig: Verlag von Klinkhardt & Biermann, 1920.

WERCKMEISTER, O. K. "Klee im Ersten Weltkrieg." In *Paul Klee: Das Frühwerk 1883–1922*. Exhibition catalogue, compiled by Armin Zweite, pp. 166–266. Munich: Städtische Galerie im Lenbachhaus, 1979–80.

WILHELM LEHMBRUCK MUSEUM. *Paul Klee und seine Malerfreunde. Die Sammlung Felix Klee*. Exhibition catalogue, compiled by Siegfried Salzmann and Tilman Osterwold. Duisburg: Wilhelm Lehmbruck Museum, 1971.

WILLRICH, WOLFGANG. *Säuberung des Kunsttempels*. Munich and Berlin: J. F. Lehmanns Verlag, 1937.

ZAHN, LEOPOLD. *Paul Klee: Leben/Werk/Geist*. Potsdam: Gustav Kiepenheuer Verlag, 1920.

List of Exhibitions

AMSTERDAM. 1957. Stedelijk Museum. *Paul Klee.* February 8–March 25, 1957. Exhibition catalogue, with excerpts from Jürg Spiller, ed., *Das bildnerische Denken*, 1956 (translated by Ralph Manheim as *Paul Klee: The Thinking Eye*, 1961). Also shown in Brussels, Palais des Beaux-Arts, April 1–May 15, 1957.

AMSTERDAM. 1962. Stedelijk Museum. *Collectie Rolf E. Stenersen.* June 1962. Exhibition catalogue, introduction by Rolf E. Stenersen.

ANTWERP. 1949. Genootschap voor Schone Kunsten. *Paul Klee.* Checklist with text by Artes.

BASEL. 1916. Kunsthalle. *Februar Ausstellung.* February 12–March 15, 1915. Exhibition catalogue.

BASEL. 1929. Kunsthalle. *Bauhaus Dessau: J. Albers/L. Feininger/W. Kandinsky/P. Klee/O. Schlemmer.* April 20–May 9, 1929. Exhibition catalogue, introduction by Ernst Kállai.

BASEL. 1935. Kunsthalle. *Paul Klee.* October 27–November 24, 1935. Exhibition catalogue. Also shown in Bern, Kunsthalle, February 23–March 24, 1935.

BASEL. 1941. Kunsthalle. *Gedächtnisausstellung Paul Klee.* February 15–March 23, 1941. Exhibition catalogue, introduction by H. Meyer-Benteli. Reduced form shown in Bern, Kunsthalle, November 9–December 8, 1940.

BASEL. 1950. Kunstmuseum. *Paul Klee, 1879–1940: Ausstellung aus Schweizer Privatsammlungen zum 10. Todestag 29. Juni 1950.* June 29–August 20, 1950. Exhibition catalogue, with a reprint of Georg Schmidt's speech at Paul Klee's memorial service in Bern on July 5, 1940.

BASEL. 1963. Galerie Beyeler. *Klee.* March–April 1963. Exhibition catalogue, with excerpts of Klee's letters to friends, texts by Walter Ueberwasser.

BASEL. 1967. Kunsthalle. *Paul Klee 1879–1940: Gesamtausstellung.* June 3–August 13, 1967. Exhibition catalogue, introduction by Will Grohmann. Also shown in New York, The Solomon R. Guggenheim Museum, February–April 1967.

BASEL. 1973. Galerie Beyeler. *Klee.* September–November 1973. Exhibition catalogue, introduction by Reinhold Hohl.

BERKELEY. 1962. University Art Gallery, University of California. *Paul Klee: An Exhibition from the Galka E. Scheyer Collection of the Pasadena Art Museum.* May 3–27, 1962. Exhibition catalogue, introduction by Herschel B. Chipp with Klee's originally untitled essay for *Schöpferische Konfession*, 1920 (translated by Norbert Guterman as "Opinions on Creation").

BERLIN. 1917. Der Sturm. *Achtundfünfzigste Ausstellung/Gösta Adrian-Nilsson/Paul Klee/Gabriele Münter.* Exhibition catalogue. December 1917.

BERLIN. 1919. Der Sturm. *Siebzigste Ausstellung.* January 1919.

BERLIN. 1920. Der Sturm. *Neunundachtzigste Ausstellung Reinhard Goering/Paul Klee.* September 1920. Checklist.

BERLIN. 1921. Landesausstellungsgebäude am Lehrter Bahnhof. *Grosse Berliner Kunstausstellung.* 1921. Exhibition catalogue.

BERLIN. 1928. Galerie Alfred Flechtheim. *Paul Klee.* March 18–April 24, 1928. Exhibition catalogue, introduction by Alfred Flechtheim, "Merci, Paul Klee," by René Crevel (translated by Thea Sternheim).

BERLIN. 1929. Galerie Alfred Flechtheim. *Paul Klee.* October 20–November 15, 1929. Exhibition catalogue, intro-

duction by Alfred Flechtheim. Also shown in New York, The Museum of Modern Art, 1930 (originally intended to be shown at J. B. Neumann's New Art Circle, but canceled there due to lack of space).

BERLIN. 1929. Galerie Ferdinand Möller. *Blätter der Galerie Ferdinand Möller*, vol. 5. October 1929. Exhibition catalogue, introduction by Ernst Kállai.

BERLIN. 1930. Nationalgalerie im Kronprinzenpalais. *Zeichnungen von Paul Klee aus der Sammlung Otto Ralfs, Braunschweig.* April 1930. Checklist.

BERLIN. 1974. Nationalgalerie, Staatliche Museen Preussischer Kulturbesitz. *Hommage à Schönberg: Der Blaue Reiter und das Musikalische in der Malerei der Zeit.* September 11–November 4, 1974. Exhibition catalogue, introduction by Werner Haftmann, essays by Werner Haftmann, Theodor W. Adorno, and Hans Heinz Stuckenschmidt.

BERN. 1931. Kunsthalle. *III. Ausstellung: Paul Klee, Walter Helbig, M. de Vlaminck, Philipp Bauknecht. Plastik: Arnold Huggler.* January 18–February 15, 1931. Checklist.

BERN. 1935. Kunsthalle. *Paul Klee.* February 23–March 24, 1935. Exhibition catalogue, introduction by M(ax) H(uggler). Also shown in Basel, Kunsthalle, October 27–November 24, 1935.

BERN. 1937. Kunstmuseum. *Paul Klee (Leihgaben der Frau H. Bürgi und Besitz des Kunstmuseums).* Checklist.

BERN. 1940. Kunsthalle. *Gedächtnisausstellung Paul Klee/Paul Kunz/Bern/Plastik.* November 9–December 8, 1940. Exhibition catalogue, foreword by H. Meyer-Benteli. Also shown in Basel, Kunsthalle, February 15–March 23, 1941.

BERN. 1947. Kunstmuseum. *Ausstellung der Paul Klee-Stiftung.* November 22–December 31, 1947.

BERN. 1956. Kunstmuseum. *Stiftung und Sammlung Hermann und Margrit Rupf.* February 4–April 2, 1956. Exhibition catalogue, foreword by Max Huggler.

BERN. 1956. Kunstmuseum. *Paul Klee: Ausstellung in Verbindung mit der Paul Klee-Stiftung.* August 11–November 4, 1956. Exhibition catalogue, foreword by Max Huggler.

BERN. 1987–88. Kunstmuseum. *Paul Klee Leben und Werk.* September 25, 1987–January 17, 1988. Exhibition catalogue compiled by the Paul Klee Stiftung, Kunstmuseum Bern, and The Museum of Modern Art, New York, foreword by Jürgen Glaesemer, with essays by Jürgen Glaesemer, Carolyn Lanchner, Ann Temkin, and O. K. Werckmeister. Also shown in New York, The Museum of Modern Art, February 12–May 5, 1987, and Cleveland Museum of Art, June 24–August 16, 1987.

BEVERLY HILLS. 1948. The Modern Institute of Art. *Exhibition Klee: 30 Years of Paintings, Water Colors, Drawings and Lithographs by Paul Klee and in a Klee-like-mood/2000 Years of Coptic, Persian, Chinese, European and Peruvian Textiles.* September 3–October 6, 1948. Exhibition catalogue.

BOLOGNA AND MILAN. 1971. Galleria de' Foscherari, Bologna, and Galleria Eunomia, Milan. *Paul Klee.* November/December 1971–January 1972. Exhibition catalogue, with Italian translation of Klee's 1924 Jena lecture "Über die moderne Kunst" ("On Modern Art," translator unknown).

BOSTON. 1939. The Institute of Modern Art. *The Sources of Modern Painting.* March 2–April 9, 1939. Exhibition catalogue, foreword by James S. Plaut.

BRUSSELS. 1928. Galerie "L'Époque." *Paul Klee 40 Aquarelles.* End of March–April 1928. Exhibition catalogue.

BRUSSELS. 1928. Galerie Le Centaure. *Exposition P. Klee/ Exposition R. Sintenis.* December 22–30, 1928. Exhibition catalogue.

BRUSSELS. 1948. Palais des Beaux-Arts. *Paul Klee.* March 1948. Exhibition catalogue, preface by Georges Limbour.

BRUSSELS. 1957. Palais des Beaux-Arts. *Paul Klee.* March 29–May 12, 1957. Exhibition catalogue, with French translation of excerpts of Klee's 1924 Jena lecture "Über die moderne Kunst" (translated by Pierre Algaux).

CAMBRIDGE, MASS. 1955. Busch-Reisinger Museum, Harvard University. *Artists of the Blaue Reiter.* January 21– February 24, 1955. Exhibition catalogue, introduction by [Charles Kuhn].

CANBERRA. 1986. Australian National Gallery. *20th Century Masters from the Metropolitan Museum of Art, New York.* March 1–April 27, 1986. Exhibition catalogue, introductions by Philippe de Montebello, William S. Lieberman, and Raoul Mellish. Also shown in Brisbane, Queensland Art Gallery, May 7–July 1, 1986.

CHICAGO. 1941. The Arts Club of Chicago. *Paul Klee Memorial Exhibition.* January 31–February 28, 1941. Exhibition catalogue, introduction by James Johnson Sweeney. Addenda to the exhibition *Paul Klee* circulated by The Museum of Modern Art, 1941.

CHICAGO. 1962. The Arts Club of Chicago. *Paul Klee: Works from Chicago Collections.* January 16–February 20, 1962. Exhibition catalogue, foreword by Everett McNear.

CINCINNATI. 1942. Cincinnati Art Museum (assembled by the Cincinnati Modern Art Society). *Paintings by Paul Klee and Mobiles and Stabiles by Alexander Calder.* April 7– May 3, 1942. Exhibition catalogue.

CLEVELAND. 1987. Cleveland Museum of Art. *Paul Klee.* June 24–August 16, 1987. Exhibition catalogue compiled by Carolyn Lanchner, with essays by Jürgen Glaesemer, Carolyn Lanchner, Ann Temkin, and O. K. Werckmeister. Also shown in New York, The Museum of Modern Art, February 12–May 5, 1987, and Bern, Kunstmuseum, *Paul Klee Leben und Werk,* September 25, 1987–January 17, 1988.

COLOGNE. 1979. Kunsthalle. *Paul Klee: Das Werk der Jahre 1919–1933 Gemälde, Handzeichnungen, Druckgraphik.* April 11–June 4, 1979. Exhibition catalogue, introduction by Siegfried Gohr, with essays by Placido Cherchi, Marcel Franciscono, Christian Geelhaar, and Eva-Maria Triska.

COLOGNE-BRAUNSFELD. 1955. Werner Rusche. *Klee.* Spring 1955. Sale catalogue.

COPENHAGEN. 1918. Georg Kleis. *"Der Sturm" International Kunst/Ekspressionister og Kubister Malerier og Skulpturer.* Checklist.

DENVER. 1963. Denver Art Museum. *Paul Klee in Review.* April 7–May 7, 1963. Checklist.

DES MOINES. 1973. Des Moines Art Center. *Paul Klee: Paintings and Watercolors from the Bauhaus Years, 1921–1931.* September 18–October 28, 1973. Exhibition catalogue, introduction by Marianne L. Teuber.

DRESDEN. 1918. Galerie Richter. May 1918.

DRESDEN. 1919. Galerie Ernst Arnold. *Sonderausstellung/Der Sturm/Expressionisten/Futuristen/Kubisten.* April 1919. Exhibition catalogue, foreword by Herwarth Walden, text by [Wassily] Kandinsky.

DRESDEN. 1926. Galerie Neue Kunst Fides. *Ausstellung Paul Klee.* May 21–end of June 1926. Exhibition catalogue.

DRESDEN. 1929. Galerie Neue Kunst Fides. *Paul Klee zum 50. Geburtstag (Aquarelle aus den Jahren 1920–1929).* February 1–March 1929. Exhibition catalogue, introduction by Rudolf Probst.

DUISBURG. 1974–75. Wilhelm Lehmbruck Museum. *Paul Klee: Das graphische und plastische Werk (mit Vorzeichnungen, Aquarellen und Gemälden).* October 20, 1974– January 5, 1975. Exhibition catalogue, with essays by Marcel Franciscono, Christian Geelhaar, Jürgen Glaesemer, and Mark Rosenthal. Reprinted by the Kunstmuseum Bern, 1975 (Schriftenreihe der Paul Klee-Stiftung No. 2).

DURHAM, N.C. 1951. Women's College Library Gallery (now the Duke University Museum of Art). *Klee, Kandinsky, Feininger.* February 3–28, 1951. Organized by the Duke University Arts Council. Checklist.

DÜSSELDORF. 1922. Haus Leonhard Tietz. *Katalog der Ersten Internationalen Kunstausstellung Düsseldorf 1922.* May 28– July 3, 1922. Exhibition catalogue.

DÜSSELDORF. 1930. Galerie Alfred Flechtheim. *Paul Klee: Aquarelle, Zeichnungen und Graphik aus 25 Jahren.* February 15–March 10, 1930. Exhibition catalogue, introduction "Hommage à Paul Klee," by Louis Aragon (translated by T[hea] S[ternheim]), with excerpts from Will Grohmann's book *Paul Klee* (Paris: Éditions Cahiers d'Art, 1929).

DÜSSELDORF. 1931. Kunstverein für die Rheinlande und Westfalen. *Ausstellung* [Paul Klee]. June 14–July 6, 1931. Exhibition catalogue, introduction by Will Grohmann. Organized in conjunction with the Galerie Alfred Flechtheim, Düsseldorf.

DÜSSELDORF. 1967. Städtische Kunsthalle und Kunstverein für die Rheinlande und Westfalen. *Kunst des 20. Jahrhunderts aus rheinisch-westfälischem Privatbesitz.* April 30– June 18, 1967. Exhibition catalogue compiled by Uwe M. Schneede, forewords by Karl Ruhrberg and Karl-Heinz Hering.

DÜSSELDORF. 1987. Kunstsammlung Nordrhein-Westfalen. *Museum der Gegenwart-Kunst in öffentlichen Sammlungen bis 1937.* September 11–November 15, 1987. Exhibition catalogue, with essays by Walter Grasskamp, Anette Kruszynski, Sabine Lange, Gert Mattenklott, and Jörn Merkert.

ESSEN. 1928. Museum Folkwang. *Kunst und Technik.* June 8–July 22, 1928. Exhibition catalogue.

ESSEN. 1969. Museum Folkwang. *Paul Klee: Aquarelle und Zeichnungen.* August 22–October 12, 1969. Exhibition catalogue, introduction by Uta Laxner.

FRANKFURT AM MAIN. 1950. Galerie Buchheim-Militon. *Paul Klee: Gemälde, Aquarelle, Zeichnungen, Graphik.* Exhibition catalogue, introduction by Will Grohmann.

FRANKFURT AM MAIN. 1968. Frankfurter Kunstverein. *Aus dem Traumbuch der Maler/Phantasie und Vision.* August 10– September 29, 1968. Exhibition catalogue, introduction by Ewald Rathke.

GENEVA. 1959. Galerie D. Benador. *Paul Klee: aquarelles et dessins.* July 1959. Exhibition catalogue, introduction by Felix Klee, with statement by Paul Klee as introductory text.

GENEVA. 1960. Galerie du Perron. *Paul Klee (1879–1940).* July 1960. Exhibition catalogue, with 1902 statement by Paul Klee as introductory text.

GENEVA. 1965. Galerie du Perron. *Paul Klee.* July 6–end of August. Checklist.

GERA. 1925–26. Städtisches Museum (assembled by the Gerarer Kunst-Verein). *Paul Klee*. December 25, 1925–mid-January 1926. Exhibition catalogue.

GÖTEBORG. 1958. Konstmuseum. *Paul Klee i Rolf Stenersens Samling*. Exhibition catalogue, with essays by Alfred Westholm, Agnes Widlund, and Rolf Stenersen. October 30–November 23, 1958.

HAMBURG. 1956–57. Kunstverein. *Paul Klee*. December 2, 1956–January 27, 1957. Exhibition catalogue, introduction by Alfred Hentzen.

HANNOVER. 1931. Kestner-Gesellschaft. *Paul Klee*. March 7–April 5, 1931. Checklist.

HANNOVER. 1952. Kestner-Gesellschaft. *Paul Klee*. May 20–June 22, 1952. Exhibition catalogue, introduction by Alfred Henzten.

HOLLYWOOD. 1930. Braxton Gallery. *The Blue Four/Feininger/Jawlensky/Kandinsky/Paul Klee*. March 1–15, 1930. Exhibition catalogue, preface by Harry Braxton.

JERUSALEM. 1966. The Israel Museum. *Works of Art from the Collection of Mr. and Mrs. Markus Mizne*. Summer 1966. Exhibition catalogue, introduction by Ladislas Segy.

LONDON. 1945–46. National Gallery. *Paul Klee 1879–1940*. December 1945–February 1956. Exhibition catalogue, introduction by Rolf Bürgi.

LONDON. 1946. The Arts Council of Great Britain. *Paul Klee 1879–1940*. Exhibition catalogue, introduction by Rolf Bürgi. Reduced form of exhibition *Paul Klee 1879–1940* shown at National Gallery, London, 1945–46; traveled to Castle Museum, Norwich, May 11–June 1; Graves Art Gallery, Sheffield, June 8–29; Hanley Public Museum and Art Gallery, Stoke-on-Trent, July 6–27; Art Gallery and Industrial Museum, Aberdeen, August 3–24; Bluecoat Chambers, Liverpool, August 31–September 21; City Art Gallery, Manchester, September 28–October 19, 1946.

LONDON. 1958. The Arts Council of Great Britain. *Paintings from the Urvater Collection*. Exhibition catalogue, foreword by Gabriel White. Shown at Museum and Art Gallery, Leicester, September 13–October 4; City of York Art Gallery, York, October 11–November 11; Tate Gallery, London, November 12–December 14, 1958.

LONDON. 1959. Marlborough Fine Art Limited. *XIX and XX Century European Masters*. Summer 1959. Exhibition catalogue, introduction by Christopher Cumberlege.

LONDON. 1959. Marlborough Fine Art Limited. *Art in Revolt: Germany 1905–25*. October–November 1959. Exhibition catalogue by Will Grohmann.

LONDON. 1961. Molton Gallery. *Paul Klee*. June 21–July 15, 1961. Exhibition catalogue.

LONDON. 1966. Marlborough Fine Art Limited. *Paul Klee*. June–July 1966. Exhibition catalogue, introduction by Will Grohmann (translated by Frank Whitford).

LONDON. 1966. Brook Street Gallery. *Klee*. June–September 1966. Checklist.

LONDON. 1978. Hayward Gallery. *Dada and Surrealism Reviewed*. January 11–March 27, 1978. Exhibition catalogue, introduction by David Sylvester, essay by Elizabeth Cowling. Organized by The Arts Council of Great Britain.

LOS ANGELES. 1940. Stendahl Gallery. *Paul Klee*. March 11–30, 1940.

LUCERNE. 1936. Kunstmuseum. *Paul Klee/Fritz Huf*. April 26–June 3, 1936. Exhibition catalogue.

LUCERNE. 1953. Kunstmuseum. *Deutsche Kunst: Meisterwerke des 20. Jahrhunderts*. July 4–October 2, 1953. Exhibition catalogue by Ludwig Grote, Adolf Reinle, and Leonie von Wilckens.

MANNHEIM. 1924. Kunsthalle. *Zwei Malerphantasten: Paul Klee und Alfred Kubin*. November–December 1924. Exhibition catalogue.

MANNHEIM. 1927. Kunsthalle. *Wege und Richtungen der abstrakten Malerei in Europa*. January 30–March 27, 1927. Exhibition catalogue, text by G. F. Hartlaub.

MANNHEIM. 1933. Kunsthalle. *Kulturbolschewistische Bilder*. April 4–June 5, 1933. Also shown in Munich, Kunstverein, June–July 1933, and Erlangen, Kunstverein, July–August 1933.

MINNEAPOLIS. 1955. The Minneapolis Institute of Arts. *40 Works by Paul Klee from the Collection of F. C. Schang*. June 5–August 31, 1955. Checklist.

MUNICH. 1915. Neue Kunst Hans Goltz. *Frühjahrsausstellung*. April 1915. Exhibition catalogue.

MUNICH. 1916. Galeriestrasse 26. *Münchener Neue-Secession: II. Ausstellung*. June 1–September 30, 1916. Also shown in Frankfurt am Main and Wiesbaden. Exhibition catalogue.

MUNICH. 1917. Galeriestrasse 26. *Münchener Neue-Secession: III. Ausstellung*. Opened June 10, 1917. Exhibition catalogue.

MUNICH. 1918. Galeriestrasse 26. *Münchener Neue-Secession: IV. Ausstellung*. June–October 1918. Exhibition catalogue.

MUNICH. 1920. Neue Kunst Hans Goltz. *Paul Klee: Katalog der 60. Ausstellung der Galerie Neue Kunst Hans Goltz*. May–June 1920. Special issue of the magazine *Der Ararat. Zweites Sonderheft: Paul Klee* served as catalogue.

MUNICH. 1921. Glaspalast (Westflügel). *Münchener Neue-Secession: VII. Ausstellung*. Exhibition catalogue.

MUNICH. 1922. Neue Kunst Hans Goltz. *Zehn Jahre neue Kunst in München: Aquarelle/Zeichnungen/Graphik*. November–December 1922.

MUNICH. 1925. Hans Goltz. *Paul Klee: 2. Gesamtausstellung 1920/1925*. May–June 1925. Exhibition catalogue.

MUNICH. 1979–80. Städtische Galerie im Lenbachhaus. *Paul Klee: Das Frühwerk 1883–1922*. Exhibition catalogue compiled by Armin Zweite, with essays by Marcel Franciscono, Christian Geelhaar, Jürgen Glaesemer, Rosel Gollek, Charles Werner Haxthausen, Jim M. Jordan, Regula Suter-Raeber, Marianne L. Teuber, and O. K. Werckmeister. December 12, 1979–March 2, 1980.

NEWCASTLE UPON TYNE. 1950. Hatton Gallery, King's College in the University of Durham. *Paintings of the Twentieth Century from the Collection of Mr. Douglas Cooper*. March 1–May 1950. Checklist.

NEW YORK. 1930. The Museum of Modern Art. *Paul Klee*. March 13–April 2, 1930. Exhibition catalogue, introduction by Alfred H. Barr, Jr. Earlier shown in Berlin, Galerie Alfred Flechtheim, 1929.

NEW YORK. 1936. The Museum of Modern Art. *Cubism and Abstract Art*. March 2–April 19, 1936. Exhibition catalogue by Alfred H. Barr, Jr.

NEW YORK. 1936–37. The Museum of Modern Art. *Fantastic Art, Dada, Surrealism*. December 7, 1936–January 17, 1937. Exhibition catalogue by Alfred H. Barr, Jr.

NEW YORK. 1938. Buchholz Gallery. *Paul Klee*. March 23–April 23, 1938. Exhibition catalogue.

NEW YORK. 1938. Nierendorf Galleries. *Exhibition Paul Klee*. November 1938. Checklist, with introduction by Perry Rathbone.

NEW YORK. 1939. Buchholz Gallery. *Paul Klee*. November 1–26, 1939. Exhibition catalogue.

NEW YORK. 1940. Buchholz Gallery. *Landmarks in Modern German Art*. April 2–27, 1940. Exhibition catalogue, introduction by Perry T. Rathbone.

NEW YORK. 1940. Buchholz Gallery/Willard Gallery. *Paul Klee*. October 9–November 2, 1940. Exhibition catalogue, introduction by James Johnson Sweeney.

NEW YORK. 1941. Traveling exhibition prepared by Department of Circulating Exhibitions, The Museum of Modern Art. *Paul Klee*. Exhibition catalogue, with essays by Alfred H. Barr, Jr., James Johnson Sweeney, and Julian and Lyonel Feininger. Shown at Smith College Museum of Art, Northampton, Mass.; The Arts Club of Chicago; The Portland Art Museum; The San Francisco Museum of Art; Stendahl Galleries, Los Angeles; The City Art Museum of St. Louis; The Museum of Modern Art, New York; Wellesley College, Wellesley, Mass.

NEW YORK. 1944. Buchholz Gallery. *"The Blue Four" Feininger/Jawlensky/Kandinsky/Klee*. October 31–November 25, 1944. Exhibition catalogue, with excerpts from the artists' letters to Galka E. Scheyer.

NEW YORK. 1947. Nierendorf Galleries. *A Comprehensive Exhibition of Works by Paul Klee from the Estate of the Artist*. October 1947. Checklist.

NEW YORK. 1948. Kende Galleries at Gimpel Brothers. April 1948.

NEW YORK. 1950. Buchholz Gallery. *Paul Klee*. May 2–27, 1950. Exhibition catalogue, with excerpts from Klee's diary.

NEW YORK. 1952. J. B. Neumann's New Art Circle. *Klee*. April 18–May 30, 1952. Checklist.

NEW YORK. 1953. Curt Valentin Gallery (formerly Buchholz Gallery). *Paul Klee*. September 29–October 24, 1953. Exhibition catalogue, with unpublished excerpts from Klee's diary.

NEW YORK. 1954–55. Curt Valentin Gallery. *Der Blaue Reiter*. December 7, 1954–January 8, 1955. Exhibition catalogue, with excerpts from a letter by Kandinsky of 1930, and an essay by Franz Marc of 1912.

NEW YORK. 1955. Saidenberg Gallery. *Paul Klee*. October 10–November 19, 1955. Exhibition catalogue.

NEW YORK. 1957. Saidenberg Gallery. *Paul Klee*. November 11–December 14, 1957. Exhibition catalogue.

NEW YORK. 1958. World House Galleries. *Modern German Art*. October 29–December 10, 1958. Exhibition catalogue, introduction by J. B. Neumann.

NEW YORK. 1960. World House Galleries. *Paul Klee*. March 8–April 2, 1960. Exhibition catalogue.

NEW YORK. 1967. The Solomon R. Guggenheim Museum. *Paul Klee 1879–1940: A Retrospective Exhibition*. February–April 1967. Exhibition catalogue, introduction by Will Grohmann, foreword by Felix Klee (translated by Alfred Werner). Also shown in Basel, Kunsthalle, June 3–August 13, 1967.

NEW YORK. 1969. The Museum of Modern Art. *Twentieth Century Art from the Nelson Aldrich Rockefeller Collection*. May 28–September 1, 1969. Exhibition catalogue by William S. Lieberman, foreword by Monroe Wheeler, preface by Nelson Rockefeller.

NEW YORK. 1977. Serge Sabarsky Gallery. *Paul Klee: The Late Years, 1930–1940*. Fall 1977. Exhibition catalogue.

NEW YORK. 1984. Leonard Hutton Galleries. *The Blue Four*. March 30–May 24, 1984. Exhibition catalogue, foreword by Peg Weiss.

NEW YORK. 1984–85. The Museum of Modern Art. *"Primitivism" in 20th Century Art*. September 19, 1984–January 15, 1985. Exhibition catalogue in two volumes edited by William Rubin, with essays by Ezio Bassani, Christian F. Feest, Jack D. Flam, Sidney Geist, Donald E. Gordon, Rosalind Krauss, Jean Laude, Gail Levin, Evan Maurer, Jean-Louis Paudrat, Philippe Peltier, Laura Rosenstock, William Rubin, Kirk Varnedoe, and Alan G. Wilkinson.

NEW YORK. 1985. The Metropolitan Museum of Art. *Selection II*. June 4–September 2, 1985. Checklist.

NEW YORK. 1987. The Museum of Modern Art. *Paul Klee*. February 12–May 5, 1987. Exhibition catalogue compiled by Carolyn Lanchner, with essays by Jürgen Glaesemer, Carolyn Lanchner, Ann Temkin, and O. K. Werckmeister. Also shown in Cleveland, Cleveland Museum of Art, June 24–August 16, 1987, and Bern, Kunstmuseum, *Paul Klee Leben und Werk*, September 25, 1987–January 17, 1988.

OSAKA. 1979. Gallery Kasahara. *Paul Klee*. Exhibition catalogue.

OTTERLO. 1957. Rijksmuseum Kröller-Müller. *Verzameling Urvater*. June 29–September 2, 1957. Exhibition catalogue, foreword by Gabriel White. Also shown in Liège, Musée des Beaux-Arts, 1957. Circulated in 1958 by The Arts Council of Great Britain as *Paintings from the Urvater Collection* to Museum and Art Gallery, Leicester; City of York Art Gallery, York; Tate Gallery, London. Also shown in Belgrade, Art Pavilion, April 7–21, 1959, and Zagreb, Gallery of Modern Art JAZU, April 29–May 18, 1959.

PALM BEACH. 1951. Society of the 4 Arts. *Paintings by Paul Klee 1879–1940*. March 9–April 1, 1951. Exhibition catalogue.

PARIS. 1925. Galerie Vavin-Raspail. *39 aquarelles de Paul Klee illustrant le mot du peintre seront exposées pour la première fois en France*. October 21–November 14, 1925. Exhibition catalogue, with text by Louis Aragon and poem "Paul Klee" by Paul Éluard.

PARIS. 1927. Galerie Vavin-Raspail. *23 aquarelles de Paul Klee illustrant le mot du peintre seront exposées pour la deuxième fois en France*. March 16–31, 1927. Exhibition catalogue.

PARIS. 1929. Galerie Georges Bernheim et Cie. *Exposition Paul Klee*. February 1–15, 1929. Exhibition catalogue, with introduction by René Crevel. Crevel's text was originally published in the catalogue of the Klee exhibition at Galerie Alfred Flechtheim, Berlin, 1928.

PARIS. 1948. Musée National d'Art Moderne. *Exposition Paul Klee*. February 4–March 1, 1948. Exhibition catalogue, introduction by Henri Hoppenot. Also shown in Brussels, Palais des Beaux-Arts, March 1948.

PARIS. 1955. Berggruen et Cie. *L'Univers de Klee*. May 17–July 9, 1955. Exhibition catalogue, with a poem by Jacques Prévert originally published in *Cahiers d'Art* 20–21 (1945–46).

PARIS. 1959. Berggruen et Cie. *Klee et Kandinsky: Une Confrontation*. March 1959. Exhibition catalogue, introduction by Pierre Volboudt.

PARIS. 1961. Berggruen et Cie. *Klee lui-même/20 oeuvres: 1907–1940*. April 1961. Exhibition catalogue, introduction by Claude Roy.

PARIS. 1969–70. Musée National d'Art Moderne. *Paul Klee*. November 25, 1969–February 16, 1970. Exhibition catalogue, introduction by Jean Leymarie, essay by Françoise Cachin-Nora.

PARIS. 1971. Berggruen et Cie. *Paul Klee: les années 20.* May–July 1971. Exhibition catalogue.

PARIS. 1974. Grand Palais. *Jean Paulhain à travers ses peintres.* February 1–April 15, 1974. Exhibition catalogue, foreword by Jean Leymarie, introduction by André Berne-Joffroy.

PASADENA. 1967–68. Traveling exhibition organized by The Solomon R. Guggenheim Museum in collaboration with the Pasadena Art Museum, 1967–68. *Paul Klee 1879–1940: A Retrospective Exhibition.* Exhibition catalogue, introduction by Will Grohmann, foreword by Felix Klee (translated by Alfred Werner). Shown at Pasadena Art Museum; San Francisco Museum of Art; Gallery of Fine Arts, Columbus; Cleveland Museum of Art; William Rockhill Nelson Gallery, Kansas City; Baltimore Museum of Art; Washington University Gallery of Art, St. Louis; Philadelphia Museum of Art. Different exhibition from: *Paul Klee 1879–1940: A Retrospective Exhibition* shown at The Solomon R. Guggenheim Museum, New York, 1967.

PHILADELPHIA. 1944. The Philadelphia Art Alliance. *Paul Klee: Paintings, Drawings, Prints.* March 14–April 9, 1944. Exhibition catalogue, with statements by Elizabeth Morgan and James Johnson Sweeney.

SAARBRÜCKEN. 1930. Staatliche Museum. *Paul Klee/Aquarelle aus 25 Jahren, 1905 bis 1930.* March 23–April 22, 1930. Exhibition catalogue, introduction by Fr. Grewing.

SAINT-PAUL. 1977. Fondation Maeght. *Paul Klee.* July 9–September 30, 1977. Exhibition catalogue, foreword by Jean-Louis Prat, introduction by Antoni Tapies.

SAN FRANCISCO. 1931. California Palace of the Legion of Honor. *The Blue Four/Feininger/Jawlensky/Kandinsky/Paul Klee.* April 23–May 8, 1931. Exhibition catalogue, foreword by Lloyd La Page, text by Diego Rivera.

SAN FRANCISCO. 1940. San Francisco Museum of Art. *Contemporary Art/Paintings, Watercolors and Sculpture Owned in the San Francisco Bay Region.* January 18–February 5, 1940. Exhibition catalogue, foreword by Grace L. McCann Morley.

SAN FRANCISCO. 1941. San Francisco Museum of Art. *Paul Klee: Memorial Exhibition.* April 14–May 5, 1941. Checklist, with works by Klee from the Galka E. Scheyer Collection, introduction by Grace L. McCann Morley. Addenda to the exhibition *Paul Klee* circulated by The Museum of Modern Art, New York, 1941.

SANTA BARBARA. 1960. Museum of Art. *The Art of Paul Klee.* April 12–May 8, 1960. Checklist.

STOCKHOLM. 1961. Moderna Museet. *Paul Klee.* February–April 1961. Exhibition catalogue, introduction by K. G. Hulten. Also shown at Ateneum Helsingfors Helsinki, April 15–May 14, 1961.

STOCKHOLM. 1963–64. Moderna Museet. *Onskemuseet* (The Museum of Our Wishes). December 26, 1963–February 16, 1964. Exhibition catalogue, foreword by Gerard Bonnier, with essays by Olle Granath et al.

TOKYO. 1978. Fuji Television Gallery. *Paul Klee.* September 26–October 20, 1978. Exhibition catalogue.

TOKYO. 1981. Fuji Television Gallery. *Exhibition of Paul Klee.* October 23–November 21, 1981. Exhibition catalogue, introduction by Yoshio Doi (translated by Charles S. Terry).

TORONTO. 1954. The Art Gallery of Toronto. *A Loan Exhibition of Paintings from the Solomon R. Guggenheim Museum, New York.* April 2–May 9, 1954. Exhibition catalogue.

TURIN. 1967–68. Galleria Civica d'Arte Moderna. *Le Muse Inquietanti: Maestri del Surrealismo.* November 1967–January 1968. Exhibition catalogue, with essays by Luigi Carluccio and Luigi Mallé.

TURIN. 1971. Galleria Civica d'Arte Moderna. *Il Cavaliere azzurro.* March 18–May 9, 1971. Exhibition catalogue by Luigi Carluccio and Luigi Mallé.

VENICE. 1954. *La Biennale di Venezia (XXVII. Biennale).* June 19–October 17, 1954. Exhibition catalogue.

WALTHAM, MASS. 1960. Brandeis University, Slosberg Music Center Gallery. *Paul Klee: A Loan Exhibition from American Collections.* May 15–June 15, 1960. Exhibition catalogue.

WELLESLEY, MASS. 1950. Wellesley College. *Paul Klee, Paintings and Prints.* April 15–May 7, 1950.

WIESBADEN. 1924. Neues Museum (assembled by the Nassauischer Kunstverein und Wiesbadener Gesellschaft für Bildende Kunst). *Herbst-Ausstellung 1924.* Autumn 1924. Exhibition catalogue.

WIESBADEN. 1925. Neues Museum (assembled by the Nassauischer Kunstverein und Wiesbadener Gesellschaft für Bildende Kunst). *März-Ausstellung 1925.* March–April 1925. Exhibition catalogue.

WIESBADEN. 1926. Neues Museum (assembled by the Nassauischer Kunstverein und Wiesbadener Gesellschaft für Bildende Kunst). *August-Ausstellung 1926.* August 1926. Exhibition catalogue.

WIESBADEN. 1929. Neues Museum (assembled by the Nassauischer Kunstverein und Wiesbadener Gesellschaft für Bildende Kunst). *30 Deutsche Künstler aus unserer Zeit.* April 6–beginning of June 1929. Exhibition catalogue.

WINTERTHUR. 1952. Kunstmuseum. *Paul Klee.* September 14–November 2, 1952. Exhibition catalogue.

ZÜRICH. 1926. Kunsthaus. *Ausstellung.* April 11–May 5, 1926. Exhibition catalogue.

ZÜRICH. 1929. Kunsthaus. *Abstrakte und surrealistische Malerei und Plastik.* October 6–November 3, 1929. Exhibition catalogue.

ZÜRICH. 1940. Kunsthaus. *Ausstellung Paul Klee Neue Werke.* February 16–March 25, 1940. Exhibition catalogue.

ZÜRICH. 1943. Kunsthaus. *Ausländische Kunst in Zürich.* July 25–September 26, 1943. Exhibition catalogue, introduction by W. Wartmann.

ZÜRICH. 1955. Kunstgewerbeschule der Stadt Zürich, Schule für Gestaltung. *Der Sturm.* April 1–30, 1955. Exhibition catalogue, foreword by Willy Rotzler.

Index of Works in The Berggruen Klee Collection

(Titles of works are listed in English and in German, which appears in *italic* type.)

Index of Names

BAUHAUS (Weimar, 1919–25; Dessau, 1925–32; Berlin, 1932–33), school founded by Walter Gropius (q.v.) in Weimar. It attempted a synthesis between the arts and crafts under the aegis of architecture.

BAYER, HERBERT (1900–85), Austrian-born designer. Former Bauhaus student; later in charge of typography and advertising techniques at the Dessau Bauhaus from 1925–28; he was active in the U.S.A. after 1938 as a photographer and designer.

BLOESCH, HANS JÖRG (1878–1945), Swiss writer and close friend of Paul Klee.

BLUE FOUR (Ger., *Die Blaue Vier*) was a group of four artists—Klee, Kandinsky (q.v.), Feininger (q.v.), and Jawlensky (q.v.)—founded at the instigation of Galka E. Scheyer (q.v.) in 1924 in order to show their works in the U.S.A., which Scheyer visited that May and where she lived until her death in 1945.

BLUE RIDER (Ger., *Der Blaue Reiter*) was an informal avant-garde group of lyrical Expressionist painters founded by Wassily Kandinsky (q.v.) and Franz Marc (q.v.) in Munich in 1911 and named after a painting by Kandinsky. Without a real program or dogma, the members recorded in the *Blaue Reiter* almanac (1912) their interest in the arts of children and primitive people, in folk art, in the art of the avant-garde and the past, in music, and in things somewhat mystical.

BREUER, MARCEL (1902–81), Hungarian-born architect and designer. Former Bauhaus student; later he directed the cabinetmaking workshop at the Dessau Bauhaus from 1925 to 1928; designed a famous tubular steel chair in 1925. He emigrated to the U.S.A. in 1937, where he accepted a professorship at Harvard University. After 1946 he had his own architectural firm in New York.

BÜRGI-BIGLER, HANNAH (1880–1938), collector, wife of the Swiss architect Alfred Bürgi (1873–1919) in Bern.

DIX, OTTO (1891–1969), German painter of the so-called New Objectivity movement.

FEININGER, LYONEL (1871–1956), American painter, active in Germany after 1887. He was the first painter to join the teaching staff at the Bauhaus, where he remained from 1919 to 1933 (Weimar, Dessau, and Berlin), directing the printing workshop at Weimar. He joined the Blue Four (q.v.) in 1924; returned in 1936 to the U.S.A.

FLECHTHEIM, ALFRED (1878–1937), German art dealer who had galleries in Berlin and Düsseldorf.

GEISER, BERNARD FRIEDRICH (1891–1967), Swiss art historian and authority on Pablo Picasso's (q.v.) graphic work. See his *Picasso: Peintre-Graveur. Catalogue illustré de l'oeuvre gravé et lithographie 1899–1931* (Bern, 1933).

GOLTZ, HANS (1873–1927), German art dealer in Munich mainly for the avant-garde.

GROPIUS, WALTER (1883–1969), German-born architect and founder and director of the Bauhaus in Weimar and Dessau from 1919 to 1928. He emigrated to the U.S.A. in 1937 and from 1938 to 1952 was chairman of the Department of Architecture at Harvard University.

HECKEL, ERICH (1883–1970), German painter. Belonged to the avant-garde group of Expressionist artists called *Die Brücke*, founded in Dresden in 1905 and disbanded in 1913.

HESSE, FRITZ (1881–1973), mayor of Dessau, Germany, from 1918–32 and again from July 1945–Nov. 14, 1946. After World War II he was active as a lawyer in West Berlin.

ITTEN, JOHANNES (1888–1948), Swiss painter and sculptor. He was an influential art teacher and created the famous preliminary course at the Bauhaus.

JAWLENSKY, ALEXEI VON (1864–1941), Russian painter. Active in Germany after 1896. In 1909 founding member of the NKV (Neue Künstlervereinigung-München) along with Wassily Kandinsky (q.v.), Gabriele Münter (q.v.), and Marianne von Werefkin (q.v.); joined the Blue Four (q.v.) in 1924.

KAESBACH, WALTER (1879–1961), German art historian. He was director of the Düsseldorf Academy during Klee's brief teaching career there (1931–33).

KANDINSKY, WASSILY (1866–1944), Russian painter. Founding member of the NKV in 1909, and, in 1911, founder of the Blue Rider group (q.v.) along with Franz Marc (q.v.); he taught at the Bauhaus from 1922–32 (Weimar, Dessau, and Berlin). Joined the Blue Four (q.v.) in 1924. Moved to Paris in 1934.

KLEE, EFROSSINA, née Greschowa (1901–77), Bulgarian first wife of Felix Klee.

KLEE, HANS WILHELM (1849–1940), German father of Paul Klee and music teacher.

KLEE, IDA MARIE, née Frick (1855–1921), Swiss wife of Hans Klee (q.v.) and mother of Paul Klee.

KLEE, LILY, née Stumpf (1876–1946), German wife of Paul Klee and a piano teacher.

KLEE, LIVIA MEYER- (b. 1922), Swiss second wife of Felix Klee, and daughter of Hannes Meyer (q.v.).

KUBIN, ALFRED (1877–1959), Austrian painter and graphic artist.

MACKE, AUGUST (1887–1914), German painter; belonged to the Blue Rider group (q.v.).

MAHLER, ALMA (1879–1964), née Schindler; Austrian wife and muse of Gustav Mahler (q.v.), Walter Gropius (q.v.), and Franz Werfel.

MAHLER, GUSTAV (1860–1911), Austrian composer of symphonies and songs.

MARC, FRANZ (1880–1916), German painter and founder of the Blue Rider group (q.v.) with Wassily Kandinsky (q.v.).

MEYER, HANNES (1889–1954), Swiss stonemason and urban planner. He opened his own architectural firm in Basel in 1919, and was director of the Dessau Bauhaus from 1928–30. Worked in Moscow from 1930–36, in Mexico from 1942–49, and returned to Switzerland in 1949.

MIES VAN DER ROHE, LUDWIG (1886–1969), German-born architect and director of the Dessau and Berlin Bauhaus from 1930 to 1933. Emigrated to the U.S.A. in 1938, where he became architect of the Illinois Institute of Technology in Chicago and head of the School of Architecture.

MOHOLY-NAGY, LÁSZLÓ (1895–1946), Hungarian-born painter, sculptor, designer, and author. Invented the "photogram" (photography without camera) and directed the metal workshop and the preliminary course at the Bauhaus from 1923–28; he was co-editor of the books issued by the Bauhaus. Emigrated to the U.S.A. where he directed his own School of Design in Chicago from 1938 on.

MOILLIET, LOUIS-RENÉ (1880–1962), Swiss painter and friend of Paul Klee.

MÜNTER, GABRIELE (1877–1962), German painter and companion of Wassily Kandinsky (q.v.). Founding member of the NKV in 1909. Belonged to the Blue Rider group (q.v.).

PICASSO, PABLO (1881–1973), Spanish painter, sculptor, and graphic artist.

RALFS, OTTO (1892–1955), German businessman and art collector from Brunswick who founded the Klee Gesellschaft (Klee Society) in 1925.

RÄTEREPUBLIK (literally, "Soviet Republic"). Short-lived Communist Munich governments lasting from April 7–13 and April 13–May 3, 1919. Also called "Red Terror" of soldiers', peasants', and workers' councils. Founded by Gustav Landauer, Erich Mühsam, and Ernst Toller (q.v.), it followed on the heels of the November 7, 1918, Revolution fomented by Kurt Eisner (1876–1919), which overthrew the Wittelsbach monarchy in Bavaria.

REICHEL, JOHANNES (Hans) (1892–1958), German painter, writer, and friend of Paul Klee.

RILKE, RAINER MARIA (1875–1926), German poet.

RUPF, HERMANN (1880–1962), Swiss art collector and businessman in Bern.

SCHEYER, GALKA E. (1889–1945), German art enthusiast who founded the Blue Four (q.v.) in 1924.

SCHLEMMER, OSKAR (1888–1943), German painter, sculptor, dancer, and choreographer. Joined the Bauhaus faculty in 1920, where he was in charge of the sculpture workshop; also taught mural painting. He directed the theatrical activities from 1923 on, became director of the theater workshop in 1925, and from 1926 of the experimental stage in the new building of the Dessau Bauhaus. Later taught in Breslau and Berlin.

SCHREYER, LOTHAR (1886–1943), German painter, lawyer, and theater director; he was in charge of the stage workshop at the Weimar Bauhaus from 1921–23 and later was editor of *Der Sturm* magazine.

STUMPF, LUDWIG (1846–1939), German professor of medicine and father of Lily (q.v.), who became Klee's wife.

TOLLER, ERNST (1893–1939), German dramatist, poet, and revolutionary. He was co-founder of the April 1919 Räterepublik (q.v.). Imprisoned from 1919 to 1924, he came to New York in 1936, where he committed suicide.

Triadic Ballet, Oskar Schlemmer's (q.v.) major choreographic work, whose genesis dates back to before World War I and which premiered at the State Theater in Stuttgart in 1922. The ballet evolves around the number three. There are three acts, three dancers (in solos, duos, trios), and 12 scenes. The dancers wear 18 different costumes, which were constructed in such unconventional materials as wood, glass, metal, and stuffed and padded fabrics. Geometrically shaped, the costumes restricted the dancers' movements and made them seem like puppets or automatons.

WEREFKIN, MARIANNE VON (1860–1938), Russian painter. Active in Germany after 1896; founding member of the NKV in 1909; long-time companion of Alexei von Jawlensky (q.v.).

Addendum: Klee's Notations from His Oeuvre Catalogue

Inventory numbers in □ denote works the artist sold.
A=Aquarell (watercolor); G=Gemälde (painting); Z=Zeichnung
(drawing). The earliest work in the Berggruen Collection,
Junkerngasse in Bern, 1893, is not listed in the oeuvre
catalogue.

p. 59	1908	73	Bildnisscizze nach Felix Schwarzaquarell auf Beilpapier
p. 68	1914	□ 94	Aquarell (wie 1914 85) Verkauft Goltz Mai Juni 1920
p. 70	1914	147	Aquarel
p. 64	1914	□ 199	Hammamet mit der Moschee Aquarell auf Ganson Dr. Probst
p. 60	1914	213	Garten in St-Germain b. Tunis Aquarell deutsches Bütten (Fichtner)
p. 72	1915	53	Bewegung gotischer Hallen Aquarell auf dünnes Fabriano
p. 75	1915	85	vor der Stadt Aquarell auf dünnes saugend. Japan Okt. 1919 verkauft durch Walden
p. 77	1915	175	⟨schweres Pathos⟩ Aquarel auf Kreidegrundpapier [later notation on a different page:] <u>Verkäufe der M. Neuen Secession in Frankfurt a. Main</u> (lt. Frl. Weeber 1915 175 250 netto 600 brutto)
p. 79	1917	□ 4	Städtisches Juwel Besitzer Goltz franz. Ingres teilweise gipsgrund
p. 80	1917	□ 29	Triebkraft des Urwaldes im Febr. 1921 Verkauft Goltz Aquarell, Kreidegrund-Leinen
p. 82	1917	□ 54	Verkauft Goltz Mai Juni 20 Aquarell Kreidegrund
p. 85	1918	4	Komp. m. dem gelben Halbmond und dem Y Aquarell dicker Gipsgrund
p. 86	1919	□ 49	Revier eines Katers volkstümliches Aquarell Flugzeugleinen kreidegrundiert Verkauft Goltz Mai Juni 20
p. 90	1919	A 80	Tunesische Gärten Aquarell ital. Ingres gebürstet
p. 92	1919	144	Landschaft m. d schwarzen Säulen Aquar. und Feder dünnes Fabriano
p. 95	1919	201	Herabstossende Vögel und Luftpfeile Aquarell u. schwarze Ölfarbezeichnung Ingres kreidegrundiert
p. 99	1919	206	Abstürzender Vogel Aquarell u. schw. Ölfarbezeichn. v. Gelder
p. 100	1919	A 213	Heuchlerpaar Aquar. u. schwrz. Ölfarbezeichnung v. Gelder
p. 102	1919	222	Dame mit geneigtem Haupt (orange u. gelb) Aquarell u. Ölfarbezeichnung franz. Ingres
p. 104	1920	28	Landschaftliche Holzarchitectur oder Bühnengebirgs-Konstruktion Öl glattes Papier geleimt auf [indecipherable]
p. 107	1920	□ 35	Scene aus Kairuan (nach der Bleist.zchn 1914) Ölfarbezeichnung aquarelliert Japan-Perg. Pap. Besitz. Marianne v. Werefkin
p. 110	1920	□ 38	Kubischer Aufbau (mit kobaltviolettem Kreuz) Ölbild kleiner, fast quadratisch/Pappendeckel Verkauft Goltz April 21
p. 112	1920	62	Abgeworfener und verhexter Reiter Feder Briefpapier
p. 115	1920	Z 98	Zeichnung in der Art eines Netzes geknüpft Feder Briefpapier
p. 117	1920	A □ 147	Liebespaar, erotisches Aquarell monumentalen Stils französ. Ingres Verkauft Goltz Sep 1920
p. 123	1920	□ 174	Perspectiv-Spuk Ölfarbezeichn.u. Aquarell Italien Ingres gelbl.-grau Verkauft Goltz Dez. 1921
p. 119	1920	□ 179	Wunderbare Landung oder „112" Ölfarbezeichn. und Aquarell Canson-Mongolfier-Ingres bräunlich Dr. Hausenstein geschenkt III 21
p. 125	1920	A 186	Tempelgärten (auf gelb gegründet) Aquarell französ. Ingres
p. 120	1920	189	Zeichnung zu 1920/174 (Perspective-Spuk) Federzeichnung Briefpapier
p. 128	1921	□ 6	Wo die Eier herkomen und der gute Braten (für Kind Galston) Ölfarbezeichnung und Aquarell französ. Ingres (Canson)
p. 130	1921	□ 12	Adam und Evchen Ölfarbezeichnung und Aquarell französ. Ingres (leicht getönt) gehört Jawlensky
p. 132	1921	A 18	Hoffmaneske Geschichte Ölfarbezeichnung und Aquarell französ. Ingres (Canson weiss)
p. 135	1921	A 19	Der Mann unter dem Birnbaum Ölfarbezeichnung und Aquarell französ. Ingres MBM weiss
p. 137	1921	26	Gelber Hafen† Ölfarbezeichnung und Aquarell französ. Ingres d'Arches MBM (weiss)
p. 139	1921	28	Winterreise† Ölfarbezeichnung und Aquarell französ. Ingres (Canson)
p. 140	1921	66	Kalte Stadt Aquarell/(aus gelb u.-violett) Fabriano grobkörnig